Learning to Look at Modern Art

Learning to Look at Modern Art is an accessible guide to the visual understanding, history and analysis of modern art. It suggests that the best way to understand the art of the modern and postmodern period is to look closely at it and to consider the different elements that make up each art work – composition, space and form, light and colour, and subject-matter.

This engaging and beautifully written book covers key art movements including Expressionism, Constructivism, the Bauhaus, Surrealism, Pop Art, Conceptual Art and Young British Art. Mary Acton considers a range of modern art forms, such as architecture and design, sculpture and installation, and works on canvas. The book is richly illustrated with 112 black-and-white images and 27 colour images by the artists, designers and architects discussed, ranging from Picasso and Matisse to Le Corbusier, Andy Warhol and Rachel Whiteread.

Mary Acton is an Associate Tutor and a Course Director of the Undergraduate Diploma in the History of Art at Oxford University Department for Continuing Education. Her first book for Routledge, *Learning to Look at Paintings* (1997), is a bestseller.

Learning to Look at Modern Art

Mary Acton

Routledge
Taylor & Francis Group

LONDON AND NEW YORK

First published 2004 by Routledge
11 New Fetter Lane, London EC4P 4EE

Simultaneously published in the USA and Canada
by Routledge
29 West 35th Street, New York, NY10001

Routledge is an imprint of the Taylor & Francis Group

Typeset in Galliard and Gill by M Rules
Printed and bound in Great Britain by
TJ International Ltd, Padstow, Cornwall

British Library Cataloguing in Publication Data
A catalogue record for this book is available from the British Library

A Library of Congress Cataloging in Publication Data
A catalog record for this book has been requested

ISBN 0–415–23811–0 (hbk)
ISBN 0–415–23812–9 (pbk)

With many thanks to my husband, family, friends and colleagues for their patience with me while writing this book, and the encouragement and interest they have continually shown during its progress.

'The past is interesting not only by reason of the beauty which could be distilled from it by those artists for whom it was the present, but also precisely because it is the past, for its historical value. It is the same with the present. The pleasure which we derive from the representation of the present is due not only to the beauty with which it can be invested, but also to its essential quality of being present.'

Charles Baudelaire

Contents

Colour Plates

Black-and-white Plates

Chronology of Modern Art

Dates are approximate; this chronology is not intended to be comprehensive, but to be used as a guide or an *aide memoire* to modern art movements and the main artists involved.

Fauvism (1905–7) France: Henri Matisse, André Derain, Maurice Vlaminck and others.

Expressionism – first phase: Die Brücke (1905–13) Germany: E. L. Kirchner, Eric Heckel, Karl Schmidt-Rottluff and others.

Analytical Cubism (1909–12) and **Synthetic Cubism** (1912–14) France: Pablo Picasso, Georges Braque, Juan Gris and others.

Orphism (1912–14) France: Robert and Sonia Delaunay.

Expressionism – second phase: Der Blaue Reiter (1911–16) Germany: Wassily Kandinsky, Paul Klee, Auguste Macke and Franz Marc.

Futurism (1909–14) Italy: F. T. Marinetti, Umberto Boccioni, Gino Severini and others.

Vorticism (1913–17) England: Percy Wyndham Lewis, Henri Gaudier-Brzeska, Jacob Epstein and others.

Suprematism (1915–19) Russia: Kasimir Malevich.

Constructivism (1917–22) Russia: Naum Gabo, Alexander Rodchenko, Liubov Popova and others.

De Stijl (1917–28) Holland: Theo van Doesburg, Gerrit Rietveld, Piet Mondrian and others.

The Bauhaus (1919–33) Germany: Walter Gropius, Mies van der Rohe, Paul Klee, Wassily Kandinsky and others.

Dada (1915–24) Switzerland and Germany: Marcel Duchamp, Kurt Schwitters, Max Ernst and others.

Neue Sachlichkeit *or* **New Objectivity** (*c.*1920–33) Germany: Otto Dix, George Grosz and others.

Surrealism (1924–39) France: André Breton, Max Ernst, Salvador Dalí, Joàn Miró and others.

Peinture Informelle *and* Art Brut (1945–54) France: Jean Fautrier, Jean Dubuffet and others.

Abstract Expressionism (1947–*c*.1957) America: Jackson Pollock, Mark Rothko, Barnett Newman and others.

Pop Art (1960–75) England: Richard Hamilton, Peter Blake, David Hockney. America: Andy Warhol, Claes Oldenburg, Roy Lichtenstein and others.

Conceptual Art (1960–) Europe and America: Joseph Kosuth, Sol Le Witt, Christo and Jeanne-Claude, Richard Long, Mona Hatoum, Ian Hamilton Finlay and many others.

Arte Povera (1962–) Italy: Michelangelo Pistoletto, Jannis Kounnellis, Mario Merz and others.

Fluxus (1962–) Germany: Joseph Beuys, Anselm Kiefer and others.

Post-Painterly Abstraction (1964–) America: Morris Louis, Ellsworth Kelly, Frank Stella and others.

Minimalism (1965–) America: Robert Morris, Carl Andre, Donald Judd and many others.

Photographic Realism, Hyperrealism *or* Superrealism (late 1960s–) Gerhard Richter and others

Neo-Expressionism (from 1980, but origins in the 1960s) Germany and individuals in other countries: George Baselitz, Markus Lüpertz, Cy Twombly.

Young British Art (1988–) The Freeze exhibition and Sensation exhibition, 1997: Damien Hirst, Mark Wallinger, Rachel Whiteread, Jake and Dinos Chapman, Tracey Emin and many others.

Preface and Acknowledgements

Learning to Look at Modern Art is intended as a companion volume to *Learning to Look at Paintings* rather than a sequel, because in many ways twentieth-century art requires a different kind of visual orientation and more detailed analysis. Some of the artists are the same as in the previous book, but not the examples of their work. I have not necessarily assumed knowledge gained from *Learning to Look at Paintings*, although aspects of modern art were included, so I would expect some cross-fertilization. Once again I have been encouraged to write this book by my students, who say they cannot find this sort of information in other books on modern art.

I have always been interested in modern art, but this interest became more focused when I started teaching art students, who needed to understand more about the background to the art of the twentieth century. It was then that I realised how much, particularly about the theoretical side, might not be intelligible outside a department of fine art. As long ago as that, I thought it must be possible to make modern art more accessible by giving more explanatory information. Since then, much has been written and, especially recently, considerable efforts have been made to reach a wider audience. This can be seen particularly in relation to institutions like London's Tate Modern and the enthusiasm it has aroused.

So, first of all it is my students and my own experience that have directly or indirectly been instrumental in encouraging me to write on modern art. Other friends and colleagues have been very helpful and positive; in particular there were those prepared to consider the architectural aspects. Barry Heathcote, who was until very recently the head of the School of Architecture at the University of Dundee, read Chapter 6 in particular several times and advised me where various buildings should go in relation to other chapters too. Dr Hazel

Conway, the distinguished landscape and architectural historian, helped me especially with my discussion of Daniel Liebeskind's Jewish Museum. I was also inspired to write my section on film and fine art through being introduced to the work of Ken Adam by the film producer Stephen Evans; he worked with Ken Adam on *The Madness of King George* and invited me to a memorable exhibition of Adam's designs at the Serpentine Gallery in 1999; his wife Lyn read several chapters and this was very helpful, as it was with the previous book.

Many other friends and colleagues have been encouraging and taken an interest; most of all I would like to thank my husband, John, who has read every word of the manuscript, and whose experience as a designer and maker of furniture has provided many valuable insights. Our son Harry, who is a research student with a deep interest in twentieth-century fiction, has helped particularly with the important distinction that needed to be made between Modernism and Postmodernism. He also read the first two chapters when I was in the initial stages of writing.

My editor at Routledge, Rebecca Barden, was enthusiastic about the book from the start and very encouraging in many ways; she sent the synopsis and the draft manuscript out to a number of readers whose positive and often trenchant criticisms have helped me to tighten up some of the chapters and to make their arguments more effective. There has also been considerable support and encouragement from Moira Taylor, Senior Development Editor at Routledge, in bringing the book to production, particularly in connection with the complex area of copyright permissions for the illustrations. My copy editor, Gerard Hill, and Ruth Jeavons, Senior Production Editor, were especially helpful in the final stages. Finally, I would like to say how much I have appreciated the patient assistance of Andrew Occleshaw and Daphne Honeybone at Backup Business Services, who enabled me to send the original manuscript and its illustrations to Routledge in an acceptable form. We are indebted to the people and archives below for permission to reproduce photographs. Every effort has been made to trace copyright-holders but in a few cases this has not been possible. Any omissions brought to our attention will be remedied in future editions.

Mary Acton

Introduction

The aim of this book is to try to address some of the questions most commonly asked about modern art. Why does it appear so different from the art of the past? Why is it so difficult to understand? Why does it often seem to need so much theory? How should we approach it? This book tries to make sense of modern art through explanation, analysis and insight.

With the art of the modern era, by which I mean the twentieth century, we have to take into account the major changes in ideas and world history: the period was disrupted by two world wars. Modern art often reflects this; so we need to look at some of those changes and see how they encouraged artists to work in a new way. This cannot necessarily be academically proved in terms of cause and effect; it may be more a matter of insight and judgement, a sort of 'reading between the lines' of visual and verbal expression. The theories of modern art are also crucial because artists have frequently wanted to explain themselves. We often know a great deal about their ideas at first hand from primary sources and we need to look at what they mean, as they were often published for that reason.

As far as possible I have tried to use the manifestos and writings of the artists themselves, because they form a significant and integral part of modern art. They help us with what would in the past have been called the iconography or meaning of the works. This visual orientation might seem unnecessary, but it often helps if one can understand the ideas that lay behind modern art. So there will be some quite detailed examination of the theoretical background where it is relevant. Some brief references will be made to different approaches to the art history of the twentieth century, like Marxism, Feminism, Ethnicity and Deconstruction, but not in any detail and always in relation to selected visual examples.

Once again the focus will be on trying to understand by looking. The layout of the book is similar to that of *Learning to Look at Paintings* in the sense that the chapters are thematic and include titles like composition, space and form, light and colour, and subject-matter. Chapters are divided into sections discussing selected works of art; these will include architecture and design, sculpture, three-dimensional work and installations, as well as paintings. The divisions between the different arts have become less defined in the modern period and this book tries to reflect that. Single examples, of course, cannot hope to give an understanding of, for instance, modern architecture as a whole, but they can give insight into the relationship between architecture and the other arts.

Chronology will not be emphasized, but as a point of reference I have provided a table of modern art developments listed in a historical way (pp. xix–xx). Also, some artists or movements will crop up in several contexts in different parts of the book, like Picasso, Braque and Matisse who were working at the beginning of the century and were still there by the middle, or the Abstract Expressionists who were influenced by Monet's lily paintings. Monet is generally considered a nineteenth-century painter but he lived through the avant-garde movements of the early twentieth century and did not die till 1926.

Connections can also be made between modern art and the past, between Futurist sculpture and the Baroque, or developments in Surrealism and the traditions of Symbolism and Fantasy Art. Some conceptual artists, like Ian Hamilton Finlay, look back to the classical tradition of Western art, in the work of Poussin for instance, or to the earlier twentieth century, as does Dan Flavin with his interest in Russian Constructivism. These characteristics have been picked up in order for us to feel the continuity of much modern art, particularly in Chapter 8 on traditional subjects. For the most part though, in each section, the works of art will be discussed in a roughly chronological order; this means that distinctions between Modernism in the early twentieth century and Postmodernism after the 1960s can be clearly drawn in a number of different contexts.

In any writing about modern art we have to try and make a distinction between Modernism and Postmodernism in order to be clearer about the changes that occurred in art in the 1960s. This is not a book about theory and philosophy, but there is now a vast amount of critical writing about art, no longer seen as a library of secondary texts, but as a body of knowledge in its own right. Some of

this will be used in this book, but only where appropriate. On the whole I have tried to take a straightforward view. I am suggesting that Modernism is about communicating a dynamic, forward-looking sense of our world through the aesthetic and abstract qualities of painting, sculpture and architecture, where the processes of creating them are more clearly revealed.

In his essay on Modernist painting first published in 1960, the famous American critic Clement Greenberg outlined the difference between Modernism and the Old Masters:

> Realistic, illusionist art had dissembled the medium, using art to conceal art. Modernism used art to call attention to art. The limitations that constitute the medium of painting – the flat surface, the shape of the support, the properties of pigment – were treated by the Old Masters as negative factors that could be acknowledged only implicitly or indirectly. Modernist painting has come to regard these same limitations as positive factors that are to be acknowledged openly.
>
> (Greenberg, in Harrison and Wood, (eds)
> *Art in Theory, 1960–1990*: 755–6)

Greenberg means here that in Modernist work the processes of painting are more clearly revealed and abstract pictorial qualities become more important, rather than the creation of an illusion as you might find in the meticulous paintings of Dutch seventeenth-century still life for instance. Greenberg's analysis of Modernism is regarded as a defining text in relation to this view of painting; it is sometimes called formalist, because it takes account of aesthetic qualities first and foremost. But Modernism also expresses a radical, dynamic and transcendent view as we shall see, particularly in the first two chapters.

In contrast to this Modernist standpoint lies the Postmodernist position, which stresses the importance of the quest for meaning in art over aesthetics. The meaning is not definite, but more a shifting, questioning attitude that involves the spectator in a philosophical debate about the nature of art itself. Duchamp and his idea about painting being at the service of the mind, which we will discuss in Chapter 3, has become very influential since the 1960s. That was when it began to be felt that the Modernist position was not enough; in particular, it did not take into account what the artist Robert Morris called the terrible experiences of the twentieth century, from

'the irrationalities of World War One to the still incomprehensible irrationalities of the Holocaust'.

The ideas behind Postmodernism are probably most clearly expressed through architectural theory. Another seminal piece of writing was that of the architect Robert Venturi in his book *Complexity and Contradiction in Architecture*, which has become a widely used definition of Postmodernist characteristics:

> elements which are hybrid rather than 'pure', compromising rather than 'clear', distorted rather than 'straightforward', ambiguous rather than 'articulated', perverse as well as 'impersonal', conventional rather than 'designed', accommodating rather than 'excluding', redundant rather than simple, vestigial as well as innovating, inconsistent and equivocal rather than direct and clear.
> (Venturi, *Complexity and Contradiction in Architecture*: 16)

So the postmodern artist, instead of always pushing forward to a utopian ideal, enters into more of a dialogue with the past and with other aspects of the present, which can include anything from the world of advertising, photography and film. In much postmodern work the meaning is mediated through reproductive imagery. This period of the 1960s and 1970s really marks the watershed between Modernism and Postmodernism, which nevertheless remain very generalized terms. In order to make the distinction between them clearer most of the themes in each section of the book will be divided between these two positions, except in the first two chapters and Chapter 8.

After the first two chapters, which are essentially about looking at early Modernism and establishing many of the themes of modern art in both theory and practice, each chapter is divided between the earlier and the later twentieth century. In Chapter 3 we look at Marcel Duchamp and his move away from the aesthetic and visual appeal in art to a search for meaning, which is full of ambiguity and uncertainty. He has been very influential on Conceptual Art, which is also more concerned with ideas and with making the spectator think, question and become involved. We will see work by Ian Hamilton Finlay, David Mach, Mona Hatoum and Bill Viola, where meaning is suggested without losing the aesthetic dimension. At the end there will be a brief consideration of Duchamp's influence on Dada and Surrealism and their origins in the traditions of Fantasy Art and the theories of Freud.

In Chapter 4 we consider Expressionism from Kandinsky onwards and how, from the 1960s, artists like Joseph Beuys became concerned with autobiographical expression, which in turn became political and social. Beuys was also interested in confronting the past and its effect on the present; this is true of architecture as well in Libeskind's Jewish Museum in Berlin. The development of self-expression in the work of some female artists like Louise Bourgeois and Cindy Sherman, for instance, will be considered here, with a brief discussion of the impact of Feminism on art and art history in general.

In Chapter 5 we look at composition in modern art and in particular the influence of collage, which was invented by Picasso and Braque. Inspired by the theories of Apollinaire, it started as the random and anarchic gathering of found objects and putting them into an aesthetic arrangement. We will begin with *papier collé* and then go on to explore the combines of Robert Rauschenberg. In Surrealism, composition becomes a painted organization of freely associated ideas, as in a dream where suggested meaning is more important. Other new types of composition will be considered like Peinture Informelle and Art Brut. Then there is a shift of emphasis in Pop Art in the 1960s where the compositions use the reproductive imagery of advertising, photography, packaging and the cinema to reflect the new visual appearance of the postwar world. The same period marked the arrival of Minimalism and its anti-consumerist stance, so that the work of art does not exist as an art object except when arranged and composed in an art gallery, or in the landscape as an installation. At the end of this chapter there will be a discussion of the eclectic and free-ranging approach to some postmodern architecture, its revolt against Modernism, and its theories as expressed in the work of Charles Jencks.

In Chapter 6 we look at the twentieth-century treatment of space and form, starting with the utopian Modernism of artists like Gabo and Malevich and moving on to the architecture and design of Frank Lloyd Wright, Gerrit Rietveld and Le Corbusier, with their different interpretations of dynamic space. Some interesting connections with painting will be made in the work of Piet Mondrian, for instance, and the Purism of Le Corbusier as a painter. After a consideration of space in the Abstract Expressionism of Jackson Pollock, a direct contrast is made with the work of later artists like Michelangelo Pistoletto, Christo, Rachel Whiteread and the architecture of Frank O. Gehry, where the spectator's experience of space and form is

thought-provoking as well as visually exciting. In the conclusion of this chapter, there will be a brief discussion of the Postmodernist philosophy of Deconstruction and why it has been so influential.

In Chapter 7 on light and colour, the shift in sensibility is from those artists who painted it (like Pierre Bonnard or John Piper) to later ones who work with real coloured light (like Dan Flavin or James Turrell). Exploration of light and colour in the Orphism of Robert Delaunay will be considered, particularly in relation to the idea of simultaneity and the emotional expression of colour and light. The use of light in architecture is looked at briefly in Norman Foster's Great Court at the British Museum; it is interesting that in many ways Foster's work remains Modernist in its so-called high-tech approach to architecture. In Chapter 8 on traditional subjects, we will see how these have continued throughout the century, with particular emphasis on the later period, to show that tradition has not died out but is being constantly re-interpreted in painting, sculpture and architecture.

In Chapter 9, in the Epilogue, there is a brief discussion of the interaction between film, photography and fine art, which has been so significant in the twentieth century. There will be consideration of one or two specific cases where one has influenced another, as in the work of Francis Bacon or the film sets of Ken Adam, followed by the final conclusion. So, the contrast between Modernism and Postmodernism will be considered from several different angles, according to the direction of that particular chapter, allowing the reader to ponder the issues involved, and the different ways in which we are being encouraged to look at and think about art.

The idea behind this book is to try and take the reader/viewer along in an open-minded visual exploration of modern art, because there are no orthodoxies here. The 'learning to look' aspect really means encouraging the spectator to see for themselves rather than setting out a special or personal opinion in relation to modern art. The points made are more like suggestions for further looking and consideration. The idea of keeping an open mind is to preserve this book from creating a closed argument in which a particular point of view is discussed in order to prove a particular set of conclusions. Instead the intention is to keep all options open so we can try and understand and appreciate modern art in a more transparent and informed way. It is also not intended to be developmental, in the sense of moving from the simple to the more sophisticated, and it has had to be selective so that some aspects are inevitably left out. The

majority of the works I have chosen are in public galleries and are therefore accessible and have been recognized by others as significant. Also, I have tried to use examples that can be explained clearly.

Each chapter is bounded by introductory and concluding paragraphs, in order to focus more directly on its theme. Quite often these introductions and conclusions bring in another idea that adds a further dimension to the subject under discussion in that chapter. This has been done deliberately to amplify the content and provide more stimulus and interest for the reader/viewer. For instance, at the beginning of Chapter 5, photomontage is introduced in order to extend the subsequent observations on collage. At the end of Chapter 6, there is a discussion of the theory of Deconstruction which relates to the previous section on the use of space in Frank O. Gehry's Guggenheim Museum at Bilbao. The idea is that the reader/viewer will be able to see the subject from more than one position and add to the observations already made. Some works of art referred to are not illustrated, but often appropriate illustrations can be found in *Learning to Look at Paintings*. In several places colour is referred to in the text, though the reproduction is in black and white; this has been done to give a fuller explanation. Apart from this, all the examples discussed in detail have reproductions. At the end there is a book list, a glossary and list of questions to ask yourself when standing in front of a work of modern art.

This book hopes to provide, not answers as such to the questions proposed at the beginning of this introduction, but visual and information tools for looking at modern art in a more constructive and analytical way. Marcel Duchamp believed that 'the creative act is not performed by the artist alone'; he wanted a more active, positive, questioning role for the spectator. That is what this book aims to encourage.

Chapter 1

Picasso and Modernism

PICASSO

Plate 1 *Les Demoiselles d'Avignon* by Pablo Picasso, 1907

The words radical, dynamic, exciting are still the ones you would use to describe the painting of *Les Demoiselles d'Avignon* by Picasso; it has so many ideas going on in it, that it can be used as a point from which to move out and discuss various themes relevant to modern art; it is regarded by all who study twentieth-century art as a kind of icon of the period. The sorts of questions we need to ask are: How was it possible for Picasso to paint such a radical picture as early as 1907? And why does it look as it does?

Les Demoiselles d'Avignon can be seen as a forceful expression of new directions and yet in one way it is a very traditional painting, because its subject is a group of nude female figures like the bathers in mythological paintings by Titian or Rubens. But Picasso's sources were complex and wide ranging; certainly he had looked at the re-interpretations of nude figure compositions that Cézanne had been doing and he was influenced by African sculpture, which he saw as representing an alternative tradition; and there is a strong expressionist element too, which we will explore. All this and more eventually gave rise to Cubism, which Picasso and Braque worked on together. Cubism particularly involved changes in the treatment of form and space, although the subject-matter they chose – nudes, portraits and still life – was largely traditional.

There is no doubt that Picasso's contemporaries regarded the picture as strange and new. In her book *The Unknown Matisse*, Hilary Spurling says that 'Georges Braque said that it made him feel as if he had eaten tow or swallowed petrol.' Picasso himself kept the painting in his studio for a long time and it was not even exhibited until

1916. Eventually it was acquired by the Museum of Modern Art in New York, where it still takes pride of place in their collection.

In this chapter we shall see that *Les Demoiselles d'Avignon* was heir to a whole collection of changes, which were not necessarily all artistic in origin. We will begin by analysing the painting visually and then go on to look in more detail at the background, comparing it with traditional work and with pictures that had more recently preceded it and presaged its coming. From as early as the 1850s there had been changes in aesthetic, scientific and philosophical attitudes which meant that the world and our place within it were no longer viewed in the same way.

Early modernism will be considered and the reasons for its development. There will be a discussion of the advent of Cubism and what it was about, particularly in relation to new interpretations of space and form. The influence of ethnographic art will be considered, as will the work of Cézanne. Experiments with photography play a significant part in the development of Cubism as well. Towards the end of the chapter we will look at the importance of Expressionism in the early work of Picasso and also in that of Munch and Kirchner. Many of these arguments cannot be conclusive, but, when taken together, they help us to understand how this picture, painted nearly a hundred years ago, can still appear today as radical and quintessentially modern.

When you first look at this painting it still appears strange, violent, radical and expressive. Everywhere there are sharp angles such as the elbows, the noses and the pointed breasts. All the bodies are in tension, even the seated figure in the bottom right-hand corner. The colours are strident and not particularly pleasant. Then, if you have not done so already, you begin to see that some of the faces are extraordinary; they are all extremely simplified, but the profile on the left is dark like that of an ancient tribeswoman. More extraordinary is the one in the top right-hand corner which has striations as though it was carved, and a strange appearance as if the face was covered by a mask, not a fancy-dress mask of course, but a mask from a non-European culture. But the strangest part of all is the head in the bottom right-hand corner, which is clearly seen from more than one viewpoint.

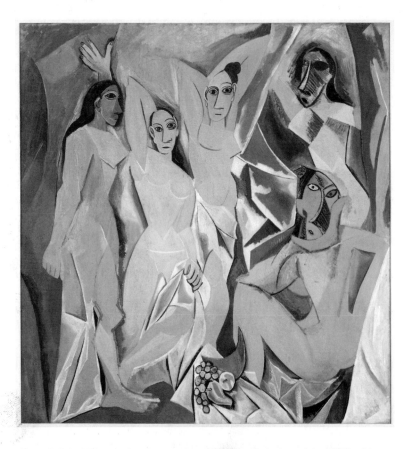

Plate 1 Pablo Picasso, *Les Demoiselles d'Avignon* (Paris, June–July 1907). Oil on canvas, 8 ft × 7 ft 8 ins (243.9 × 233.7 cm).

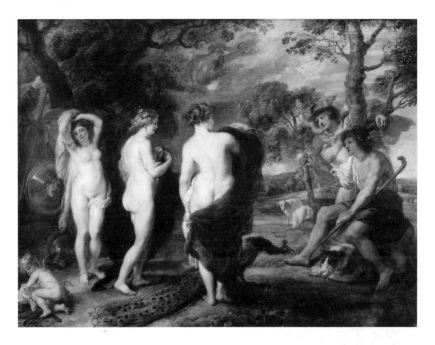

Plate 2 Peter Paul Rubens, *The Judgement of Paris* (1632–5). Oil on oak panel, 144.8 × 193.7 cm.

Plate 2 *The Judgement of Paris* by Peter Paul Rubens, 1632

At this moment you could say that you do not like this painting and dismiss it; but there is something intriguing about it, especially when you start to ask yourself why it looks as it does. It is clearly trying to present a different way of seeing this traditional subject, the nude female figure. If you compare Picasso's picture with a famous painting by Rubens of *The Judgement of Paris* of 1632 (Plate 2), you will see that the composition is organized in a similar way, with two figures on the right and three on the left. Indeed, as John Russell has suggested in his book *The Meanings of Modern Art*, Picasso may have used the format of Rubens' picture as one of his many sources for *Les Demoiselles d'Avignon*.

Neither painting is naturalistic in the sense of what you would

actually see, but Rubens' picture is more intelligible in that we are looking at the figures from only one viewpoint, they appear naturalistically rounded and they seem to be standing or sitting in a believable space. The artist has used subtle tonal variations on the bodies to achieve the form, and the single viewpoint perspective is enhanced by the blue of aerial perspective to create a sense of space. In Picasso's painting there is no feeling of distance, and the figures are not naturalistic in the way they are painted; the inter-relationship between background and foreground has gone; instead Picasso's figures are presented in a series of simplified planes and placed right on the picture's surface, rather than being viewed as if set in a three-dimensional landscape. The space between the two sets of figures is a series of flat facets as is the curtain on the left-hand side. Since Picasso could draw like Raphael or Rubens if he chose (see Plate 9), so we have to ask ourselves what he is expressing.

CÉZANNE AND AFRICAN SCULPTURE

Plate 3 *Bathers* by Paul Cézanne, 1900–1906

Obviously, this way of painting did not appear out of nowhere. Among other things Picasso had looked at the work of Cézanne and at African sculpture. Cézanne had done a whole series of paintings of bathers and had explored the subject in a number of experimental ways. In *Bathers* ('Les Grandes Baigneuses') of 1900–1906 (Plate 3) there is clearly distortion in the way the human figure is treated, especially the one to the right of the centre who appears to have only one foot, and the other on the left with her broad back, and the one next to her by the tree who appears much taller. Then there is the mysterious woman in the background on the right, who is elongated and set against a dark shadow. Cézanne has been playing with the idea of proportion, and using the figures as compositional elements to express space and form, rather than corresponding to a canon of proportion imposed from outside by tradition. Instead, like Picasso, Cézanne chooses a traditional subject and then experiments with it in radical ways in relation to pictorial construction.

Plate 4 Grebo mask

Picasso had also by this time looked at African sculpture, which ignores naturalism because its motivation is entirely different. Picasso

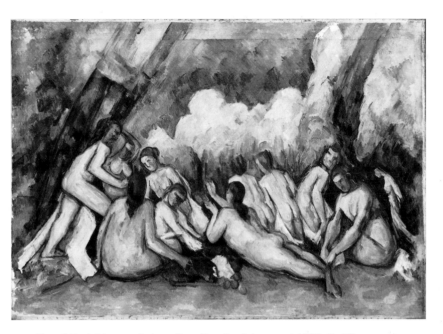

Plate 3 Paul Cézanne, *Bathers* ('Les Grandes Baigneuses', 1900–6). Oil on canvas, 127.2 × 196.1 cm.

saw the idea of the fetish very clearly and, much later on, he described his first experience of it when he visited the Trocadero Museum:

> 'When I went to the old Trocadero, it was disgusting. The Flea Market. The smell. I was all alone. I wanted to get away. But I didn't leave. I stayed. I stayed. I understood that it was very important: Something was happening to me, right?
>
> The Masks weren't just like any other pieces of sculpture. Not at all. They were magic things . . . all the fetishes were used for the same thing. They were weapons. To help people avoid coming under the influence of spirits again, to help them become independent. They're tools. If we give spirits a form, we become independent. Spirits, the unconscious (people still weren't talking about that very much), emotion – they're all the same thing. I understood. I understood why I was a painter. All alone in that awful Museum, with masks, dolls made by the redskins, dusty

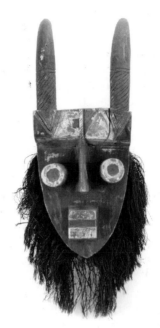

Plate 4 Grebo mask. Courtesy of musée Picasso, Paris. Wood, white paint and plant fibres, height 64 cm.

Photograph © Photo RMN – Béatrice Hatala.

manikins. *Les Demoiselles d'Avignon* must have come to me that very day, but not at all because of the forms; because it was my first exorcism painting – yes absolutely!'

(Patricia Leighten, *Re-ordering the Universe*: 87)

In this passage, Picasso shows that his understanding of African sculpture is from the point of view of its non-natural or conceptual aspect. This photograph of a mask from the Ivory Coast in West Africa, which belonged to Picasso (Plate 4), shows that it has been constructed out of separate pieces of wood and hair, not modelled or carved as a traditional Western European sculpture would be; the face is flat, the eyes are two round cylinders, the nose is a triangle, the mouth is a cube and the forehead is surmounted by two horns; it has been designed to convey a message by means of an image which is vivid and powerful but not naturalistic.

NEW SCIENCE AND THOUGHT

All these factors I am suggesting you look at are important, but they do not altogether help to explain why this radical alteration in the attitude to art and imagery took place. One very significant area is the huge shift in sensibility caused by developments in science and philosophy; these fundamentally affected our sense of reality, our understanding of the so-called real world and how we see it. They consisted essentially in a move from a static to a dynamic view of the world based on movement and change, to a view that shifted from the visible to the invisible, from a perceptual to a conceptual comprehension of the world and our place in it. If we can begin to understand some of the basic principles in this difficult area, it can help greatly with our approach to much modern art.

Two years before Picasso painted *Les Demoiselles d'Avignon*, Einstein had published his Theory of Relativity. A central idea in the theory was that our view of the world cannot be understood in a purely three-dimensional way because of the existence of the fourth dimension, which is time. This has repercussions for our understanding of space, which becomes relative and unstable: space can no longer be conceived of as finally fixed or measurable, but depends on the situation of movement or stasis we happen to be in at the time of looking.

Earlier on, in the nineteenth century, there had been a number of changes in our understanding of the nature of matter; they seemed to suggest that the make-up of the world, including ourselves, was not as solid as we thought it was. One of the most important of these new discoveries was made through the study of chromosomes, minute bodies seen in the cells from which our bodies are composed. This observation was published in 1873 by Schneider, Flemming and Bütschli. The study of chromosomes came to be called 'cytology', a word first used in 1888 by Wäldemayer. The discovery of radium in 1898 proved that matter which appears inert can emit energy in the form of light which can move through normally opaque substances; the development of x-rays a few years earlier by Roentgen meant that it became possible to see inside the human body and into areas not normally visible.

In 1901 Max Planck published his law of radiation, the Quantum Theory, that radiation is emitted, invisibly of course, in indivisible quanta of energy which depend on the frequency of the oscillation of electrons; this was extended in 1912 to include all kinds of energy,

not just radiation, and was called the General Quantum Theory. Quantum Theory also makes the outcome of an event (at the sub-atomic level) depend on whether it is observed or not; until observed, reality remains in a state of indecision, as it were, between various possibilities. This perhaps was the most revolutionary aspect of the theory.

Another example of realizing the invisible lying beneath the visible was the publication in 1900 of Freud's *Interpretation of Dreams*, where the idea was proposed that the unconscious mind exists unseen below the conscious, but influences it and reveals itself through dreams; this revolutionized the way we see ourselves and attempted to produce evidence, rather than intuitive knowledge, that the person you know is not just what you see on the outside. Freud and his sub-sequent development of psychoanalysis travelled well beyond art, but his ideas were particularly influential on Dada and Surrealism in the 1920s and 1930s, as we shall see in Chapter 3. Other theories and discoveries asked fundamental questions about our beliefs, like the ideas of Darwin and Nietzsche. As far back as 1859, Charles Darwin had published *On the Origin of Species* which expressed the theory of Evolution, and famously questioned the first chapter of Genesis and the beliefs about God's creation of the world.

More directly influential on the world of art was the philosophy of Friedrich Nietzsche. In *Beyond Good and Evil* in 1886 and *Thus Spake Zarathustra* of 1886–92, for instance, Nietzsche announced that 'God is Dead'. As an alternative to God, Nietzsche advocated Man as the creator, as the one who leads the way. In *Thus Spake Zarathustra*, this idea comes out clearly:

> *No-one knows yet* what is good and evil unless it is the one who cre-ates! – He, however, is the one who creates Man's goal and gives the earth its meaning and future. He is the one responsible for something's being good or evil.
>
> (Nietzche, quoted in Rudiger Safranski, *Nietzsche, a Philosophical Biography*: 322)

So the artist is the person who is capable of offering himself and his creations in place of God. Certainly Nietzsche's ideas crop up in this period before the First World War in the diaries, writings and recorded sayings of Picasso, Apollinaire and Severini, for example. According to a recent biography by Rudiger Safranski, Nietzsche's ideas were very influential in a more generalized way too, in the sense that

Nietzsche's *Lebensphilosophie* liberated 'life' from the deterministic straitjacket of the late nineteenth century and restored its characteristic freedom, namely the characteristic freedom of artistic creation.

(Ibid: 321)

Another alternative to conventional belief was established by the Theosophists who thought that it was possible to see behind the world of appearances into a more spiritual domain. Rudolph Steiner, the inventor of Anthroposophy, his own version of Theosophy, believed that this could be achieved by what he called inner necessity:

> This is again a rule based upon confidence that there is an inner necessity in things and events, that in the facts themselves there slumbers something that moves things. What is thus working within these things from one day to another are thought forces, and we gradually become conscious of them when meditating on things . . . so we train ourselves to think, not arbitrarily, but according to the inner necessity and the inner nature of the things themselves.
>
> (Rudolph Steiner, *Anthroposophy in Everyday Life*: 11)

Steiner's work has been spread widely through his writings, which are still published by the Anthroposophic Press and read by large numbers of people looking for an alternative system of spiritual belief. In our context, both Nietzsche and Steiner have been important for Expressionism, which we will look at in Chapter 4. However, most would agree that the influence of Freud and Nietzsche has been more widespread.

One of the most influential theories from the point of view of art was that of the French philosopher, Henri Bergson. His philosophy expressed above all a view of the world as dynamic rather than static, and constantly changing rather than immutable. Bergson first published his ideas in *The Immediate Data of Consciousness* in 1889, but some of his later books – like *Matter and Memory* of 1896 – were more directly influential. More importantly, Bergson lectured regularly in Paris at the Lycée Henri IV and the Collège de France at this period, where his audiences included many artists and writers. In particular, Bergson's ideas about memory – as active and influential on the way we see the present – were significant. Recent work has shown that Bergson's views affected both Matisse and the Futurists, and this will be followed up in Chapter 2.

The invention of the cinematograph by the Lumière brothers in 1895 is important too, because it meant that it was possible to record the moving rather than just the static image. This machine was able to be modified so that it could be both a camera, a film printing machine and a projector; it was mobile and could record the events of the outside world as they were going on. The Lumière brothers themselves went round the world recording the activities and lifestyles of remote peoples, their habits and costumes, which brought them alive in a way that still photography and objects in ethnographic museums could not do. Arguments about the role of art and photography had been going on since the middle of the nineteenth century, but the advent of the cinema seemed to take away once and for all many of the functions of art, like story-telling or communicating a message. We will explore connections between film and fine art at various points throughout this book and particularly in the concluding chapter.

CUBISM

Now, whilst it is difficult to prove that Picasso and his contemporaries were directly influenced by the changes in science and philosophy we have been discussing, we do know that they were aware of them, particularly at the time of the development of Cubism; they are directly referred to by the influential poet and writer Guillaume Apollinaire in his book *The Cubist Painters,* published in 1913. He makes it quite clear that the artists living in and around the studios of the Bateau Lavoir knew about the ideas associated with the fourth dimension:

> The new painters do not propose, any more than did their predecessors, to be geometers. But it may be said that geometry is to the plastic arts what grammar is to the art of the writer. Today, scientists no longer limit themselves to the three dimensions of Euclid. The painters have been led quite naturally, one might say by intuition, to preoccupy themselves with the new possibilities of spatial measurement which, in the language of the modern studios are designated by the term: *the fourth dimension.*
> (Guillaume Apollinaire, *The Cubist Painters* in Chipp ed.: 223)

It is often said that in the circle around Picasso there was an actuary and mathematician who was also an amateur painter, named Maurice Princet. We do not have concrete evidence of what this man did or did not say, but there seems little doubt that there would have been talk about the new ideas.

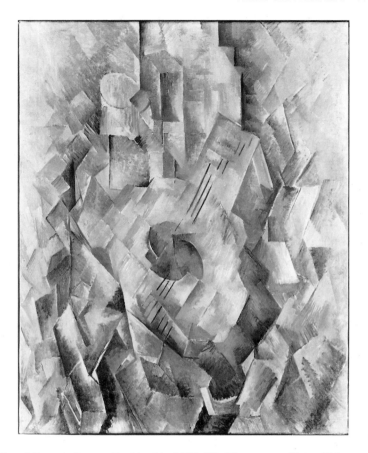

Plate 5 Georges Braque, *The Mandola* (1909–10). Oil on canvas, 71.1 × 55.9 cm.
© ADAGP, Paris and DACS, London 2003. Photograph © Tate Modern, London 2003.

Plate 5 *The Mandola* by Georges Braque, 1909–10

After completing *Les Demoiselles d'Avignon*, Picasso worked closely with Georges Braque on the development of Cubism. Braque, when reminiscing in 1954 about those early days, refers to himself and Picasso as 'rather like a pair of climbers roped together' because they were working so hard and so intuitively on the same ideas. Then he goes on to talk about a new concept of space, which they were trying to express:

I felt dissatisfied with traditional perspective. Merely a mechanical process, this perspective never conveys things in full. It starts from one viewpoint and never gets away from it. But the viewpoint is quite unimportant. It is as though someone were to draw profiles all his life, leading people to think that a man had only one eye. . . . When one got to thinking like that, everything changed, you cannot imagine how much! . . . What greatly attracted me – and it was the main line of advance of Cubism – was how to give material expression to this new space of which I had an inkling. . . . It was that space that attracted me strongly, for that was the earliest Cubist painting – the quest for space. Colour played only a small part. The only aspect of colour which concerned us was light. Light and space are connected, aren't they, and we tackled them together. . . .

> (G. Braque, in Friedenthal, *Letters of Great Artists*: 264–5)

In Braque's painting *The Mandola* (a type of lute), the Cubist technique of breaking up an object into planes seen from different angles is very evident, particularly if you look at the bottom right-hand corner. As we look, we feel the front of the picture moving behind and the back moving forward, and the two becoming interchangeable. Some of the edges of the planes are clearly defined and others blurred, and this creates the sensation of space and form shifting about on the surface of the picture, as if you were looking at it from a moving viewpoint. It is as though the top layer of all the objects, their colour and their texture had been removed and we were looking beneath the surface at the underlying structure of the forms. The subtle and beautifully painted tonal variations convey the feeling of light and space penetrating through the objects. The overall milky and translucent appearance reminds us of photographic negatives or indeed of x-rays.

PICASSO AND PHOTOGRAPHY

Plates 6 and 7 *Le Douanier Rousseau* by Pablo Picasso, 1910

When he was working on *Les Demoiselles d'Avignon* and afterwards on Cubism, Picasso certainly used photographs, as recent fascinating research has shown. There is one particular photograph in his own collection – of a group of African women – that looks very like the composition of *Les Demoiselles*. More interesting still are the

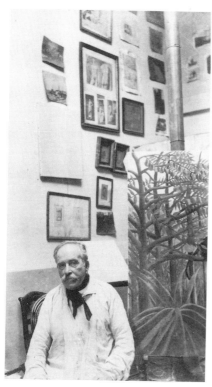
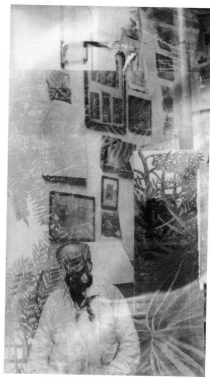

Plate 6 Pablo Picasso, *Le Douanier Rousseau* (1910). Modern gelatin silver print from flexible negative no. 117.
© Succession Picasso/DACS 2003. Courtesy of musée Picasso, Paris. Photograph © Photo RMN.

Plate 7 Pablo Picasso, *Le Douanier Rousseau* (1910). Modern gelatin silver print from flexible negative (double exposure) no. 118.
© Succession Picasso/DACS 2003.

photographs Picasso himself took of his friends and contemporaries.

In the double portrait of *Le Douanier Rousseau* of 1910 for instance, Picasso takes a fairly straightforward photograph and then superimposes another on top by double exposure. The second photograph becomes quite like a Cubist painting because of the way the background is brought to the surface, and the medium tones are

made to shift between the background and foreground of the picture. For instance, if you look at the cactus plant on the right in the more straightforward photograph, you will see that it is part of the painting in the background; then in the double exposure picture, you will see it has come forward and appears to occupy the middle ground and even to invade the foreground. This kind of spatial ambiguity is clearly transmuted into some of the Cubist paintings Picasso and Braque were making at this period.

Plate 8 *Portrait of Ambroise Vollard* by Pablo Picasso, 1909–10

Plate 9 *Drawing of Ambroise Vollard* by Pablo Picasso, 1915

If you look at Picasso's portrait of Ambroise Vollard you can see that the head is made up of a series of planes at different angles to one another, and shaded with light and dark edges which vary between blurred and defined. If you half-close your eyes, you will see that the head appears to lift off the picture plane into your space. On the body of the man, the facets are more sharply divided into dark and light and solid and opaque. This section of the picture particularly looks remarkably like an x-ray, or a picture of solid matter as a mass of cells or atoms and molecules. Such is the skill with which Picasso has manipulated the planes and the tones that we do not for a moment lose touch with either the likeness or the solidity of the form.

The portrait is presented in a much more conceptual way than the more naturalistic and perceptual drawing of Vollard done some years later, in 1915. This drawing shows quite clearly Picasso's grasp of traditional methods of picture making: the understanding of perspective and tonal gradation, the subtle variation in the pressure of the pencil, particularly in relation to the edges of the forms, the clarity of the shapes surrounding the figure, and the concentration on Vollard's palpable presence in space are made very clear. The sensation of form and space is just as great in the Cubist portrait, but it shifts and fluctuates according to where you are looking, because of the multiple-viewpoint perspective and the disrupted planes.

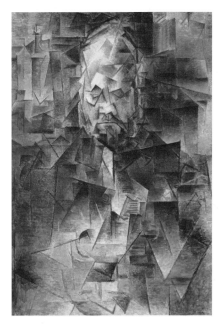
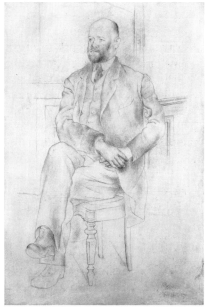

Plate 8 Pablo Picasso, *Ambroise Vollard* (1909–10). Oil on canvas, 92 × 65 cm.

© Succession Picasso/DACS 2003. Courtesy of Pushkin Museum, Moscow, Photograph © 1990 Scala, Florence.

Plate 9 Pablo Picasso, 'Ambroise Vollard' (1915). Pencil on paper, 46.5 × 32 cm.

© Succession Picasso/DACS 2003. Courtesy of The Metropolitan Museum of Art, The Elisha Whittelsey Collection, The Elisha Whittelsey Fund, 1947 [47.140]. All rights reserved The Metropolitan Museum of Art.

MODERNISM AND CONTINUITY

Apart from changes in thought through new developments in science and philosophy, there is another point of view we should bear in mind, and that is continuity. Picasso saw himself as the heir to a long tradition of painting, in particular in the treatment of the female nude. We have already discussed Rubens in relation to *Les Demoiselles d'Avignon*, but there are other artists we should compare, like Botticelli and Titian for instance. In Botticelli's painting of the *Primavera*, for instance (see *Learning to Look at Paintings*, p. 124), the proportions of the female figures are gracefully elongated,

especially the one of Venus. In the *Concert Champêtre* by Titian/Giorgione (see *Learning to Look at Paintings* p. 158) the nude figures are placed in an unreal situation in a landscape and we are supposed to appreciate it through feeling in the same way as a poem. Many paintings of the past are expressive like this, rather than naturalistic, and many are designed to tell a story. In *The Judgement of Paris* by Rubens (see Plate 2), Paris is asked to choose which of the goddesses is the most beautiful, and he awards the golden apple to Venus.

Picasso too appears to have had a meaning for his *demoiselles*, deriving from Baudelaire's essay on 'The Painter of Modern Life'. The idea behind this is that the artist should reflect aspects of city life from the point of view of the man about town, the *flâneur*. The possible subjects Baudelaire suggests include the brothel and it is thought, by John Richardson in his biography of Picasso, that the artist meant his *demoiselles* to be prostitutes; there would have been a precedent for this in Edouard Manet's painting *Olympia* executed in 1865, only two years after the publication of Baudelaire's theory. Manet's version of the female nude referred to past precedent and the role of the modern woman.

Manet was an important figure in the development of Modernism, which we are going to look at next. Certainly, whatever Picaso's *Demoiselles d'Avignon* may or may not be in terms of their iconography, they are not mythological and not telling a story but offering a re-interpretation of the traditional subject of nude female bathers. However, the fact remains that, when you look at Picasso's picture by the side of a Botticelli or a Titian or a Rubens, it looks less naturalistic and more overtly abstract and expressive; these characteristics are referred to as Modernist. We need to explore this term and what it means in relation to modern art.

Modernism is not a precise term: when applied to the visual arts, it can mean a number of things. Recently, in his fascinating book called *Farewell to an Idea*, T. J. Clark has suggested that Modernism can be seen as the visual expression of radical politics going as far back as Jacques-Louis David and the French Revolution, and as far forward as 1989 and the fall of the Berlin Wall. Modernism can also be inter-preted in the way Baudelaire did in his essay of 1863, 'The Painter of Modern Life'; there, he suggested that painting should reflect modern life and the life of the city in particular; this also becomes significant in relationship to Futurism which will be considered in Chapter 2. The other aspect of Modernism which became important was its associa-

tion with the avant-garde, with a type of forward-looking modernity which was radical in every way, a kind of cult of the new which depends upon a principled and ongoing rejection of whatever is considered aesthetically conventional or traditional. In a more general sense Modernism can also be applied to a style of painting in which the abstract qualities are more overtly revealed, where there is a lack of interest in narrative and a broad, fluid and simplified technique.

The invention of photography in 1839 and that of film in 1895 were important factors in the development of Modernism and indeed of modern art. Later on in this book, and particularly in the Epilogue, we shall see how photography and film have become part of the development not just of Modernism but of Postmodernism as well. But in the period we are looking at now the camera was seen to threaten the role of the artist because it reproduced pictures of the outside world. This meant that it became more important for the artists to reveal the abstract or pictorial qualities of painting, which became the stylistic basis of Modernism. This is not to say that artists were not interested in experimenting with photography, but it was for pictorial effect rather than mere reproduction, as we saw with Picasso's photographs earlier in this chapter.

Writing in his journal in 1859, the French Romantic painter Eugène Delacroix tells us that picture making is not about accuracy of detail, but has much more to do with the interaction between the eye and the imagination. After writing about how the camera sees in too much detail for the eye, Delacroix says:

> Even when we look at nature, our imagination constructs the picture; we do not see blades of grass in a landscape, nor minute blemishes in the skin of a charming face. Our eyes are fortunately incapable of perceiving such infinitesimal details and only inform the mind what it needs to see. Again, the mind itself has a special task to perform without our knowledge; it does not take into account all the eye offers, but connects the impressions it receives with others that have gone before, and depends for its enjoyment on conditions present at the time. This is so true, that the same view will not produce the same impression when seen from a different angle.
>
> (*Journal of Eugène Delacroix*: 388)

This passage sounds like a definition of Modernism because of the emphasis on the pictorial qualities of painting. But the artist who is

said to have set Modernism in motion during the 1850s in France is Gustave Courbet. Delacroix admired Courbet who was the founder of what is paradoxically called Realism. Courbet was friendly with the radical anarchist philosopher Pierre Joseph Proudhon and for a short time with Baudelaire as well.

Plate 10 *The Winnowers* by Gustave Courbet, 1853–4

Courbet chose to paint in a way that revealed the abstract qualities of painting whilst at the same time trying to paint what we see. For instance, in his treatment of *The Bathers* of 1853, there is no ideal-ization of the figures and the women appear large, ill-proportioned and even dirty compared with a classical figure. A clearer example of these qualities shows in Courbet's famous painting of *The Winnowers* of 1853–4, where there is no attempt to tell a story. None of the fig-ures is engaged with either of the others, and the spectator is left to appreciate the elliptical movement of the winnowing basket and the way its shape is reflected in the back of the woman's head and in her arms. The positioning of the woman on the left and the boy on the right widens the ellipse so that the whole composition expresses that shape; it is also shown in the plate on the left-hand woman's lap, and in the other ellipses of the other bowls strewn on the floor. The sub-tlety of the tonal variation – between the beiges, greys and whites, and the dark brown accents in various places including the wooden box, parts of the boy, the shoes, and the heads of the two women – enhances the pictorial relationships between the different parts of the picture. The whole effect is to make you feel and think about the abstract qualities of the painting and not so much about the subject.

In 1855 Courbet published a manifesto in which he stated his aims in painting and his desire to paint in his own way and on his own terms.

> I simply wanted to draw forth from a complete knowledge of tra-dition the reasoned and independent understanding of my own individuality.
>
> To know in order to be capable, that was my idea. To be able to translate the customs, the ideas, the appearance of my epoch according to my own appreciation of it, (to be not only a painter but a man), in a word to create living art, that is my goal.
>
> (Gustave Courbet, 'Manifesto of Realism',
> quoted in Rubin, *Courbet*: 158)

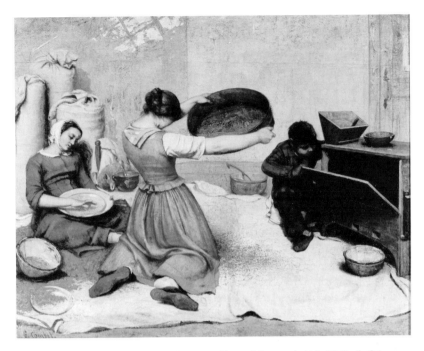

Plate 10 Gustave Courbet, *The Winnowers* ('Les cribleuses de blé', 1853–4). Oil on canvas, 131 × 167 cm.
Courtesy of Nantes, musée des Beaux-Arts. Photograph © Photo RMN – Gérard Blot.

Courbet is stating here his right to be an independent artist who expresses his own ideas in his own way, without recourse to institutions of art and their dogmas. Courbet is the first in a long line of artists in the Modernist tradition who have felt it necessary to declare their aims in a manifesto; he also made a visual statement in his famous picture *The Artist's Studio*, which was included in his one-man exhibition, held in Paris at the Exposition Universelle, in the same year of 1855. Eight years later, in 1863, another even more provocative visual statement was made by Edouard Manet in *Le Déjeuner sur l'herbe* which we look at now.

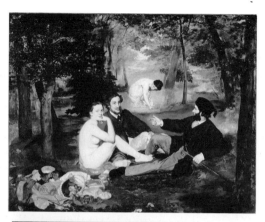

Plate 11 Edouard Manet, *Le Déjeuner sur l'herbe* (1863) [RF 1668]. Oil on canvas, 208 × 264 cm.

Courtesy of Paris, musée d'Orsay, donation Etienne Moreau-Nélaton, 1906. Photograph © Photo RMN – Hervé Lewandowski.

Plate 12 Detail of Edouard Manet, *Le Déjeuner sur l'herbe* (1863) [RF 1668]. Oil on canvas.

Courtesy of Paris, musée d'Orsay, donation Etienne Moreau-Nélaton, 1906. Photograph © Photo RMN – Hervé Lewandowski.

Plate 11 *Le Déjeuner sur l'herbe* **by Edouard Manet, 1863**

In this painting Manet used a recognizable nude model called Victorine Meurent, who is posed with two clothed men in contemporary costume. This subject matter had a respectable pedigree in past art and could be described as another type of 'bathers' painting. We know that Manet had studied old masters like Watteau and Titian, and had used an engraving of the picture of *The Judgement of Paris* by Raphael as the basis of his composition. But the free, abstract and undetailed way in which the nude was painted was revolutionary at the time. In *The Turkish Bath* of the same year Ingres had painted extraordinary versions of the nude female figure in all sorts of contorted positions; but they were done with small brushes, highly finished, in a lot of detail, and idealized in a way that would still have been acceptable.

You have to look at a detail of Manet's painting (Plate 12) like the still life in the bottom left-hand corner, to see why it is regarded as modernist. Look at the way the brushstrokes are revealed in the painting of the fruits as they tumble out of the basket, so that the viewer is left in no doubt that this is an expressive interpretation and not a description. Also, the relationship of the spectator to the picture is different because the model gazes across the picture plane into your space, asking the spectator, 'Who are you looking at?' The modern dress of the men makes the nude woman seem merely naked; this and the woman's gaze seem to imply there is more than beauty in the eye of the beholder. The theories and ideas of Michael Fried suggest convincingly that Manet was interested in a new kind of painting in which it was the narrative of seeing that was important, rather than the story in the old-fashioned sense. In other words, you as the spectator are being asked to decide what it is you are really looking at and this partly accounts for why the picture is so provocative and so modern.

You may well ask whether any artists had done this kind of work before; Rembrandt and Velázquez come to mind, not only in terms of the relationship with the spectator but more especially in a technical sense. Velázquez for instance, in a painting like the portrait of *Philip IV in Brown and Silver* of 1635, conveys the lace and embroidery on his costume by white impastoed brushstrokes suggestive of texture. We know that Manet looked at Velázquez, and Courbet admired Rembrandt.

The view of Modernism discussed so far is a fairly traditional one. In recent years a number of alternative interpretations have been presented, notably by T. J. Clark and Michael Fried to whom I have referred, and also in the more gender-based views of Linda Nochlin. This is not the place to present these different arguments, but they are worth exploring because they bring aesthetic and philosophical, political and socio-historical views to bear on the meaning of Modernism.

Picasso certainly knew about Courbet and Manet, but he also turned to other aspects of the Western European tradition in painting, some of which we have already looked at. Now we need to return to *Les Demoiselles d'Avignon* and see what connections we can find for its Modernist qualities. In particular we need to consider Picasso's relationship with Expressionism.

EXPRESSIONISM

Colour Plate 1 *The Scream* by Edvard Munch, 1893

Picasso always brought a passionate intensity to his work, and this quality was present in some of the sources he selected when he was working on *Les Demoiselles d'Avignon*, and in his own early work. Much brilliant investigation has been done in relation to the sources of the *Demoiselles* and this exploration is not intended to be exhaustive. But the expressionist aspects are important because of the wider significance of Expressionism, which we will be looking at in Chapter 4. When you look at a famous example of Expressionism, *The Scream* by Edvard Munch of 1893 (Colour Plate 1), you realize that the whole composition has been used to express the emotion contained in the idea of a scream: the extended perspective, the strident colour, the sweeping movement of the contours in the background, the schematized and simplified face and hands of the figure in the foreground. All these characteristics come together to express the feeling of a scream of anguish; naturalism in any descriptive sense has been abandoned.

Plate 13 *Apocalyptic Vision of St John* by El Greco, 1608–14

There are examples of expressionism in the art of the past and particularly in the painting tradition of Picasso's native country, Spain. In particular, as John Richardson has discovered, Picasso used the

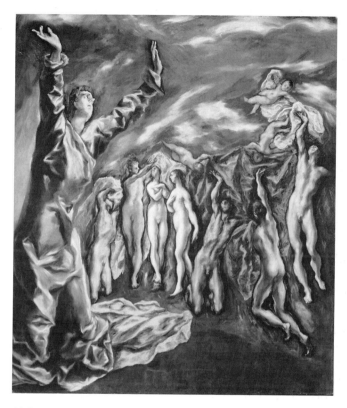

Plate 13 El Greco (Domenikos Theotokopoulos), *The Apocalyptic Vision of St John* (1608–14). Oil on canvas. 222.3 × 193 cm.

composition of El Greco's painting *The Apocalyptic Vision of St John* of 1608–14 (Plate 13), which was owned by a Spanish friend from Barcelona, Ignacio Zuloaga, who lived round the corner from Picasso in Montmartre. The elongated non-classical nudes, the distorted proportions of the large figure in the left foreground with raised arms, and the stormy sky, create an atmosphere of tension and emotion. Also, the acid greens, blues and yellows contribute to the emotional drama, much as they would in a painting by Munch or Van Gogh.

Plate 14 *Christ in Majesty* (anon.), 1123

Picasso was probably also aware of Catalan medieval mural painting like that of the Christ in Majesty of 1123 (Plate 14) in the church of San Climent de Taüll. The power of this non-naturalistic style shows in the expressive treatment of the face and the formalized abstract patterns of the drapery. This also applies to very early manuscript illumination, such as the Commentary on the Apocalyse of *c*.950 by Beatus de Liébana. The staring eyes and the sharp colours give these Catalan works a unique vitality that would have appealed to Picasso. John Richardson thinks that Picasso's friend Vidal Ventosa would have been responsible for introducing him to this exciting Romanesque work, and the earlier neo-Visigothic manuscript illumination.

Colour Plate 2 *Gypsy Girl on the Beach* by Pablo Picasso, 1898

Some of the paintings made by Picasso while he was still in Barcelona show a strong Expressionist quality, like *Gypsy Girl on the Beach* of 1898 (Colour Plate 2). The sharp contrasts of violet, pink, green, scarlet and blue show the artist's ability to use colour in an emotional way to create a mood of brooding introspection. The simplified background, the colour and the treatment of the figure herself, remind one of the work of the early German Expressionists like E. L. Kirchner in *Girl with a Cat* (Fränzi) of 1910 (see *Learning to Look at Paintings*, p. 112). In both these pictures the colour and the simplification of the people contribute to the atmosphere of anxiety and emotional claustrophobia. In a sense, it should come as no surprise to learn of Kirchner's interest in the traditions of the German medieval woodcut and woodcarving. The expressive qualities, and the ability to communicate an emotional idea, are akin to Picasso's fascination with African sculpture, and indeed Kirchner and his contemporaries were also interested in the art of non-European cultures.

Expressionism – in its concern with a more conceptual approach to art and in the way it turned to alternative cultural traditions, not only from Africa but from its own medieval past – forms an important part of the development of modern art and what early Modernism was searching for. We will follow this up in Chapter 4 on Expressionism and Self-Expression. In the same context it is worth remembering that the energy and feeling in *Les Demoiselles d'Avignon* is also close

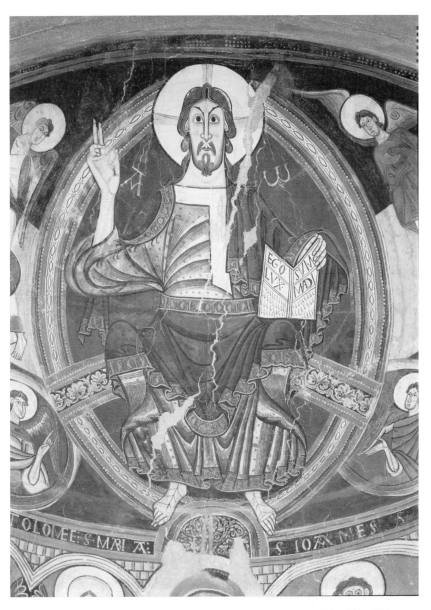

Plate 14 Christ in Majesty (San Climent de Taüll, 1123). Wall painting, 770 × 420 × 590 cm.

to the work of Matisse and early Fauvism. In the next chapter we shall see that Matisse played a significant role in modern art through the release of colour from naturalistic description (see *Learning to Look at Paintings,* p. 69) and through his understanding of how to bring a more dynamic approach to the processes of painting.

CONCLUSION

In this chapter we have seen how, in the early twentieth century, artists were affected by a whole collection of new ideas, which were a force for change; in general they marked a move away from a perceptual understanding of the world to a more generally conceptual one, with the emphasis on what lies beneath the surface of appearances. This was the result of fundamental alterations in science and philosophy but also new attitudes to the classical tradition, and the embracing of ethnographic art where the emphasis was less on likeness and more on communicating an idea. In Chapter 3 we will look at a different approach to conceptualization, where the meaning of a work became more important. But Picasso's innovations and his subsequent development of Cubism with Georges Braque were about new, more conceptual interpretations of the real world, particularly in relation to form and space. In Chapter 5, on composition, we will connect these directions with the later development of Cubism into collage and the issues that raises. In Chapter 6, the idea of the exploration of a new kind of space continues to be of interest particularly among, for example, the Russian Constructivists and the architects Frank Lloyd Wright and Le Corbusier. In the 1950s we find Braque and Matisse still extending their interest in form and space and Jackson Pollock taking it further into Abstract Expressionism.

Meanwhile the pointers raised in this chapter go some way towards answering the question with which we began about why *Les Demoiselles d'Avignon* looks as it does; they certainly help us to approach this painting and try to account for its radical appearance. The connections with tradition are also important, enabling us to see continuity where there might appear to be none and even links with medieval art. Picasso's *Demoiselles* signals a move into an area of great significance for modern art as a whole, where the communication of an idea and the power to express it became more urgent than a naturalistic interpretation.

Chapter 2

The Dynamic View

FUTURISM

The embracing of modernity by the Futurists in Italy – and their contemporaries, the Vorticists, in England – is essentially about involvement with the industrial world, with the motor car, the factory, and with speed. Many of the ideas about dynamic fluctuation and time are incorporated in their work in a more obvious way than with the Cubists, as we shall see, particularly in Boccioni's painting of *Matter*, with which we begin this chapter. The influence of Henri Bergson, and his view of the world as dynamic rather than static, is very important for Futurism and his ideas will be explored in more detail in this chapter. Some of Bergson's writings were translated into Italian and published in 1909, the same year that Marinetti's *Manifesto of Futurism* appeared. In 1911, Bergson visited a philosophy conference in Bologna and spoke about his ideas, particularly on intuition. Also, one of the Futurists, Gino Severini, was living in Paris at the same time that Picasso and Braque were developing Cubism, and from his autobiography we can learn that he was in touch with many of the new ideas about modernity which we discussed in Chapter 1.

Severini and the other Futurists were also influenced by Impressionism, particularly by the series paintings by Monet and Pissarro, and we will have a look at this connection. Monet, and the younger generation, like Bonnard (see Chapter 7), were associated with the Symbolist movement and its emphasis on suggestion and mystery in painting, poetry and music. The idea that music could influence the spectator in a way that appealed directly to the emotions was very important for Futurism, and you can see this in one of the examples we will be looking at by Russolo. Matisse was also interested in music and painting, as can be seen in his famous pictures entitled *The Dance*; it may even be that Matisse, and his friend

Matthew Stewart Prichard, saw a direct connection between music and the ideas of Henri Bergson. It is also worth bearing in mind that Kandinsky was developing similar theories – particularly about colour and music – and publishing them in *Concerning the Spiritual in Art* in 1910, as we shall see in Chapter 4.

The fact that Futurism was also involved with sculpture makes another connection with artists of the late nineteenth century like Rodin and Medardo Rosso; we shall explore their interest in movement and how it connects especially with the ideas of Boccioni. In this area there is an interesting comparison to be made with tradition in the form of the Italian Baroque sculpture of Bernini or the classical Greek *Winged Victory of Samothrace*. Vorticism also embraced the modern world and marked the arrival of Modernism in England; in particular the interest in the modern industrial scene, the rejection of tradition, and the dynamic rather than the static view of the world were the hallmarks of their work. Whilst this certainly applies to the paintings of Wyndham Lewis and William Roberts, the sculpture also contains a strong interest in ethnographic traditions. Of course Epstein's *Rock Drill* is about industrial modernity, but much of his other work is more like that of his younger colleague Henri Gaudier-Brzeska, where the emphasis is on the communication of an idea in the way we saw in Chapter 1.

Both Futurism and Vorticism also established the importance of the manifesto – and more generally the connection between writing and the visual arts – in the need to explain the direction in which they felt their art was going. In this sense the relationship between all three early Modernist movements so far considered and the poets Apollinaire, Marinetti and Ezra Pound is significant and we will look briefly at that. Essentially all their ideas are about movement, change and an urgent engagement with what they saw as modernity and the ways in which it was different from the past. Both Futurism and Vorticism are still exciting from this point of view, but both also have an aggressive, disrupted and disjointed stance too, which is presaging of the catastrophe of the First World War and the subsequent rise of Fascism; Marinetti became a follower of Mussolini.

Colour Plate 3 *Matter* ('Materia') by Umberto Boccioni, 1912

Matter is a painting which seems to express all that we have been discussing in relation to new ideas in science and philosophy, and its title

seems directly to refer to them. The sitter is presented as if divided into atoms and molecules; the background invades the foreground in the way that it would in a Cubist painting. But if you compare *Matter* with Picasso's *Portrait of Ambroise Vollard*, which we looked at in Chapter 1 (pp. 22–3), you will see that, although the technique is broadly Cubist in its use of angled planes and soft and hard edges, there are many more diagonals, most obviously in the upper section of the picture; the colour is expressive and exciting, using the primary and complementary contrast to add to the drama and indeed the beauty of the surface. The darkest area is in the lowest part of the picture so that the composition is anchored by a section of opaque black, while the colour in the upper part of the picture is brighter and more translucent.

The composition appears at first to be chaotic. The head of the figure is set amongst a series of buildings in a street, all at higgledy-piggledy angles to one another. Lower down on the right-hand side there appear to be railings and on the left a figure running or walking along. The hands, with their interlocking fingers, move out towards us and the head appears to recede. But you can see that the hands appear to be much larger in terms of proportion, as if they were seen through the lens of a camera. Boccioni – like a number of other Futurists – was interested in aspects of photography and film especially as applied to the expression of movement. But first and foremost Futurists were concerned with what they called the dynamism of modern life and several of Boccioni's works have the word dynamism incorporated into their titles, like the *Dynamism of a Cyclist* for instance. Much of this expressive style, particularly in its use of colour, derives from Impressionist and Neo-Impressionist techniques, but the intentions were different – as the Futurists made clear in their manifestos.

The first and most famous statement by the poet Filippo Marinetti was published in *Le Figaro* in Paris on 20 February 1909. It established the need for art to reflect modern life, but not in Baudelaire's sense of the social scene which we looked at in Chapter 1. Marinetti lived in Milan and his ideas were about getting in touch with the industrial and technological life of the city. Near the beginning Marinetti describes how he and his friends were up late at night:

An immense pride swelled our chests because we felt ourselves alone at that hour, alert and upright like magnificent beacons and advance guard posts confronting the army of enemy stars staring from their heavenly encampments. Alone with the stokers working

before the infernal fires of the great ships; alone with the black phantoms that poke into the red hot bellies of locomotives launched at mad speed; alone with the drunks reeling with their uncertain flapping of wings around the city walls.

(F. T. Marinetti, in Chipp (ed.),
Theories of Modern Art. 284)

Marinetti is referring here to the dynamism of modern industry and the artist–poet's need to be forward-looking in the sense of being a member of the avant-garde.

The dynamic aspect of Futurism becomes more important and more explicit in Boccioni's *Technical Manifesto* published in Milan in April 1910:

> The gesture which we would reproduce on canvas shall no longer be a fixed *moment* in universal dynamism. It shall simply be the dynamic sensation itself (made eternal).
>
> Indeed, all things move, all things run, all things are rapidly changing.
>
> A profile is never motionless before our eyes, but it constantly appears and disappears. On account of the persistency of an image upon the retina, moving objects constantly multiply themselves; their form changes like rapid vibrations in their mad career. Thus a running horse has not four legs, but twenty, and their movements are triangular.

(Umberto Boccioni, in Chipp (ed.),
Theories of Modern Art. 289)

Boccioni's emphasis – on fluidity, movement and change, on one image superimposing itself on another – is reflective of the ideas and philosophy of Henri Bergson who, as we saw in Chapter 1, wielded a considerable influence on the development of Modernism; his public lectures were attended by artists and writers in Paris and this meant that his views were widely disseminated. The best summary of Bergson's theory that I know appears in *The Catalogue of the Graphic Work of Pierre Bonnard:*

> Bergson emphasized that our consciousness is always fluid, always becoming, always dependent on emotional states so there is *no one perceptual reality.* Our immediate experience is permeated and coloured by the memory of emotions but every succeeding

experience will be influenced in turn. The truth of one's own experience in what Bergson called 'duration' is therefore too fluid and complex to be grasped by reason. Only sudden intuition can give us access to memories of past experience stored in the unconscious. Only in those moments when we are connected with the fundamental self can we act freely. So, if artists aim to capture these feelings, they must choose subjects with which they are long familiar. So they can channel the sudden subjective response.

> (Catalogue of *The Graphic Work of Pierre Bonnard*,
> Metropolitan Museum of Art, New York, 1989/90)

So Bergson believed that our understanding of the world was constantly changing, always in a dynamic state of flux, so that one state of mind, one perception or one action was constantly moving into another. Boccioni was well aware of all these ideas, as indeed were the rest of the Futurists, particularly through Gino Severini who lived in Paris from 1906.

Our knowledge of Severini is based on his autobiography called *The Life of a Painter*; in it he tells us not only about the influence of Henri Bergson on Futurism but also of Impressionism, Neo-Impressionism, the Fauves and the Symbolists. After talking about the artists of the late nineteenth century and their concern with painting modern life, Severini says:

> That was the atmosphere created by Cézanne, Renoir, Seurat, Van Gogh, Gauguin, and in the wake of such masters, Signac and Cross followed with a vaster, more systematic Neo-Impressionism. Matisse and the so-called Fauves, ever more determined to attain a new level of pictorial poetry, discussed this subject with excitement and made comparisons and confrontation with Verlaine, Rimbaud, Laforgue, Mallarmé and the Symbolist poets in general. Bergson's theories about intuition began to circulate among the artists.
>
> Clearly, Impressionism, atmosphere, light at least in the Impressionistic sense had to be considered from a new perspective. The problem was not shifted exactly, but rather was broadened and developed. The new issues were rhythm, volume, bodies in three-dimensional space. We studied the substance of colour and of drawing as separate entities, not in relation to reality. 'Local tone' was re-examined. Aesthetic taste prevailed over any other and became increasingly more refined. As Cézanne had already perceived, this bred a repugnance toward painting real things in an

objective descriptive sense, and an urge to express the invisible nature of things in painting them.

<div align="right">(Gino Severini, The Life of a Painter: 42)</div>

So, clearly the Futurist felt himself to be part of a whole maelstrom of new ideas, which (Severini says) led to considerable personal struggle on the part of the artists involved. We need to explore this further in order to understand early Modernism better. A good example to start with is Severini's painting *The Boulevard*.

IMPRESSIONISM AND SYMBOLISM

Plate 15 *The Boulevard* by Gino Severini, 1910–11

In this picture Severini takes what is essentially an Impressionist subject but, instead of broken brushstrokes, he uses geometrical blocks of primary and complementary colour; he creates a kaleidoscopic effect seen

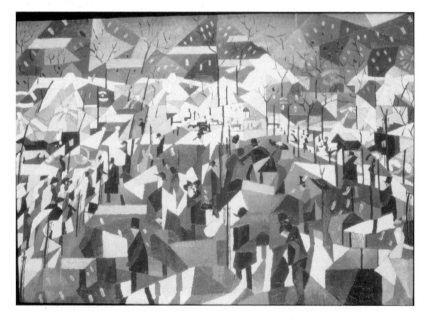

Plate 15 Gino Severini, *The Boulevard* (1911). Oil on canvas, 63.5 × 91.5 cm.

from a number of viewpoints. Triangles and squares of colour are angled to show movement and change on the surface of the picture. *The Boulevard* is more dynamic and abstract than a painting by Pissarro or Seurat would be, because the main axes of the picture are diagonal rather than vertical and horizontal. The blues, pinks and golds are all opaque. The white areas are used to open up the composition and create an effect of space, whilst the blacks, which are mostly in the lower sections, are used to give the composition weight.

As we have seen, Severini himself was convinced about the importance of the influence of Impressionism and Neo-Impressionism on Futurism. It is thought that Severini may well have seen Pissarro's series of paintings of Paris, shown in a number of exhibitions at the galleries of Durand Ruel and Bernheim-Jeune between 1908 and 1910. In particular *The Boulevard* may have been inspired by Pissarro's pictures of the Avenue de l'Opéra and Place du Théâtre Français of 1898 and 1899.

In the 1880s and 1890s the Impressionists like Pissarro and Monet had become interested in series painting. Their idea was to make a number of pictures of the same subject. Pissarro for instance painted pictures of different parts of the city of Paris. But he did not intend them to be sequential and in fact every one is slightly different, either in terms of the weather and the time of day, or in terms of the viewpoint.

You can say that these qualities and differences are not significant, but we know that Pissarro painted all fifteen of the pictures in this series from the same hotel room. In a letter to his son Lucien of December 1897 he wrote:

> I forgot to mention that I found a room in the Grand Hôtel du Louvre with a superb view of the Avenue de l'Opera and the corner of the Place du Palais Royal! It is very beautiful to paint! Perhaps it is not aesthetic, but I am delighted to be able to paint these Paris streets that people have come to call ugly, but which are so silvery, so luminous and vital. . . . This is completely modern!
>
> (Camille Pissarro, *Letters to his Son Lucien*: 316)

So Pissarro regards this city subject as modern and up to date, and the different viewpoints are deliberate, to give a shifting experience of reality. I suppose you would need to see them all together to get the full effect, but the arrangement is not sequential in terms of time of day or season. Instead, the pictures are like a series of intuitive glances

that can cumulatively give you a better idea of the character of a place. Monet used the series idea again and again, in his paintings of haystacks, poplars, Rouen cathedral and then finally – in the most extreme form – in the lily paintings of 1918–26, which we will look at in Chapter 7.

It is hard to imagine that Pissarro was not aware of Bergson's theories, and certainly we know that the younger generation of artists like Bonnard and the Nabis Group attended his lectures on 'Matter and Memory' in the 1890s. The role of memory was a key element in Bergson's philosophy. In particular, Bergson had new ideas about the role of memory in the way that we see the world so that no one image remains unaffected by what we have seen before; the role of memory is active and dynamic rather than static and unchanging. In *Matter and Memory* (published in 1896), Bergson explains how our memory works:

> In truth, it no longer *represents* our past to us, it *acts* it; and if it still deserves the name of memory, it is not because it conserves bygone images, but because it prolongs their useful effect into the present moment.
>
> (Bergson, *Matter and Memory*: 93)

This meant that our understanding of the world was constantly changing, triggered by memories associated with what we are looking at:

> For while external perception provokes on our part movements which retrace its main lines, our memory directs upon the perception received the memory-images which resemble it and which are already sketched out by the movements themselves. Memory thus creates anew the present perception; or rather it doubles this perception by reflecting upon it either its own image or some other memory image of the same kind.
>
> (Ibid: 122–3)

So our experience of reality is constantly coloured by our memory images, making our experience of it unstable, dynamic and mysterious.

The idea of reality as ultimately mysterious was central to Symbolist art theory in this period and it certainly affected the work of Gauguin (see *Learning to Look at Paintings*, pp. 110–11). The leader of the Symbolist movement, Stephane Mallarmé (whom we

will discuss in more detail in Chapter 3), was a friend of Henri Bergson whose ideas we have just been looking at. Another important element in this mixture of theories was the interest in music, and its power to communicate in a suggestive rather than a descriptive way; there is a poem by the Symbolist poet Paul Verlaine, dedicated to Music, which expresses this idea very well.

> You must have music first of all,
> and for that a rhythm uneven is best,
> vague in the air and soluble,
> with nothing heavy and nothing at rest.
>
> You must not scorn to do some wrong,
> in choosing the words to fit your lines,
> nothing more clear than the tipsy song,
> where the undefined and exact combine.
>
> Never the colour, always the shade,
> always the nuance is supreme!
> Only by shade is the trothal made
> between flute and horn, of dream with dream.
>
> (P. Verlaine, 'To Music', quoted in Catalogue of
> *The Graphic Works of Pierre Bonnard*)

This poem suggests that music can communicate feelings and ideas without description. This was one of the main themes running behind Symbolist painting and poetry; it provided an important background to the drive away from naturalism and towards more abstract interpretation in the development of Modernism which we began considering in Chapter 1. We need to explore this further now and see how it affected artists such as Matisse and then the Futurists.

MUSIC

Colour Plate 4 *The Dance* by Henri Matisse, 1910

In a book of essays called *The New Bergson*, Mark Antliff says that Bergson compares our consciousness to a melody and that colour can be an intermediary between our perceptual experience and the rhythmic pulse of our own consciousness.

For an artist it was this rhythm that served to bind the pattern of

colours and shapes that make up a canvas into an integral, organic whole.

(M. Antliff, in John Mullarkey (ed.), *The New Bergson*: 188)

Antliff suggests that Bergson had a profound influence on Matisse through his friendship with the critic and aesthetic theorist Matthew Stewart Prichard. Certainly musical terms play an important role in the titles of Matisse's paintings, most obviously in the various versions of *The Dance*.

Colour Plate 4 shows the most famous version of *The Dance*, done in flat areas of primary and complementary colour, an orangeish red for the bodies and then blue and green for the background. The bodies are distorted and exaggerated, but they create a dynamic energy and rhythm which exactly expresses the movement of the dance; it pulses with excitement. Such is his understanding of the structure of the human form that Matisse can make us believe these figures are alive, even though we know that in reality they are impossibly contorted. If you look at the standing figure on the left and you imagine what the muscles and limbs are doing in that stretching and arching motion, and similarly with the figure at the back who is bent nearly double, you can feel the movement of the dance. The way the orangeish red of the figures relates to the curving green and blue in the background also expresses the idea of the melody and rhythm of the music. Fascination with music and the relationship between sound and colour was part of artistic and aesthetic thinking at this period. The Futurists were no exception to this and painted a number of musical subjects, including the one by Luigi Russolo that we look at now.

Colour Plate 5 *Music* by Luigi Russolo, 1911

Extraordinary, disturbing and truly Futurist – in its technique and in its composition of layered, coloured planes – is Luigi Russolo's painting, *Music*, of 1911. The dark piano keyboard is placed right in the foreground at the bottom of the picture and the figure playing it is silhouetted against a curving snake-like form in blue and gold, which thickens and turns to indigo towards the top. It looks like a contemporary gramophone horn and we are reminded that this was the period of the first musical recordings. This leads the eye to the background, a series of mask-like heads with different expressions, converging in the centre. They in turn are set against a series

of paler, concentric circles, which spread out and darken towards the edges of the picture. The colours and the shapes come together to create a composition which is strident and not harmonious, disturbing rather than peaceful. Russolo's expression of the idea of music is vivid, exciting and dynamic, like the manifestos of Futurism or indeed the new forms of music in the development of jazz at this time.

Sometimes though, in addition to the dynamic energy, there can be an aggressive war-like quality in both the manifestos and some of the works produced by the Futurists. The figure in the foreground of Russolo's *Music* looks as though he is wearing an army helmet. Although we have been discussing the philosophy of Bergson, which is probably most significant, the influence of Nietzsche (see Chapter 1) should not be forgotten; Russolo had even etched a symbolist portrait of Nietzsche in 1909.

SCULPTURE

Plate 16 *Unique Forms of Continuity in Space* by Umberto Boccioni, 1913

Boccioni's *Unique Forms of Continuity in Space* takes the human form as its starting point and attempts to express in bronze the idea of dynamic movement. The draperies, like pieces of free-flowing armour that cover the figure, appear to be blown by the wind as the figure strides along. The movement resembles walking but is not related directly to any subject; it has become the expression of the dynamic force of change and flux; it moves out into the space surrounding it and that space seems also to press in upon it.

Boccioni was fascinated by the idea of the interpenetration of one section of the world by another that you would not normally see as related; we noticed this in his painting of *Matter* at the beginning of this chapter, but it comes out just as clearly in Boccioni's *Technical Manifesto of Futurist Sculpture*:

> Why should sculpture remain behind, tied to laws that no-one has the right to impose upon it? We therefore cast all aside and proclaim the ABSOLUTE AND COMPLETE ABOLITION OF DEFINITE LINES AND CLOSED SCULPTURE. WE BREAK OPEN THE FIGURE AND ENCLOSE IT IN ENVIRONMENT. We proclaim that the environment must be part of the

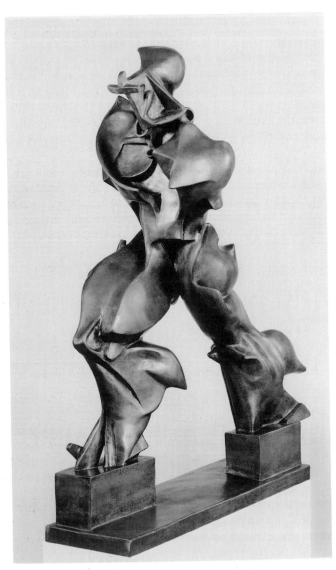

Plate 16 Umberto Boccioni, *Unique Forms of Continuity in Space* ('Forme uniche della continuità nello spazio', 1913, cast 1972). Bronze cast, 117.5 × 87.6 × 36.8 cm.

Photograph © Tate, London 2003.

plastic block which is a world in itself with its own laws; that the sidewalk can jump up on your table and your head be transported across the street, while your lamp spins a web of plaster rays between one house and another.

We proclaim that the whole visible world must fall in upon us, merging with us and creating a harmony measurable only by the creative imagination; that a leg, an arm, or an object, having no importance except as elements of plastic rhythm, can be abolished, not in order to imitate a Greek or Roman fragment, but to conform to the harmony the artist wishes to create. A sculptural entity, like a picture, can only resemble itself, for in art the human figure and objects must exist apart from the logic of physiognomy.

(Umberto Boccioni, in Chipp (ed.),
Theories of Modern Art: 302)

So Boccioni says sculpture must relate to its environment and it should not necessarily be descriptive of a subject; it need only relate to itself and to the artist's idea. This makes a fundamental break with tradition but nevertheless connections can be made between Boccioni and the Baroque, and with classical sculpture.

Plate 17 *Apollo and Daphne* by Gian Lorenzo Bernini, 1622–4

Plate 18 *The Winged Victory of Samothrace*

If we take Bernini's sculpture of *Apollo and Daphne* of 1622–4 we see that it is still true to the narrative from Ovid's *Metamorphoses*. Apollo fell in love with Daphne and pursued her until she was turned into a laurel bush to save her from his advances. Bernini depicts the moment of metamorphosis when the hair and the hands of Daphne start to change into leaves, branches and twigs; he carves the marble so that it moves and flows like water. If you look particularly at Daphne's hair spreading upwards and outwards, it does not seem possible that it is made of marble. The spaces between the figures, the way the drapery moves into the surrounding area, all make one aware of the interpenetration of form and space. But it is still tied to a story with a finite end and is not intended to express the free-flowing and never-ending change that interested the Futurists.

The magnificent Greek figure *The Winged Victory of Samothrace* is

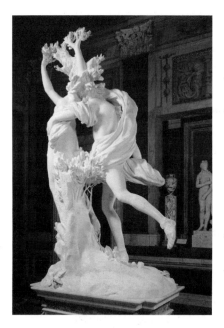 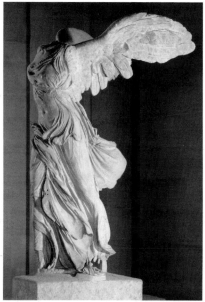

Plate 17 Gian Lorenzo Bernini, *Apollo and Daphne* (1622–4). Marble. Galleria Borghese, Rome, height 243 cm.
Photograph © 2000, Scala, Florence – courtesy of the Ministerio Beni e Att. Culturali.

Plate 18 *The Winged Victory of Samothrace* ('Nike', c.190 BC). Marble, height 3.28 m.
Courtesy of Louvre, Paris. Photograph © Photo RMN.

also about movement. Marinetti referred to it famously in his manifesto:

> A race automobile adorned with great pipes like serpents with explosive breath . . . a race automobile which seems to rush over exploding powder is more beautiful than the *Victory of Samothrace*.
> (F. T. Marinetti, *The Foundation and Manifesto of Futurism*, 1909, in Chipp (ed.), *Theories of Modern Art*: 286)

But, if you try directly comparing the Greek figure with Boccioni's sculpture, you will see that the classical figure remains solid. It is not perforated in the centre like Boccioni's form, nor does it have the effect of the corkscrewing spiral in the legs and torso. Boccioni uses

the traditional medium of bronze to express a twentieth-century idea of the dynamic. It is altogether less descriptive and more abstract than either the Greek or the Bernini sculpture.

However, there were other artists who were interested in ideas of movement and shifting patterns of reality, notably Rosso and Rodin. They are both mentioned by Boccioni in the Futurist manifesto and we know that he was aware of their work.

Plate 19 *Impression of the Boulevard: Woman with a Veil* by Medardo Rosso, 1893

In the 1890s, Rosso had made wax sculptures of Impressionistic subjects. *Impression of the Boulevard: Woman with a Veil* of 1893 is a good example. At first, in spite of the fact that it is made of wax, this

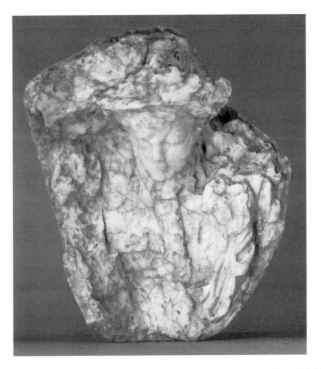

Plate 19 Medardo Rosso, *Impression of the Boulevard: Woman with a Veil* (1893). Wax, 65 × 59 × 25 cm.
The Estorick Collection, London, UK. Photograph courtesy of The Bridgeman Art Library.

sculpture looks like a piece of worn rock or stone weathered by the elements. Then, as if it were a fossil, you can just make out the features of a face bent forwards with its eyes and nose just visible and a shape like a hat above. The whole form is so fluid that it seems to be changing before your eyes, as though you were passing this woman in a busy street and catching a glimpse of her; yet the whole piece is as solid and three-dimensional as you would expect a sculpture to be.

Plate 20 *The Walking Man* by Auguste Rodin, 1884–5

Rodin too was interested in the expression of movement, clearly seen in the famous *Walking Man* of 1884–5. Rodin communicates the process of walking and shows it to us as it is happening. When you look at the feet, you see that they are both fully on the ground just at the moment when the weight is going to be shifted from one foot to the other in order to propel the body forward. You can see that Rodin has caught the twisting motion of the pelvis as the muscles and the joints work to achieve a step forward. He has only sculpted the torso and legs because the arms and head are not necessary to create the feeling of movement out into the surrounding space.

In spite of the extremely radical manifesto of Boccioni, and the new approach to form he espoused, it can be seen that recent thinking had informed and influenced Futurist sculpture as had older traditions of the past, like the baroque and the classical. Rodin's *Walking Man* and Rosso's sculpture were shown at the International Exhibition of Fine Arts held in Rome in 1911. Rodin had written about his *Walking Man* and the idea of movement in art in 1910, and he re-opened the discussion of it when he visited Rome after the exhibition, when the sculpture was erected in the courtyard of the Palazzo Farnese.

Many of the ideas we have been discussing so far in this chapter, especially those of Bergson, influenced the avant-garde in England; in particular, there was the movement known as Vorticism, led by Percy Wyndham Lewis.

VORTICISM

Plate 21 *New York* by Percy Wyndham Lewis, 1914–15

This painting is of an uncompromisingly modern subject in the Futurist sense, with its diagonal axis, its primary colours, and its

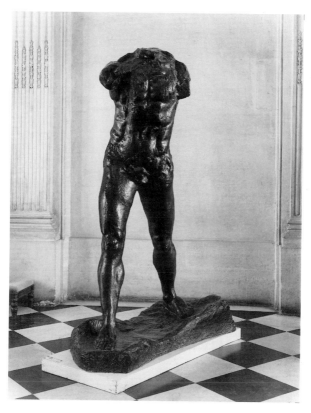

Plate 20 Auguste Rodin, *The Walking Man* ('L'Homme qui marche', 1884–5). Bronze, 213.5 × 71.7 × 156.5 cm.

Photograph: Adam Rzepka, courtesy of musée Rodin, Paris.

subject-matter of the city. The overlapping planes, and the building on the right presented at a vertiginous angle, could almost be said to represent Boccioni's idea of the ability of the sidewalk to jump up on your table. But, in a way, this view of New York seems more abstract than the exuberant movement of a Futurist work in painting or sculpture. It has a greater degree of stillness which reflects the ideas behind the Vorticist movement in England. In their magazine *Blast*, first published in June 1914, Wyndham Lewis wrote about this more static aspect:

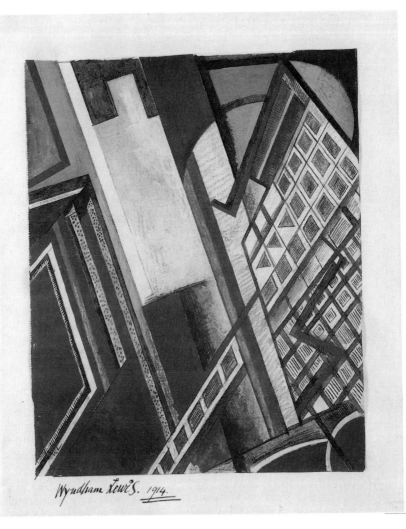

Plate 21 Percy Wyndham Lewis, *New York* (1914–15). Pen and ink, crayon, water-colour and gouache on paper; 31 × 26 cm.

The Vorticist is at his maximum point of energy when stillest.
The Vorticist is not the Slave of Commotion but its Master.
The Vorticist does not suck up to Life.
He lets Life know its place in a Vorticist Universe!
(Percy Wyndham Lewis, 'Our Vortex' in Harrison
and Wood (eds), *Art in Theory*: 155)

The front cover of the magazine presents the word 'Blast' diagonally across the page. Inside, the typography is revolutionary for the time, with the letters, words and spacing varying in size in an apparently random way. It is anti-tradition, and anti the past, not only in what it says, but in the way it sets the words on the page. Lewis associated briefly before the First World War with a number of artists including the sculptors Jacob Epstein and Henri Gaudier-Brzeska. The latter published his own manifesto of the vortex in sculpture also in the first edition of *Blast:*

VORTEX OF A VORTEX!!
VORTEX IS THE POINT ONE AND INDIVISIBLE!
VORTEX IS ENERGY! and it gave forth
SOLID EXCREMENTS in the quattro e cinquecento,
LIQUID until the seventeenth century, GASES
whistle till now. THIS is the history of form
value in the West until the FALL OF IMPRESSIONISM.
(Henri Gaudier-Brzeska, 'Vortex of blackness and silence', in
Harrison and Wood (eds), *Art in Theory*: 161)

It is clear from these extracts that the Vorticists set about rejecting traditional values and embracing the modern world rather in the way Marinetti and the Futurists had done; indeed Lewis had met Marinetti when he came to a dinner at the Florence Restaurant in London in November 1913.

Plates 22 and 23 *The Rock Drill* by Jacob Epstein, 1915

Epstein's sculpture, known as *The Rock Drill*, is one of the most famous works to come out of the Vorticist movement, and you can see why. It has a harsh, metallic, angular quality; it is tense and robot-like, not full of outward-moving energy like the Boccioni sculpture we looked at. Originally, Epstein made *The Rock Drill* in plaster and

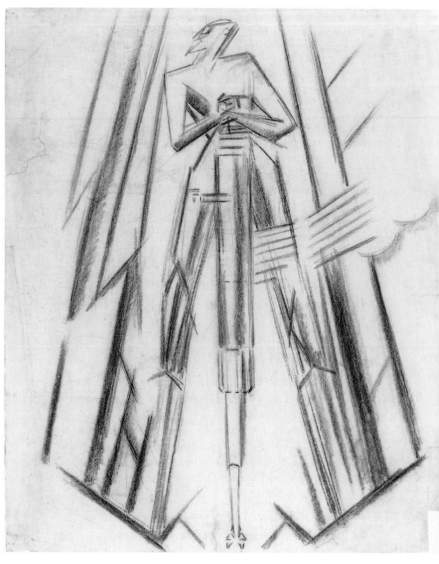

Plate 22 Jacob Epstein, 'Study for *The Rock Drill*' (c.1913). Pencil on paper.
© The Estate of Jacob Epstein/Tate, London 2003. Photograph © Tate, London 2003.

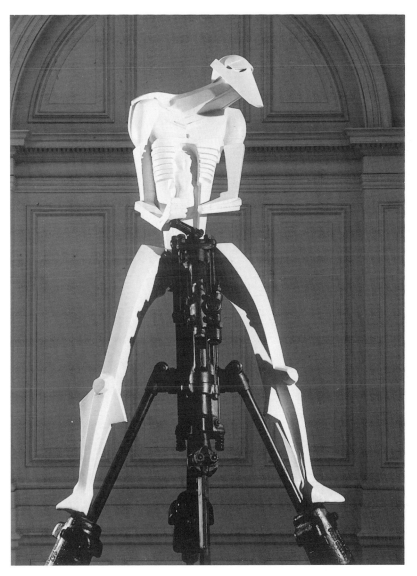

Plate 23 Jacob Epstein, *The Rock Drill* (reconstructed 1973). Plaster model.

mounted it on a miner's rock drill, but after it was first exhibited in 1915, the artist removed the drill and the legs and left only the torso; so now its correct title is 'Torso in Metal from *The Rock Drill*'. The head is a cross between a beak and a helmet with the neck set on the shoulders at a shallow angle. The left arm appears like a robot's arm and the body seems to be encased in armour, with its unborn progeny within it.

To us now this sculpture seems strangely prophetic of the machinery and armour of the First World War and this may be why the artist cut it down. Certainly the idea of incorporating a ready-made drill with the sculpture was avant-garde and equivalent to what Marcel Duchamp was doing with his 'readymades'; in fact Duchamp was working on them as early as 1914 although he did not exhibit them publicly till later. In his memoirs, published much later in 1940, Epstein merely said 'I lost interest in machinery and discarded the drill.' It is true that other sculptures Epstein made at the same time were more organic, like *Figure in Flenite* of c.1914, which also resembles a kind of bird/man figure but without the mechanization.

Plate 24 *The Crouching Woman* by Henri Gaudier-Brzeska, 1913–14

Gaudier-Brzeska uses more natural organic sources for his sculptures, like *The Crouching Woman* of 1913–14 in which the forms of the human body become almost abstract in their simplification, but express a kind of internalized energy and tension which is very exciting. The head is locked into the crook of the elbow, while the torso, breast, thigh and calf are held underneath so that the figure seems to be about to burst into action at any moment. In the simplification of the figure we can see the influence of the ethnographic images we were discussing in the first chapter in relation to Picasso. Gaudier-Brzeska also did a sculpture called the *Hieratic Head of Ezra Pound*, which is extremely simplified and yet seems to vividly express an idea of the likeness of the poet.

It was Ezra Pound who originally coined the term 'Vorticism' in an essay of that title in the *Fortnightly Review* in 1914; it referred to the vortex of artists and ideas that existed in London at this period, a vortex which included many more figures than I have been able to refer to here. Pound was influenced by the work and theories of the philosopher-poet T. E. Hulme, who expressed his views about modern art in a lecture to the Quest Society in June 1914. Hulme

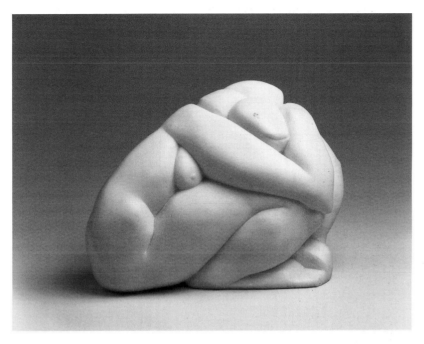

Plate 24 Henri Gaudier-Brzeska, *Crouching Figure* (1913–14). Marble, 8¾ × 12 × 4 ins.
Courtesy of Collection Walker Art Center, Minneapolis Art Center Acquisition Fund, 1957.

suggested that art needed to be more abstract, not in the way Cubism or Futurism was, but in a more geometrical fashion. Richard Cork summarized Hulme's view in his catalogue *Vorticism and its Allies:*

> His prescription for the new art turned out to be a surprisingly accurate forecast of the movement which emerged as Vorticism a few months later, for Hulme announced that 'the new "tendency towards abstraction" will culminate, not so much in the simple geometrical forms found in archaic art, but in the more complicated ones associated in our minds with the idea of machinery'. And the specific visual character of Vorticist work is adumbrated with great clarity in his belief that it would be inspired by an admiration for the qualities upheld in 'engineers' drawings, where the lines are

clean, the curves all geometrical, and the colour, laid on to show the shape of a cylinder for example, gradated absolutely mechanically'. Sculpture, likewise, would be galvanized by 'the hard clean surface of a piston rod', and play a vital role in the formation of an art 'having an organization, and governed by principles, which are at present exemplified unintentionally as it were, in machinery'.

(Richard Cork, in Catalogue of *Vorticism and its Allies*: 14)

So Hulme's idea was that art would be more geometrical:

Pure geometrical regularity gives a certain pleasure to men troubled by the obscurity of outward appearance. The geometrical line is something absolutely distinct from the messiness, the confusion, and the accidental details of existing things.

(Hulme, quoted in ibid: 14)

This clearly states the view which we have been discussing in these first two chapters that art needs to become more conceptual in order to express a world that is no longer understood as visible in the same way as it used to be. Both Hulme and Wyndham Lewis were familiar with Bergson's philosophy; Hulme translated the *Introduction to Metaphysics* in 1913 and Wyndham Lewis had attended Bergson's lectures when he was living in Paris at various periods in the early 1900s.

Colour Plate 6 Study for *Two-Step II* by William Roberts, *c*.1915

The kind of geometrical expression Hulme is talking about is shown very clearly in the clean lines and acid colour in this watercolour by William Roberts, a member of the Vorticist group. Here is another musical subject, but more purely expressive than the ones by Matisse or Russolo in the sense that it is non-figurative. All the forms have hard edges and black, or another dark tone, is used to define them. The whole composition is organized on the slant and you are looking at it from several angles simultaneously. If you look particularly from right to left upwards, the orange background appears to recede, and the angled forms seem to move into it.

At the same time you feel the objects moving past you on the left with a jerky rhythmic movement which could be compared to the sound of jazz; certainly the picture is not harmonious in the placid sense of that word, even though the whole arrangement is made to

stay within the confines of the page. The reds and blacks help to hold the painting together because they are opaque and solid compared with the more translucent pinks, greys and browns. Altogether this is a dynamic, exciting and energetic picture, which expresses clearly the ideas behind Vorticism and its modernist view of modernity.

ART AND WRITING

The relationship between Vorticism, Futurism and Cubism on the one hand, and poetry and writing on the other, is extremely important. The protagonists of Modernism continually felt the need to express themselves in words and I think, as we have seen, that this has much to do with the fact that they were concerned with interpreting a new modern world which was essentially non-visual. We need to explore this a little more in order to understand the connections between the visual arts and literature that continued to be important later in the twentieth century. You only have to think of the manifestos of Surrealism or the more recent explanatory texts of Conceptual Art to see this.

Plate 25 'It's Raining' by Guillaume Apollinaire, 1912–17

The poets Ezra Pound, Filippo Marinetti and Guillaume Apollinaire were all important catalytic figures in relation to Vorticism, Futurism and Cubism respectively. Apollinaire particularly makes the Modernist view very explicit in his poems like 'It's raining' where the words are set out visually to express the form of the idea he is writing about. They cascade down the page in lines, just like drops of rain, so the form expresses the meaning in as direct a way as possible but without the need to describe it. 'It's raining' was written between 1912 and 1917 and published in 1918 as part of a collection called *Calligrammes*. In a letter to his friend André Billy in 1918 Apollinaire said this about *Calligrammes*:

> As for the Calligrams, they are an idealization of vers-libre poetry and of typographical precision at a time when typography is brilliantly ending its career, at the dawn of new methods of reproduction, the cinema and the gramophone.
>
> (G. Apollinaire, *Selected Poems*: i)

It's Raining

it is raining women's voices as if they were dead even in memory

you also are raining down marvellous encounters of my life o little drops

and these rearing clouds are beginning to whinny a whole world of auricular towns

listen to it rain while regret and disdain weep an old fashioned music

listen to the fall of all the perpendiculars of your existence

Plate 25 Guillaume Apollinaire, 'It's Raining' (from *Calligrammes* in Apollinaire, *Selected Poems*, trans. Oliver Bernard).

It is clear that he saw the connection between new Modernist styles of writing and new types of communication. Interestingly, the earliest section of the collection that includes 'It's Raining' was originally to be called 'Et moi je suis peintre' ('And I too am a painter') indicating that Apollinaire clearly felt the connection between the visual arts and literature. Later, in Chapter 5 on composition, we will see how Apollinaire was an agent in the development of a new type of picture, the collage.

In this chapter we have seen a whole maelstrom of ideas which were expressed in the work of the Futurists, of Matisse and the Vorticists, where both painting and sculpture played their part. Bergson's theories about intuition and memory were an underlying theme as were the influence of Impressionism and Symbolism and the connection with the abstract communication through music. It was indeed a dynamic, moving kind of modernity which seemed to be present in everything from philosophy to the motor car and which needed to be visualized in a new modernist way. Poetry and writing and explanation were deeply involved in this. The strident tone of the manifestos of Futurism and Vorticism, and the subsequent positions of Marinetti and Pound in relation to Fascism, have been unfortunate. You can see how their aggressive stance and their style could have become warlike and tyrannical. But inherent within the ideas of both men was the desire to embrace changes in a new world, and this utopian view did not belong exclusively to early Modernism before the First World War.

Several of the themes explored in this chapter will recur later on. In Chapter 4 we shall connect up with the interest in music in Expressionism. In Chapter 5 we shall discover a new direction for the idea of modernity in the work of Andy Warhol and the Pop Art movement. Also, the theories of Henri Bergson go on being of interest particularly to artists in France after 1945. In Chapter 6 we shall look at how utopian attitudes and idealism are reflected in the work of other artists of this and later periods and why they became less appropriate in the Postmodernist era after the 1960s.

Chapter 3

Duchamp and Conceptual Art

DUCHAMP

So far in this book we have been broadly considering themes to do with why works of modern art look as they do. This will continue to be important; but equally significant has been what could be termed the search for new meanings and the need to express them in a different way. Crucial in this context is the work of Marcel Duchamp and his influence, particularly on what is termed Conceptual Art, where the idea behind the work is as important as its appearance. We have been looking at early Modernism as art for a changed world, art which moved from an emphasis on the visible to an interpretation of the invisible or what lies beneath the surface. We have talked about a move from a perceptual to a more conceptual stance, but as indicated at the end of Chapter 1 this is not the same as Conceptual Art.

Conceptual Art developed from the 1960s onwards, mainly as a result of the influence of Duchamp. Here the shift in sensibility is not about experimenting with appearances but more about communicating meaning and involving the spectator in a dialogue about what the work says rather than how it looks. In this context the written word can be as important as the visualization. By this I mean that, in Conceptual Art, theory, writing and explanation become part of the artist's expression and the viewer's engagement. But before we go on to examine Duchamp's development and his impact on the future, we must investigate aspects of his background.

Plate 26 *Yvonne and Magdalena Torn in Tatters* by Marcel Duchamp, 1911

Duchamp began his work as part of early Modernism and you can easily consider his *Nude Descending a Staircase* as one of the key works

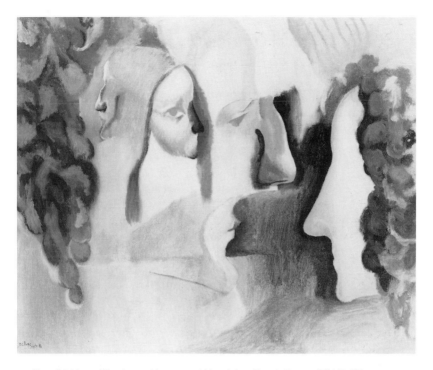

Plate 26 Marcel Duchamp, *Yvonne and Magdalena Torn in Tatters* (1911). Oil on canvas, 23¾ × 28⅞ ins.

© Succession Marcel Duchamp/ADAGP, Paris and DACS, London 2003. Courtesy of Philadelphia Museum of Art: The Louise and Walter Arensberg Collection. Photography by Eric Mitchell, 1992

of that period. It belongs with Cubist and Futurist concerns about space and dynamic movement, although as we shall see it is not entirely about that. But as a young artist, as early as 1911 and even before that, Duchamp had become more interested in the search for meaning. If you go to the Arensberg Collection in Philadelphia you can see in the early paintings how he tried out mainly a kind of symbolism with shifting meanings and ambiguous expressions. This is most obvious in a painting called *Yvonne and Magdalena Torn in Tatters* (Plate 26), where the profiles of his two sisters are shown with a number of more masculine silhouettes, which, as you look at them, appear to move in and out of focus between the foreground and the background.

Of course Duchamp is most famous for his invention of the ready-made, where the making and crafting of the object was not the most important thing. As early as 1914 he was working on the *Bicycle Wheel* (Plate 29). At the end of his life he said:

> I'm not at all sure that the concept of the readymade isn't the most important single idea to come out of my work.
>
> (Calvin Tomkins, *Marcel Duchamp*: 158)

In the development of the readymades and works like *The Bride Stripped Bare by her Bachelors, Even* or *Etant Données*, which we will look at, the role of the spectator is extremely important. When Duchamp designed the Arensberg Gallery in the Philadelphia Museum of Art in 1954, he put *The Bride* opposite a specially installed window so that you look through and not at the work. In his famous lecture of 1957 called 'The Creative Act' he described the role of the artist as like that of a medium, who creates the atmosphere in which communication can take place with the spectator:

> The spectator brings the work in contact with the external world by deciphering and interpreting its inner qualifications and thus adds his contribution to the creative act.
>
> (Ibid: 397)

Duchamp believed that the viewer completes the work of art and the whole thing only exists properly when this interaction is taking place.

Now you may well ask what this has to do with Conceptual Art and the answer is a great deal, because most Conceptual Art is about meaning. Later in this chapter we are going to consider in particular what is broadly termed Installation Art, where the meaning is the most important point and the spectator's experience of the work is what counts. But there are many more examples in other parts of the book. We shall see examples of land art, light installations and video work, all of which could be called conceptual because they involve the spectator in thinking and participating and the emphasis is not on the craft of making the object.

Duchamp is also famous for his connection with the Dada movement which happened during and after the First World War; it was completely against tradition of any kind and in particular against the fine-art tradition. Duchamp's representation of a reproduction of the *Mona*

Lisa with a moustache does make you ask yourself questions about art, Leonardo da Vinci and gender, and you get involved. He was interested in exploring subjects that had not been tried before and in creating greater freedom for the role of art.

Duchamp said he was against what he called 'retinal painting' from Courbet onwards which as we have seen was modernist and aimed mainly at expressing aesthetic considerations, and revealing abstract qualities and the painting process. Yet Duchamp based his last work called *Etant Données* on Courbet's picture of a nude called *The Origin of the World*. Duchamp is an artist who is full of ambiguities and contradictions and this is partly why he is important to Postmodernist artists. But he is also the heir to a long tradition of shifting meanings in art and, towards the end of this chapter, we shall look at examples of this in the work of William Blake, Odilon Redon and Salvador Dalí. Finally, we will look at the connection with Freud, André Breton and Surrealism, which is certainly important because the Surrealists were obviously influenced by Duchamp and Dada and their work quite definitely is full of suggestion and uncertain meaning.

In his tribute to Marcel Duchamp after his death in 1968, the American artist Jasper Johns said that he had

> moved his work through retinal boundaries which had been established with Impressionism into a field where language, thought and vision act upon one another.
>
> (Jasper Johns, *Art Forum*, November 1968)

This sounds like a definition of Conceptual Art. As early as 1913, Apollinaire in his book *The Cubist Painters* recognized Duchamp as 'liberated from aesthetic preoccupations'. This is the main aspect of Duchamp's work and influence that we explore now.

THE SEARCH FOR NEW MEANINGS

Plate 27 *Nude Descending a Staircase (No. 2)* by Marcel Duchamp, 1912

Like *Les Demoiselles d'Avignon* this painting has become an icon of twentieth-century art; it is a sequential image in the sense that the movement of the figure down the stairs is expressed in sequence rather as it would be on film or in a chronophotograph. Indeed the figures are so dislocated it is hard to see whether they are nudes.

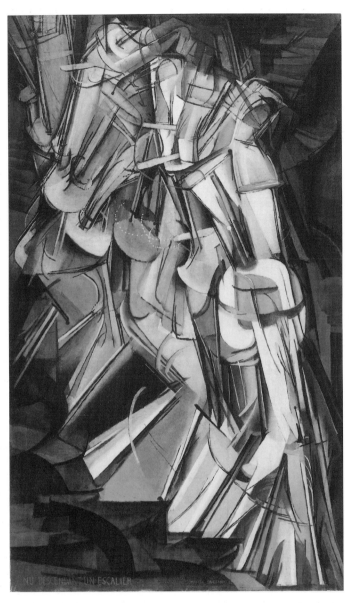

Plate 27 Marcel Duchamp, *Nude Descending a Staircase (No. 2)* (1912). Oil on canvas, 57⅞ × 35⅛ ins (147 × 89.2 cm).

There is obviously the influence of Cubism in the way the figures are divided up into facets. The front figure on the right appears to be lifting off the picture plane and the ones behind seem to be leaning against it and projecting it forward. You seem to be looking at it from several points of view.

If you start in the bottom left-hand corner of the painting, you can see the steps of the staircase. Then as you move your gaze upwards there are the lower parts of the legs up to the bended knees. But, further on, the figures seem to become a series of dislocated angles which could be a reference to the skeleton or to a metallic kind of armour plating. You seem to look from the right as if the figure was coming towards you, and from the left as if it was moving past you, or up into it as if you were viewing it from below. But, when you look at the steps, you feel you must be above them as if you were walking up them yourself in the opposite direction to the descending nude. The dark areas in this lower section, and in the top right-hand corner, create the effect of a framework for the sequence of figures. The dark lines, which emphasize the edges of the planes, are angled in different directions and they also help to create the effect of movement and of the joints of the body working to enable it to walk downstairs. The figure in front leans back slightly and the rest point forward; this seems to accentuate the downward motion.

In his expression of dislocation and movement it has been suggested that Duchamp was influenced by Cubism, Futurism and chronophotography. He himself denied this in an interview in 1946:

No, I do not feel there was any connection between the 'Nude Descending a Staircase' and Futurism. The Futurists held their exhibition at the Galerie Bernheim Jeune in January 1912. I was painting 'the *Nude*' at the same time. The oil sketch for it, however, had already been done in 1911. It is true I knew Severini. But I was working quite by myself at the time – or rather with my brothers. And I was not a café frequenter. Chronophotography was at the time in vogue. Studies of horses in movement and of fencers in different positions as in Muybridge's albums were well known to me. But my interest in painting 'the *Nude*' was closer to the Cubists' interest in decomposing forms than to the Futurists' interest in suggesting movement, or even to Delaunay's *simultaneist* suggestions of it. My aim was a static representation of movement – a static composition of

indications of various positions taken by a form in movement – with no attempt to give cinema effects through painting.

(Marcel Duchamp, 'Painting at the service of the mind', in Chipp (ed.), *Theories of Modern Art*. 393)

However, in spite of Duchamp's statement of denial, you would have to say that the *Nude Descending a Staircase* could be compared as much with *Matter* by Boccioni as with Picasso's *Portrait of Ambroise Vollard* or his photographs of the Douanier Rousseau, which we looked at in earlier chapters. But, unlike any of these, Duchamp's painting has an air of ambiguity about it which is not just visual. The figure in front appears monkish as if it was wearing a cowl and its face is half hidden as if to convey an air of mystery about who it is and what it is really doing. We find ourselves tempted to ask why it is descending the staircase and where it is going.

Earlier in the same interview, Duchamp talks about wanting to abandon what he called retinal painting which, as we saw in the introduction to this chapter, he felt had been too dominant since the time of Courbet:

For me Courbet had introduced the physical emphasis in the nineteenth century. I was interested in ideas – not merely in visual products. I wanted to put painting once again at the service of the mind. And, my painting was, of course, at once regarded as 'intellectual', 'literary' painting. . . .

In fact, until the last hundred years, all painting had been literary or religious: it had all been at the service of the mind. This characteristic was lost little by little during the last century. The more sensual appeal a painting provided – the more animal it became – the more highly it was regarded.

(Ibid: 394)

Here Duchamp is effectively attacking the Modernist position, with its emphasis on the pictorial qualities of painting that we discussed in Chapter 1. Instead he wants a return to moral and philosophical content; this had certainly been tried at the end of the nineteenth century by the French Symbolist movement, which we glanced at in Chapter 2. It explored the power of the human imagination to respond to suggestion in a way that was often non-specific; its leader, the poet Stephane Mallarmé, spoke about the ideas behind Symbolism like this:

To evoke an object little by little in order to reveal a state of mind or, inversely to choose an object and to derive from it a state of mind by a series of decipherments – that is the perfect use of mystery.

(Paul Hayes-Tucker, Catalogue of *Monet in the '90s*: 101)

So the work of art should aim to be mysterious and the observer should respond by trying to feel what it is about. This certainly sounds like Duchamp himself and he acknowledged the influence of the French Symbolist movement:

Mallarmé was a great figure. This is the direction in which art should turn; to an intellectual expression, rather than to an animal expression. I am sick of the expression '*bête comme un peintre*' – 'stupid as a painter'.

(Marcel Duchamp, 'Painting at the service of the mind', 1946, in Chipp (ed.), *Theories of Modern Art*: 395)

But the relationship between content, subject and execution is much more complex in Duchamp's work than just the straightforward influence from French Symbolism. In his fascinating book, *Marcel Duchamp and Max Ernst: The Bride Shared*, David Hopkins suggests that Duchamp's iconography was a complex mixture of ideas which aimed at bringing things into the open that normally remain hidden in conventional society. The connection with Freud and psycho-analysis is obvious in the sense of releasing underlying meanings – particularly erotic ones – which normally reside in our unconscious minds. Hopkins quotes Duchamp as saying:

Eroticism is really a way to bring out in the daylight things that are constantly hidden – and that aren't necessarily erotic – because of the Catholic religion, because of social rules.

(David Hopkins, *Marcel Duchamp and Max Ernst: The Bride Shared*: 62)

Now we need to go on and see how Duchamp engages us in a dia-logue with his works which establishes a more ambivalent and questioning relationship with the spectator.

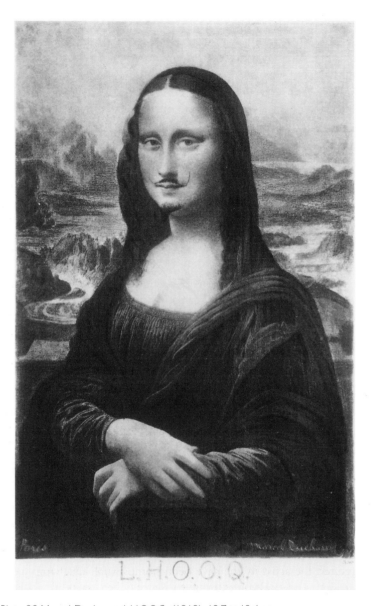

Plate 28 Marcel Duchamp, *L.H.O.O.Q.* (1919). 19.7 × 12.4 cm.

THE IDEAS OF DADA

Plate 28 *L.H.O.O.Q.* by Marcel Duchamp, 1919

The interaction between the spectator and the picture here is of crucial importance – not in the visual and perceptual sense, as you might find with the space and form in a Cubist painting, but more in the sense of how you relate to it as a work of art. Duchamp has used a reproduction of the *Mona Lisa* by Leonardo da Vinci, one of the most famous pictures in the Western canon; he has given her a moustache and the initials of a French saying about female sexuality which is in phonetic code. So the letters do not stand for the words in the sense that L is for Leonardo but for their sounds. In French they make *elle a chaud au cul*, which in English means 'she's got a hot arse'. So the title is presented as a *double entendre*, but so is the picture. If the Mona Lisa has become a man, then who are you, the spectator, a man or a woman? If it has a moustache and is anyway a reproduction, can it be a work of art at all? Duchamp is looking askance at the whole idea of works of art and their institutions and asking you to make up your own mind about what you think of it. 'Think' is the operative word here, not feeling or an intuitive or visual response; instead, the cerebral reaction is what is important.

The ambiguity of gender in *L.H.O.O.Q.* was recognized by Duchamp himself when he described it like this:

> The curious thing about that moustache and goatee is that when you look at the *Mona Lisa* it becomes a man. It is not a woman disguised as a man; it is a real man, and that was my discovery, without realizing it at the time.
>
> (Duchamp, quoted in Calvin Tomkins, *Marcel Duchamp*: 222)

Duchamp created *L.H.O.O.Q.* at the time of the 400th anniversary of Leonardo's death in 1919, when there was a lot of interest in this artist who was himself an enigmatic figure. Freud had written a psychoanalytical biography of Leonardo in 1910 in which he had suggested the artist might have been homosexual. Duchamp went on to create a female persona called Rrose Sélavy soon after this in 1920.

This picture was created in 1919, just after the First World War when Duchamp was part of the Dada movement; the artists involved were concerned with abandoning tradition, respect for your elders

and betters, and the institutions of art and government. Duchamp described it like this:

> Dada was an extreme protest against the physical side of painting. It was a metaphysical attitude. It was intimately and consciously involved with 'literature'. It was a sort of nihilism to which I am still very sympathetic. It was a way to get out of a state of mind – to avoid being influenced by one's immediate environment, or by the past: to get away from clichés – to get free.
>
> (Marcel Duchamp, 'Painting at the service of the mind', in Chipp (ed.), *Theories of Modern Art*: 394)

In this passage, Duchamp talks about nihilism, an important ingredient in Dada. It was derived from their interpretation of the philosophy of Nietzsche, where (as we saw in Chapter 1) belief in God or any other moral system was totally abandoned in favour of faith in the self, particularly the creative self, its lust for power and its drive for personal fulfilment. Naturally this attitude is seen as a reaction to the horrors of the First World War and the institutions that perpetrated it. Duchamp's friend, the artist Francis Picabia wrote later in 1923:

> There is no such thing as a moral problem; morality like modesty is one of the greatest stupidities. The asshole of morality should take the form of a chamber pot, that's all the objectivity I ask for it.
>
> (Francis Picabia, 'Thank you Francis', 1900–90, in Harrison and Wood (eds), *Art in Theory*: 272)

Like the Vorticists whom we looked at earlier, the Dadaists were against all convention and presented a form of anarchism in relation to everything. One of the most extreme examples is the poet Tristan Zara, who famously threw torn pieces of newspaper into the air and then created a poem from the random order in which they fell!

So it was in this climate that Duchamp abandoned aesthetic considerations and turned against Modernism, with its concentration on the aesthetic, in favour of meaning – but meaning that is often obscure and deliberately requires the spectator to question and speculate. Nowhere is this more true than in the case of his readymades, which in some sense are not works of art at all because they are not 'made' in the same way as a traditional painting or sculpture would be. The most famous of these is *Fountain* of 1917 in which he turned a urinal on its back and signed it 'R. Mutt, 1917'.

The urinal was shocking of course and all the more provoking because it was rendered useless by being on its back. You are bound to ask yourself what it is doing in an art gallery and not in its proper place. The innuendo implied is humorous in one sense and insulting to the idea of the temple of art on the other. On one level you think to yourself: What could the artist have been thinking of and how dare he insult the world of art and artists in this way? Of course, you can simply dismiss it and say what a pointless thing to do. But, like the *Mona Lisa*, you can be made to ask questions about what art is and why we revere it, what its purpose is and what it communicates to us.

Plate 29 *Bicycle Wheel* by Marcel Duchamp, 1913

Sometimes, like the *Bicycle Wheel*, originally done in 1913–14, Duchamp's works have had to be reconstructed, but this is in a way unimportant because the skill does not lie in the making but in the interpretation and the meaning. They are, as Duchamp called them, readymades, but they are enigmatic and ironical because they are rendered useless. The bicycle wheel is raised in the air and fixed into the seat of a stool. You want to touch the wheel and spin it, of course, but it is useless; it is a functional object removed from its proper context. Duchamp's objects are all rendered useless so that you are forced to contemplate them in a different way.

Plates 30 and 31 *Etant Données* by Marcel Duchamp, 1946–66

Duchamp is most famous for his *Large Glass* – the alternative title of *The Bride Stripped Bare by her Bachelors, Even* of 1915–22 – but *Etant Données* ('Given') which we are going to look at is less well known and even more enigmatic. Both these works are about the mystery of the relationship between men and women and particularly the sexual one. The *Large Glass* takes a mechanistic view of copulation. The evidence for this comes from the collection of notes Duchamp left about it in what he called the Green Box. David Hopkins says:

> Obviously, Duchamp conceived of the Bride in the *Glass* going through three definite psychic or psychosexual states; first a fantasized stripping by the Bachelors, secondly an imagined state of

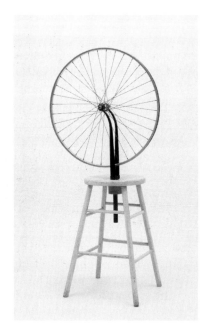

Plate 29 Marcel Duchamp, *Bicycle Wheel* (1951, after lost original of 1913). Assemblage: metal wheel, 25½ ins (63.8 cm) diameter, mounted on painted wood stool 23¾ ins (60.2 cm) high; overall size, 50½ × 25½ × 16⅝ ins (128.3 × 63.8 × 42 cm).

auto-eroticism, and thirdly some state dependent on the dialectical resolution of the previous two states into a form of complete Bridehood.

(David Hopkins, *Marcel Duchamp and Max Ernst: The Bride Shared*: 42)

Diagrams are published to explain Duchamp's layout, but what you end up with is a feeling of the mystery and complexity of heterosexual relations.

'Given' on the other hand presents a similar theme but in a more overt way. You are invited to gaze through two holes in a wooden door at the body of a woman. The sexual parts face your eye blatantly

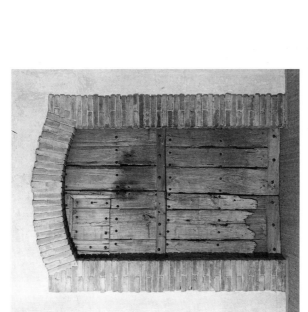

Plates 30 and 31 Exterior and Interior no. 2 of Marcel Duchamp, *Étant données*: 1 'La chute d'eau', 2 'Le gaz d'éclairage' ('Given: 1. The waterfall, 2. The illuminating gas', 1946–66). Mixed-media assemblage: wooden door, bricks, velvet, wood, leather stretched over an armature of metal, twigs, aluminium, iron, glass, Plexiglas, linoleum, cotton, electric lights, gas lamp (Bec Auer type), motor, etc., 95½ × 70 ins (242.6 × 177.8 cm).

© Succession Marcel Duchamp/ADAGP, Paris and DACS, London 2003. Courtesy of Philadelphia Museum of Art: Gift of the Cassandra Foundation, 1969.

as your gaze penetrates through the holes; it is a form of pornography, or at least a commentary on it, which again encourages you to ask those fundamental questions about who we are and what we are doing. It is really an installation in a separate room off the main Duchamp gallery in Philadelphia. There is a closed wooden door which is bricked in and there are two holes for you to look through like two prying eyes.

You go into this room as into a booth in a fairground and spy on the naked woman; you cannot see her head but you do see her female parts facing you as you look through the door. The body is made from an armature covered with pigskin which gives it a soft appearance and she lies on twigs and brushwood in the foreground with an illuminated waterfall on the right and landscape behind; the waterfall moves and appears to sparkle in the sunlight and the gas lamp in the girl's hand is lit. The landscape is a blown-up photograph of a Swiss ravine near Puidoux, hand-coloured by Duchamp with some collage elements. The whole creation conveys an air of mystery and stillness, which is as enigmatic as anything Duchamp had made before.

The whole nature of our sexuality and its powerful drives had been opened up to fresh analysis by Freud. Even if you think that Duchamp was just 'cocking a snook' at the world and sending up the whole idea of art, the fact remains that he has had a huge influence on subsequent developments, particularly since the 1960s. Much of what we see in the art of today, with its emphasis on shock and sensation, is the result of his legacy. It seems to have a nihilistic lack of belief in anything, a kind of permanent scepticism which many would see as originating in the philosophy of Nietzsche. It relies entirely on the spectator's ability to try and make sense of it and on their ultimate acceptance of the ambiguity of much of what we look at and experience. Are we expected to laugh, cry, get angry or remain indifferent? The questions remain unanswered and we sense that we cannot expect to understand everything in a logical and organized fashion. It is the opposite of the kind of utopian Modernism we were looking at in earlier chapters, where the idea was to provide answers as to where the world, and particularly art, was going, and to create new solutions in a changed world.

DUCHAMP'S LEGACY

The legacy of Marcel Duchamp is most clearly seen in what is called Conceptual Art where the idea is paramount and so is the questioning

participation of the spectator. The term is used to cover everything from Happenings and Performance Art to the most refined and reductive works of Minimalism, aspects of which are dealt with in other chapters. One of the leading theorists behind the development of Conceptual Art was the artist and theorist Joseph Kosuth. In his essay of 1969 entitled 'Art after philosophy' he acknowledged the importance of Duchamp's work, particularly the readymades:

> With the unassisted Ready-made, art changed its focus from the form of language to what was being said. Which means that it changed the nature of art from a question of morphology to a question of function. This change – one from 'appearance' to 'conception' – was the beginning of 'modern art' and the beginning of Conceptual art. All art (after Duchamp) is conceptual because art only exists conceptually.
>
> (Paul Crowther, *The Language of Twentieth-century Art: A Conceptual History*: 174)

The extract is quoted from an extremely interesting book in which Paul Crowther makes the case that Kosuth's ideas were a reaction against the emphasis on pictorial and formal values at the expense of meaning. This emphasis was one of the legacies of Modernism and abstract art. Crowther says:

> Formalism as a critical doctrine in art arose as a means of legitimising certain formal innovations, notably lack of 'finish' and conventional narrative structure. The adverse consequence of this was to establish a rigid dichotomy between 'formal values' and elements of 'idea' or content, with distinctively artistic significance located firmly in the realm of the former. Given this, it is easy to understand why artists should seize upon the conceptual emphasis in Duchamp's work and see it as a new beginning or new foundation for art practice. For it seems to go beyond the facile anti-intellectualism of formalism, without merely reverting to the idioms of conventional art.
>
> (Ibid: 172)

So, as Crowther makes clear, Kosuth is talking about putting back the meaning into art and getting away from aesthetic considerations. On the face of it this sounds like Duchamp himself when he said he was against 'retinal painting'. However, as we have seen, Duchamp was

interested in communicating complex meanings through much of his work.

But in many more recent instances, the shift to art as concept has become much more superficial. The result is in theory that anything you choose can be art; it does not involve any visual transformation, so aesthetic judgement becomes irrelevant. However, exceptions to this are artists like Ian Hamilton Finlay, David Mach, Mona Hatoum and Bill Viola, where a questioning message is conveyed through the visual configuration of the work. The desire to communicate or express an idea through art is not new; it could be said to apply to much of the art of the past, and in particular to the classical tradition, which is referred to directly by Hamilton Finlay and Mach in the examples we are going to look at now.

CONCEPTUAL ART: THE CLASSICAL TRADITION

Plate 32 *Et in Arcadia Ego* by Ian Hamilton Finlay, 1976

In his garden at Stoneypath Ian Hamilton Finlay sets out to create resonances of the classical tradition. Much of this is achieved through plaques (which are beautifully carved but not necessarily by the artist himself) with words written on them like 'See Poussin, Hear Lorraine'. You come upon this one by surprise, lying next to a pool in a semi-wild and apparently uncultivated setting. Of this plaque Finlay says, 'The thought is that Poussin's landscapes are very defined plastically; Claude's are more lyrical and melodious. One can see the surrounding landscape in either way,' So he is using the plaques in his garden to make connections with the past and in particular with the pastoral tradition of classical poetry like that of Virgil or Horace where an idealized and arcadian view of the countryside is created.

In the catalogue of the *Encounters* exhibition at the National Gallery, Finlay's garden was described like this:

> A key location of Finlay's use of the pastoral is his remarkable garden at Stoneypath, his home in the southern uplands of Scotland. This has been described as 'his own very personal gardening concept: a philosophical and poetic total work of art, a *gesamkunstwerk*, comprised of the natural environment, art and poetry, composed of references, metaphors, words and

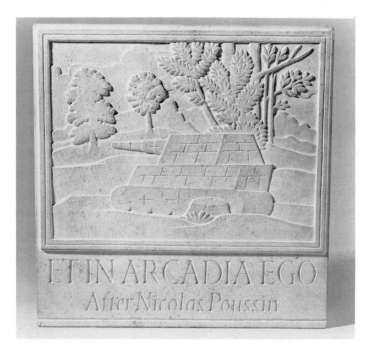

Plate 32 Ian Hamilton Finlay, *Et in Arcadia Ego* (1976). Stone plaque, garden at Stoneypath, near Edinburgh.
Courtesy of the artist. Photograph © Scottish National Gallery of Modern Art (GMA 1583).

labyrinthine connotations' . . . language and nature enter into a highly complex pattern of interaction. The one is no longer conceivable without the other. His garden 'represents the yearning for an ideal Arcady'.

<div align="right">(Richard Morphet in Catalogue of Encounters: 119)</div>

The tradition of seeing landscape in terms of poetry and in terms of painting goes back to the classical poet Horace's famous dictum *Ut pictura poesis* – 'As in painting, so in poetry'. This idea, that the experience of a picture can be poetic, has been expressed by many artists, notably those belonging to the Venetian tradition of the sixteenth century like Giorgione and Titian (see *Learning to Look at Paintings*, pp. 157–8). The idea behind this kind of painting – known in English

as a *poésie* – was that it could communicate as a poem does without the structure of a specific narrative. The important point about this in the context of modern art is that we have a clear association between text and image in the sense that they are regarded as interchangeable and not incompatible; they can belong together rather than being seen and understood separately. So, as Horace implied, a picture or a poem can carry equal meaning. However, I think that in order to get nearer to what Finlay is trying to do we need to look closely at his plaque of *Et in Arcadia Ego* and compare it with the famous painting of *The Arcadian Shepherds* by Poussin.

Plate 33 *The Arcadian Shepherds* by Nicolas Poussin, c.1638

Hamilton Finlay's version is a plaque carved in various depths of relief with the words 'Et in Arcadia Ego' placed underneath. The relief is cut deeper in the foreground and shallower in some parts of the background. Poussin's style of painting is also sculptural in the sense that the edges of the forms are very clearly defined so that they stand out in a relief-like way. The landscape is more softly treated in order to emphasize the three-dimensional qualities of the foreground; in that sense it is almost like a painted relief. The stone tomb in front is set against a landscape with trees and the arrangement is similar in both works, except that Hamilton Finlay has no figures present. The idea behind both these pieces is to create associations with the classical past and in particular with the poetic concept of Arcadia, the ideal of the natural world where everything is beautiful and nothing nasty can happen.

But the point of the tomb is that death is always with us, even in this wonderful place. The inscription on Hamilton Finlay's plaque – the words of the Grim Reaper, 'Even in Arcady, I' – is the same that the shepherds are poring over in Poussin's painting, but now the outline of the tomb, and its shape at the bottom, makes reference to the tank and to the caterpillar tracks which propel it. The forces of destruction are there to devastate the landscape through war. Both works are pastoral in the classical sense, but Hamilton Finlay's refers not only to man's personal mortality but also to his ability to destroy others. This gives Hamilton Finlay's work a disturbing edge because it upsets our preconceived ideas about the classical tradition and brings it uncomfortably into the modern world; it forces us to think and respond to his new interpretation of old ideas.

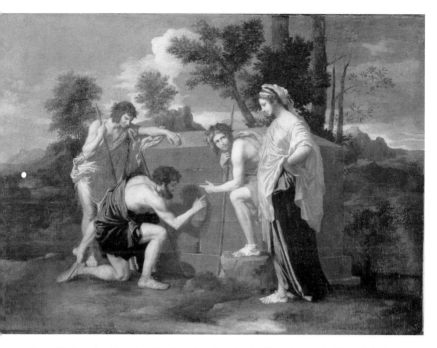

Plate 33 Nicolas Poussin, *The Arcadian Shepherds* ('Les Bergers d'Arcadie', also known as *Et in Arcadia Ego*, c.1638). Oil on canvas, 85 × 121 cm.
Courtesy of Louvre, Paris. Photograph © Photo RMN.

Plate 34 *The Parthenon* by David Mach, 1987

This is what is called an installation, which means that it is not a painting or a sculpture in the normal sense: it is composed of ready-made objects, in this case used rubber tyres; it is installed by the artist and their assistants on a specific site and left for a limited time; it is photographed and afterwards dismantled. It might be installed again at another site or in a museum or gallery space, but it is not intended to be permanently in existence, as a traditional art object would be. Mach's *Parthenon* is made of the rubbish or detritus of the modern world, not unlike a giant collage.

It could also be considered a piece of performance art in the sense that the materials are collected and then Mach and his assistants build it together, so it is not the product of a single artist's hand. When making an installation for the Edinburgh Festival exhibition

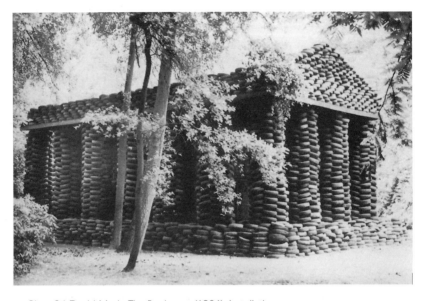

Plate 34 David Mach, The Parthenon (1986). Installation.

called *The Vigorous Imagination* in 1987, Mach described the process like this:

> I am particularly interested in working 'on site' like this. I consider this kind of work, given its temporary nature, not as an 'installa-tion' at all, but more of a kind of 'live' performance of the piece, making it a bit like a piece of music performed by a band or orchestra.
>
> There are many ingredients to be considered in such a piece then, not just the theme of the show, but the physical space, the image of that space (is it an art venue, a gallery or museum, or is it a shopping centre, bank etc?). The audience (will the piece be made behind closed doors or open to the public while it is made?), the materials, the image, so many ingredients that I would find it impossible to say which is more important than the other. So, by giving pride of place to the image of an idea in your head, for instance, it instantly places restrictions on the process, in just the

same way that allowing the process to dominate interferes with the idea. It is in these situations that I find myself wondering exactly what is my role – am I the sculptor, the catalyst or what?

Working to a time scale is another essential ingredient. It increases the performance element in the work and enhances a speed of action. This speed is essential to finding the energy of the material. That energy source is an abstract idea rather like dealing with the grain in a piece of wood or stone or when stone-carvers talk about releasing the energy inside. The materials and objects I use have a similar kind of energy. Working fast with assistants means I can get closer to that energy because it is impossible for me to have total control.

(David Mach in Catalogue of *The Vigorous Imagination*: 86)

In this passage Mach is talking about the qualities of the performance of Conceptual Art, the fact that it is not solely his production, and about the importance of the idea. Through its title and its form, *The Parthenon* makes obvious reference to the classical tradition and in particular to the most important building in ancient Athens; it has the columns, the pediment and the roof, and the raised platform instead of steps upon which the building sits.

But of course we are not being asked to look at it as a simple representation of the Parthenon; it is designed to set up resonances and invite questions in the mind of the spectator. There is no orthodoxy here about the way we are supposed to look at it, but the associations are about the idea that here is a replica of one of the icons of Western art, made out of tyres, which are used on the car, the main means of transport in the modern world. The car relies on petrol which is a fossil fuel, the rubber for the tyres comes from trees which grow in plantations, and this version of the Parthenon is positioned in a wood whilst the original was a temple dedicated to the goddess Athene. So, are we ruled by the institutions which control the oil, the rubber and the manufacture of the car? Together they are damaging our environment, maybe beyond repair. Are we controlled by them just as our culture has been controlled by the classical tradition and the institutions which buttress it?

After an installation is made, it is left for a while for people to visit; then, when it has been photographed, it is taken down and the site returns to its natural state. So it is not an object at all in the normal sense of an art work housed in a museum, art gallery or institution. But it does have some aesthetic qualities – in this case tone, in the

sense of variation in the greys achieved by the way the light catches the layers of tyres and the contrast with the much darker interior, giving it a lowering and sinister appearance. It is neither a sculpture nor a building in the traditional way of understanding but it makes reference to both. It is not a readymade in Duchamp's sense of that word because it is a new construction of some power. Our reaction to it is cerebral and conceptual. It is not about something perceived in a sensory sense. It appeals to our minds.

CONCEPTUAL ART: RECENT RESONANCES

Plate 35 *Light Sentence* by Mona Hatoum, 1992

Your relationship (as the spectator) with this installation is truly environmental because you literally have to walk through it to experience the full effect. It is made out of a series of wire lockers, which look like cages such as you might find in a battery hen house. They are piled one on top of the other and arranged in a U-shape. They rise to above head height and create a claustrophobic yet translucent atmosphere. A single bare bulb shines overhead and is made to swing so that the wire lockers cast their shadows all over the walls and ceiling, creating a feeling of spatial and emotional disorientation in the spectator.

This work also sets up resonances about prisons, cages, our treatment of animals, captivity, dislocation generally. The artist herself says:

> The title, *Light Sentence*, is a play on words, as a prison sentence. A bank of wire-mesh lockers above human height create a U-shaped enclosure. I saw these units advertised in a catalogue as a cheap form of locker with the advantage of being able to survey the contents. So there is this implication of surveillance. I immediately saw the potential for several connotations. On the one hand they look like animal cages so the whole set-up could be some kind of laboratory environment where animal experiments could have been taking place. On the other hand there is an architectural dimension. They also look like tower blocks. So the whole environment begins to look like an architectural model of a city lined with the kind of boring, uniform, functional and box-like architecture designed to provide cheap housing for the working class. So perhaps I am saying that existing in these conditions is like having a prison sentence but not a heavy one.
>
> (Mona Hatoum, personal communication, 2003)

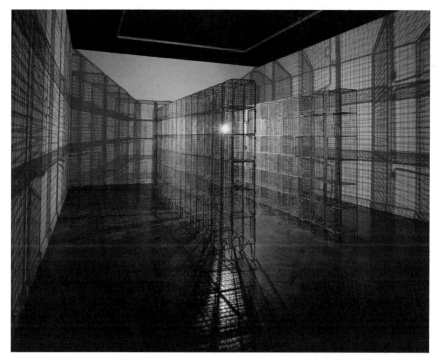

Plate 35 Mona Hatoum, *Light Sentence*, 1992. Installation: Chapter, Cardiff. Wire-mesh lockers, slow-moving motorized light bulb, 198 × 185 × 490 cm.
Photo: Edward Woodman. Courtesy of the artist.

The light bulb is motorized and moves up and down and swings in the darkened room, so that the light projects shadows that distort and dislocate the edges of the forms, which are not solid. The shadows of the lines and squares in the wire lockers appear to join up at some points and then dissolve and extend into space. It is neither solid nor void, neither transparent nor opaque and as a result the appearance is enigmatic and non-plussing. When you come out your emotions are disturbed and you feel moved by your experience even if you are not sure why.

Mona Hatoum is a Palestinian exile living in England who is very aware of her nationality and the currently cruel and disrupted situation of Palestine. In an interview in 1998 Hatoum herself said:

How that manifests itself in my work is a sense of disjunction. . . . This is the way in which the work is informed by my background. On the other hand I have now spent half of my life living in the West, so when I speak of works like *Light Sentence*, *Quarters* and *Current Disturbance* as making a reference of some kind of institutional violence, I am speaking of encountering architectural and institutional structures in western urban environments that are about the regimentation of individuals, fixing them in space and putting them under surveillance. What I am trying to say here is that the concerns in my work are as much about the facts of my origins as they are a reflection on or an insight into the Western institutional and power structures I have found myself existing in for the last twenty-odd years.

(Mona Hatoum, interview, 1998)

As we have already said an installation is not a sculpture or a painting in the traditional sense but, when done well like this one, installation work creates an experience which can be aesthetic but enigmatic at the same time, and unresolved. Hatoum's work makes oblique reference to pain and suffering so that we are moved when we see it. Like most conceptual art the resonances in *Light Sentence* are implicit rather than explicit but all the more effective because of that. The more obviously cerebral and intellectual work of David Mach or Hamilton Finlay makes connections with the classical tradition in Western art, but Hatoum is more intuitive and creates a more emotional response. An installation cannot be hung on a wall but it is a new form of art using different means to establish contact with the spectator.

CONCEPTUAL ART: THE OLD MASTERS

Colour Plate 7 *The Visitation* by Jacopo Pontormo, 1528–9

Colour Plate 8 *The Greeting* by Bill Viola, 1995

Another type of installation involves the use of video, particularly in the work of an artist like Bill Viola, who works with video exclusively. He has sometimes taken an Old Master painting as a starting point, such as, for example, *The Visitation* by the Italian Mannerist painter Jacopo Pontormo (Colour Plate 7). The colours, the composition and the movement all serve to enhance the effect of Viola's interpretation of

Pontormo's original painting and give it another dimension in a modern context. More subtle and complex is the work done for the recent *Encounters* exhibition where he used *Christ Mocked/The Crown of Thorns* by Hieronymus Bosch; this painting inspired his video called *Quintet of the Astonished*; here he used five actors to display various degrees of astonishment. It goes on in real time and the spectator watches in silence as the different expressions are played out by each individual in a remarkable variety of ways. They do not all express the same feeling at the same time and this has a mesmerizing effect on the spectator.

The artist himself has discussed the idea of a constantly shifting and changing pattern of interaction which can be applied just as well to his video of *The Greeting* because it deals with the notion of working with a moving rather than a static image:

> As you come in, right away you notice that these people have distinct emotional expressions. One person might be obviously visibly angry, another person very sad, another very distraught, another extremely calm and peaceful. So it causes you to have a set of assumptions about their relationships with each other. Then you get involved in the visual aspect of the image. What people are wearing is very important, the colours and the way the whole thing is composed looks very much like a painting, feels like a painting, and it is striking in some ways. So you get caught up in the image for a while and then you realise at a certain point that the guy who was very angry now is happy, and you couldn't really tell when he changed. And you're beginning to see that in fact all of these emotional expressions of these people are shifting, and they were in the process of shifting before you entered the space and after you leave they are going to continue to shift. And you never really get anywhere. There's never a conclusion, there's never an end result. It's a continuing shifting pattern of emotions that flicker across the field of faces in extended time, causing you to continually change your reading and assumptions of their relationship to each other.
>
> (Bill Viola in Catalogue of *Encounters*: 311)

Of course, it would not be possible to do this without the aid of the moving image on film. The interaction between film and fine art is an interesting one, which we will investigate in the concluding chapter; it is explored by Viola in a way that allows the idea of the single

image to be extended. Whether he would have denied it or not, it does relate quite closely to Duchamp's *Nude Descending a Staircase* with which we started this chapter. The idea of change, of sequence, of the suggested and the mysterious is implicit in both works. The fascination with these qualities is present in a number of pictures from the past and I want to go on and explore that now.

FANTASY ART, SYMBOLISM AND DREAMS

We have already seen connections between Duchamp and French Symbolism, Hamilton Finlay and Poussin, and now Viola and Pontormo and Bosch. All these artists have been interested in the power of suggestion, the idea of resonance and association, and the importance of the spectator's active and questioning reaction. There are other artists like Blake, Redon and Dalí who should at least be mentioned in this context.

Plate 36 *The Red Dragon and the Woman Clothed with the Sun* by William Blake, *c.*1805

The art of William Blake is a classic example of much that we have been discussing, in the sense that he often encourages you to see one thing in terms of another. This famous watercolour is a good example; it is supposed to be an illustration to a passage in Chapter 12 of the Book of Revelation: 'Woe . . .! for the devil is come down unto you having great wrath.' When you first look at it you think that it is a great nude male figure with its back to you, its arms raised and its feet apart. Then you look at the head and it appears to be facing forwards with eyes that turn out to be claws and a row of jagged teeth above. Then, out of the buttocks comes a huge reptilian tail with scaly wings spreading on either side in a huge fan shape. The size of the figure seems enormous and full of tension, creating uncertainty if not fear in the mind of the spectator. Down below is the lyrical, elongated and graceful figure of the woman who stands for Israel and the church having just given birth to a male child to rule the nations of the earth.

Plate 37 *The Eye as a Balloon Moving towards Infinity* by Odilon Redon, 1882

As we have already seen, the French Symbolist movement at the end of the nineteenth century explored the power of the human imagination

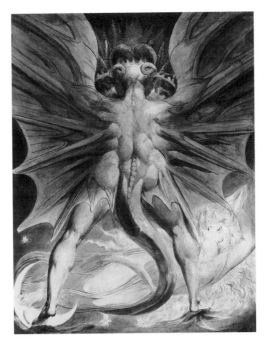

Plate 36 William Blake, *The Red Dragon and the Woman Clothed with the Sun* (c.1805). Watercolour and graphite on paper, 21½ × 17 ins (43.5 × 34.5 cm).
Gift of William Augustus White [acc. no. 15.368]. Courtesy of Brooklyn Museum of Art.

to respond to suggestion in a way that was often non-specific; and it is significant in the context of Fantasy Art too, for example, in the work of Gustave Moreau. But one of the most outstanding examples of this is Moreau's fellow Symbolist, Odilon Redon, who could create images that were very strange. In *The Eye as a Balloon Moving towards Infinity*, he has brought the ideas of the eye, the balloon and infinity together in a way that could occur only in a dream. We cannot make sense of it but we recognize it as a powerful and memorable image, which strikes at our imaginations directly in a subliminal or intuitive way, bypassing reason or logic, so that we react without necessarily knowing why or being able to explain our feelings.

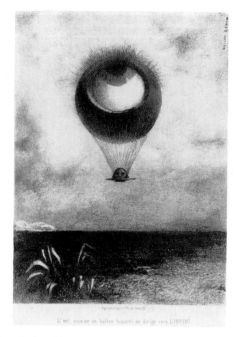

Plate 37 Odilon Redon, *The Eye as a Balloon Moving Towards Infinity* (1882). Lithograph, 26.2 × 19.8 cm.

Cliché Bibliothèque nationale de France.

Plate 38 *Soft Construction with Boiled Beans* (Premonition of Civil War) by Salvador Dalí, 1936

The idea of bypassing reason or logic was of course fundamental to the Surrealist movement of the 1920s and 1930s which most obviously followed Duchamp and Dada. Like French Symbolism – which was important to Duchamp, as we have seen – Surrealism began as a literary movement led by the poet André Breton. Breton's colleague, the famous Surrealist painter Salvador Dalí, shows us a splendid visualization of dream-like imagery in this picture. This is an extraordinarily vivid image meticulously painted in a smooth and detailed way so that you can see what is there even if you cannot make sense of it.

The boiled beans of the title are in the foreground and of apparently no importance at all, but what are the body parts doing? There is a hand on the left with no proper wrist attached, then there is part of an arm from which another arm erupts turning into another hand: it is

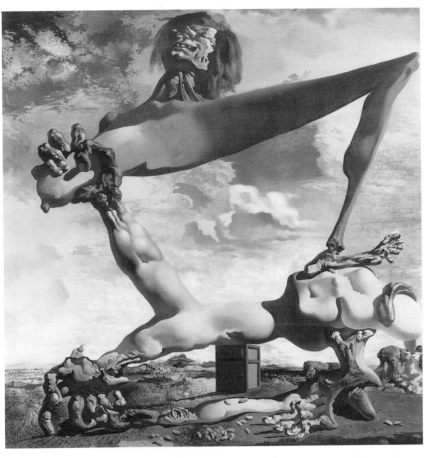

Plate 38 Salvador Dalí, *Soft Construction with Boiled Beans (Premonition of Civil War)* (1936). Oil on canvas, 39⁵/₁₆ × 39³/₈ ins (99.9 × 100 cm).

impossible to describe in any logical sense, and yet the agonized expression on the face, the tension in the neck and the effect of bodies pulled asunder is overwhelming. This is indeed very symbolic of civil war and the picture is associated of course with the Spanish Civil War of the same year. Dalí has created a really convincing and charged image that convinces us of its reality in spite of not being logical or descriptive.

SURREALISM AND FREUD

The meanings of all the works we have considered in this chapter are uncertain, indefinite and not laid down, so the iconography – as it would have been called in relation to much past art – is not clear. Instead, the spectator is invited to make their own meaning rather as they would in a psychoanalytical way. The influence of Freud and psychoanalysis has been pervasive, and nowhere more so than in the area of free association, which is connected with encouraging the subconscious to come to the surface, as it would in a dream. Then an interpretation is made on the basis of an association of ideas, which would not necessarily come together in ordinary circumstances, but are personal to the individual concerned. In his influential book *The Interpretation of Dreams*, Freud described the process of restoring the logical links which would have been destroyed in a dream:

> In the course of this transformation, however, the logical links which have hitherto held the psychic material together are lost. It is only, as it were, the substantive content of the dream thoughts that the dream-work takes over and manipulates. The restoration of the connections which the dream-work has destroyed is a task which has to be performed by the work of analysis.
>
> (Sigmund Freud, in Harrison and Wood (eds)
> *Art in Theory, 1900-1990*: 27)

In the best Surrealist paintings, like the one by Dalí we have just looked at, these dream-like associative qualities are used to great advantage. André Breton acknowledged the influence of psychoanalysis, whose techniques he had practised in the First World War; he had even visited Freud in Vienna after the armistice in 1918. André Breton remembered his interest in Freud at this period:

> Preoccupied as I still was at that time with Freud, and familiar with his methods of investigation, which I had practised occasionally

upon the sick during the war, I resolved to obtain from myself what one seeks to obtain from patients, namely a monologue poured out as rapidly as possible, over which the subject's critical faculty has no control – the subject himself throwing reticence to the winds – and which as much as possible represents spoken thought.

(André Breton, in Chipp (ed.), *Theories of Modern Art*: 41)

Surrealism grew out of Dada and the influence of Duchamp. Breton wrote a number of books about many of the ideas we have been discussing. One of his recurring themes is that an iconographical programme of meaning is not the intention of art, but instead the spectator should make up their own mind. Writing about Salvador Dalí, Breton suggests that Dalí's work is disturbing because 'he is able to make other people believe in the reality of his impressions'. In other words, the artist's aim is to convince the spectator of the reality of the image, however illogical it may seem. You could argue that this is the legacy of Fantasy Art and Symbolism, and that Duchamp and his influence is part of that tradition.

Bill Viola would have us believe that all art is interconnected and that we should take a delight in it:

I don't believe in originality in art. I think we exist on this earth to inspire each other, through our actions, through our deeds, and through who we are. We're always borrowing. I think it's a beautiful, wonderful thing.

(Bill Viola in Catalogue of *Encounters*: 322)

The connections between Fantasy Art, Symbolism, Dada, Surrealism, Conceptual Art and the influence of Duchamp are not always obvious to the casual observer perhaps. But at the very least one would have to say that they all set great store by the search for – and communication of – meaning, and they involve the spectator in that quest where questions are as important as answers. The interaction between artist and onlooker through feeling and suggestion has also been part of what we have been discussing in this chapter. But there are other interpretations of this which we need to go on to now, where the individual and the expression of emotion become very important, in connection with Expressionism and self-expression.

Chapter 4

Expressionism and Self-Expression

Expressionism is a theme running right through twentieth-century art, cropping up not just in movements of the early period like Die Brücke and Der Blaue Reiter, but also in some aspects of Surrealism or Neo-Realism and at the Bauhaus. In America after the Second World War, Expressionism became Abstract Expressionism in the work of Jackson Pollock and his contemporaries. Later on, in the 1980s there was a form of Neo-Expressionism that seemed to herald the arrival of what was then referred to as a new spirit in painting.

REACHING THE SPECTATOR'S FEELINGS

In the first chapter we saw how important Expressionism had been in the work of Munch and Kirchner. A later phase, just before the First World War, was Der Blaue Reiter or the Blue Rider group, in which Kandinsky led his fellow members such as Marc, Macke and Klee into an understanding of how to communicate directly with the soul of the spectator through the expressive use of colour. In a book published in 1910, Kandinsky made this very clear:

> The sequence is: emotion (in the artist) → the sensed → the art work → the sensed → emotion (in the observer.) The two emotions will be like and equivalent to the extent that the work of art is successful. In this respect painting is in no way different from a song: each is a communication. The successful singer arouses in listeners his emotion; the successful painter should do no less.
> (Wassily Kandinsky, *Concerning the Spiritual in Art:* 24)

Expressionism is about the emotional and spiritual connection between the artist, their work and the spectator, and therefore it

does not necessarily need a subject. The association with music here is important and we are reminded that this is the same period as Matisse's painting of *The Dance*, discussed in Chapter 2.

Related closely to Expressionism is the idea of self-expression. Some modern art has been and still is intensely autobiographical in the sense that it deliberately explores the artist's life and background as in the work of Louise Bourgeois, Cindy Sherman, Sam Taylor-Wood or Tracey Emin. There are many women artists who fall into this category and the Feminist movement generally has been very encouraging to this kind of work. Connected with this is the idea of confronting our history, taking autobiography or self-expression out into a more extended context, facing the memory of what has happened in the twentieth century not just to ourselves but to the wider world as well. These themes apply to the work of such artists as Joseph Beuys and also to the architecture of Daniel Libeskind, as we shall see in Chapter 5.

Colour Plate 9 *Murnau-Staffelsee* I by Wassily Kandinsky, 1908

Colour Plate 10 *Into the Dark* by Wassily Kandinsky, 1928

The landscape of *Murnau-Staffelsee* I is based on the expressive power of colour, aquamarine in the sky, purple in the mountains, dark blackish indigo in the centre with two orangeish pink sections and green, pink and blue in the foreground. The intensity of the colours is achieved by the use of strong, almost saturated primaries and complementaries, the oranges against the purples, the pinks and reds against the greens, and sharp streaks of blue and blobs of yellow in the foreground. The brushwork is loose and lively and the treatment broad and undetailed. The whole picture is designed to convey emotion and has little to do with what you might actually see; in this sense the interpretation is abstract and simplified and the colour is what speaks to you. Yet there is still sufficient figuration in the composition for you to see it as a landscape.

The later subject of *Into the Dark* (Colour Plate 10) is completely abstract, a series of triangles like set-squares laid one behind the other, moving upwards, some with segments cut out of them and some complete. The picture is executed in watercolour and so it has a more delicate appearance than the earlier painting. The squares

and rectangles in the background of the lower part of the picture are yellow and cream and more or less translucent and those in the upper section are more opaque. The watercolour has been thinly diluted and sprayed with an atomizer by Kandinsky through different geometrical shapes. The colour range is the same as in the landscape but the watercolour and its application give the surface a completely different appearance. Instead of being rough and full of brush marks it is flat, but the expression lies in the careful gradation of the colours, the sharpness of the edges and the subtlety of the arrangement of shapes and the dynamic tension between them; Kandinsky makes you believe that the forms are moving into the dark as the title indicates. The way this is achieved is by putting the more opaque and cooler colours near the top of the picture and the warmer, more translucent colours in the lower section.

By the time Kandinsky painted the later picture in 1928, he was working at the Bauhaus, an art school where the idea was to study the pictorial elements of painting in order to teach the students the qualities of their basic abstract structure and organization. Kandinsky's second important book, *Point and Line to Plane* (first published in 1926), was regarded by him as a sequel to *Concerning the Spiritual in Art,* which we discussed in the introduction to this chapter. The second book is more scientific and analytical in tone, but the idea of seeing beneath the surface of the picture and doing without the subject is the same. Near the beginning of the book, Kandinsky says:

> Aside from its scientific value, which depends upon an exact examination of the individual art elements, the analysis of the individual art elements forms a bridge to the inner pulsation of a work of art.
> (Wassily Kandinsky, *Point and Line to Plane*: 17)

Kandinsky also makes comparisons with music as he did in *Concerning the Spiritual in Art,* for instance when he turns the first two bars of Beethoven's Fifth Symphony into points of different sizes. Then, later on, when he talks about the basic plane (which he calls the B.P.), he refers to the present-day human being and how

> His vision is becoming sharper, his ear keener, and his desire to see and hear the inner in the outer ever increases. Only that way are we able to feel the inner pulsation of even as taciturn and as modest a thing as the B.P.
> (Ibid: 134)

Even though Kandinsky refers to the theories in this book as the science of art, the emphasis is always on making contact with what lies beneath the surface and the inner feeling of the spectator. As a young man Kandinsky had been influenced by the Theosophy of Madame Blavatsky and the Anthroposophy of Rudolph Steiner. These philosophies believed in seeing the divine or spiritual dimension behind the world of appearances. We discussed Steiner briefly in the background to the first chapter and Kandinsky attended his lectures on colour in 1907. In *Concerning the Spiritual in Art,* Kandinsky refers to Madame Blavatsky and Rudolph Steiner, both of whom were interested in providing alternative means of spiritual communication now that religion had been so fundamentally questioned. Of Madame Blavatsky, Kandinsky says this:

> Theosophy, according to Blavatsky, is synonymous with *eternal truth*. 'The torch bearer of truth will find the minds of men prepared for his message, a language ready for him in which to clothe the new truths he brings, an organization awaiting his arrival, which will remove the merely mechanical, material obstacles and difficulties from his path'. And then Blavatsky continues: 'The earth will be heaven in the twenty first century in comparison with what it is now,' and with these words ends her book.
>
> (Wassily Kandinsky, *Concerning the Spiritual in Art*: 33)

It is easy to see the connection between these kinds of ideas and what Kandinsky was trying to do; he certainly influenced Klee and Macke, as we shall go on to see now.

Plate 39 *The Dance of the Moth* **by Paul Klee, 1923**

Colour Plates 11 and 12 *The Harbinger of Autumn* **by Paul Klee, 1922**

For *The Dance of the Moth* and other pictures like it, Klee developed a technique called oil transfer drawing. He would copy an existing drawing onto tracing paper; then he covered a piece of thick Japan paper with black oil paint and waited until it was nearly dry, at which point he traced the drawing onto it so that it picked up the black paint unevenly. Thus a broken line was left, with rough edges and some effect of smudging, which was transferred to the paper. The watercolour background was done beforehand and allowed to dry; it

is very finely painted in terms of different shades of aquamarine which are gradated so the edges are created from dried watercolour and not pencil. The colours are arranged so that the subtle changes of tone move from deep sea blue through to cream in the centre.

The moth-like creature with gossamer wings seems to float against the background as though it were hovering near the light. The watercolour is made to look like chiffon or some other translucent material. The buff and black surrounding mount on which Klee framed the picture enhances the effect of space and increases the feeling that the background might be made of tulle, such as you might have in front of a window to break up the light. When you look more closely at the figure it does not entirely resemble a moth but it is suggestive of its character.

So the meaning is partly suggested by the title and partly by the configuration of the design which hovers between the figurative and the non-figurative in a very suggestive way. Like the Surrealists, who were his contemporaries, Klee makes an image that sets up associations in the mind of the spectator, but he always maintained that his pictures were not based on psychoanalytical free association as much as on what he famously called 'taking a line for a walk' and discovering what the picture itself became. It is true that Klee studied child art and the art of mental patients, but this was more because they often seem to convey the idea behind the image more vividly and with the kind of simplification he was interested in.

In *The Harbinger of Autumn*, the orange tree does indeed bear some resemblance to child art in its flat reduction to the bare essentials; but the way it is placed in the space and sits in the background, in spite of its orange colour, is achieved through a very sophisticated understanding of the way the exact cadence of the orange works with the complementaries surrounding it. The rectangles of blue, indigo, pink, purple and aquamarine appear to be both in front and behind. The angles of the forms on the right and the left of the picture lead the eye towards the orange tree with its black trunk in the background. If you look at this picture reproduced both in colour and in black and white, you can see how subtly the tone of it relates to the rest of the composition. When the orange becomes grey in the monochrome reproduction it connects with greys on both sides of the picture, and the black of the tree trunk joins with the weightier sections of the lower part of the picture.

This sort of understanding of the relationship between tone, colour and composition was the kind of practice that Klee would

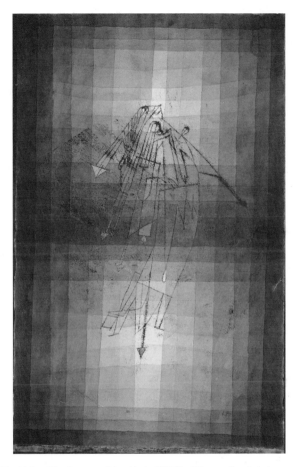

Plate 39 Paul Klee, *The Dance of the Moth* (1923). Oil transfer drawing.
© DACS 2003. Photograph courtesy of the Aichi Prefectural Museum of Art, Nagoya, Japan.

have taught the students at the Bauhaus where no distinction was made between fine art and design, or between art and craft. Klee and Kandinsky both made studies of the processes of picture making; Klee felt that it was analogous with the growth of a tree. In his book *On Modern Art* – based on his famous lecture delivered at Jena in 1924 – Klee said this:

Nobody would affirm that the tree grows its crown in the image of its root. Between above and below can be no mirrored reflection. It is obvious that different functions expanding in different elements must produce vital divergences.

But it is just the artist who at times is denied those departures from nature which his art demands. He has even been charged with incompetence and deliberate distortion.

And yet, standing at his appointed place, the trunk of the tree, he does nothing other than gather and pass on what comes to him from the depths. He neither serves nor rules – he transmits.

His position is humble. And the beauty at the crown is not his own. He is merely a channel.

(Paul Klee, *On Modern Art* in Harrison and Wood, eds: 344)

As far as Klee is concerned, the artist is a kind of conduit for visual expression, which grows from a starting point like the root of a tree and becomes transformed into something very different by the end or the completion of the work of art.

Colour plate 13 *Large Bright Walk* by Auguste Macke, 1913

Auguste Macke was an associate of Kandinsky and Klee, and a member of the Blue Rider group to which they belonged; he was killed in the First World War and so did not live to join them at the Bauhaus afterwards. This painting shows the use of colour in an expressive way to communicate an air of mystery. The white and yellow are used to create the effect of light filtering through the trees but you are not sure what time of day it is. The patches of blue in the background recede and they create a complementary contrast with the yellow and with the reds of the tree trunks and the faces of the male figures and parts of the background. Also there is a lot of opaque white which helps to brighten the composition and make it more luminous.

This is a subject that Monet or Renoir might have painted but it is given an extra emotional edge by Macke because the figures are extremely simplified and are not looking at us. What is the relationship between the two men and the woman in the foreground? Who are the parents of the children playing in the background? Has the man in the bowler hat come to bring some news and what are the two men on the right discussing? We are left to wonder and that is

part of the meaning of this painting which is poetic in the sense that it communicates obliquely rather than directly with the spectator. It reminds us of the kind of symbolism of suggestion which we discussed in previous chapters. However, Macke was quite clear about his Expressionism and shows his closeness to Kandinsky in this passage, where he describes the spirit of the Blue Rider group:

> Intangible ideas are expressed in tangible forms. Tangible through our senses as stars, thunder, flowers, as form. To us form is a mystery because it is an expression of mysterious powers. Only through form are we able to divine the hidden powers, the 'invisible God.' The senses form the bridge from the intangible to the tangible.
>
> (Catalogue of *German Art of the Twentieth Century*: 33)

The mystical idea of direct communication with the soul of the spectator is as present here as it is in the theories of Kandinsky. We can only regret that Macke did not live to join Kandinsky and Klee at the Bauhaus to develop his expressionist ideas further, as they did. Partly as a result of the devastating waste and destruction of the Great War there was a shift of emphasis in the direction of some aspects of Expressionism, as we shall go on to explore now in the work of Otto Dix and George Grosz.

Colour Plate 14 *Pregnant Woman* by Otto Dix, 1919

Dix's paintings of women are amongst his most original and moving works. *Pregnant Woman* expresses hope for the future through fertility and subsequent generations; it was painted in the immediate aftermath of the First World War, before disillusionment set in. In reproduction it is hard to tell whether it is a watercolour or an oil painting, such is the translucency and delicacy of the colour and design. In fact it is oil paint applied smoothly and thinly in glazes, which give the colour its richness and intensity. Dix used the three primary colours of red, yellow and blue in a series of interlocking circles and curves to give a feeling of floating yet dynamic movement, as if the air were water or amniotic fluid. The figure is both mother and child and in its transcendent symbolism it resonates with the best traditions of medieval art and in particular with stained-glass windows.

CONFRONTING REALITY

Dix went on to do graphic, explicit and disturbing pictures of the aftermath of war as in *The Skat Players* of 1920 (see *Learning to Look at Paintings*, pp. 145–7). His was an Expressionism that confronted reality in the way that Dix wanted to, hence the name of this type of painting, *Neue Sachlichkeit* which implies realism and tangibility; it translates as Neo-Realism or Verism. Dix described himself thus:

> I am a realist, who has to see everything with my own eyes in order to confirm that this is how it is. . . . So I'm a man for reality. I've got to see everything. I have to experience myself all the unplumbed depths of life; that's why I volunteered.
>
> (Catalogue of *Otto Dix*: 28)

Dix had fought in the First World War from the beginning. He was subsequently to do a series of etchings recording and expressing its horrors rather as Goya had done in his Disasters of War a hundred or so years before. Dix was also very profoundly influenced by the philosophy and ideas of Nietzsche and regarded him as the most important single influence on his work. Dix's only known sculpture was a portrait bust of Nietzsche which was sold at the Nazi auction of forbidden works in Lucerne in 1939 and has not been seen since. The work of George Grosz is equally expressive in this realist way but more overtly political.

Plate 40 *The Eclipse of the Sun* by George Grosz, 1926

This picture is not Expressionist in the manner of Kandinsky or Klee because it is much more strongly figurative and painted in a very detailed and highly finished way. Like Dix, George Grosz wanted to confront reality particularly in Germany after the First World War. We see two men on the right of the picture; one is covered in medals and decorations and huge epaulettes, obviously a military man; the one next to him on the other hand looks more like a businessman or profiteer wearing a bowler hat and with a train of guns mounted on his suit. The other people in the picture have no heads, as if they were stuffed shirts unable to do anything except what they are told.

Grosz's technique is meticulous and he clearly wants you to look into the picture to find its meaning. The colours are lurid, with the

strong contrast between acid pinks and reds cropping up all over the picture. The table, painted in a sharp green, is tipped up in front of our eyes at a steep angle so that we are forced to face the subject directly. Grosz admired Hogarth and his idea of the importance of conveying a moral message, and in a way you do need a verbal description in order to understand this picture properly. Grosz himself explained his relationship with Hogarth and other great moralists like Goya and Daumier:

> What interested me was the work of the committed outsiders and moralists of painting: Hogarth, Goya, Daumier and their like. I drew and painted out of a spirit of contradiction, and through my work I sought to convince the world that it, the world, was ugly, diseased and perfidious.
>
> <div align="right">(quoted in the catalogue of The Berlin of
George Grosz: 37)</div>

The subject of this picture is the corrupt government in Germany in the 1920s, when galloping inflation and rising unemployment were being protected temporarily by financial backing from America. Frank Whitford in the catalogue of *The Berlin of George Grosz* describes the subject vividly:

> The old warrior Hindenburg, now German president, is in conference with a group of capitalists, one of whom is offering him weapons and a railway engine. Meanwhile a blinkered donkey – the German public – feeds on the popular press and a prisoner rots beneath the bars of an oubliette. In the background the sun is being totally obscured by the dollar on which the German economy, soon to be ruined again by the New York stock market crash, depended.
>
> <div align="right">(Ibid: 15)</div>

Once you have the iconography of the painting you can see what it is about and the impact of its allegory is much greater. You could say that this is not Expressionism at all, but the exaggeration in the forms, the claustrophobic space and the lurid colours add enormously to the emotional impact of the painting. Indeed these qualities were recognized by contemporary writers of the time like G. F. Hartlaub, who wrote about this very subject in the preface to the catalogue of the *Neue Sachlichkeit* exhibition in 1925:

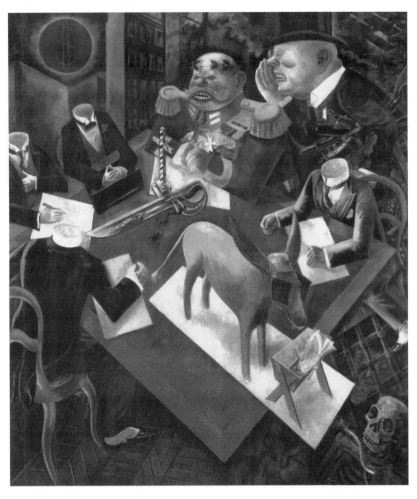

Plate 40 George Grosz, *The Eclipse of the Sun* (1926). Oil on canvas, 218 × 188 cm. © DACS 2003. Courtesy of the Heckscher Museum, Huntingdon, New York.

One may concede that some painters represented in the exhibition grasp the concrete current reality in a way that departs markedly from the objectless, almost transcendental expressive discoveries of certain 'Expressionists'. But if one considers the uninhibited *intensity* with which some express their inner history, others their exterior constitution, or if one attends to the *constructive* trend which is as strong in today's realist art as it was among yesterday's Cubists and Futurists, one finds much *common ground*, which could have been used as a common denominator of the 'isms'. Today, buffeted as we are by the most profound upsets and wild fluctuations in our lives and values, we see the differences more clearly: the move towards topical, restrained findings in some, the emphasis on concreteness, the technical precision is all. Soon one would know that the germ of the new art lay embedded in the old and that even in 'Verism' much of the visionary fantasy of the old lives on.

(G. F. Hartlaub, 1925 in Washington-Long (ed.),
German Expressionism: Documents: 290)

I think one could certainly agree that all the pictures we have looked at so far in this chapter have been concerned with conveying feeling, whether it is spiritual, creative, social or political. The work of Kandinsky, Klee or Macke may be less detailed and tangible than that of Dix or Grosz, but they are all concerned to make that emotional bridge to the mind and spirit of the spectator. In order to do this all are prepared to use the elements of painting in an expressionist way. This quality could also be applied to some of the work of the Surrealists like Max Ernst in *The Forest* in Chapter 5 or Dalí in the *Premonition of Civil War* in Chapter 3. Indeed some would say that Surrealism and its influence fuelled the next phase of Expressionism in America after the Second World War.

In the meantime, all these works we have been considering as Expressionist – and many others – were declared degenerate when Hitler came to power in Germany. This caused an emigration of avant-garde artists who fled all over Europe and especially to America. Mark Rothko, whom we look at now, went from Russia to New York as a refugee.

ABSTRACT EXPRESSIONISM

Colour plate 15 *Black on Maroon* by Mark Rothko, 1958

This is one of a series of paintings which, when hung together, create a sombre mood conducive to spiritual contemplation. All are large and this one is 15 ft wide by nearly 9 ft high (4.6×2.7m). The two purple oblongs appear like two openings in the centre of the picture. As you look at them you feel you could go through them into another world, or they can appear to float in relation to the black sections. In fact both the black and the purple are painted over a colour field of maroon. The edges of the shapes are soft and blurred, and this contributes to their ambiguity. Are they openings or are they floating on the surface? One is reminded of stained-glass windows except that there is no pattern or decoration. The size of the picture makes you feel you could move into it and beyond it, that you could literally become part of it. In fact the purple is thinly painted and you can see the maroon background coming through. The black edges to the extreme right and left are blurred against the maroon so that the whole picture can appear like a black window frame with space beyond. None of the meanings is certain (see *Learning to Look at Paintings*, pp. 115–16).

This whole series of pictures started as a commission for the decoration of the Four Seasons restaurant in the Seagram building in New York designed by Mies van der Rohe. In the end Rothko withdrew from the project because he did not feel the paintings would be suitable for the materialistic and consumerist world of a fashionable restaurant. Rothko was anti-Stalinist but had Communist and anarchist sympathies; now the paintings have a gallery to themselves at Tate Modern in London, where you often find people talking in hushed voices as if they were in church. The maroon shade dominates and one is aware of the power of colour, shape and size to influence the mind and spirit of the spectator.

One is reminded of Kandinsky and his ideas expressed in *Concerning the Spiritual in Art*, and the influence of Theosophy and the Anthroposophy of Rudolph Steiner, which we looked at earlier. Like Kandinsky, Rothko was Russian and his preoccupation with the spiritual is shown in the way he expressed his ideas. In 1945, before an exhibition in Washington he said this:

The abstract artist has given material existence to many unseen worlds and tempi. But I repudiate his denial of the anecdote just as I repudiate his denial of the material existence of the whole of reality. For art to me is an anecdote of the spirit and the only means of making concrete the purpose of its varied quickness and stillness.

(Catalogue of *Mark Rothko*: 82)

So painting can act as a bridge between the world of the spirit and the soul of the spectator, just as the Expressionists had believed earlier in the century. The size and scale were important too, as Rothko makes clear here:

I paint very large pictures. I realize that historically the function of painting large pictures is something very grandiose and pompous. The reason I paint them however – I think it applies to other painters I know – is precisely because I want to be very intimate and human. To paint a small picture is to place yourself outside your experience, to look upon an experience as a stereopticon view or with a reducing glass. However, you paint the larger picture you are in it. It isn't something you command.

(Ibid: 85)

Just like his contemporary, Jackson Pollock, whom we will look at in Chapter 6, Rothko believed in immersion in the painting, and certainly the cumulative effect of this group when seen together is one of total involvement.

At the time of the Second World War a number of major European artists came to live in America. Avant-garde art was forbidden by Hitler. Expressionism was banned in Germany and so was Surrealism; they were replaced there and in Russia by Social Realism. Rothko's family were Jews and they escaped from Russia to America. This diaspora helped to push New York into the limelight as a centre for art and in particular for this large-scale work known as Abstract Expressionism (see also Jackson Pollock in Chapter 6 and Barnett Newman in Chapter 8).

CONFRONTING MEMORIES

More recently, Postmodernist artists in Germany have sought to at least try to come to terms with their country's terrible past: Joseph Beuys, Anselm Kiefer, Gerhard Richter (see Chapter 8) and the

architect Daniel Libeskind have all sought to confront it. In doing so they have taken Expressionism and the idea of self-expression further in different ways.

Plate 41 *The End of the Twentieth Century* by Joseph Beuys, 1983–5

This installation is made out of basalt, clay and felt. The basalt is not carved or crafted in a traditional way but instead is left in a more or less natural form and laid out in an apparently random formation on the floor of a large gallery. The circles in each piece of basalt are cones of stone fixed in place with clay and felt. The whole work relates of course to the idea of the readymade, in the sense that the basalt pieces are virtually 'found objects', and also to Conceptual Art because the artist has not 'made' them but only been responsible for the arrangement.

The use of felt has an autobiographical content in the famous story of how Beuys, who was a *Luftwaffe* pilot, was shot down in the Crimea in 1944 and picked up by a group of Tartar tribesmen who looked after him by wrapping him in felt and fat. The intensely personal nature of this reference is important for the kind of expression which is behind this installation. Beuys took this experience as a starting point for much of his work, where he often uses both felt and fat.

There appears to be no order and no logic in these lumps of basalt and the way they are arranged. They are large, irregular and strewn about as if they were lying on a beach. But the scale and the idea behind the project are impressive. You can walk in amongst the stones in any way you wish and experience a feeling that the state of the world is beyond control. *The End of the Twentieth Century* does make you think about the environment as many land installations are meant to do, but Beuys intends other meanings to be communicated as well. He expresses ideas that are more philosophical, moral and political, connected with the state of the world and man's responsibility within it. As you walk round and among the basalt lumps you can be reminded of skeletons, of bones, of concentration-camp victims and the destructive side of humanity. Many members of Beuys' own family died in the Holocaust. The largest version of *The End of the Twentieth Century* consists of forty-four pieces of basalt. Sometimes the sites Beuys has chosen are deliberately historically resonant, as when this piece was installed in

the former gallery built by Hitler for the officially approved art of Nazi Germany.

Beuys was politically active: he was a founder member of the Green Party, with its anti-nuclear stance; basalt, which he has used here, does contain traces of radioactive material. He believed that Germany should confront its past and that art and artists should be able to help with that. A number of younger German artists like Gerhard Richter, whom we shall look at in Chapter 8, believed that too. Beuys also influenced artists of Arte Povera like Michelangelo Pistoletto (see Chapter 6). Beuys belonged to the Fluxus movement which believed in the power of art to change the world through action. We can see the origin of these ideas in Nietzsche and Beuys was very interested in that philosophy, which he had studied in Weimar in 1941.

In an interview in 1972 entitled 'Not just a few are called, but everyone', Beuys was asked 'Why do you turn almost all your energy towards education and enlightenment?' and he replied:

It is the consequence of widening the concept of art. The 'Political Office' has self determination as its focus. And art has the same focus. Every man is a plastic artist who must determine things for himself. In an age of individuation, away from collective group-ings, self determination is the central concept. But one should not lose sight of actual practice, daily coming into being under one's hands.

(Joseph Beuys, in Harrison and Wood (eds), *Art in Theory*: 891)

Beuys is beginning to sound like Nietzsche here, in the idea of the creative urge of the individual being the driving force behind us rather than religion or some other belief system. There are also traces of Rudolph Steiner in the concept of art education as the basis of all learning and the development of creative potential in everybody:

A total work of art is only possible in the context of the whole of society. Everyone will be a necessary co-creator of a social archi-tecture and, so long as anyone cannot participate, the ideal form of democracy has not been reached.

(Ibid: 891)

Beuys believed that art is a political act and that everyone should participate; you cannot have true democracy without universal art education.

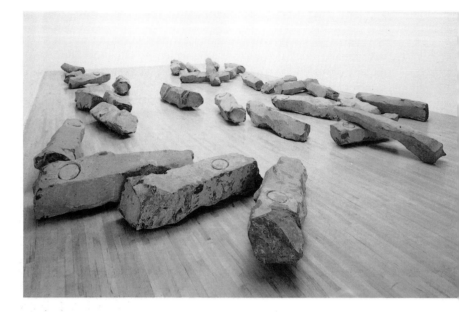

Plate 41 Joseph Beuys, *The End of the Twentieth Century* (1983–5). Installation: basalt, clay and felt.
© DACS 2003. Photograph © Tate, London 2003.

Plate 42 The Jewish Museum, Berlin by Daniel Libeskind, 1999

The question of confronting the past can also be applied to architecture; it has been described by the architect Daniel Libeskind as 'the space of encounter'. It seems strange perhaps to be including architecture in a chapter on Expressionism and Self-Expression. There is an autobiographical reference here too as Libeskind lost many members of his family in the Holocaust. His Jewish Museum in Berlin could certainly be described as expressionist architecture in the sense that it tries to use the design and structure of the building to encompass the history of the Jews of Berlin in a psychological or symbolic way. It is a building that expresses the tragedy of the Jews in Nazi Germany through Libeskind's design, which tries to make the spectator feel the history through the organization of the space and light.

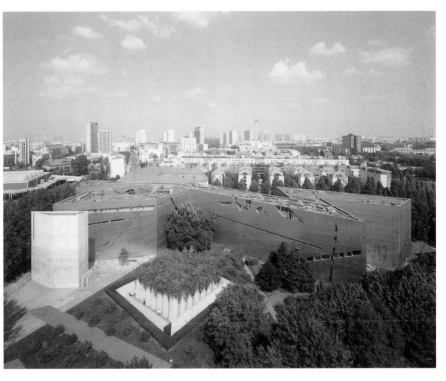

Plate 42 Daniel Libeskind, Jewish Museum, Berlin (1999).
© Jüdisches Museum Berlin. Photograph: Jens Ziehe, Berlin.

The entrance is through the former Prussian court house, a German baroque building on Lindenstrasse, one of Berlin's main streets. You enter through this historic setting and move below ground in order to travel in time before you meet the new museum; then you can take one of three routes, which form the iconographical themes. First there is a path that leads to the Hoffmann Garden – named after E. T. A. Hoffmann, the nineteenth-century writer, who lived near the site – and this path is supposed to represent all those Berlin Jews who went into exile. The second route goes to the Holocaust Tower, a reinforced-concrete void with no proper windows, no heating and no air-conditioning. You cannot get into it except from underground; it is a strange, sharp-angled shape 37 m (121 ft) high and when you get inside, it is a triangular space with only a crack of light at the top. For the visitor this is a very disorientating experience and it is meant to be. The third path leads towards the galleries of the museum, which represent life continuing in spite of everything. The path to these parts forms a straight line through the zig-zag form of the building whose underlying matrix is a distorted Star of David. This path remains empty to represent the absence of people who gave so much to German culture and now no longer exist.

Libeskind has described all these ideas himself because he believes the psychological content in this building is very important and that the spectator should maintain a dialogue with it. In his lecture at the opening of the museum in 1999, Libeskind described it all in detail and then went on to say this:

> Whatever theories and written text have been published about this building, we are now in a concretized space of encounter. A space whose figures are not neutral. But neither is this history. Neutral architecture is perhaps appropriate for non-events. The articulated spaces in the Jewish Museum make the incredible fluctuations of Jewish history, with all its highs and lows, move through the abyss created by the Holocaust into the future.
>
> (Daniel Libeskind, *The Space of Encounter*: 27–8)

Like Beuys in his attitude to art, Libeskind believes that architecture

> is a political act; it is not a private one. It is not just sitting in a studio and inventing whatever one wants to invent. It is a deeply

political act, as it can only be built through agreement, through discussion, through discourse and through a democratic view of what is best for the citizens of a city.

(Daniel Libeskind, *The Jewish Museum*: 14–15)

The design is essentially in a zig-zag form in which the right-angle is avoided as much as possible. When asked about this, Libeskind said that he thought that the right-angle was no longer appropriate in our present world where there are no certainties of ideology or belief:

We no longer operate with the right-angle in the sciences, economics, chemistry or in our daily life. So, it seems that we should ask: what do we operate with? What are our geometries? What are our orientations? . . . it is not a coincidence that the world which we see today – in the news, in photographs, and on television – does not really look like that. Its shadows, its light, its appearance are different.

(Ibid: 38)

In particular, the windows in the Jewish Museum appear to be random and many of them look like lines of light such as you might see out of the slits at the top of a cattle truck; you might catch a glimpse of something as you are moving along or travelling. In fact their design is based on the directions of the names and addresses in the Jewish quarter of Berlin, reflecting its map and layout. A great deal of profound imaginative thought has gone into trying to make an architectural expression of a terrible past. Only by encountering that past and being made to feel it can you help prevent it happening again.

CONFRONTING ONESELF: FEMINISM

Another area in which the idea of confronting the past is very important is of course in the purely personal sense, particularly in relation to the idea of self-expression. We have already seen in this chapter artists, like Beuys for instance, who have used parts of their personal past; but in terms of the exploration of individual feelings and past experience there are a number of female artists particularly who have experimented with this in a number of ways.

Plate 43 *Femme-Maison* ('Woman-House') by Louise Bourgeois, 1983

The sculptures of Louise Bourgeois can be both voluptuous and disturbing. This one is suggestive of the relationship between the woman and her home with the model of a house at the top where the head would be. The rest of the sculpture below looks like a torso with the shoulders, arms and a lap, but it is not treated in a naturalistic way. We do not know whether the legs are crossed on the floor or whether the body is simply cut off at that point, but certainly the width of the lower section anchors the sculpture on its pedestal and makes you feel that the body is sitting. Also the forms at the bottom look like large toes as if they were part of a foot. The shoulders come down into a suggested arm and hand on the right-hand side; this is less obvious on the left, but there is a solid form under the drapery which links the two sides of the sculpture in a draped semicircle. In the centre is a half-moon shape through which you can just see two breast-like forms. The body seems to be draped with fabric and the surface has a sensual quality that makes you want to touch it, as though it was soft and warm rather than cold and hard like the marble it is carved from.

There are meanings obviously suggested here, connected with the role of woman as nurturer, organizer of the house and sexual being. Bourgeois is also very articulate and believes in writing, talking and drawing as well as making sculpture. All her work is autobiographical and she is quite clear about what she means by that. In a conversation with Bill Beckley in 1997, she said that her art was a kind of exorcism of past emotion:

> In my sculpture, it's not an image I am seeking, it's not an idea.
> My goal is to re-live a past emotion. My art is an exorcism, and beauty is something I never talk about.
> My sculpture allows me to re-experience fear, to give it a physicality so that I am able to hack away at it. I am saying in my sculpture today what I could not make out in the past. . . . Since the fears of the past are connected with functions of the body, they re-appear through the body. For me, sculpture is the body. My body is my sculpture.
> (Louise Bourgeois, *Writings and Interviews, 1923–1997*: 357)

So this sculpture does not describe the femme-maison or tell a story about her, but tries to express the idea of woman and home.

The inspiration for Bourgeois' sculpture comes from her childhood and the meaning is not specific but shifting. Even though you know you could touch it because it is solid, the work remains more suggestive than tangible and is all the more powerful for that. This piece was made in 1983, but Bourgeois was born in Paris in 1911. She knew Marcel Duchamp and also the Surrealists. Obviously there are overtones in *Femme-Maison* of Surrealism and the influence of psychoanalysis. But more recently Bourgeois has been taken up by the Feminist movement and championed as one of its significant artists.

Since the 1970s Feminism has had a very important influence on our culture. Although this book is not the place to discuss Feminism and its theories in detail, we do need to glance at it because its effect on the arts and humanities has been particularly potent. In art history this does not just mean looking at the work of women artists, although they have come much more to the fore in recent years and we will be looking at the work of some of them in this and succeeding chapters. But there is a wider social, political and cultural meaning attached to Feminism which it is important to understand. In her classic book *Women, Art and Society*, Whitney Chadwick quotes Griselda Pollock as saying that

> feminism signifies a set of positions, not an essence; a critical practice, not a dogma; a dynamic and self critical response and intervention, not a platform. It is the precarious product of a paradox. Seeming to speak in the name of women, feminist analysis perpetually deconstructs the very term around which it is politically organized.
>
> (Whitney Chadwick, *Women, Art and Society*: 11)

The use of the word 'deconstructs' here links Pollock and Feminism with a number of postmodern attitudes and with other art movements of this period, which we will be considering later on. Like the Minimalists, for instance, the Feminists saw art history as supporting the art market in its exclusive concentration on attribution, stylistic analysis, the art object and the world of dealers and connoisseurs. In other words art history was treating art as a commodity to be bought and sold. So Pollock means that the gender point of view does not consider just women but other 'minorities' as well:

> This artistic practice intends to re-insert art in the social (context) and in history – and that means it addresses and works upon

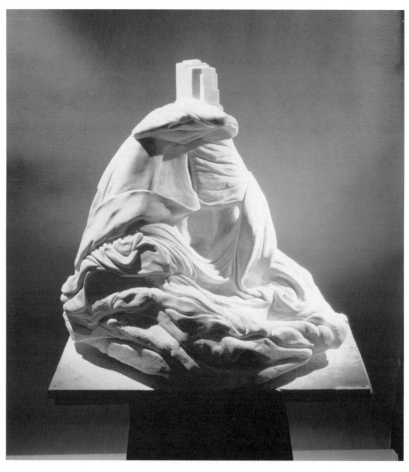

Plate 43 Louise Bourgeois, *Femme-Maison* ('Woman-House', 1983). Marble, 25 × 19½ × 23 ins.

Courtesy Cheim & Read, New York. Photograph: Allan Finkelman.

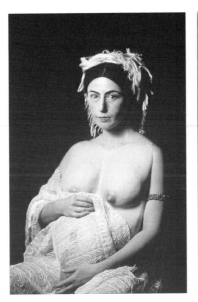 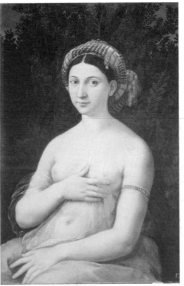

Plate 44 Cindy Sherman, 'Untitled' (1989). Colour photograph, 61½ × 48¼ ins.
Courtesy of the artist and Metro Pictures, New York.

Plate 45 Raphael (Raffaello Sanzio), *La Fornarina* ('Portrait of a Nude Woman',
c.1518). Oil on panel, 85 × 60 cm.
Galleria Nazionale d'Arte Antica, Rome. Photograph © 2003 Scala, Florence – courtesy of the
Ministero Beni e Att. Culturali.

the ideologies and social relations of class, gender and race.
(Griselda Pollock 1985, in Robinson (ed.), *Feminism –*
Art-Theory: An Anthology 1968–2000: 136)

In art history these attitudes have encouraged a move away from
the study of the single heroic male artist into more broadly based
angles of approach. In describing how she changed her teaching of
eighteenth- and nineteenth-century painting in France, Moira Roth
says this:

Thus, by the end of the fourth lecture, we had explored the
period's possibilities in artists' training, professional opportunities
and genre in their historical and geographical frames. Gender
became a distinctive perspective through which to study both
male and female artists, not just a way to include notable women
artists.
(Moira Roth, 1987, in Robinson, *Feminism –*
Art-Theory: An Anthology 1968–2000: 136: 144)

We can look at art and art history from a number of different per-
spectives and, on the whole, this has been an enriching experience,
encouraging debate and discussion instead of a fixed view. Now we
should go on and look at the work of women artists who have
encouraged this kind of approach through the self-expression in their
work.

Plate 44 'Untitled' by Cindy Sherman, 1989

Plate 45 *La Fornarina* ('Portrait of a Nude Woman')
by Raphael, *c*.1518

This pair of images could be said to bring together a number of the
issues we have been discussing. Sherman's picture is not a painting
but a photograph of herself and is based on Raphael's famous
portrait known as *La Fornarina,* whose subject is traditionally
thought to have been his mistress, therefore reflecting the role of the
heroic male artist and his female model. Raphael presents her
as beautiful and seductive with her hands placed in suggestive
and provocative positions, with his name on her left arm,
denoting ownership. Sherman shows herself looking out of the
picture slightly more directly than Raphael's figure. The head-dress

and hairline look similar, although in fact they are not. Sherman has no parting in her hair making the shadow across her forehead darker, and the scarf is ragged and untidy.

Then, when you move down Sherman's body, you realize her breasts are those of a pregnant woman and that the cloth across the stomach covers her distended abdomen. In fact, Sherman is wearing a plastic prosthesis and we realize with a shock that this image invites us to ask questions about the role and position of women in society, both in the sixteenth century and now. Who was or is the real person behind the image? What are the roles that women played and still play in the lives of men and of artists? Whose is the child and how will she manage? Or, worse still, is she wearing the prosthesis to cover something up? We do not know the answers to any of these questions because the picture is not illustrative or narrative and does not have a title; Sherman invites the spectator to meditate on painting and photography, on art and reproduction, on human reproduction, on sex and on the role of women in a male-dominated society, both then and now.

Sherman often uses portraits of herself in various guises to involve the viewer in an active dialogue so the picture becomes an aid to thinking and ideas in the way that Duchamp wanted when he abandoned 'retinal painting' (see Chapter 3). Meaning is conveyed by signs based on a photograph of a well-known painting. The artist does not even give the clues that I have given by identifying the picture from which it is taken. All this uncertainty as to the meaning makes Sherman's picture more disturbing rather than less, and asks for a more radical and feminist interpretation of Raphael's painting too.

Plate 46 *Still Life* by Sam Taylor-Wood, 2001

Still Life is a very beautiful composition with rich colours (see cover for colour) for the luscious fruit against a dark background. It reminds one of the Old Masters like Chardin because of the richness of texture, the red apples, red and yellow peaches and golden pears with purple grapes. The contrast between the texture of the basketwork plate and the fruit is enjoyable, and so are the tonal relationships of dark and light across the composition. Then you realize that it is gradually moving and changing, so in fact it is film and not still photography. Over a period of 3 minutes 44 seconds the fruit turns to a nasty black liquid mess.

You stand and watch; first the blemishes appear, then a grey mould arrives, followed by insects and finally the whole composition is

engulfed in its own disintegration. Of course it is a *memento mori* done on film but taken from the Old Masters and especially the Dutch seventeenth-century period. However, what makes this still life poignant is that we know that Sam Taylor-Wood has recently suffered two bouts of life-threatening cancer, and she is still only 34. When asked about how her work would change after her illness, she said in an interview that it was obviously unavoidable because 'my work is me'. The presence of death in the still life can be interpreted as directly autobiographical. Instead of telling a story, Taylor-Wood uses an image to communicate the idea of mortality, through which we draw our own conclusions both about her and ourselves. But Taylor-Wood is interesting not only because of these kinds of auto-biographical connections, but because in her private life she exemplifies something that has become significant, namely the association between art and celebrity. Through her association with the young British artists' group and her marriage to Jay Jopling, one of the most successful dealers on the London art scene, Taylor-Wood has also become a celebrity.

Plate 46 Sam Taylor-Wood, *Still Life* (2001). 35mm film/DVD, duration: 3 mins 44 secs.
© the artist. Photograph: Stephen White. Courtesy Jay Jopling/White Cube (London).

The relationship between celebrity status and art can be confusing. Nowhere is this more true than in the work of Tracey Emin who has become a celebrity but whose work is concerned with the most intense kind of autobiographical expression; she has even gone as far as making a mask of her own face and setting it in a glass case at an angle as if it were a death mask. There is a kind of sad morbidity in her work that reminds us of Edvard Munch, who has been an important influence on Emin (see Chapter 1). In 1998 the famous unmade bed called simply *My Bed* became notorious and shocked people in the way that Duchamp's *Fountain* had done. Breaking down barriers between the acceptable and the unacceptable is part of what art can be about, but in Emin's case the work can become subsumed by media hype. In a more serious way it can be argued that the reason for Emin's popularity is that she represents many of the anxieties of women in the post-Feminist era. In some sense her expression is invested in herself and her personality as much as in her art.

SENSATION AND SHOCK

Andy Warhol had perceived the importance of celebrity in our society back in the 1960s. His famous saying that everyone can be famous for fifteen minutes has proved prophetic, especially through the medium of television, where people involved in events, particularly disasters, are captured on film. Warhol's celebrity portraits, like the famous one of Marilyn Monroe (see *Learning to Look at Paintings*, pp. 151–3), are presented on a large scale and often as multiples like the Campbell's Soup cans we will see in Chapter 5. The problem about connecting celebrity with art is that it can lead to a kind of shock horror atmosphere as happened at the *Sensation* exhibition in 1997. The media attention which surrounded this event has I think obscured the underlying seriousness of some of the work, much of which is about issues that concern us all like death, murder and the abuse of children. A number of artists in that show wanted to express those ideas and so to shock us into consideration of them, rather as Dix and Grosz had done earlier in the century.

Plate 47 *The Physical Impossibility of Death in the Mind of Someone Living* by Damien Hirst, 1991

This piece has achieved such celebrity status that almost anyone would know what you meant if you referred to it as just The Shark.

However, the proper title is important since one has to assume, as with all Conceptual Art, that the text holds a meaning in conjunction with the image. You can look at the shark as a symbol of death with its mouth half open. If you look at it from the side it appears like a stuffed animal exhibit in a natural history museum, but a number of characteristics change that assumption.

First, the shark is presented in a solution of formaldehyde like a specimen in a biology laboratory, but there is far more liquid: the shark is surrounded as if it were in the sea. Secondly, it is positioned at an angle in the tank between one corner and another. So, when you walk round it, as you would with a piece of sculpture, the refractions and reflections of water and glass make the single fish appear to multiply and swim towards you. If this were really to happen, you would die, and so the title becomes a real possibility suggested in your mind and leads you to think about death and to confront the possibility or indeed the certainty of it one day happening to you.

Plate 48 *Tragic Anatomies* **by Jake and Dinos Chapman, 1996**

This installation sets a series of mannequin-like models of children in a woodland setting. They are very disturbing because of their unnatural and suggestive positions. This piece is clearly about child abuse, an issue that has come out more into the open recently. The models of the children are seen half hiding behind the foliage in this secretive place where people prefer not to look. Of course, cases of child abuse, once they come to court, are much more widely reported than ever before, but the horror of this and the need for vigilance bring the spectator to a point of confrontation that is harder to achieve through the media of television and news print. The lone individual is left with their own thoughts and feelings after looking at this.

There is an aspect of the Victorian fairground or the chamber of horrors at Madame Tussauds about this piece, but there is no doubt about the disturbing emotional charge that it carries. You can argue about whether this is an appropriate way to express these powerful and basic feelings, and whether the shock tactics are somehow denigrating or belittling, like the emotional frissons at a fairground, or even whether it is pornographic. This art has been referred to by some as Neo-Victorianism and indeed aspects of it – as in the taxonomy references in Hirst's work or the waxwork associations in the Chapman brothers' creation – can be associated with that period.

EXPRESSIONISM

Altogether you probably could not call these works we have just been looking at Expressionist, or say that they are about self-expression, but they are concerned with making metaphors for some of the troubling issues of our time, and encouraging us to feel and think about them. The form in which the artists make the works though is more like Conceptual Art, as in Hirst's and the Chapmans' installations, and so is the way they set up resonances in the mind and feelings of the spectator. The boundaries and distinctions between terms like Expressionist and Conceptual Art are often blurred; they are more like themes which mix and intermingle.

In this chapter we have looked at Expressionism and self-expression as denoting a wide range of approaches in twentieth-century art, but all of them are in the realm of expressing emotion. From Kandinsky in *Concerning the Spiritual in Art*, through to the intensely autobiographical work of Bourgeois, Sherman or Beuys, there is the desire to use art to communicate a range of personal, political or social feelings as well as ideas with the spectator. In Safranski's recent biography of Nietzsche, vision, protest and transformation were described as constituting the holy trinity of Expressionism and this could be applied to much of the work we have been discussing. Expressionism has a long history, particularly in Germany, going back at least as far as Grünewald in the sixteenth century and even into the medieval period. However, it is modern art that has really taken Expressionism furthest in some of the ways we have been considering. In the next three chapters these areas and others discussed earlier on will reappear in our consideration of composition, space and form, and light and colour in modern art.

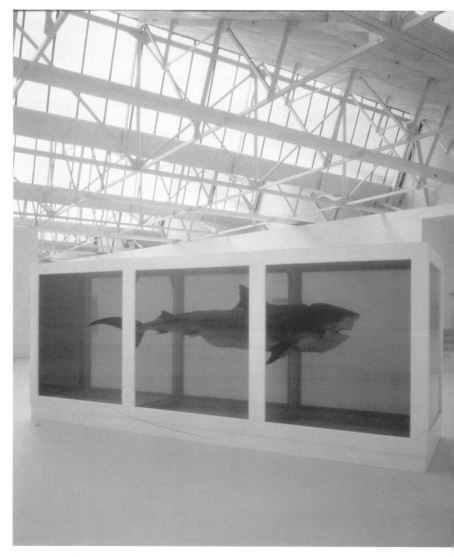

Plate 47 Damien Hirst, *The Physical Impossibility of Death in the Mind of Someone Living* (1991). Tiger shark, glass, steel and 5% formaldehyde solution, 213 × 427 × 213 cm.

© the artist. Courtesy of Jay Jopling/White Cube (London).

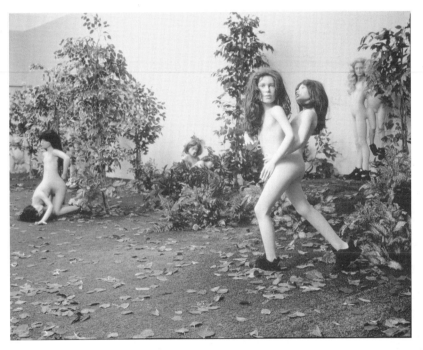

Plate 48 Jake and Dinos Chapman, *Tragic Anatomies* (1996). Fibreglass, resin, paint and smoke devices, dimensions variable.

© the artists. Courtesy of Jay Jopling/White Cube (London).

Chapter 5

New Concepts of Composition

COLLAGE

By composition of course we mean the general overall arrangement of a work of art. Exploration of different kinds of composition has been a very important part of modern art, but this kind of experimentation can be difficult to understand when you look at it if you are not aware of the methods and the background of ideas behind it. To start with in this chapter we will be looking at collage, where the picture is not painted in the traditional sense and where random objects or pieces of paper are brought together and organized into a composition. Collage was a development from the first phase of Cubism, which was considered in Chapter 1. The idea of breaking up the planes of an object and putting them together in a new way expressed new kinds of space and form, which came out in front of the picture plane, as in Picasso's portrait of Ambroise Vollard (see Plate 8) for instance. One of the important ideas behind Cubism was that it should stay in contact with reality, and Picasso and Braque continued to use traditional subject-matter; they did not want to become abstract painters.

One of the weaknesses in this Analytical Cubism was that the compositions seemed to become confused; you can see this beginning to happen in the painting of *The Mandola* by Braque (see Plate 5). The idea behind collage, incorporating pieces of paper and so-called found objects into the picture, meant that the overlapping planes could be shown more clearly, and colour and texture could be used to greater effect. If you compare *The Mandola* with *Bottle, News-paper, Pipe and Glass*, which we will look at shortly, you can see this happening. Collage – and its variants in the work of artists like Rauschenberg, whom we will go on to examine – was a revolutionary new way of making a fine-art object that was neither a painting

nor a sculpture but a construction, which was neither painted nor modelled nor carved in any traditional sense. These radical ideas – about the relationship between painting and sculpture, particularly – have been influential in all sorts of areas of modern art.

One very important distinction needs to be made and that is between the use of collage for purely aesthetic reasons, as with the Cubists, and collage used to communicate meaning; here you may sense echoes of the comparison we made between early Modernism and Duchamp and Dada. Surrealist composition used the random juxtaposition of objects to communicate meaning but usually the pictures were painted, as we shall see with de Chirico and Ernst. At the same time as Surrealism, especially in Germany and Russia, there was the development of photomontage in which photographs were juxtaposed to communicate a message.

Plate 49 *Spartakiada/Moscow*, **1928 by Gustav G. Klucis**

The political photomontage of John Heartfield comes to mind here, as does the work of Gustav Klucis in Russia; his posters for the sporting event called Spartakiada in 1928 are a graphic expression of this (Plate 49). The huge S for Spartakiada is set at a dynamic angle across the body of the athlete, which in turn is superimposed on pictures of players and a sports stadium. On the back of these postcard-sized posters are slogans praising the outcome of the Russian Revolution:

> Only in the country of the proletarian dictatorship does physical culture completely serve the interests of the workers.
> (Catalogue of *Art of the Avant-Garde in Russia*: 274)

This shows the use of collage composition for political propaganda through the juxtaposition of photographic images. The theory behind photomontage is also interesting in that the photograph started to be recognized as a means not just of recording the visible world, but to communicate meaning.

The influential Marxist literary critic, Walter Benjamin, thought that montage of this kind could also be applied to writing; as early as the 1920s, Benjamin suggested that in writing it was more important to juxtapose images and allow the reader to make up their own mind. Benjamin's project about urban life called *Passagenwerk* was never finished but was meant to create a word picture of Paris and its new

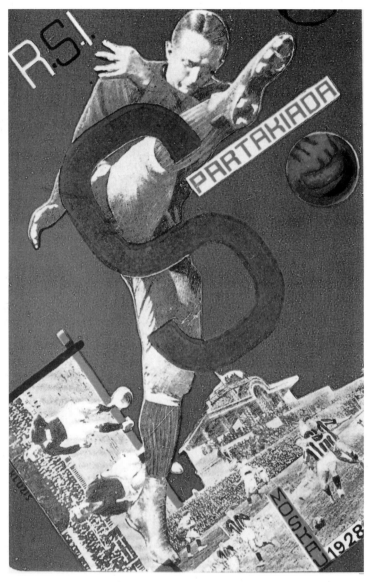

Plate 49 Gustav G. Klucis, *Spartakiada/Moscow* (1928). Photomontage postcard. Colour printing on postcard, 14.6 × 9.1 cm. Printed on reverse: 'Only in the country of the proletarian dictatorship does physical culture completely serve the interests of the workers.'

Courtesy of the State Museum of Art, Latvia.

consumer society out of apparently random word images. Benjamin Buchloh, writing in an essay on the photograph collection of Gerhard Richter, says this about Walter Benjamin and his

> extraordinary and unfinished montage project of the late 1920s, a textual assemblage which had attempted to construct an analytical memory of collective experience in nineteenth century Paris. Benjamin had equally associated his *Passagenwerk* with the montage techniques of the Surrealists and had explicitly identified it in those terms when he wrote that 'the method of this work is literary montage. I have nothing to say, only to show.'
> (Benjamin Buchloh, *Photography and Painting in the Work of Gerhard Richter*: 17)

The meaning comes from the juxtaposition of ideas rather than a logically constructed and shaped argument. The influence of Benjamin's theories and those deriving from photomontage was felt in the development of Postmodernism and in Pop Art composition, as we shall see.

After 1945, artists – particularly in France – rebelled against tradition by adopting a different means of constructing a picture, the so-called Peinture Informelle of Jean Fautrier and Dubuffet. In this they deliberately denied the elements of painting like composition, space and form in the traditional sense, either building up material on the surface of the picture or using the crude techniques of graffiti artists. Pop Art in the 1960s introduced a new element into the realm of composition because of its desire to interpret the changed visual appearance of the postwar world, what was referred to as 'the world of the ad man'. Pop Art collage used the idea of a painted series of signs often with a cryptic title; Richard Hamilton's *Just What is it that Makes Today's Homes so Different, so Appealing?* takes the techniques of advertising and puts them into painting. In different ways, this applies to the work of Andy Warhol and his contemporaries.

The kind of composition used in minimalist art, which emerged at about the same time as Pop Art, is about another anti-traditional stance. Instead of embracing the consumer society as the pop artists did, the Minimalists were against consumerism and particularly in relation to art as a commodity in the world of dealers and salerooms. This attitude took other forms at about the same time in the work of Joseph Beuys, as we saw earlier, and in relation to Michelangelo

Pistoletto and Arte Povera, as we shall see in the next chapter. However, the Minimalists propose that art can be controlled by the artist, as if the artist were a designer instructing someone to carry out their ideas. Artists like Robert Morris use items that they could buy in the hardware store and then control them by careful measurement and spacing. Like the installations we looked at, they are not permanent objects and when dismantled they cease to be; they do not exist as a picture or a piece of sculpture would, but are constructed for a particular place. This applies to the idea of the Happening, which we shall look at, and to Land Art too, like Walter de Maria's *Lightning-Field*. However, all these works are very carefully composed and the aesthetic element plays an important part, not in a traditional sense but by using industrial or natural materials in ways that are pleasing to the eye.

During recent years the move towards meaning has also affected architecture, particularly of the so-called Postmodernist kind. At the end of this chapter we shall consider these aesthetic stances in relation particularly to the architecture and ideas of Charles Jencks. The connections with collage and composition may not seem obvious, but it seems to me that the breaking-up of the classical language of architecture or the use of buildings to communicate a meaning are part of this same set of ideas. You might ask why I have used buildings to discuss this in a chapter on composition: the point is that much Postmodern architecture is about bringing forms together in a new way to communicate meaning. It is linked to the theory of Deconstruction as well, which we will consider in Chapter 6. In the beginning though, as we shall see now, collage presented a means for developing Cubist composition.

PAPIER COLLÉ, ASSEMBLAGE AND COMBINE

Plate 50 *Bottle, Newspaper, Pipe and Glass* by Georges Braque, 1913

This picture is called a collage because it is not painted in the traditional sense; the idea is that random objects or pieces of paper are brought together and then organized into a composition. It is more properly called a *papier collé* or glued paper composition, because it is made out of various papers pasted onto a paper ground, but the effect is similar to collage. Here, pieces of newspaper have been placed to the right and near the middle. The black section recedes

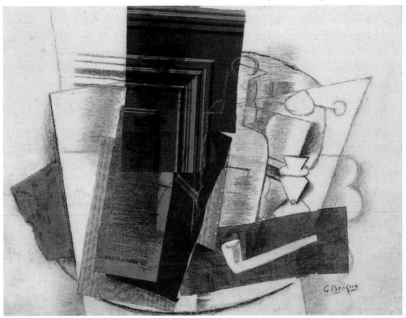

Plate 50 Georges Braque, *Bottle, Newspaper, Pipe and Glass* (1913). *Papier collé.*
Charcoal and various papers pasted on paper, 48 × 64 cm.
© ADAGP, Paris and DACS, London 2003.

but is held in place by the lighter paper immediately behind which looks like patterned wallpaper. On the far left is a piece of brown paper with a torn edge and in the upper part of the arrangement is an area of dark brown paper painted to look like wood or panelling. The papers are layered one on top of the other at very carefully calculated angles. You as the spectator appear to be looking at it from above.

But the reason the picture works so well together from a compositional point of view is the way the tones are modulated to create the effect of air between layers so that the pile of papers seems to lift off the surface and become three-dimensional; it appears to move into the spectator's space in a similar way to a Cubist painting. This effect of form and space is greatly enhanced by the use of drawing in charcoal. The bottle lies behind the paper veneer; behind this are a series of flat, white shapes including a triangular artist's palette and a stick with a bundle of rags or chamois leather on the end called a mahlstick. They are then shaded lightly in some places and more darkly in

others, with the strokes of charcoal moving in different directions. On the left-hand side of the picture, the shapes are flatter and the edge of the largest white shape is firmly delineated; the medium-brownish toned paper behind them stands out more against the curved line, which becomes the indication of an oval table top; this is then emphasized at the bottom of the picture and in the top right-hand corner. Further up on the left-hand side, the moulding that started dark and opaque is continued in charcoal and becomes more translucent. In fact, the juxtaposition of opacity and translucence is an important part of the composition for creating visual variety.

The idea demonstrated here of choosing random pieces of dis-carded paper is turned into an ordered and visually satisfying composition. There are also some curious illusions and ambiguities which add to the subtlety of this arrangement. The pipe on the right-hand side appears to be cut out of white paper and laid on the newsprint but in fact it has been cut out of the newspaper to reveal the white paper below and then shaded to indicate the roundness of its bowl. The bottle is even more ambiguous because on the right-hand side it is quite clearly behind the dark layers, but on the left it has been drawn in, in white, to make it appear further forward. The artist is playing with three-dimensional effects in a subtle and aes-thetic way.

However, in Braque's picture there is on the left a paragraph about the parricide of Montreuil – between the advertisements for Violette de Parme soap and Houbigant's perfume called Fougère Royale. We do not feel that we are being asked to read the extract, because it has been shaded to prevent it from appearing too obvious. In her book *Re-ordering the Universe*, Patricia Leighten has suggested that the choice of cuttings by both Picasso and Braque in their collages may have been more deliberate than was hitherto thought. Leighten makes a connection between the random pieces in a collage and rad-ical anarchist thinking, suggesting that this form of Modernism may indeed have had a political angle in the way that was referred to in Chapter 1.

One of the sources for the idea of the collage lies in Apollinaire's theory of random plasticity, where things come together by accident and are then placed in an ordered way to express an idea, as in the poem 'It's Raining' (see Plate 25). This concept of plasticity was linked with current theories about music and its ability to communi-cate directly with the soul of the spectator, as we saw also in Chapter 2. In his classic study of this period, *The Banquet Years*, Roger

Shattuck suggests that Apollinaire's use of the word plasticity was fairly precise:

> Yet blurred as it is by Apollinaire's shifting poetic terminology, a position emerges which centres around the words 'plasticity' and 'music'. By 'plasticity' he meant a totally free manipulation of appearances of things, a freedom that marks all phases of cubism and simultanism. It subsumes both composition, the method of putting together parts to form an artistic whole, and inspiration, the subjective state of the artist who composes. Plasticity, or freedom from conventional patterns, liberates both. 'Music' was Apollinaire's metaphor for a state of painting not burdened by any fidelity to external appearances, the way musical sounds are not burdened by any semantic function of language.
>
> (Roger Shattuck, *The Banquet Years*: 302)

Shattuck is suggesting here that Apollinaire's theory of plasticity is about freedom from conventional patterns, which is certainly what collage was concerned with, because it was a new way of making compositions. So the communication of meaning is not the prime aim and object.

The idea of putting things together in a random way without making reference to any logical process is very familiar to us from the free-flowing association of images in advertising and television and magazines, the visual juxtapositions which come together by accident every day of our lives. But of course, in the context of the history of art in the early twentieth century, collage was a radical new idea; its influence has been huge when we think of its connection with both Dada and Surrealism and the way it enabled the psychoanalytic theory of free association to be harnessed to the visual arts, which we looked at in Chapter 3.

Composition in both Dada and Surrealist work is about direct communication with the spectator in Apollinaire's sense. The work of the Dada artist Kurt Schwitters is a good example of this. Schwitters was connected with the Dadaist movement founded by Marcel Duchamp; his collages perfectly embody the idea of randomness and control expressed in Apollinaire's idea of plasticity. His pictures are referred to as assemblages which is really just another word for collage or *papier collé*. Schwitters himself called them *Merz* which meant the combination for artistic purposes of all conceivable materials. The principle is basically similar in the sense that the composition is

made from different pieces of paper and card apparently picked at random. (See *Learning to Look at Paintings*, pp. 74–5.)

Plate 51 *Door* by Robert Rauschenberg, 1961

Combines like this are also a kind of collage in the sense that they amalgamate disparate parts together to form a whole; it is less focused than either of the others, leaving the spectator to move their gaze around all over the surface, unable to rest. It is said that this aspect of Rauschenberg's work was due to the influence of the composer John Cage and his idea of inducing a reverie in the mind of the spectator. When writing about Rauschenberg in the same year as this combine was made, Cage said this:

> There is no more subject in a *combine* than there is in a page from a newspaper. Each thing that is there is a subject. It is a situation involving multiplicity. (It is no reflection on the weather that such and such a government sent a note to another). (And the three radios of the radio combine, turned on, which provides the subject?). Say there was a message. How would it be received? And what if it wasn't? Over and over again I've found it impossible to memorize Rauschenberg's paintings. I keep asking 'Have you changed it'? And then notice while I'm looking it changes.
>
> (John Cage, in Harrison and Wood (eds),
> *Art in Theory 1900–1990*: 719)

Cage is suggesting here that there is indeed a lack of focus in Rauschenberg's work which is intended to allow the spectator to think and feel what they like and to think and feel differently each time they look at it. Compared with the Braque or Schwitters, Rauschenberg's combine contains the widest selection of objects: wire netting, coins, wood, a vest and some stones are the most obvious elements. Then the objects are mounted within an oblong frame as if it was a picture. But, at the same time you feel it could be freestanding because there is no framing at the bottom, as though it was designed to rest on the floor rather than hanging on the wall so that you could walk round it.

Neither of the collages we have looked at could really be described as paintings or sculptures, because they are not drawn, painted or carved or modelled in the traditional sense of those words. They all

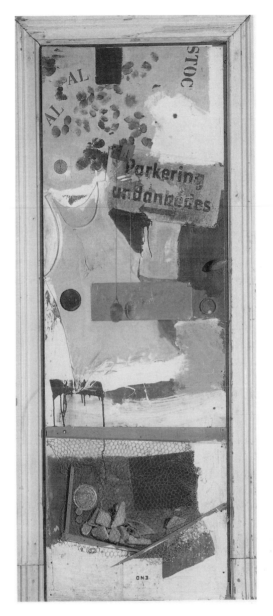

Plate 51 Robert Rauschenberg, *Door* (1961). Combine painting: mixed media on wood, 219 × 94 cm.

set out deliberately to contradict tradition so that they are impossible to categorize. The Braque is most like a painting because it involves illusion and a foreground and background. The Rauschenberg should be most like a sculpture but in fact is painted in parts and then framed. They both succeed in creating a different kind of composition and a new interpretation of form and space. They are built or constructed rather than being crafted in the normal sense of that word. But the balance of tone, colour and texture is still exact and precise in all of them.

SURREALIST COMPOSITION

Plate 52 *The Song of Love* by Giorgio de Chirico, 1914

Both de Chirico and Ernst met Apollinaire in Paris before the First World War. They would have been familiar with the idea of plasticity and the principles of collage. Although not a member of the Surrealist group, de Chirico establishes here the qualities of what can be called Surrealist composition. The principles of collage are used – in the sense of the composition being made of disparate objects brought together in an apparently random way – but there are no found objects or glued paper here. The whole picture is painted and the elements within it are used to create a mysterious feeling in what de Chirico appropriately named his Enigma paintings. A classical plaster bust, a red rubber glove, a green ball set against a dark brown background and a sky of deep aquamarine are brought together. The sharp contrasts of dark and light, and the rich primary and complementary colours contribute to the atmosphere.

But most of all it is the dislocation and re-arranging of the objects in an illogical way that makes the effect. The plaster bust, apparently weightless against the dark wall, its face half in light and half in shadow; the red glove pinned against the wall next to it and the ball in the foreground; the colonnade on the right that seems smaller than it should be, its top steeply sloping like that of the wall in the foreground; the train in the background with the puff of smoke that yet seems to be going nowhere. Whilst you can understand the composition in terms of foreground, middle ground and background, nevertheless you would not expect to see objects juxtaposed like this. They are randomly chosen, but put together in an ordered way and then painted in detail, so that you find the image believable even though it should not be.

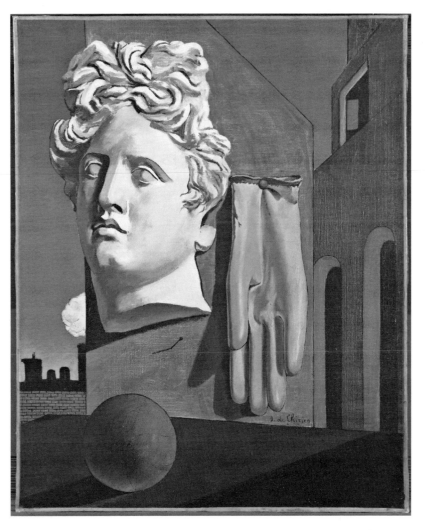

Plate 52 Giorgio de Chirico, *The Song of Love* (1914). Oil on canvas, 28³/₄ × 23³/₈ ins (73 × 59.1 cm).

This kind of association and dislocation of objects was described vividly by de Chirico when he recalled sitting outside the church of Santa Croce in Florence. This familiar place suddenly became unfamiliar and enigmatic while he was looking at the statue of Dante:

> The autumn sun, warm and unloving, lit the statue and the church façade. Then I had the strange impression that I was looking at all these things for the first time, and the composition of my picture came to my mind's eye. Now each time I look at this painting I again see that moment. Nevertheless the moment is an enigma to me, for it is inexplicable. And I like also to call the work which sprang from it an enigma.
>
> (Giorgio de Chirico, in Chipp (ed.),
> *Theories of Modern Art*, 1968: 398)

In de Chirico's hands, the principles of collage and its methods become a powerful way of suggesting meaning. He had an influence on members of the Surrealist movement, such as Max Ernst, who really made their mark in the 1920s. By this date the influence of Freud and his psychoanalytical theories had become important, partly because French translations of his works became available. In 1924 André Breton, who was an associate of Ernst's, published his manifesto of Surrealism in which he suggests how to use the techniques of free association when writing:

> Having settled down in some spot most conducive to the mind's concentration upon itself, order writing material to be brought to you. Let your state of mind be as passive and receptive as possible . . . Write quickly without any previously chosen subject, quick enough not to dwell on, and not to be tempted to read over, what you have written.
>
> (André Breton, in Chipp (ed.),
> *Theories of Modern Art*, 1968: 413)

Max Ernst experimented with free association in paintings like *The Elephant Celebes* of 1921 (see *Learning to look at Paintings*, pp. 149–51) where he explores a similar way of making composition to that of de Chirico.

Plate 53 *The Forest* **by Max Ernst, 1927–8**

The possibility of discovering new methods of making compositions led Ernst to experiment constantly; one of the most famous of his inventions was frottage, in which you use the texture of different surfaces to provide the starting point of your composition. In his book *On Frottage* published in 1936, Ernst describes how he tried it out for the first time when,

> finding myself one rainy evening in a seaside inn, I was struck by the obsession that showed to my excited gaze the floor boards upon which a thousand scrubbings had deepened the grooves. I decided then to investigate the symbolism of this obsession and, in order to aid my meditative and hallucinatory faculties, I made from the boards a series of drawings by placing on them, at random, sheets of paper which I undertook to rub with black lead. In gazing attentively at the drawings thus obtained, 'the dark passages and those of a gently lighted penumbra', I was surprised by the sudden intensification of my visionary capacities and by the hallucinatory succession of contradictory images superimposed, one upon the other, with the persistence and rapidity characteristic of amorous memories.
>
> (Max Ernst, in Chipp (ed.), *Theories of Modern Art*, 1968: 429)

Ernst is exploring the possibility of seeing and making images from various textures. In *The Forest* he uses the effect of frottage to create a spooky atmosphere. The trunks of the trees are tall and slender and leaning at various angles. The textures are achieved by scraping back the paint in various amounts and defining the edges of the forms by scoring them with the end of the brush. The effect of the dark, textured tones against the cold, greyish green of the sky makes a contrast that corresponds to the character of moonlight. Some of the edges are jagged as if they had been broken in a gale and some of their angles make them reminiscent of a war-torn landscape. They also look as though they might move about independently, as if they were partly human. You may think that these suggestions are fanciful but the fact remains that the composition is meant to make you think in a dreamlike and associative way about the idea of a forest. Is the circle behind meant to represent the moon or an eclipse of the sun with its lightened edge on the top left-hand side? The darkness in the foreground with the weird lightness round the outside of the tree

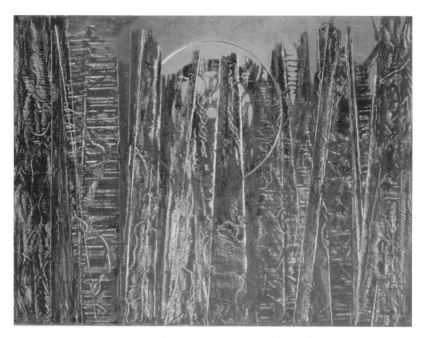

Plate 53 Max Ernst, *The Forest* ('Der Wald', 1927–8). Oil on canvas, 96.5 × 129.5 cm.

trunks is certainly suggestive of moonlight or the sudden darkness caused by an eclipse of the sun.

Other ideas and techniques for making compositions included grattage and *décalcomanie* – variations on the theme of frottage – and oscillation, which was a way of dripping the paint onto the surface of the canvas. But most of all, Ernst is the creator of some of the most powerful images in the Surrealist canon, where association and suggestion are uppermost in the way he composes the picture.

PEINTURE INFORMELLE

Plate 54 *Oradour-sur-Glane* by Jean Fautrier, 1945

Oradour-sur-Glane is a picture in which no attempt has been made to explore the relationship between form and space, where the paint itself has been ladled onto the surface like pâté or wet plaster. This was deliberate on the part of Fautrier, who belonged to a group of artists who called this way of working Peinture Informelle, ('informal painting'), where any attempt at formal or pictorial considerations has been denied. The title of this painting refers to a village in France deliberately destroyed by the Nazis, who shot every inhabitant. The picture is made to resemble a map or an aerial photograph in which topographical description in the conventional sense has been ignored.

We cannot recognize this image in the normal way but have to read it as a sign or a visual configuration that symbolizes what it is. The green, textured background makes reference to the effects of aerial photographs and the thickly impastoed surface stands out against it. As you look at it you see a series of profiles of faces in pink outlined on the pale background, which in turn stands out against the green. One profile in the bottom left-hand corner is especially clear where it moves into the green section; otherwise the faces are layered like the remains of bodies in a mass grave.

Fautrier also did a series of heads called Hostages in both painting and sculpture. They express the idea of pain and suffering in different ways. Fautrier himself, who was a member of the French Resistance, had been imprisoned by the Gestapo and then later released; he then spent some time hidden in a hut in the grounds of a mental hospital on the outskirts of Paris. There he heard the cries of people being tortured and executed in the woods, but was unable to see them. In the Hostages series it seems that the sculpted works were earlier and inspired Fautrier's new painting method, where the impasto was

made from white oil paint ladled really thickly onto a coloured background in layers. The coloured pastel powder was mixed with varnish and spread over the whole composition to bind it together.

The involvement in the painting is sculptural in the sense that the material itself provides the means of expression, without recourse to spatial or formal illusion. The interaction between painting and sculpture in an artist's work is not new, if you think of Michelangelo in the Renaissance or Daumier and Degas in the nineteenth century. The use of paint which itself becomes solid matter is characteristic of the impasto of Rembrandt or Van Gogh. But in Fautrier's case there is a sense in which the material becomes the form – as it would in a sculpture – so that, as with the collages, we find ourselves crossing the traditional boundaries of painting and sculpture in a new way.

Fautrier's contemporary Jean Dubuffet developed his own version of Peinture Informelle. Dubuffet's textured effects were referred to as *hautes pâtes*, meaning thick, pasty layers of paint. He himself named his work l'Art Brut, referring to its deliberately crude and rough-and-ready character; his brutal lithographs of such subjects as different kinds of torture victims make reference to the awful memories and aftermath of the Nazi Occupation. The series was called Matter and Memory after Henri Bergson's famous book of 1896, which we referred to in the chapters on early Modernism. Bergson died at the hands of the Nazis in 1941 because he refused to deny his Jewish origins; the book was appropriate in many ways to this postwar period because of Bergson's belief in the importance of memory and the way it influences our present perceptions.

Jean-Paul Sartre, the founder of Existentialism, also acknowledged Bergson; and connections are often made between Peinture Informelle and the background of Existentialism in post-war Paris. Under the leadership of Sartre the Existentialist movement involved many of the contemporaries of Fautrier and Dubuffet, including writers like Beckett, Camus and de Beauvoir. Simone de Beauvoir's description of how Existentialism caught on is worth quoting here. She says that people had

> lost their faith in perpetual peace, in eternal progress, in unchanging essences; they had discovered History in its most terrible form. They needed an ideology which would include such revelations without forcing them to jettison their old excuses. Existentialism,

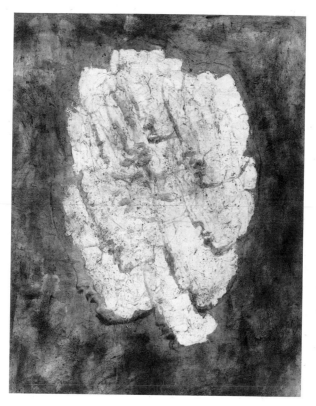

Plate 54 Jean Fautrier, *Oradour-sur-Glane* (1945). Peinture informelle, 145.1 × 113.7 cm (57⅛ × 44⅜ ins).

struggling to reconcile history and morality, authorised them to accept their transitory condition without renouncing a certain absolute, to face horror and absurdity while still retaining their human dignity, to preserve their individuality.

(Catalogue of *Paris Post-War:* 18)

The work of Fautrier and Dubuffet, as we have seen, makes reference to the experience and knowledge of the atrocities committed both during and after the Second World War. The photographs of concentration-camp victims, and indeed the arrival in Paris of

emaciated and suffering people, was influential on artists. The ravaged treatment of the human body by artists such as Giacometti and Germaine Richier is another example, which we will look at in Chapter 8. Simone de Beauvoir has become a heroine of the Women's Movement; she was writing about the awful postwar period in 1965 in her book *Force of Circumstance* from which the above extract comes.

Existentialism had a widespread and important influence because of the idea that all belief systems had been found wanting and that the only thing left was the individual. In other words there were no external moral truths except those we created; in a sense we are free but we can at the same time find ourselves in a void or a vacuum with nothing to aspire to. This way of thinking was very important in the development of Postmodernism and Deconstruction, where these ideas were expanded. It is interesting too, I think, that at the same time as de Beauvoir was writing in 1965, the art scene was already changing, particularly in Britain and America with the advent of the Pop Art movement.

POP ART

Plate 55 *Just What is it that Makes Today's Homes so Different, so Appealing?* by Richard Hamilton, 1956

The artists and writers who started Pop Art recognized that the visual character of the modern urban world had been changed by television, advertising and film, and that this should be reflected in the art shown at exhibitions, museums and galleries. The Independent Group, which began in England in 1952, was the earliest manifestation of this shift in attitude; it contained artists such as Richard Hamilton and Eduardo Paolozzi, writers like Reyner Banham, and the architects Alison and Peter Smithson. In 1956 the Smithsons explained their views like this:

> Advertising has caused a revolution in the popular art field. Advertising has become respectable in its own right and is beating the fine arts at their old game. We cannot ignore the fact that one of the traditional functions of fine art, the definition of what is fine and desirable for the ruling class and therefore ultimately that which is desired by all society, has now been taken over by the ad man.

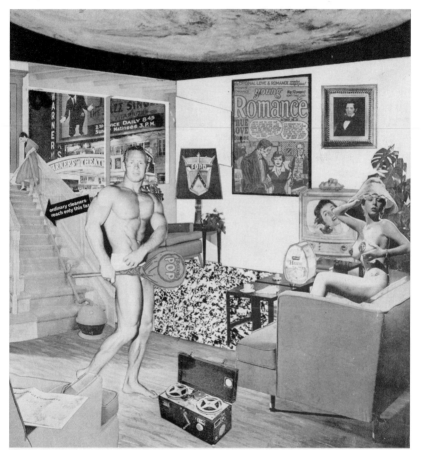

Plate 55 Richard Hamilton, *Just What is it that Makes Today's Homes so Different, so Appealing?* (1956). Collage on paper, 26 × 25 cm.

The fine artist is often unaware that his patron, or more often his patron's wife who leafs through the magazines, is living in a different world to his own. The pop-art of today, the equivalent of the Dutch fruit and flower arrangement, the pictures of second rank of all Renaissance schools, and the plates that first presented to the public the Wonder of the Machine Age and the New Territories, is to be found in today's glossies – bound up with the throw-away object.

(Catalogue of *Pop Art*: 162)

The Smithsons are suggesting that much of the visual meaning or the iconography of the modern world lies in the images presented in magazines and advertisements and that these images are the 'still lifes' of the twentieth century. An obvious example of this would be the famous picture by Richard Hamilton of 1956, *Just What is it that Makes Today's Homes so Different, so Appealing?* Hamilton employs the technique of collage to communicate meaning, rather than for the purely pictorial considerations of Braque or Rauschenberg, which we looked at earlier. He uses a series of photographs of items from modern life: the tape recorder in the foreground, the male pin-up displaying his muscles, the vacuum cleaner advertising its reach, and the housewife at the top of the stairs. Outside the window is a cinema and on the wall a blown-up picture of the romance page from a magazine. Further down is a television, a female pin-up in a provocative pose, and a tin of Ye Old Oak Ham. We are invited to recognize these images and look at them as signs of modern life. The equivalent in the past would have been symbols in religious painting, which would have been familiar to the spectator in medieval times. Another interpretation of this must be the multiple images made by Andy Warhol as a different kind of composition with meaning.

Plate 56 *One Hundred Campbell's Soup Cans* by Andy Warhol, 1962

This picture by Warhol is called a multiple image because the same subject is represented over and over again. There is no composition in the traditional sense of the word, because there is no foreground or background and the objects are not seen in relation to anything else. The frame, if you can call it that, comes right up to the edges of the cans all the way round and is not decorative in any way. The cans fill the whole surface of the canvas, crowding it so that you do not

know what to look at first; they appear to be completely uniform until you start to see that the gaps between the stacks vary in size. The widest space is between the third and fourth cans from the left. There are ten cans across and ten cans from top to bottom to make the hundred and so it appears to be completely symmetrical. The third can in from the left is just about on the golden section. This is a division based roughly on the relationship of three-eighths to five-eighths, where the proportion of the smaller part to the larger part is the same as the proportion of the larger part to the whole (see *Learning to Look at Paintings*, p. 4).

The dark sections between the sides and the bases of the rows of tins vary in size, and in the bottom one they are only partly present having been cut off two thirds of the way down. The medallions on the labels are without any decoration and the words are more blurred in some places than in others. Once you start noticing these variations it makes you stop and look at the image and consider it in a more detailed way than you ever would in a supermarket. We are so used to commodities stacked and arranged in rows apparently looking the same that we never stop to consider them. Warhol came to painting from commercial art and was fascinated by the world of consumerism. The Pop Art movement to which he belonged tried to break down the barriers between so-called fine art and the world of advertising.

We have looked at Marcel Duchamp and his search for new meanings in the visual arts. Warhol's soup cans are not a ready-made in Duchamp's sense of the word nor are they a collage but they are more enigmatic than Hamilton's picture. Warhol asks questions of the spectator about the appearance of the twentieth century and whether this kind of subject is appropriate in an art gallery. It could be interpreted as a still life in the way the Smithsons suggest, and it is a painting; he screen-printed his images onto canvas and then finished them by hand in oil paint. Warhol used assistants to help him as did the Old Masters, like Rubens for instance, who kept numbers of pupils to help him with the multiplicity of commissions he received. It has also been suggested that Warhol's portraits of celebrities like Marilyn Monroe, Elvis Presley or Jackie Kennedy are the modern equivalent of the society portrait of the past.

But, having said all this, Warhol's *One Hundred Campbell's Soup Cans* is not treated in a traditional way in terms of its composition and general appearance; it is about repetition, packaging, labels, stacking and the appearance of the world dominated by commodities

and consumerism. By organizing it and composing it in the way he has, Warhol aims to force us to *look* at it at length and consider it, rather than be seduced by it or simply glance and pass by in the way we would in a supermarket.

The blurred distinction between the art work and the shop is carried further by Warhol's contemporary Claes Oldenburg, particularly in his so-called soft sculpture of everyday objects like *Soft Typewriter, 'Ghost' Version* of 1963 (see *Learning to Look at Paintings*, pp. 77–8). He summed up many of the issues we have been considering when he said:

> I've never made the separation between, say, the museum and the hardware store. I mean, I enjoy both of them, and I want to combine the two.
>
> (Catalogue of *Pop Art*: 51)

Oldenburg was not by any means the only artist to state radical views about the art object at this time because the early 1960s also saw the arrival of what is called the Auto-Destructive Happening. The principle behind this idea is that the work of art is not allowed to continue to exist after being exhibited. One of the most famous examples of this is *Homage to New York* by Jean Tinguely. Designed in 1960 and shown in the grounds of the Museum of Modern Art in New York, it consisted of a series of mechanized parts that moved about in various ways and it incorporated all sorts of sounds. It no longer exists because it was intended to destroy itself, although in fact, during the process of auto-destruction, it caught fire and the New York fire brigade had to be called in to put out the flames.

Tinguely had worked on this kind of art for some time before, but in 1960 he joined a movement called the New Realism which felt that there should be no distinction between art and life. The work of art should be lived and experienced while it was going on and then should disappear. It should not be commodified as an object but should just exist as an experience. Therefore traditional methods of painting and sculpture were outmoded and this was expressed in a manifesto originally published on 16 April 1960 in the catalogue to an exhibition held at the Galerie Apollinaire in Milan:

> It is not just another formula in the medium of oil or enamel. Easel painting (like every other type of classical means of expression in the domain of painting or sculpture) has had its day. At the

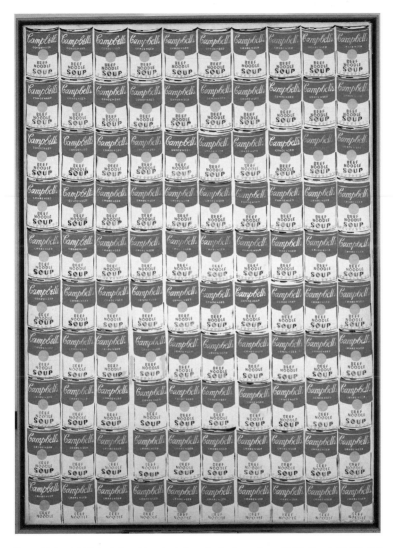

Plate 56 Andy Warhol, *One Hundred Campbell's Soup Cans* ('100 Cans', 1962). Oil on canvas, 72 × 52 ins (182.88 × 132.08 cm) overall.

moment it lives on in the last remnants, still sometimes sublime, of its long monopoly.

What do we propose instead? The passionate adventure of the real perceived in itself and not through the prism of conceptual or imaginative transcription. . . . It is sociological reality in its entirety, the common good of all human activity, the great republic of our social exchanges, of our commerce in society, which is called to appear.

(Pierre Restany, in Harrison and Wood (eds),
Art in Theory 1900–1990: 711–12)

This manifesto is suggesting that the traditional practices of painting and sculpture should be abandoned. The work of art as an object should cease to exist so that no one can possess it. In this way art should become more democratic, less elitist and more truly popular. The embracing of popular culture was part of the legacy of the 1960s and manifested itself most clearly in Pop Art, which started at about the same time as Tinguely was making this work.

Homage to New York belongs to a cluster of ideas surrounding the concept of the work of art as performance; it is experienced in real time, it cannot be possessed and so it cannot become part of the consumer culture. In this sense, Tinguely's work can be linked with Minimalism, Land Art, Video Art and Installations. They are all concerned with the concept of what can be referred to as 'the disappearing object'. In terms of composition, of course, *Homage to New York* does not seem relevant to this chapter. But it is the very idea of a work of art that does not have a composition and must be experienced in real time that is important here.

MINIMALISM

Plate 57 'Untitled' by Robert Morris, 1965–71

An alternative heading for this section could be 'Robert Morris and the disappearing object'. I referred to this idea at the end of the last section and we can see the legacy of many of the points we were discussing in connection with Tinguely and the Happening expressed here. The debate about art and consumerism continues in minimalist work in a different way. The central idea behind Minimalism seems to be that the artist designs the work and then hands it over to assistants who make it with industrial precision; most of the time the

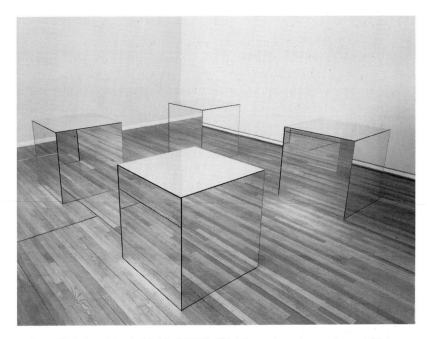

Plate 57 Robert Morris, 'Untitled' (1965–71). Mirror plate, glass and wood, 91.4 × 91.4 × 91.4 cm each cube.

objects are three-dimensional and made of pre-fabricated materials so that there is no sign of the creator's hand anywhere. The artist becomes more like an architect or designer who measures everything up and then has someone else execute it. The concept of the artist as original hero – carving, modelling or placing his brushmarks to make a unique and original work – has apparently gone, although he is still the orchestrator and organizer of the forms.

Morris's cubes are made out of industrial mirror plates and then carefully placed on the floor. The spectator walks round and between them and because they are made of reflective surfaces they seem almost to disappear and so does your sense of where you are in relationship to them. They are placed directly on the floor so you look at them from above as well as from the side. Their clean lines, their setting in a white gallery, and their relationship to one another dissolves as you look at them so that your sense of form and space, object and

subject, disappears and you are made to feel that they do not really exist.

Morris himself, writing in *Art Forum* in 1966, expressed these ideas quite clearly:

> Such work which has the feel and look of openness, extendibility, accessibility, publicness, repeatability, equanimity, directness, immediacy and has been formed by clear decision rather than groping craft would seem to have a few social implications, none of which are negative. Such work would undoubtedly be boring to those who long for access to an exclusive specialness, the experience of which reassures their superior perception.
>
> (Robert Morris, in Harrison and Wood (eds)
> *Art in Theory, 1900–1990*: 821)

These cubes are far from boring because they are about perception in the sense that you are made to explore reflections of yourself and your surroundings in a constantly shifting pattern. This experience allows the spectator to ask questions about themselves and how they relate to the world around them. Morris and his colleagues like Carl Andre and Sol Le Witt refer to their work as three-dimensional and not as painting or sculpture because, as Le Witt says in *Sentences on Conceptual Art*, those words set up too many resonances:

> When words such as painting and sculpture are used they connote a whole tradition and imply a consequent acceptance of this tradition, thus placing limitations on the artist who would be reluctant to make art that goes beyond the limitations.
>
> (Sol Le Witt, in Harrison and Wood (eds)
> *Art in Theory, 1900–1990*: 837)

Minimalist art like these examples often shows great clarity and refinement through the production of uncluttered lucid shapes. The art is depersonalized and yet retains considerable aesthetic appeal through this clear expression. Minimalism comes under the wide umbrella of Conceptual Art, which we discussed earlier on; it has been tremendously influential on interior design and in particular on the simplified, clean look prevalent during the 1990s and still fashionable today.

ENVIRONMENTAL COMPOSITION

Plate 58 *The Lightning-Field* by Walter de Maria, 1977–8

This is one of the most extreme forms of what is called Land Art and an example of environmental composition. In the process of making the work, the landscape is changed forever. In a remote part of New Mexico, Walter de Maria has set up a vast grid of four hundred stainless steel poles, all at exactly the same height. As the sun goes down, its light glances across them and they turn golden as if they were on fire. When there is lightning, which there frequently is in this region, the effect becomes spectacular because the poles attract the electricity in the lightning and increase its effect. *The Lightning-Field* belongs to an arts corporation called the Dia Foundation. Visiting is restricted, severely controlled and expensive. Recently, a journalist named Sean Thomas made the journey and described the experience of seeing it at sunset:

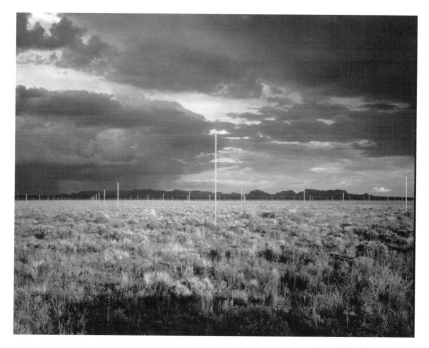

Plate 58 Walter de Maria, *The Lightning-Field* (1977). Quemado, Mexico.
Courtesy of the artist. Photo: John Cliett. © Dia Art Foundation.

Then the miraculous happens. As the sun liquefies into apricot and claret the slanting light strikes the polished steel of the spears, turning them into long sabres of reflected gold, gilded Excaliburs, each and every one exquisitely machined, tenderly masculine, silently worshipful. It is awe inspiringly beautiful.

(*The Times*, 8 July 2000)

You might well ask what is the point of this work, if it is so difficult for ordinary people to visit; but, like the Auto-Destructive Happening, it cannot be consumed or bought and sold on the open market. It is trying, in an offbeat way, to express the idea of the work of art as remote and uniquely precious, but also it is about the fragile time-sensitive beauty of the planet we are busy destroying. It is difficult and expensive to visit as are other works of a similar kind like *Double Negative* (by Michael Heizer) or *Spiral Jetty* (by Robert Smithson) in Nevada and Utah respectively. Land Art is another example of the move away from the categories of painting and sculpture into what is broadly termed three-dimensional work. It is formed and conceived by the artist but not crafted or composed in a traditional way.

POSTMODERNISM IN ARCHITECTURE

The idea we call collage – plucking pieces of paper, bus tickets, chicken wire or any other piece of detritus from the modern world and putting them together in a new way – applies as we have seen to a number of types of twentieth-century composition. It also can be applied to a cluster of ideas from the late 1960s that can be loosely referred to as postmodern. Such ideas have been very influential right across the fields of the arts and humanities, as we have seen; they have also been associated with a type of architecture whose classical language has been reassembled in a new way. Instead of putting together a classical façade with its portico, pillars, pediment and windows all arranged in proportion to one another, Postmodernist architecture takes the stylistic qualities of classicism and puts them together in a form that does not necessarily add up to much in terms of traditional ideas of coherence. Sometimes this can be very successful, as in the Garden Quadrangle of St John's College, Oxford, by Richard MacCormac (see Chapter 8) or the Sainsbury Wing of the National Gallery in London by Robert Venturi and Louise Brown. We came across Venturi in the Introduction to this book, as

one of the major forces behind the theory of postmodernism. Another important figure in this context is Charles Jencks.

Plate 59 Garagia Rotunda by Charles Jencks, 1977

Charles Jencks is a leading writer and architect in the field of post-modernism whose book *The Language of Post-Modern Architecture* published in 1977 has become a classic. In it Jencks looks at buildings from the point of view of what they mean or symbolize rather than from the point of view of the relationship between form and function. So he uses words like metaphor, symbol and sign rather than describing the way the façade of a building expresses the layout of the spaces inside. A rather extreme example of this approach is Jencks' own design of the Garagia Rotunda at Wellfleet of 1977. The configuration of the arches over the windows and the central panel could remind us of eyebrows and the two sections of

Plate 59 Charles Jencks, Garagia Rotunda (1977). Wellfleet.
Courtesy of Charles Jencks.

window behind could be seen as eyes and the lower part as a
mouth. Jencks gives his own description like this:

> Symmetrical ends of pitched buildings often produce a physiog-
> nomic expression quite by chance. Here the face is partly in
> purdah, with the teeth basement hidden by shrubbery. The eyes
> and nose are painted blue on the inside face to give a reflected
> light and contrast with the sky. The metaphor is somewhat veiled
> as a geometric pattern of arches and verticals.
> (Charles Jencks, *The Language of Post-Modern Architecture*: 116)

Plate 60 *Head of a Catalan Peasant* by Joán Miró, 1925

Jencks is interpreting this design in terms of its meaning rather as a
Surrealist or a Pop Artist might. You could even compare it to a
painting like the Surrealist artist Miró's *Head of a Catalan Peasant*
of 1925 (Plate 60) where the eyes are circles joined by a horizontal
line that is bisected by a vertical line, which carries on down to the
area where the mouth is. Above the eyes is a red curling formation
that corresponds to the hair and below the mouth are a series of
squiggles, which could be interpreted as a beard. Miró is experi-
menting with the language of signs here in the way that fascinated
the Surrealists with their theories of association, which we looked at
earlier. In fact Jencks himself compares postmodern architecture
with Surrealism:

> Nonetheless the spiritual function of architecture remains, in fact
> will not go away even if a religion and metaphysics are lacking, and
> thus the postmodern architect, like the Surrealist painter, crystal-
> lizes his own spiritual realm around the possible metaphors at
> hand.
>
> (Ibid: 113)

This kind of idea also derives from the use of the principles of collage
in Pop Art to communicate meaning, which we also discussed and
which becomes part of the whole development associated with the
1960s and the shift to the postmodern sensibility. Jencks also refers
to the idea of the Collage City where urban development happens
almost by accident and is characterized as a kind of organic growth

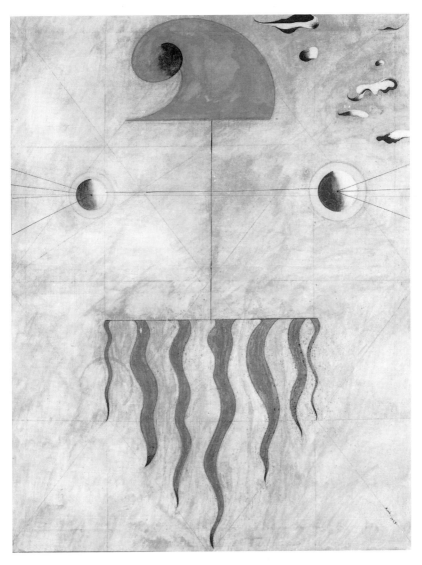

Plate 60 Joán Miró, *Head of a Catalan Peasant* (1925). Oil on canvas, 92.4 × 73 cm. © Successio Miro, DACS, 2003. Photograph © Tate, London 2003. Courtesy of Tate and Scottish National Gallery of Modern Art.

rather than the kind imposed by an ideological view of the so-called Ideal City. Some would say that this sort of thinking is a reaction to the kinds of extreme Modernism seen in the work of Le Corbusier or Mies van der Rohe, which we will be looking at in Chapter 6. It is also associated with a profound philosophical change known as Deconstruction, along with important technical developments in computer-aided design. These are aspects we will explore next in the dynamic new interpretations of space and form.

In conclusion to this chapter, it could be argued that these Postmodernist views have nothing to do with composition in the normal sense of that word and in a way they do not. But it is very interesting to speculate that aspects of this Postmodernist thinking could be traced back to Apollinaire's idea of plasticity and its visual expression in collage. Few would deny the influence of collage as a new, free-ranging and boundary-breaking method of making and composing works of art.

Chapter 6

Space and Form

CONSTRUCTION

The more conceptual and dynamic view of the world that we have discussed influenced the visual arts throughout the twentieth century, particularly in relation to the interpretation of space and form. We saw these innovations in the work of artists like Picasso, Braque and Boccioni in chapters 1 and 2, but they were taken further in many directions. They were greatly helped by the advent of new materials and techniques; for instance, early in the century in the work of the Russian Constructivists, different methods of making sculpture were invented that did not involve modelling in clay or carving in stone, as in the constructed sculpture of Gabo. In painting at the same period artists continued to use paint on canvas but in some cases they learned to do without the subject as in the work of Malevich, or at least to carry simplification and lack of detail to extremes. Modernism of this kind continued after 1945 in pictures by Braque and Matisse and others, reaching a climax with Jackson Pollock and Abstract Expressionism.

The connection between these changes and architecture was very close, blurring traditional distinctions and categories. The development of reinforced and pre-stressed concrete and the use of the steel joist gave architects greater freedom in design and construction. In fact the word 'construction' was applied by the Russian Constructivists to all the visual arts and is still used in relation to sculpture, architecture and indeed painting, when collage and installation are involved. These developments were linked to the growth of industry, and the new materials and techniques that came with it. For this reason alone, much of the work we are going to look at now would be considered modern because the means of making it did not exist earlier.

This technical aspect also applies to the architecture of Frank Lloyd

Wright, Gerrit Rietveld, Le Corbusier and Mies van der Rohe and is particularly true of the new computer technology used in the design of buildings like those of Frank O. Gehry in the Guggenheim Museum at Bilbao (see Plates 80–83). The possibility of making three-dimensional computerized plans from a basic sketch has revolutionized design possibilities, compared to what could be achieved with architectural drawing in the traditional sense. The architecture of Postmodernism and Deconstruction can also be seen as a reaction to the failure of Modernism and its utopian ideas about the city. The often disastrous building of tower blocks on the out-skirts of towns and the reorganization of city centres, which took place in the post-war era with the best of intentions for improving living conditions, led to a reappraisal of Modernist ideals.

A proper discussion of these social design issues is beyond the scope of this book, but it is interesting that the criticism of Modernism in architecture coincided with the changes we have already seen in the direction of art during and after the 1960s. In this chapter we will consider ways in which the expression of space and form moved into a more conceptual interpretation at this period based on thought, memory and confronting the past. Artists like Michelangelo Pistoletto and Rachel Whiteread use space and form to disturb the spectator's preconceptions and encourage them to re-orientate their ideas. The radical changes in thinking associated with the philosophy of Deconstruction will be briefly explored at the end of this chapter to help us to understand more about the difference between the Modernist and Postmodernist frame of mind.

SEEING FORM IN TERMS OF SPACE

Plate 61 *The Large Head* ('Constructed Head No. 2') by Naum Gabo, 1916

Instead of being carved or modelled, Gabo's *Large Head* is con-structed out of Cor-ten steel sheets and welded together. It is like a portrait bust in the sense that it shows the head and shoulders only. The head is built out of flat sheets of metal set at angles to one another, to express the form by means of planes. So, if you look at the head face-on you can see quite clearly where the eyes, nose, mouth and forehead would be. The nose is a space and the way the light catches it makes it appear solid because it is dark and so are the spaces on the head. The curves of the shoulders are angled in such a

way that you see them as solid too. The figure looks tense, alert and expressive; it seems to be leaning slightly forward with a mildly expectant or attentive expression; look at it from the side and you can see this more clearly.

Observing it in more detail, you see that the shapes of the outside edges of the planes correspond to the underlying structure of the head and shoulders and that it is actually the spaces between the metal sheets that are making the form, so you see the space as volume. The breaking up of the volume into planes resembles a Cubist painting in its method of construction and the way the eye moves round it is reminiscent of that shifting, dynamic expression of space and form that the Cubists and Futurists were using. Gabo studied medicine, natural sciences and engineering. In his manifesto of 5 August 1920 he expresses the dynamic ideas of space and time as lucidly as any of the artists of this period:

> The realization of our perceptions of the world in the form of space and time is the only aim of our pictorial and plastic art.
>
> In them we do not measure our works with the yardstick of beauty, we do not weigh them with pounds of tenderness and sentiments.
>
> The plumb-line of our hand, eyes as precise as a ruler, in a spirit as taut as a compass . . . we construct our work as the universe constructs its own, as the engineer constructs his bridges, as the mathematician his formula of the orbits.
>
> We know that everything has its own essential image; chair, table, lamp, telephone, book, house, man . . . they are all entire worlds with their own rhythms, their own orbits.
>
> That is why we in creating things take away from them the labels of their owners . . . all accidental and local, leaving only the reality of the constant rhythm of the forces in them
> (Naum Gabo, in Chipp (ed.), *Theories of Modern Art*: 328)

Gabo is talking here about making space and form, and 'the constant rhythm of the forces in them', visible in constructed sculpture. He refers directly to the ideas of space and time, which the Cubists and Apollinaire had been interested in exploring. But Gabo started to construct sculptures out of modern materials like perspex and early plastics, which express sculptural form with space even more clearly than *The Large Head*.

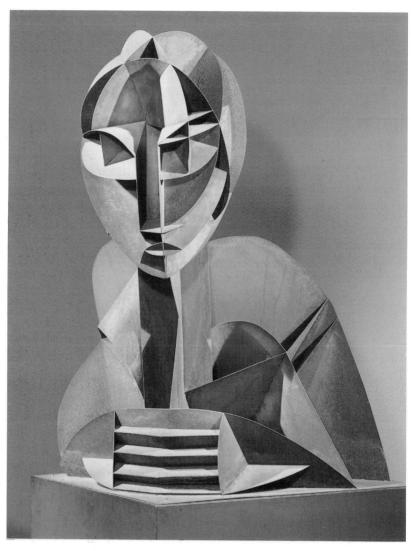

Plate 61 Naum Gabo, *The Large Head* ('Constructed Head No. 2', 1916, enlarged version 1964). Cor-ten steel, 69 × 52¾ × 48 ins.

The works and writings of Naum Gabo © Nina Williams. Photograph © Tate, London 2003.

Plate 62 *Column* by Naum Gabo, 1923

Gabo made this sculpture out of four transparent, rectangular planes set at right-angles to one another. Then the opaque, circular shapes are placed at the base to make a contrast not only between solid and void but also between light and dark. The three-dimensional shape of *Column* is also expressed by the flat, rounded squares about one-third of the way up and the circular band set at an angle nearer the base. The transparent rectangles of perspex express the form of the column whilst at the same time enabling you to see through it so that it can be interpreted as both solid and transparent at the same time; in other words, the space becomes the form and vice versa. The spectator can walk round it as solid volume and at the same time see through it. It becomes an experience of space and form that is dynamic rather than static. In a similar vein and at the same time, Russian artists like Alexander Rodchenko were making what is called Kinetic sculpture. This has an open structure and is often suspended from the ceiling so that it is constantly moving.

Plate 63 *Spherical Non-Objective Composition* by Ivan Klyun, 1922–5

Similar qualities of translucence and opacity are also expressed in the *Spherical Non-Objective* composition by Klyun which was contemporary with Gabo's *Column*. The sphere in the upper section of the picture appears three-dimensional and translucent like a large soap bubble; it both expresses and denies the form by making you feel it as solid and diaphanous at the same time. Down below to the right is another circular form, which seems further back and flatter because of the semi-circular gaps on either side of the dark rectangle behind. The layers of geometrical shapes in the near and far distance are painted both with more and less definition so they seem to move and change as you look at them. This use of soft and hard edges adds to the sense of space in the background and in between the geometrical forms.

The use of translucent and opaque colour adds to the feeling of space because the variations in the colours are so subtle. The black shape in the upper section invades the edge of the sphere, and the oblong area of opaque ochre changes to white and green and virtually disappears near the top right-hand corner, giving us a sense of extension into a world beyond the frame. These artists of the Russian Constructivist movement were preoccupied with the same set of

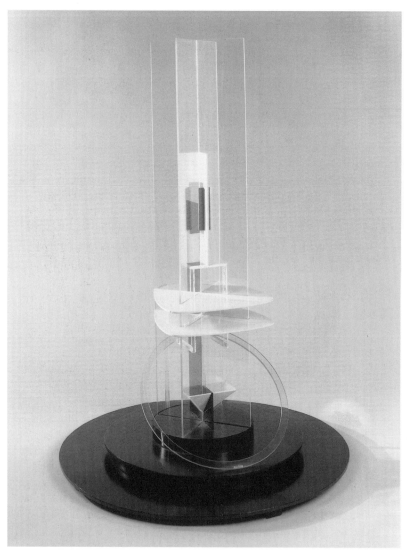

Plate 62 Naum Gabo, *Column* (*c.*1923, reconstructed 1937). Glass, perspex, metal and wood, 105 × 74 × 74 cm.

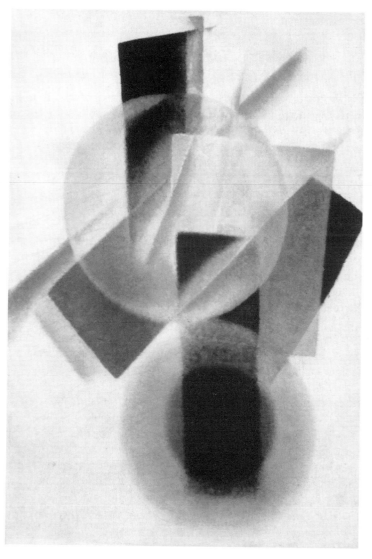

Plate 63 Ivan Klyun, *Spherical Non-Objective Composition* (1922–5). Oil on canvas.
Courtesy of State Museum of Contemporary Art – George Costakis Collection, Thessaloniki.

ideas whether they were working as sculptors or painters. The Suprematism of Kasimir Malevich is an even more extreme version of similar character.

Colour Plate 16 *Suprematist Painting* by Kasimir Malevich, 1916

In this picture Malevich creates a sensation of dynamic and infinite space with the minimum of means. There is no subject as such, but simply the use of the primary colours and black and white. All the shapes are geometrical. They are arranged diagonally except for a large, black horizontal near the middle and one smaller yellow one behind on the right-hand side. The feeling of movement is increased by varying the size of the rectangles so that the smaller ones appear further away and as if they are receding. The intervals between the opaque blocks vary considerably, creating greater recession in some places than in others. By these subtle means the artist generates space that is both dynamic and infinite; we see and feel it most in those variable white areas between the coloured shapes.

Malevich's philosophy of what he called Suprematism involved the idea of infinite space inviting the spectator to meditate on the cosmos in a generally spiritual way. Malevich's writings are full of a kind of abstract and semi-mystical thinking, which can at times become almost unintelligible. In the following passage Malevich refers to the dynamic qualities of Suprematism:

> I call the additional element of Suprematism 'the suprematist straight line' (dynamic in character). The environment corresponding to this new culture has been produced by the latest achievements of technology, and especially of aviation, so that one could also refer to Suprematism as 'aeronautical'. The culture of Suprematism can manifest itself in two different ways, namely as dynamic Suprematism of the plane (with the additional element of the 'suprematist straight line') or as static Suprematism in space – abstract architecture (with the additional element of the 'suprematist square').
>
> (K. Malevich, in Chipp (ed.), *Theories of Modern Art*: 338)

The references here to technology, aviation and dynamism remind one of Futurism, and indeed Malevich was certainly influenced by Futurist ideas as he was by Cubism as well. But there is also the

interest in what he calls abstract architecture, which refers to his fascination with architectural forms and the construction of pictorial space. This aspect applies to other artists apart from Malevich, notably Liubov Popova whose abstract paintings are very architectural and sometimes make you feel that the forms could construct themselves into a building at any moment.

THE UNITY OF ART AND DESIGN

You could say that all the Constructivist works we have looked at so far are architectural because of their geometrical forms, lack of detail, visibly constructed appearance and above all their interest in space. Also some of the artists did variations on their designs or different versions of the same one, so for instance, Gabo's *Column* of 1923 is re-made in 1937 in a slightly altered form. It is as if they were architects or designers instructing others to implement their ideas. In fact there were a number of art movements around 1920 that were concerned with what could be called a primarily architectural expression: the Constructivists in Russia, De Stijl in Holland and the Bauhaus in Germany.

There is a sense in which the forms of sculpture, architecture and indeed painting become interchangeable at this period. Gropius, in his manifesto of the Bauhaus in April 1919, made this idea of the unity of art and design very clear:

> Let us therefore create a *new guild of craftsmen* without the class-distinctions that raise an arrogant barrier between craftsman and artist! Let us together desire, conceive and create the new building of the future, which will combine everything – architecture *and* sculpture *and* painting – in a *single form* which will one day rise towards the heavens from the hands of a million workers as the crystalline symbol of a new and coming faith.
>
> (Walter Gropius, in Whitford,
> *The Bauhaus*: 202)

There is a utopianism in the way these ideas are expressed that still seems radical and inspiring. This kind of belief is characteristic of much Modernist thinking and we need to go on now and explore two important projects that were never made but which demonstrate this sort of idealism very clearly.

THE UTOPIAN IDEAL

Plate 64 *Monument to the Third International* by Vladimir Tatlin, 1919–20

Tatlin's extraordinary construction was never built. It was designed as a communications tower and models of it have been made once or twice; the famous photograph of it in Tatlin's studio with the artist in the foreground on the left shows the model made out of wood and wire. It was a series of spirals on a tilted axis that were intended to move constantly, each section at a different speed: the top section was to turn once a day, the centre once a month and the bottom once a year. It was to house conferences, to give out information and news bulletins to the general population. It is an example of the expression of form and space in a dynamic way, but ultimately it is utopian in the sense that it was unrealizable in that form, although subsequent development of media communications and the internet now makes it look prophetic.

Tatlin's tower reminds us that the dynamic view of space and form was not just a theoretical idea which was put into practice by artists for purely aesthetic reasons of modernity. They really believed their art, and particularly abstract art, would become the preferred artistic expression of the democratic state because it did not presume any classical education on the part of the spectator. They famously tried to take their art to the people by decorating trains and stations with abstract art. In architecture particularly, there were potent ideas about what can loosely be called the 'design for living', the view that the disposition of space and form can influence the way we live.

In itself of course this is not a new idea if you remember that all architecture is about the enclosing and articulation of space. You only have to think of the classical harmony of an interior by Bramante or the excitement of the baroque churches of Borromini to know that. But the idea of architecture as a kind of social engineering is different; it was often allied to improving the housing of the ordinary person and often involved socialist or communist ideals. The avant-garde architecture of this period carries on the radicalism we saw expressed in the work of the Cubists, Futurists and Vorticists. The utopian side is best seen in the idea and design of the ideal city; artists and architects have for centuries explored this theme.

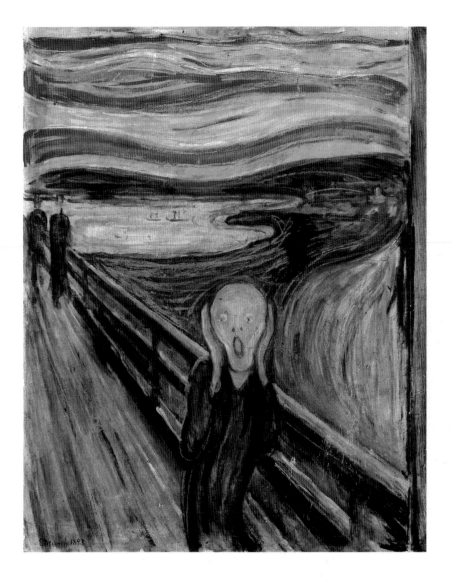

Colour Plate 1 Edvard Munch, *The Scream* (1893). Tempera and pastel on board, 91 × 73.5 cm. © Munch Museum/Munch – Ellingsen Group, BONO, Oslo, DACS, London 2003. Photograph: J. Lathion © National Gallery, Norway 1999.

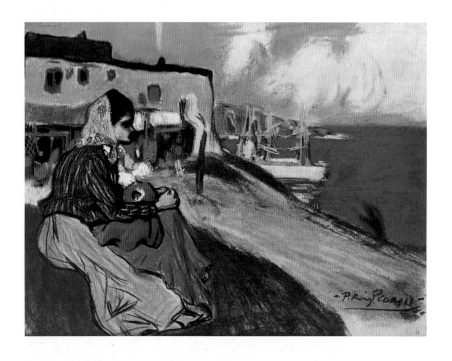

Colour Plate 2 Pablo Picasso, *Gypsy Girl on the Beach* (1898), private collection, Paris. © Succession Picasso/DACS 2003.

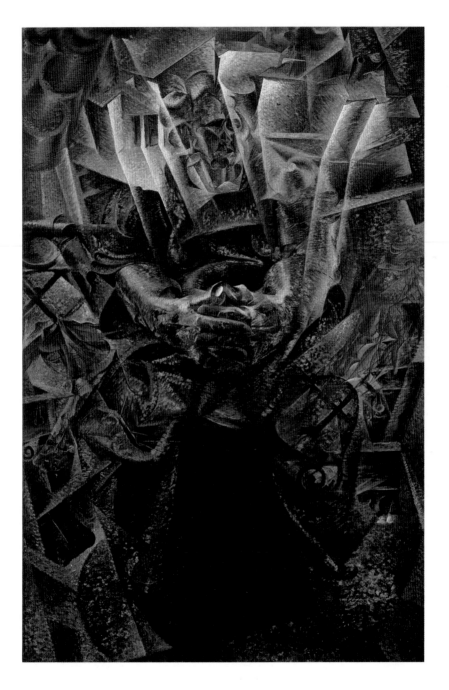

Colour Plate 3 Umberto Boccioni, *Matter* ('Materia', 1912). Oil on canvas, 225 x 150 cm. Courtesy of The Gianni Mattiolo Collection (on long-term loan to the Peggy Guggenheim Collection, Venice).
Photograph © 2002 The Gianni Mattiolo Collection.

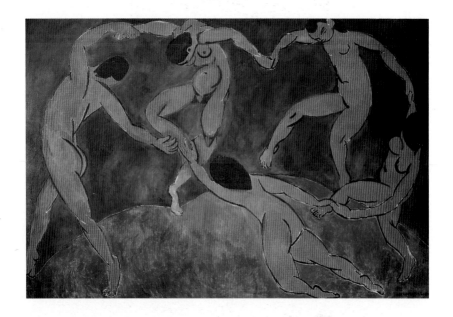

▲ *Colour Plate 4* Henri Matisse, *The Dance* (1910). Oil on canvas, 8 ft 5⅝ ins × 12 ft 9½ ins. © Succession H. Matisse/DACS 2003. Courtesy of Hermitage Museum, St Petersburg. Photograph © The Bridgeman Art Library.

▶ *Colour Plate 5* Luigi Russolo, *Music* ('Musica', 1911). Oil on canvas, 220 × 140 cm. The Estorick Foundation, London. Photograph courtesy of The Bridgeman Art Library.

▶ *Colour Plate 6* William Roberts, Study for *Two-Step II* (c.1915). Pencil, watercolour and gouache, 30 × 23 cm. Courtesy of the William Roberts Society. Photograph © The British Museum.

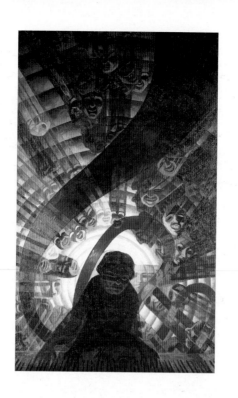

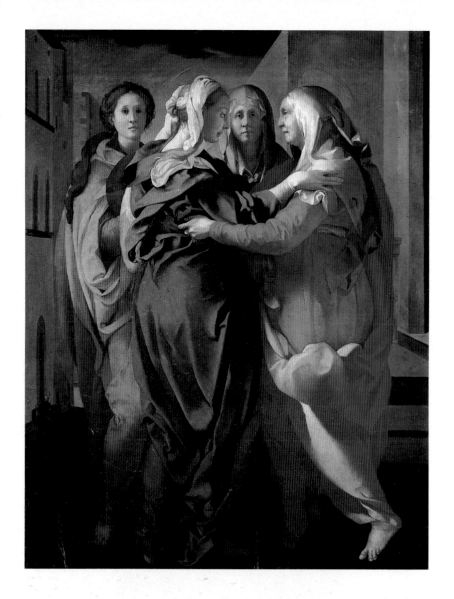

Colour Plate 7 Jacopo Pontormo, *The Visitation* (1528–9). Oil on canvas, 202 × 156 cm. Carmigano San Michele, courtesy of Diocese di Pistoia. Photograph © 1990 Scala, Florence.

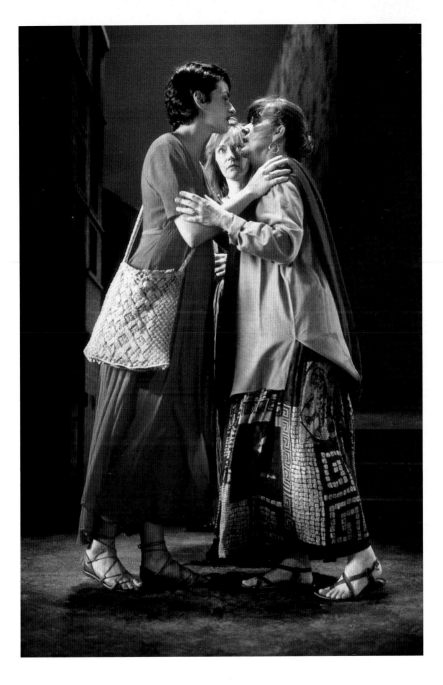

Colour Plate 8 Bill Viola, *The Greeting* (1995). Video/sound installation, 4.3 x 6.6 x 7.8 cm. Photograph: Kira Perov. Courtesy of the artist.

Colour Plate 9 Wassily Kandinsky, *Murnau-Staffelsee 1* (1908). Oil on paper laid on board, 338 x 445 cm. © ADAGP, Paris and DACS, London 2003. Photograph courtesy of the Ashmolean Museum, Oxford.

Colour Plate 10 Wassily Kandinsky, *Into the Dark* (May 1928). Watercolour on paper, 48 x 31.8 cm. © ADAGP, Paris and DACS, London 2003. Photograph: David Heald © The Solomon R. Guggenheim Foundation, New York.

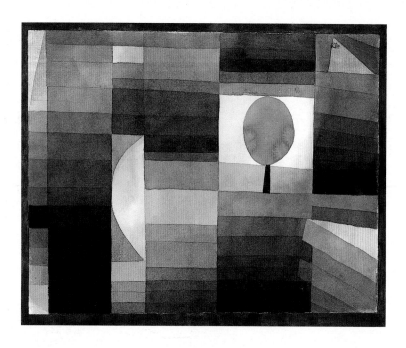

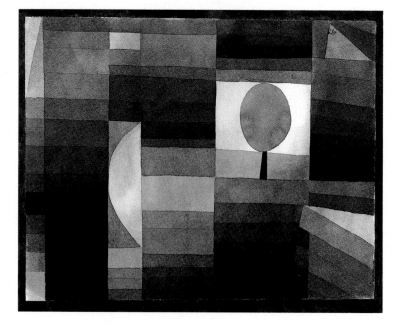

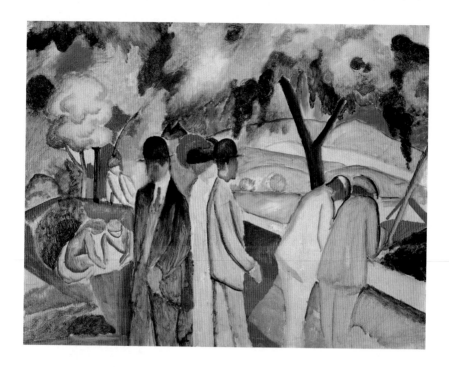

▲ *Colour Plate 13* Auguste Macke, *Large Bright Walk* (1913). Oil on board, 81 × 103.5 cm. Courtesy of Westfälisches Landesmuseum für Kunst und Kulturgeschichte, Münster.

◄ *Colour Plate 11* Paul Klee, *The Harbinger of Autumn* (colour version, 1922). Watercolour and pencil on paper, bordered with watercolour and pen mounted on card, 24.3 × 31.4 cm. Courtesy of Yale University Art Gallery. © DACS 2003.

◄ *Colour Plate 12* Paul Klee, *The Harbinger of Autumn* (black-and-white version, 1922). © DACS 2003.

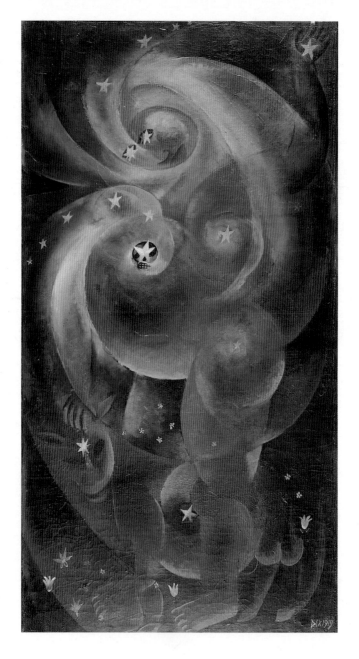

Colour Plate 14 Otto Dix, *Pregnant Woman* (1919). Oil on canvas, 135 × 72 cm. Galerie Valentien, Stuttgart, © DACS 2003.

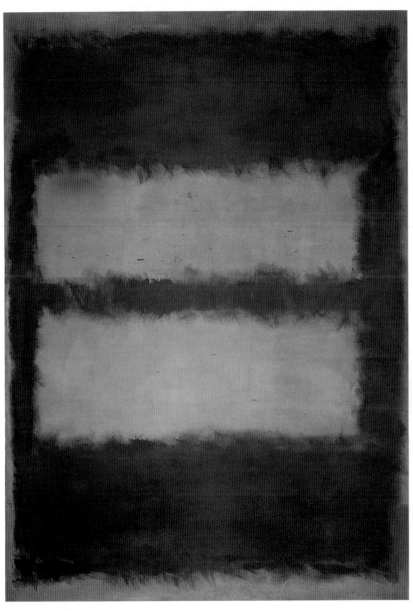

Colour Plate 15
Mark Rothko, *Black on Maroon* (1958). Oil on canvas, 266.7 × 457.2 cm. © 1998 Kate Rothko Prizel and Christopher Rothko/DACS 2003. Photograph © Tate Gallery, London 2003.

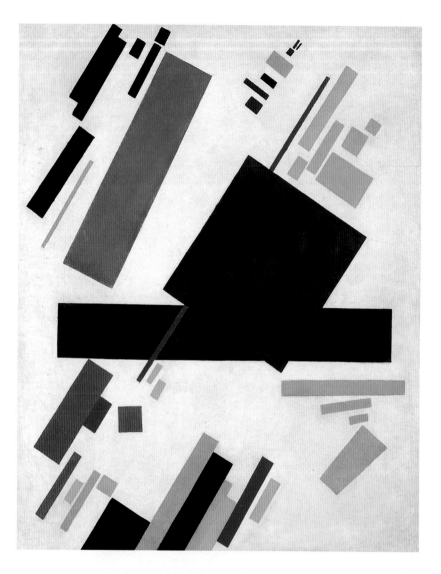

Colour Plate 16 Kasimir Malevich, *Suprematist Painting* (1916). Oil on canvas, 88 x 70.5 cm. Courtesy of Stedelijk Museum, Amsterdam.

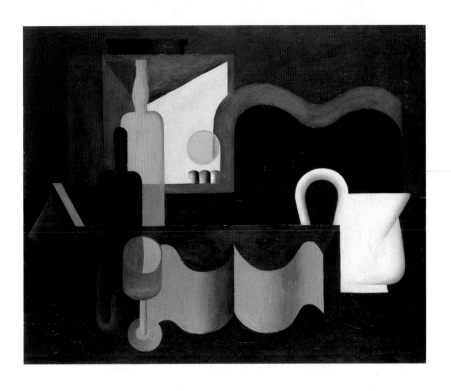

Colour Plate 17 Charles E. Jeanneret (Le Corbusier), *Still Life with White Pitcher on Blue Background* (1919). Oil on canvas, 65 × 81 cm. © ADAGP, Paris and DACS, London 2003. Courtesy of Oeffentliche Kunstsammlung Basel, Kunstmuseum. Gift Raoul La Roche, Basel. Photograph: Oeffentliche Kunstsammlung Basel, Martin Bühler.

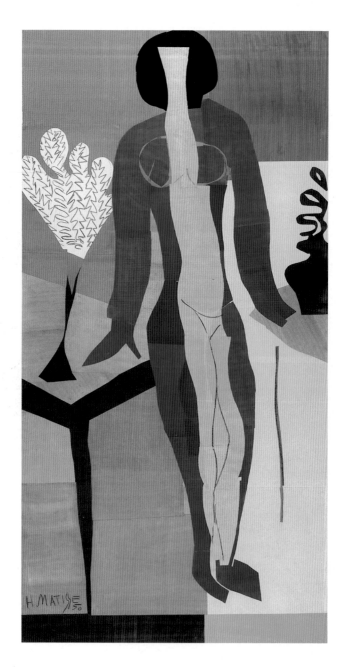

Colour Plate 18 Henri Matisse, *Zulma* (1950). Gouache on paper, cut and pasted on paper and crayon, 238 × 133 cm. © Succession H. Matisse/DACS 2003. Johannes Rump Collection. Courtesy of Statens Museum for Kunst, Copenhagen. Photographer: Hans Petersen.

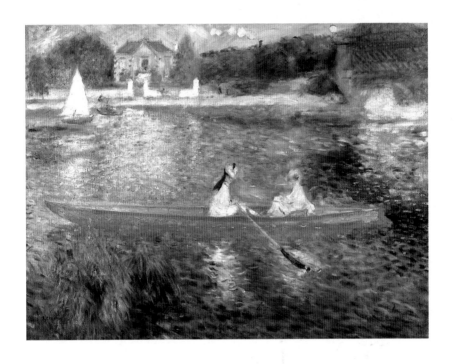

Colour Plate 19 Pierre Auguste Renoir, *Boating on the Seine* (c.1879–80). Oil on canvas, 71 x 92 cm. © 2000 National Gallery, London. All rights reserved.

▲ Colour Plate 20
Claude Monet, detail of
Soleil couchant
(Orangerie, room 1,
west wall; part of
Grandes Décorations,
1918–26). Oil on
canvas, permanently
mounted on wall, 200 ×
600 cm approx. ©
ADAGP, Paris and
DACS, London 2003.
Courtesy of musée
national de l'Orangerie,
Paris. Photograph ©
Photo RMN.

▲ Colour Plate 21 Pierre
Bonnard, *White Interior*
(1932). Oil on canvas,
109 × 156 cm.
© ADAGP, Paris and
DACS, London 2003.
Photograph © Musée
de Grenoble.

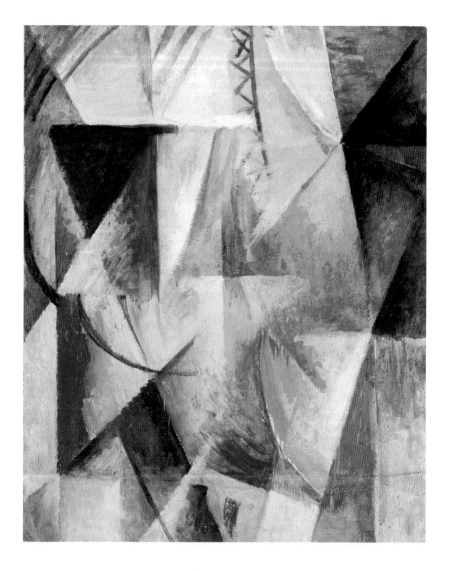

Colour Plate 22 Robert Delaunay, 'Une Fenêtre: étude pour *Les 3 fenêtres*' ('A window', 1912). Oil on canvas, 110 × 92 cm. Coll. MNAM, Centre Pompidou, Paris. © L & M Services, B.V. Amsterdam 20030802.

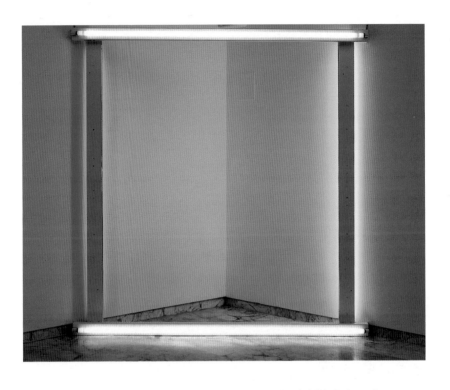

Colour Plate 23 Dan Flavin, 'Untitled (*To Donna* 5a)' (1971). Coloured fluorescent tubes, 29 × 245 × 24 cm. © ARS, New York and DACS, London 2003. Courtesy of Centre Pompidou-MNAM-CCI, Paris. Photograph © CNAC/MNAM/Dist RMN – Adam Rzepka.

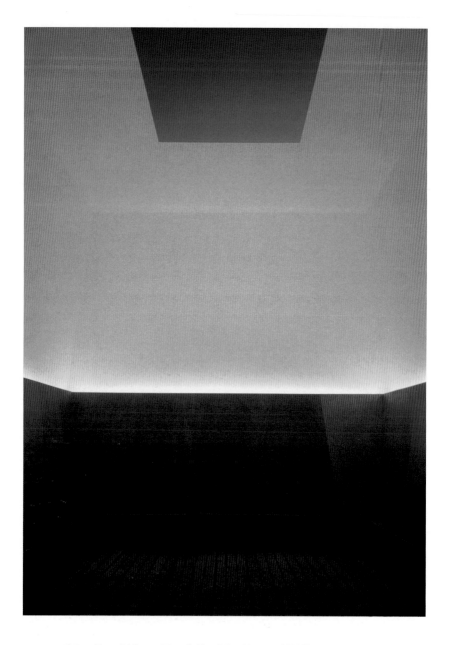

Colour Plate 24 James Turrell, *The Other Horizon* (1998). Interior view.
Photograph: Gerald Zugmann, courtesy of MAK – Austrian Museum
of Applied Arts/Contemporary Art, Vienna, and the artist.

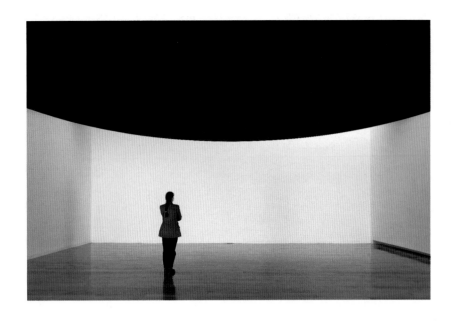

Colour Plate 25 Anish Kapoor, *At the Edge of the World* (1998).
Fibreglass and pigment, 500 × 800 × 800 cm. Courtesy of the artist.
Photograph: John Riddy, London, courtesy of the Lisson Gallery.

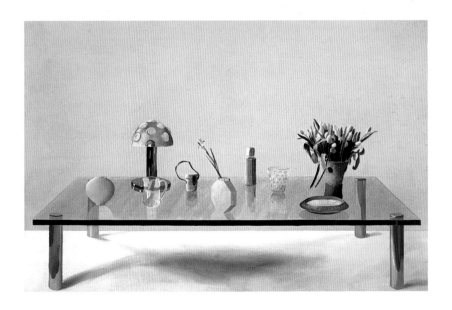

Colour Plate 26 David Hockney, *Still Life on a Glass Table* (1971–2).
Acrylic on canvas, 6 × 9 ft. Courtesy of the artist. © David Hockney.

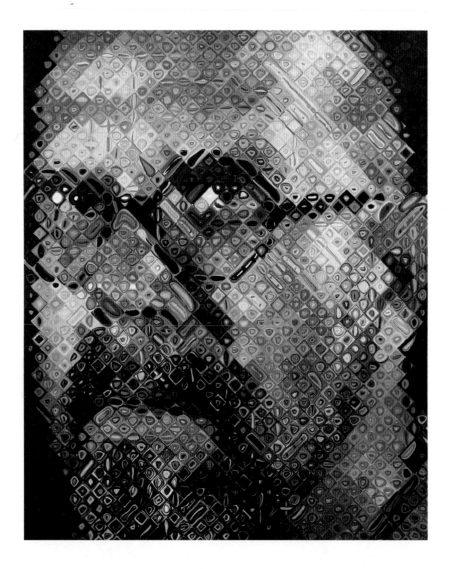

Colour Plate 27 Chuck Close (b.1940) *Self-Portrait* (1997). Oil on canvas, 8 ft 6 ins × 7 ft (259.1 × 213.4 cm). New York Museum of Modern Art (MoMA), Gift of Agnes Gund, Jo Carole and Ronald S. Lauder, Donald L. Bryant, Jr., Leon Black, Michel and Judy Ovitz, Anna Marie and Robert F. Shapiro, Leila and Melville Strauss, Doris and Donald Fisher, and purchase. 215, 2000. Courtesy of Pace Wildenstein, New York. © 2004 Chuck Close. Digital image © 2003, The Museum of Modern Art, New York/Scala, Florence.

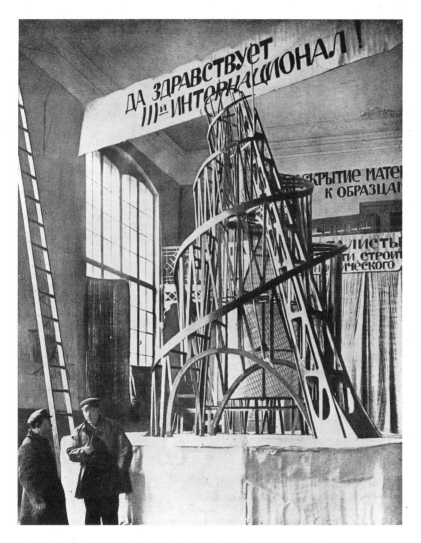

Plate 64 Vladimir Evgrafovich Tatlin, Model for *Monument to the Third International* (1920).

© DACS 2003. Photograph courtesy of Moderna Museet, Stockholm.

Plate 65 *La Città Nuova* by Antonio Sant'Elia, 1914

An artist of the early twentieth century who embodies the idea of the ideal city and projects it into the future is Antonio Sant'Elia in his drawings for his new city, the *Città Nuova* of 1914. The drawing shows tower blocks, one with a flat façade and one receding. The lifts (elevators) and services appear to be on the front of the building. Down below is what looks like a railway line on the right going inside the building, and then a series of bridges and roads criss-crossing one another at different levels, particularly on the right-hand side. Of course Sant'Elia is not making a technical drawing as an instruction for building but rather creating an imaginative scheme where your size in relation to the picture is minute. The design seems powerful and lowering and dehumanized; it may look modern but one does not think one would like to live in it. The strong contrasts between dark and light add to this effect. The artist is creating a dynamic and moving space that makes his vision exciting in the way Futurist paintings are exciting.

Sant'Elia was loosely associated with the Futurists in Milan, and he published a Futurist manifesto in July 1914 which Marinetti endorsed. In May 1914 he had taken part in an exhibition called *Nuove Tendenze* – 'New Tendencies' – and in the catalogue he wrote:

We must invent and rebuild *ex novo* the modern city like an immense, tumultuous building yard, agile, mobile, dynamic in all its parts, and the modern house like a gigantic machine. Elevators must not huddle in stairwells like solitary worms, rather staircases – now rendered useless – must be abolished, and elevators must swarm up the facades like serpents of iron and glass. The house of cement, glass, iron, stripped of painting and sculpture, enriched solely with the inherent beauty of its lines and its relief, extraordinarily ugly in its mechanical simplicity, as tall and as wide as it need be rather than as prescribed by municipal law, must rise on the brink of a tumultuous abyss: the street will no longer stretch out like a doormat at ground level but will plunge into the earth by means of several stories that will bring together the traffic of the metropolis and be connected by metal catwalks and swift-moving conveyor belts for necessary displacements.

(E. da Costa Meyer, *The Work of Antonio Sant'Elia*, Appendix 1: 211)

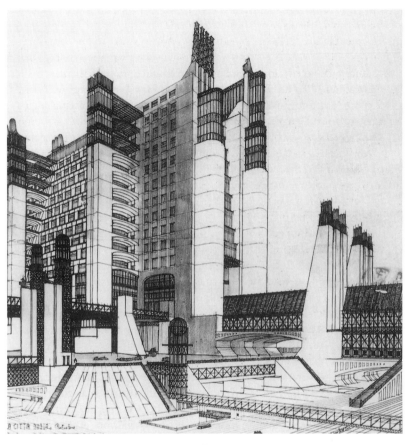

Plate 65 Antonio Sant'Elia, detail of *La Città Nuova* (1914). Museo Civici, Como

From Esther da Costa Meyer, *The Work of Antonio Sant'Elia*, Yale Publications in the History of Art, ed. Walter Cahn, Yale University Press.

The clear association here between architecture and the machine, between the city and industry sounds familiar if you think of the manifestos of Marinetti or the Constructivists, or the designs of architects like Le Corbusier, Gropius or Mies van der Rohe. The idea of lifts going up the outside of the building makes one think of more recent work like Richard Rogers' Lloyds Building. Sant'Elia finishes his message like this:

> And finally I declare that, just as the ancients took their artistic inspiration from the elements of nature, so too must we [who are] materially and spiritually artificial – find our inspiration in the elements of the new mechanical world that we have created, of which architecture must be the most beautiful expression, the most complete synthesis, the most effective artistic integration.
>
> (Ibid: 212)

There is no doubt, as Sant'Elia indicates here, that new developments in engineering – like the discovery of reinforced concrete and the understanding of steel and concrete construction – went hand in hand with the development of modern architecture. We need first to go to Chicago where there had been a ferment of engineering and architectural invention in the late nineteenth century. It is the home of the skyscraper, which introduced a new method of constructing buildings based on a skeletal steel frame and concrete or other cladding, rather than on structural load-bearing walls made from bricks and mortar. It meant that you could build much higher, that you could abandon the classical language of architecture and create designs that were simple, undecorated and a symbol of the modern industrial city. Frank Lloyd Wright, whom we look at next, had worked in the office of Louis Sullivan, who was the greatest of the early exponents of this new method of construction. Although he always admired Louis Sullivan and adapted many of his ideas, it is as a designer of the house that Wright is best known. Wright's ideas became seminally influential in Europe through the volumes published by Ernst Wasmuth in Berlin in 1910–11. That is how his work came to be known to the De Stijl movement in Holland and the Bauhaus in Germany.

DESIGN FOR LIVING

Plates 66 and 67 The Robie House by Frank Lloyd Wright, 1910

In 1909, five years before Sant'Elia's manifesto, Wright had designed for Mr Robie the greatest of his prairie houses, which embodies both a design for living and a free-flowing dynamic space. If you start by looking at this famous house from across the road, the long, low, horizontal front is what strikes you first; this contrasts with the vertical trunks of the trees in the foreground. The low wall in front lines up with the pavement helping the house to look as though it belongs to its site; it appears smaller than you imagine from photographs partly because it is dominated by the more vertical Victorian houses down the road and the size of the neo-gothic university buildings in the vicinity. The plot on which the Robie house stands is also small, being only 60 ft by 180 ft (18 × 55 m), and its low horizontal lines accentuate this effect; it looks like a ship that has dropped anchor in a harbour surrounded by tall warehouses. In fact it appears to be lying on the ground and indeed Wright laid his buildings directly on a concrete base.

The low retaining wall in front helps to bring the first floor down to your eye level and the pointed windows at either end look like the prow and stern of a ship, especially with the deep cantilevered eaves of the roof stretching horizontally out beyond. In his autobiography, Wright described this effect:

> And at this time I saw a house, primarily, as a liveable interior space under ample shelter. I liked the *sense of shelter* in the look of the building. I still like it.
> The house began to associate with the ground and become natural to its prairie site.
>
> (F. L. Wright, *Autobiography*. 128)

So Wright's idea was to make the house marry with its site and become part of the landscape to express in particular the wide, open spread of the prairie. This is greatly helped by the strong long lines, the thin elongated bricks with the horizontal mortar contrasting in colour and the upright pointing mortar dyed pink to match the bricks so that it does not interrupt the horizontal axis of the façade. The pale coping sitting on the brickwork continues this process, and

helps to create a contrast with the dark sections under the broad and protective eaves, and below the parapet behind which the ground-floor rooms are situated. The chimney rising in the centre adds to the effect of sheltered protection which Wright talks about. The whole structure looks as though it grew there over time, like the striations in a rock face.

However, Wright also said that what happened on the outside was there 'chiefly because of what happened inside'. The position of the entrance to the Robie house is not visible and you have to go round behind the left-hand end of the street front to where the porch is integral with the building and embraces you as you come into it. Wright's idea about the interior space was that it should move and flow; he expressed this brilliantly in the Robie House (Plate 67), particularly in the organization of the first-floor living room and dining room. You approach this part of the house – the second storey – by a staircase coming up behind the fireplace, which is in the middle of the space; there are two flues on either side of the fireplace and an opening directly above the hearth through which it is possible to see to either end of the room. There are no doors to shut off your appreciation of horizontal space.

As you enter the sitting room, you can approach from either side of the fireplace and you can turn to see the hearth occupying the middle ground. Along each wall are rows of casement-opening windows, which Wright called light screens because they appear continuous from the inside instead of being holes punched in the wall. They allow the light to enter from the outside in a way that extends the feeling of space and links the exterior with the interior of the house. They are decorated with a sparse pattern of yellowish green glass, which corresponds to the shape and colour of the foliage outside. Although subsequent owners have sealed them shut, they were originally all designed to open like patio doors onto the terrace. The cold of Chicago's winter made this completely impractical but the visual effect is really successful. The idea therefore that the outside and the inside should interact was an important part of Wright's philosophy.

> My sense of 'wall' was no longer the side of a box. It was enclosure of space affording protection against storm or heat only when needed. But it was also to bring the outside world into the house and let the inside of the house go outside. In this sense I was working away at the wall as a wall and bringing it towards the

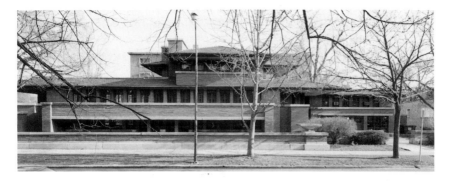

Plate 66 Frank Lloyd Wright, south façade of Frederick C. Robie House, Chicago, Illinois (1910).

Photographer: Tim Long. Courtesy of the Frank Lloyd Wright Preservation Trust.

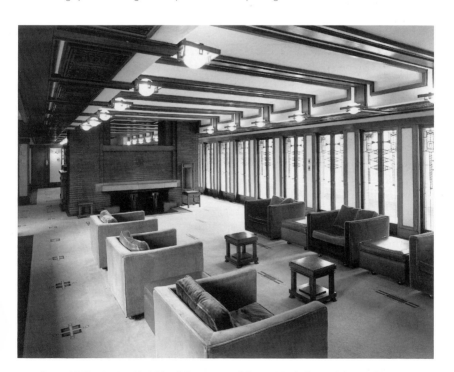

Plate 67 Frank Lloyd Wright, living room of Frederick C. Robie House, Chicago, Illinois (1910).

© ARS, New York and DACS, London 2003. Photographer: Judith Bromley. Courtesy of the Frank Lloyd Wright Preservation Trust.

function of a screen, a means of opening up space which, as control of building materials improved, would finally permit the free use of the whole space without affecting the soundness of the structure.

(Ibid: 128)

This effect is continued in the dining room where the light and space flow round the table. But here the high-backed chairs encourage an oasis of room-like intimacy for conversations and human relationships through the act of eating together. In the whole of this space, which extends from one pointed window to the other at either end, like the deck of a ship, there is a kind of plasticity and movement. It is at once free-ranging and controlled; it allows for freedom of movement but also makes sure you always know where you are so you never feel disorientated. In his autobiography, Wright explained this idea:

Here entered the important new element of plasticity – as I saw it. And I saw it as an indispensable element to the successful use of the machine. The windows would sometimes be wrapped around the building corners as inside emphasis of plasticity and to increase the sense of interior space.

(Ibid: 129)

Certainly the idea that glass should be made to turn corners is very evident in the end windows, which allow the reflected light under the cantilevered roof to enter at either end of the dining room and sitting room. The other very strong characteristic is the lack of decoration in the traditional sense. Much of the furniture was built in; the lamps and other fixtures and fittings were designed by Wright himself. He believed that the simplification and lack of embellishment in Modernist art and design derived from the influence of the Japanese print:

If Japanese prints were to be deducted from my education, I don't know what direction the whole might have taken. The gospel of elimination of the insignificant preached by the print came home to me in architecture as it had come home to the French painters who developed *Cubism* and *Futurism*. Intrinsically the print lies at the bottom of all this so-called *Modernism*. Strangely unnoticed, uncredited. I have often wondered why.

(Ibid: 183)

By the time he began writing his *Autobiography* in 1926, Wright had visited Japan and worked on his design for the Imperial Hotel in Tokyo between 1916 and 1922. But he would have known about the Japanese print before that, as did all artists and designers of his generation. More interesting still is his mention of the Cubists and Futurists here and the ideas associated with Modernism. It has often been said that the dynamic expression of space and form in Cubist and Futurist work finds its equivalent in the architecture of Frank Lloyd Wright. The cube-like forms and the way their planes interact particularly on the outside of the Robie House could be related to *Portrait of Ambroise Vollard* by Picasso (see Plate 8, pp. 22–3) or the painting of *Matter* by Boccioni (see Colour Plate 3).

The influence of Frank Lloyd Wright was brought to Europe principally through two volumes of his designs which were published in Europe in 1910 and 1911. He was also championed through the lectures and articles of the Dutch architect H. P. Berlage who had been to Chicago and studied his buildings at first hand. Also Russian Constructivist and Suprematist ideas came through El Lissitsky, a contemporary of Malevich, who visited Holland during the 1920s. The Netherlands, which were neutral during the First World War, saw the development of the De Stijl movement beginning in 1917. Their design ideas are best seen in the work of Gerrit Rietveld.

Plates 68 and 69 The Schröder House by Gerrit Rietveld, 1924

In the Schröder House of 1924 by Gerrit Rietveld, the spaces were designed to be flexible so that they could be changed according to what the family was doing. Mrs Truus Schröder, the widow of a lawyer from Utrecht who commissioned the house, played an active part in its design. Like Wright, Rietveld wanted interconnection between the inside and the outside. On the first floor you can see how the windows open beyond the corner of the building so that it seems to disappear; you can just see where the upright steel support has been moved to the left. The plan can be open or closed, according to whether the screens are up or down; if they are not in position then the whole first floor becomes an open space. Mrs Schröder's idea was that the main living area should be upstairs with light and air able to flood in, while downstairs each room should have separate access to the outside creating a freedom of movement that corresponded to the special flexibility on the first floor.

The house is built of a series of flat slabs, originally intended to be of reinforced concrete, which became bricks and mortar rendered with painted plaster of different shades of grey and white. They look like the interlocking planes in a Cubist painting although the influence in fact comes much more directly from the abstract paintings of Mondrian. If you put one of his abstract paintings (see *Learning to Look at Paintings*, p. 154) next to a good photograph of the interior of the Schröder House you can see that the emphasis on black, white and grey, the three primary colours, and the horizontal and vertical axes of Mondrian's picture have been made three-dimensional by Rietveld. The use of glass and the way the light dissolves the edges of the forms adds to the feeling of a spatial movement, which is lighter and airier than in a Wright house. Also in this picture you can see on the left-hand side Rietveld's famous chair, which is made out of laminated wood painted in the three primary colours with a black frame; it is bolted together and built like a Constructivist sculpture.

Rietveld belonged to the De Stijl group which was founded in 1917 and led by Theo Van Doesburg and which published its ideas in the magazine *De Stijl*. Their theories were influenced most by Piet Mondrian, who believed that painting did not need a subject: artists could express themselves at the deepest level with the minimum of pictorial means, such as the vertical and horizontal line, the three primary colours, and black and white.

> Composition allows the artist the greatest possible freedom, so that his subjectivity can express itself, to a certain degree, for as long as needed. The rhythm of relations of colour and size makes the absolute appear in the relativity of time and space.
>
> (Piet Mondrian, *Natural Reality and Abstract Reality*, 1919, in Chipp (ed.), *Theories of Modern Art*: 323)

Like the writing of Malevich on Suprematism, this passage shows the idealism and the almost mystical quality of much in Mondrian's theory, which he called Neo-Plasticism. He was also deeply interested in the new scientific ideas of space and time and his pictures influenced interior design in the way we have seen.

The other point about interior design at this period that we should not ignore is the advent of electric light and of houses with smaller rooms. This meant that the whole of a space could be seen and in order to expand it, glass, steel and clean lines were used to create the

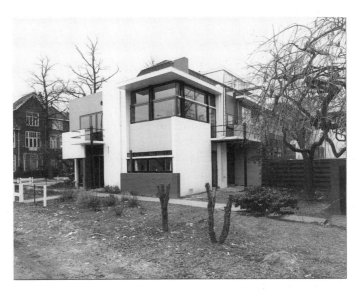

Plate 68 Gerrit Rietveld, exterior of Schröder House, Utrecht (1924).
Photo: Centraal Museum Utrecht, © Centraal Museum Utrecht.

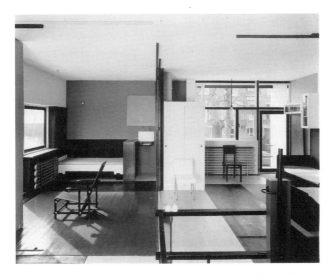

Plate 69 Gerrit Rietveld, interior of Schröder House, Utrecht (1924).
© DACS 2003. Photograph © Jannes Linders.

maximum effect of spaciousness within the minimum area. The Schröder House is a good example of this; it still communicates the idea of modernity very potently.

Plates 70 and 71 The Villa Savoye by Le Corbusier, 1929

This private house by Le Corbusier at Poissy outside Paris is in many ways the complete opposite of both the Robie and the Schröder houses. It is a white cube set in a landscape and it stands out from its environment with its stark lines making it look as unnatural as possible. The whole house is raised on pillars (called *pilotis* in French) so that you can see underneath it, and the drive up to it leads straight into the garage. Instead of looking as though it belongs to the landscape, the house is deliberately made to stand out: like a piece of sculpture the cube displaces the space surrounding it. As you approach the house you walk past the columns towards the entrance which is set in a translucent glass cylinder in the centre of the building.

In an extraordinary way, when you get inside you feel as though you are in a Cubist painting. If you look at the view of the ramp and staircase (Plate 71) you can see the way the overlapping flat planes penetrate one another, making shifting viewpoints like those we noticed in the *Portrait of Ambroise Vollard*. Certainly the shapes in the staircase and the ramp, the variation between opaque and translucent surfaces, and between the solid forms and the striations in the window could all be said to be Cubist. The darkness of the black metal bannister rails makes for a tonal contrast between dark and light, which is very similar to the variations of tone in the planes in a Cubist painting. The visitor is led either up the spiral staircase, creating a rising circular motion, or up the ramp in a series of zig-zags, creating a dynamic experience of space and form.

The staircase and ramp lead to the first floor where all the living spaces look out onto the roof garden. Here the textures of the landscape and the clean lines of the white box are carefully juxtaposed. You do not feel that there is a flow from the inside to the outside as you do in a Wright or a Rietveld house, but they are arranged as a composition rather as they would be in a painting. The white house was made from moulded reinforced concrete, which was then plastered and whitewashed. It was a fascinating and liberating technological development because it meant that architects could

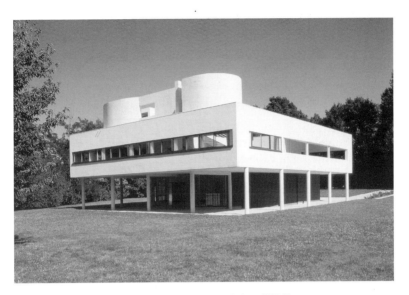

Plate 70 Le Corbusier, exterior of Villa Savoye, Poissy (1929).
© FLC/ADAGP, Paris and DACS, London 2003. Photograph: courtesy of Fondation Le Corbusier.

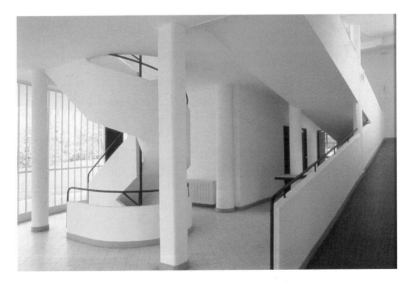

Plate 71 Le Corbusier, interior of Villa Savoye, Poissy (1929).
© FLC/ADAGP, Paris and DACS, London 2003.

design buildings in a greater variety of forms than they had been able to do before.

Colour Plate 17 *Still Life with White Pitcher on Blue Background* by Charles Jeanneret, 1919

It comes as no surprise to learn that Le Corbusier had been trained as a painter and continued with his painting throughout his life. For a short time he had been a member of the Purist movement in Paris, which included artists like Amedée Ozenfant, Fernand Léger and Juan Gris. Essentially they believed their work should express the clean, geometrical lines of machine-made products. As a painter Le Corbusier always used his given name, Charles Jeanneret. In the *Still Life with White Pitcher on a Blue Background* of 1919 (Colour Plate 17) you can see the influence of Cubism in that the space appears to be in front of the picture plane, as it does in a Cubist painting, but the tone and colour are more opaque and the edges of the objects more clearly defined.

Le Corbusier was quite clear about the relationship between architectural space and painted space:

> A painting is an association of purified, related, and architectural elements. A painting should not be a fragment, a painting is a whole. . . . Space is needed for architectural composition; space means three dimensions. Therefore we think of the painting not as a surface but as a space.
>
> (Le Corbusier, *Le Purisme*, 1921, quoted by Carol S. Eliel in Catalogue of *Purism in Paris, 1918–25*: 54)

As a painter, Le Corbusier is making an architectural composition in which the colour also plays a part, in the sense that the blue recedes and the earthy red comes forward. The white is particularly striking because it helps to locate the objects in the middle section of the picture. Le Corbusier thought that colour could be architectural too, expressing and articulating space in a building:

> If this or that wall is blue, it recedes; if it is red, it holds the plane, or brown; I can't paint it black or yellow . . . Architectural polychromy doesn't kill the walls, but it can move them back and classify them in order of importance. Here a skilful architect has wholesome and powerful resources to draw

on. Polychromy belongs to the great living architecture of all times and of tomorrow . . . colour, dispenser of space and classifier of essential things and accessory things. Colour is as powerful an instrument of architecture as the plan and the section are. Better still: colour is the very element of the plan and the section.

(Ibid: 58)

But in spite of his enthusiasm for and practice of painting, Le Corbusier believed that architecture was the foremost art, because it held in its power the salvation of society. In his influential book of 1923, *Towards a New Architecture*, he says:

It is a question of building which is at the root of the social unrest of today: architecture or revolution.

(Le Corbusier, *Towards a New Architecture*: 8)

So far we have looked at private houses designed for wealthy private clients, but it is worth remembering that Le Corbusier was interested in the idea of the overall design for living, in the sense that architecture could influence all our lives. His Unites d'Habitation in Marseilles of 1946–52 are the most famous example of this. When you first see the block, it looks like an ocean liner rising on giant *pilotis* and dominating the surrounding area.

The so-called machine aesthetic was very important to Le Corbusier and, as early as 1921, he designed his Citrohan house, which could be mass-produced in the same way as cars were in the Ford factory. It is in this context that he famously talked of a house as a machine for living in. More interesting still is the idea pinpointed by John Summerson in his book *Heavenly Mansions* where he suggests that it was through painting that Le Corbusier was able to bring his ideas together:

Le Corbusier has effected nothing less than a re-evaluation of architecture itself. He has found fragments of real architecture lying around outside the rather unreal category of which 'architecture' is the traditional label. He has found architecture in the worlds of engineering, of shipbuilding, of industrial construction, of aircraft design. What has enabled him to bring these fragments together and fuse them into buildings possessing style is his own personal vision – the vision which is his as well as Picasso's and

Braque's and Léger's – the vision of the modern school of painting.
(John Summerson, *Heavenly Mansions*: 192)

Summerson is suggesting that the new interpretation of space and form influenced architecture through painting. Certainly it would seem that, for a number of artists whom we have looked at in this chapter, painting acted as a kind of catalyst in developing new concepts of space to express a different and more dynamic visual understanding of the world; it could be argued, as Summerson suggests, that it was the spatial experiments of Cubism which were the initiators of this.

However, the story of the dynamic interpretation of space and form does not end there. What has happened more recently? Undoubtedly, Modernist views continued, but new attitudes were also coming to the fore as a result of the aesthetics of Postmodernism. If you were looking at the art of the period immediately after the Second World War you could say that in some respects it carried on as before because a number of the established figures from early in the century were still working, Braque and Matisse for instance. First of all we need to explore some interpretations of space and form in the immediate post-war period.

Colour plate 18 *Zulma* by Henri Matisse, 1950

This extraordinary picture is made almost entirely of cut and pasted paper like a *papier collé*. But the primary and complementary colours are the means by which space and form are expressed dynamically. The central section of the figure is gold with a rich ultramarine blue round the outside. The artist has drawn in the lower part of the body to show where the pelvis and the inside edges of the legs are. Further up the breasts are shown by revealing their edges through the ochre underneath. The gold section in the centre moves forward and the blue goes back, allowing us to see the figure as three-dimensional. This effect is enhanced by the patch of yellow on the right-hand side, which appears to come forward, and the green on the left-hand side, which appears to recede. The pink and brown areas on either side seem to exist on a diagonal with the table on the right further back than the table on the left.

The colours are making an active space and form that interacts with the surface of the picture, allowing us to experience the figure as flat and three-dimensional at the same time. The brown and gold

sections at the bottom of the picture are very important from that point of view. Matisse had experimented with this kind of interpretation of space and form as far back as 1905 in the *Portrait with a Green Stripe* (see *Learning to Look at Paintings*, pp. 69–70) and here he is in 1950 going to even more daring lengths to do it with flat sheets of coloured paper. The consistency of both Braque and Matisse is remarkable and shows that Modernism and its preoccupations were still active in the post-war period as they were in architecture too.

TRANSPARENT SPACE

Plate 72 The Farnsworth House by Ludwig Mies van der Rohe, 1945–50

Plate 73 The Chicago Federal Center by Ludwig Mies van der Rohe, 1959–73

Translucency and transparency were the hallmarks of the designs of Mies van der Rohe, a contemporary of Le Corbusier. Like the Villa Savoye, the Farnsworth House is a box raised off the ground – on a steel frame instead of *pilotis* – but it is literally made out of glass. Instead of appearing as a piece of solid sculpture in the landscape like the Villa Savoye, this house can be seen through from one side to the other. It almost disappears in the landscape, not by making the structure resemble rock striations as Wright would have done, but by making it transparent.

The idea of being able to see through a building from one side to the other was most obviously used in Mies' office blocks; the Chicago Federal Center is an example of where the skyscraper construction is made visible through the use of glass curtain walling rather than opaque cladding. Mies himself had been clear since the 1920s about the importance of using glass:

We can see the new structural principles most clearly when we use glass in place of the outer walls, which is feasible today since in a skeleton building these outer walls do not actually carry weight. The use of glass imposes new solutions. . . .

I discovered by working with actual glass models that the important thing is the play of reflections, and not the effect of light and shadow as in ordinary buildings.

Banham, *Theory and Design in the First Machine Age:* 268)

Mies was famously associated in the 1920s with Walter Gropius and the Bauhaus. Gropius had designed glass curtain walls before the First World War in the Fagus Shoe Factory building of 1911–13. Mies became director of the Bauhaus in the 1930s until it was closed down by the Nazis; he came to Chicago in 1938 and stayed till his death in 1969 in the place that had seen the birth of skyscraper construction at the end of the nineteenth century.

In the Chicago Federal Center, Mies shows clearly that he realized that if you run I-beams from floor to ceiling in a high-rise building you would create integral decoration as well as the effect of soaring. The office blocks in the Federal Center are like tall slim cubes. The support for their structure comes from the lift shaft, which is made of massive amounts of poured concrete and has all the services contained in its tower; then the skeletal glass and steel structure springs out from that. You do not need any load-bearing walls at ground level, creating a see-through effect at the base of the building.

The effect of this method of construction is that the light penetrates from one side of the building to the other at eye level; as there are several buildings including the single-storey post office in the square, the reflections and views from one to the other create the effect of continuous space – what came to be known as universal space. The outside interacts with the inside and vice versa, creating its own visual variety in refractions and reflections that seem to be endless, like a series of moving and interpenetrating rectangles.

The proportions and the detailing are crucial here as they always are with Mies's designs. He may have said 'less is more' but his attention to detail is outstanding. The vertical lines in the building match and are taken up in the joins in the pavement outside and also exactly match up with the floor inside. This enhances the effect of precision and the interconnection between the exterior and the interior; here space is almost turned inside out. There is no surface decoration and the matt black carbon paint on the outside of the I-beams adds to the sense of vertical streamlining. The visual vocabulary, and in particular the simplified cube, is derived from the ideas of the early twentieth century which were also explored by Frank Lloyd Wright and Le Corbusier at whom we looked earlier.

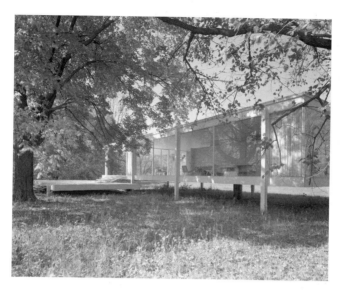

Plate 72 Ludwig Mies van der Rohe, Farnsworth House (1945–50).
Photographer: Hedrich Blessing. Courtesy of the Chicago Historical Society.

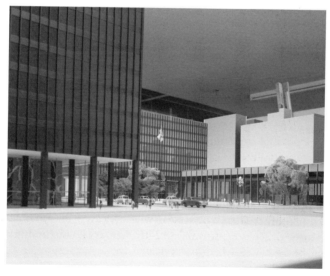

Plate 73 Ludwig Mies van der Rohe, Model of the Chicago Federal Center (n.d.).
Photographer: Hedrich Blessing. Courtesy of the Chicago Historical Society.

Plate 74 *One*, Number 31 by Jackson Pollock, 1950

This picture is about the expression of form and space in a dynamic way; it is also about taking the painting process to extremes both in the sense that it is completely abstract and in its method of execution. We know from Hans Namuth's film of Pollock at work that he painted his pictures with the canvas on the ground, walking backwards and forwards while dripping the different colours and tones out of cans and layering them one on top of the other to create a dense jungle of lines. The effect Pollock created is remarkable because, as you look at the picture, the painted surface seems to come forward and surround you. This is partly of course to do with the size of the picture – nearly 9 ft high and over 17 ft wide (269.5 × 530.8) – so you cannot see the edges clearly. You literally 'get lost' in the painted surface and become part of the picture; this is what the artist himself meant when he talked about being 'in my painting'. His wife Lee Krastner, who was also a painter, described her husband's approach to his work:

> I would always be astonished by the amount of work that he had accomplished. In discussing the paintings, he would ask 'Does it work?' Or in looking at mine, he would comment 'It works' or 'It doesn't work'. He may have been the first artist to have used the word 'work' in that sense. There was no heat in his studio either, but he would manage in winter if he wanted to; but he would get dressed up in an outfit the like of which you've never seen.
>
> (Friedman, *Jackson Pollock, Energy Made Visible*: 87)

In a way, the whole process became part of making the picture. Pollock used a combination of oil, enamel and aluminium paint, and the colours and tones create recession and depth which makes them strangely three-dimensional. For this reason the spatial experience is sometimes referred to as environmental because it involves total immersion on the part of the spectator.

One, Number 31 is concerned with the kind of dynamic space and form we saw in Cubism and Futurism at the beginning of this book, but taken further. Pollock had looked carefully at Cubism and was fascinated by the idea of making the space and form move into the area between the spectator and the picture plane. He was also interested in Surrealism and its search for meaning through the unconscious and the world of dreams; he had experienced

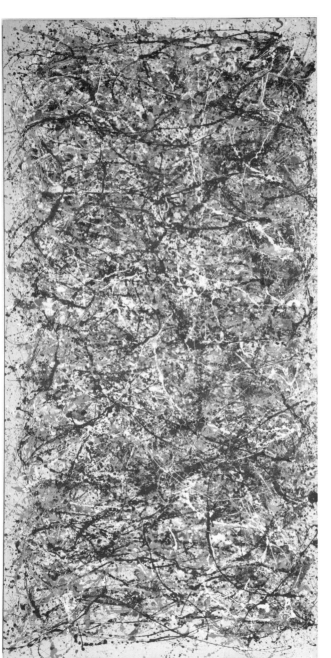

Plate 74 Jackson Pollock, *One, Number 31* (1950). Oil and enamel on unprimed canvas, 8 ft 10 ins × 17 ft 5⅝ ins (269.5 × 530.8 cm). Sidney and Harriet Janis Collection Fund (by exchange). © ARS, New York and DACS, London 2003. Courtesy of The Museum of Modern Art, New York. Digital image © 2003 The Museum of Modern Art, New York/Scala, Florence.

psychoanalysis and the techniques of free association at first hand. Pollock's painting was influenced by the Indian sand painters whom he studied for their ritual methods of working; he had seen a demonstration at an exhibition of Indian art in New York in 1941. He also saw the great exhibitions of Cubism and Surrealism at the Museum of Modern Art, New York, in 1936.

Pollock's work encompasses both the extremes of Modernism in its abstract qualities and the search for meaning in its desire to communicate unconscious feelings. On one level his dynamic interpretation of space and form connects back to the early twentieth century, but the free-flowing method of work, particularly in terms of its performance on film, opened up possibilities for the future.

In the 1950s Pollock was championed along with other abstract artists by one of the most famous critics of the twentieth century, Clement Greenberg, whom we came across in the introduction to this book. He believed that abstract art represented a benchmark of aesthetic quality. In an essay entitled 'Abstract, representational and so forth', originally published in 1954, Greenberg wrote this:

> Art is a matter strictly of experience, not of principles, and what counts first and last in art is quality; all other things are secondary. No-one has yet been able to demonstrate that the representational as such either adds or takes away from the merit of a picture or statue. The presence or absence of a recognizable image has no more to do with value in painting or sculpture than the presence or absence of a libretto has to do with value in music. Taken by itself, no single one of its parts or aspects decides the quality of a work of art as a whole. In painting and sculpture this holds just as true for the aspect of representation as it does for those of scale, colour, paint quality, design etc. etc.
>
> (Clement Greenberg, in Chipp (ed.),
> *Theories of Modern Art*: 577)

In putting forward the view that abstract art was the be-all and end-all of Modernism and modern art, Greenberg was supporting the views of Alfred H. Barr, Curator of the Museum of Modern Art, New York. Barr had produced a flow chart showing the relentless development of the twentieth century towards abstraction. There was bound to be a challenge to this view and it started in the 1960s, eventually leading to the more pluralistic character of Postmodernism.

POSTMODERN SPACE AND FORM

The use of the term 'postmodern' is very imprecise, and much less definable than Modernism, but it refers to the shift in sensibility of the 1960s. We have already seen it in other chapters in connection with Conceptual Art and the influence of Duchamp, and in Chapter 5 on composition. At the simplest level it marks the move away from the idea of art as any kind of commodity – for instance into Performance Art, Pop Art and Minimalism, which we have looked at. We have also seen that it can be connected with a reconsideration of the past, particularly the classical tradition.

Many of these changes belong with what is sometimes referred to as the Legacy of 1968, the questioning of the structure of society, the desire for greater freedom in all areas and the rejection of traditional standards of judgement, not only in relation to art; in other words saying goodbye to much that is familiar in the Western cultural tradition and asking some fundamental questions about where we go from here. In his very interesting and lucid book *Art of the Post-Modern Era*, Irving Sandler has this to say at the end of his chapter on the Legacy of 1968:

> The confrontation of critics on the right and the left over the artistic legacy of the Vietnam War, the student uprisings of 1968, the counter culture and Watergate were still unresolved in the 1990s. Questions remained. Was the art, no matter how perverse, established by the art world consensus, the true expression of how it really felt to be alive at that time? Or was it a nihilistic assault on more than twenty five centuries of Western civilization in the name of marginalized 'others' – women, gays, people of colour, and other minorities? If one valued Western civilization, were the barbarians at the gate? Or had the world, succumbing to rampant tribalism and nationalism, ethnic cleansing, population explosion, and ecological devastation, degenerated into barbarism?
>
> (Irving Sandler, *Art of the Post-Modern Era*: 368)

The questions about which direction art might be going in remain and the debate continues. But however important the theories may be, there is undoubtedly some very interesting practice going on at the same time. It seems to me that it is in new interpretations of space and form that some of the most potent postmodern work has been and is being done.

Plate 75 *Vietnam* by Michelangelo Pistoletto, 1965

Michelangelo Pistoletto invites the spectator to look at him- or herself in a reflected space. This is achieved by painting figures on tissue paper and sticking the picture onto highly polished stainless steel. The figures here are carrying a Vietnam banner so the picture is obviously about the protests connected with the Vietnam war although it is not clear whether they are for or against the war. As you look at it you see the reflected floor of the gallery receding towards a group of figures in the background who are the spectators looking at the protestors from behind. If we were really standing in front of this picture we would see ourselves reflected there looking on as the young people walk by.

There is a political message here of course, but there is also an ambiguous spatial message too. You stand there apparently confronting the protestors, but your reflection is behind them. The effect is curiously disorientating like the illusionism in a baroque ceiling decoration or Velázquez' painting of *Las Meninas*. In both the artist does away with the picture plane and makes you feel as though you are entering the picture. But Pistoletto does not do this to make you look at space in a new way as a modernist artist would have done, but to make you think. Pistoletto was quite clear about the need for art to confront issues connected with the past and the present, hence his allusion to the Vietnam war here. In 1962 he wrote:

> Born in 1933, I live in the heart of this century, in this gigantic century . . . at ten years of age I find myself in the middle of the 'World War', the last 'Great War', terribly great, great as terror. The mountains are mountains of death, the factories are factories of death, the chimneys smoke bodies, the chimneys smoke cannons. Oceanic rows of boys dressed in black on their way, rows of the wretched in tatters, the hungry and the dying coming back.
> My problem is therefore great.
> What is God: Great problem.
> What is Art: An equally great problem.
> . . .
> My problem is so great that I look at myself in the mirror and search within myself, in my image, for the answer, the solution, in my own image. And I work on the mirror.
> (Catalogue of *Italian Art in the Twentieth Century*: 366)

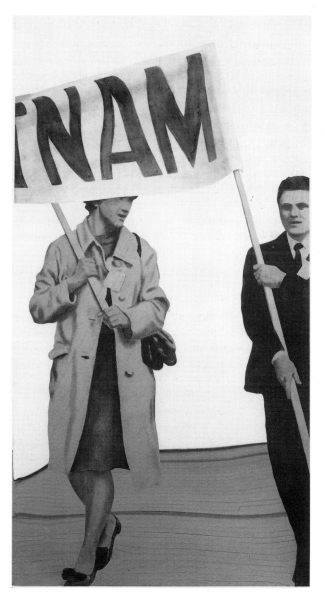

Plate 75 Michelangelo Pistoletto, *Vietnam* (1965). Graphite and oil on cut transparent paper mounted on polished stainless steel, 220 × 120 × 2.2 cm.

Courtesy of the artist. Photograph: George Hixson, Houston. Courtesy of the Menil Collection, Houston.

Pistoletto is suggesting that we can no longer move forward as the modernists have done because we must confront the past, we must start asking questions. He belonged to an Italian movement called Arte Povera which began about 1962, part of the move to a more conceptual approach to art (see Chapter 3). While there is a concern with space in Pistoletto's work it is more what one might call thinking space, space that requires a meaning and a context.

Plate 76 *Running Fence, Sonoma and Marin Counties, California* by Christo and Jeanne-Claude, 1972–6

We have already looked at Jackson Pollock's paintings in the context of environmental space, but another example of this would be two works that are not painted at all. Like Walter de Maria's *Lightning-Field* in the Chapter 5, Christo and Jeanne-Claude use the real world but their projects are not permanent.

Christo and Jeanne-Claude have made a point of deliberately altering the landscape or the cityscape by wrapping up buildings or making fences across the countryside. One of the most famous examples of this is the way they created the *Running Fence* in California. By taking thousands of metres of material and carrying it across the landscape in the form of a fence, they hoped to underline its configuration and the way we see the space. Certainly it makes you look at the area differently and you see the rolling hills and valleys because the 2,150,000 square feet (200,000 sq. m) of white nylon suspended from 2,050 metal posts stands out against the undulations in a much more noticeable way. It is about making you think about the landscape and the environment, so it is more visible.

It is not painted or sculpted in the traditional way, as so much of the art of this period was not; it is about aesthetic appreciation of the real world, a new version of landscape art in which the organization of the project is the technique. In his book *Art of the Post-Modern Era*, Irving Sandler describes *Running Fence*, saying that their craftsmanship is not based on traditional skills, but instead their colours are the farmers, the politicians, the variety of government agencies, the people who own the land. [We] need to mix these colours to get the chemistry right. If [we] fail, [we'll] never realize our project.

. . . They declared that all efforts pro and con enriched their work.
(Irving Sandler, *Art of the Post-Modern Era*: 168)

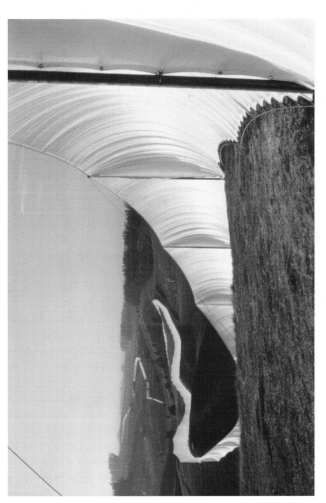

Plate 76 Christo and Jeanne-Claude, *Running Fence, Sonoma and Marin Counties, California* (1972–6). Nylon fabric (200,000 sq. m), steel poles and steel cables, 18 ft high, 24½ miles long.

Photograph: Jeanne-Claude. © Christo 1976.

Christo and Jeanne-Claude raise the money for their projects by selling their early works of the 1950s and 1960s, and preparatory drawings, but they do not receive any money from photographs, postcards, posters, books or films; it is similar to a happening in the sense that the work does not continue to exist afterwards and therefore cannot become a commodity like an easel painting.

Plate 77 *Ghost* by Rachel Whiteread, 1990

Plates 78 and 79 *House* by Rachel Whiteread, 1992–4

All Rachel Whiteread's sculptures are casts of spaces; so they are all ambiguous in the sense that where the space would normally be has become solid. When you look at this photograph of *Ghost* you think at first you are looking at a doorway in a recess. Then you see that what would normally be on the inside of the wall is now on the outside. The sculpture is of a room turned inside out: it is a solid form of the space you would normally occupy in your living room, because that is what its subject is. Rather than experiencing the space as you would in a sculpture by Gabo, like the ones we looked at earlier, you are being asked to think about the idea of the rooms we inhabit and their associations.

This sculpture is cast in plaster and built out of a series of blocks on a steel frame, so although it looks solid, it is in fact hollow – and lighter and more fragile than it appears. So this space is ambiguous and thought-provoking, making us consider where we live, the memories of what has happened there, almost like a memorial. It even looks like a tomb, and the artist herself says she has always thought about death; the title of this piece invokes those kinds of associations. So, *Ghost* is about space, but it is also about absence and a kind of poetic, fugitive presence. You can clearly see the influence here of the kind of conceptual art we looked at in Chapter 3, one where the questions asked are as important as the answers.

Whiteread has described her interpretation of space as invented space. In a recent interview she said:

> As an undergraduate, I studied painting, though I wasn't very disciplined about the edges of the canvas – everything always ended up as three-dimensional drawings, drawings you could walk

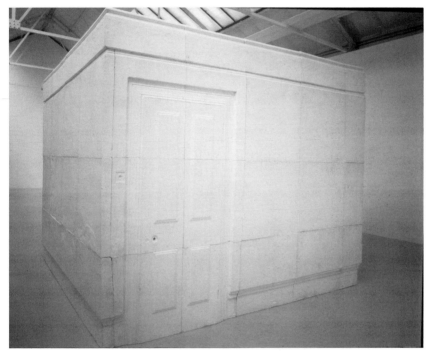

Plate 77 Rachel Whiteread, *Ghost* (1990). Plaster on steel frame, 269 × 355.5 × 317.5 cm.

Courtesy of the artist. Photograph: courtesy of Gagosian Gallery, London.

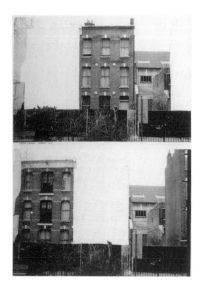

Plate 78 Rachel Whiteread, Study for House (1992–3). Correction fluid on laser copy, 60 × 42 cm (two sheets).
Courtesy of the artist.

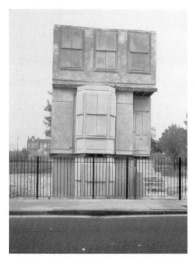

Plate 79 Rachel Whiteread, House ('Untitled', 1993; destroyed Nov. 1994), Grove Road, Bow, London.
Courtesy of the artist. Photograph: courtesy of Gagosian Gallery, London.

through and around. In retrospect I think I was dealing with, even then, what I understood to be invented space.

(Interview with Lisa Corrin, March 2001, in Catalogue of *Rachel Whiteread:* 19)

This means that we are being asked to look at space as a psychological experience as much as a visual one. This applies even more to Whiteread's most famous work, *House* of 1993-4, where she cast a whole house in the East End of London. The house was due to be demolished and she left the plaster cast of its interior spaces in the exact place where it had originally stood.

Also very interesting are the studies Whiteread did of photographs of houses in the East End, using correction fluid on laser copies. The feeling of absence and of empty spaces next to the buildings is very powerful. The translucence of the correction fluid means you can just make out the façade underneath as if it were a ghost, or a lost image appearing beneath the surface. The artist has described these as architectural drawings:

I have drawings that were done before *House* was realised that are very architectural. I began doing them in 1991.

(Ibid: 25)

For everyone who saw *House*, it was an uncanny experience because it was both there and not there, present and absent; what we were looking at was the house turned inside out, facing us with the memory of the living which had gone on inside. It was a poignant memorial to the past lives of Londoners and a witness to inevitable change. Then, after a lot a of protests, the piece was destroyed as originally intended, another example of a work of art that could not be commodified.

FREE-FLOWING SPACE AND FORM

Plates 80–83 The Guggenheim Museum, Bilbao, by Frank O. Gehry, 1997

This is an extraordinary and exciting building, which appears to defy convention in every way – design, geometry, construction and materials. When you first approach it from the narrow viewpoint of a nineteenth-century street (Plate 80) you see at the end a series of

silvery three-dimensional shapes rising to fill the space, with Jeff Koons' flowery sculpture called *Puppy* in front. As you walk towards the building it becomes more and more extensive although when you first see it you might not think it was a building at all, but a huge piece of sculpture. A series of curved and flowing metal shapes at different angles to one another reflect the light off their shiny surfaces. At first you cannot discern an entrance or any windows, but the three-dimensional effect is almost overwhelming. As you look at it more closely you can see that the titanium surface is made from rectangles that look like fine patchwork. It is their setting in different planes that gives the building its varied sheen.

By the side and on the approaches are extensive areas of fine limestone paving. The straight sections of the building itself are made of the same stone, creating a unity between walls and ground. You realize as you get nearer that the museum is sited beside a river; and when you walk round to the other side you can see the water flowing past and a shallow pool at the base of the building that captures its fantastic shapes as reflections (Plate 81). The water is the same colour as the glazing, which now becomes visible in various places. From the riverside you can see that the titanium-covered curves extend towards and under an existing tall bridge and a road system. The end of the building emerges on the other side of the bridge like an enormous fish's tail or the stern of a ship. Both these analogies are appropriate, as it turns out, because Gehry has been inspired by the form of the fish for many years. The site was previously used for shipbuilding and Bilbao was a great industrial port where the ships came up and moored on the Nerviòn river, although now they are too big for it.

Your experience of this end of the building is greatly enhanced by the steps that lead up to the bridge, changing from stone to industrial metal as they do so. As you go under the bridge, you hear the cars going over and this noise reminds you even more effectively of the industrial past. From the platform right at the end you can see the configuration of titanium shapes more clearly; and from a different perspective the titanium reflects the light in a similar way to a fish's scales and the shapes of the huge forms curving along the river make the building look like a swimming fish or a moving ship. As there are virtually no straight lines in the structure you find yourself experiencing a swaying sensation as if you were on board ship and you feel the need to hold the hand rails.

As you come down the stairs again, you realize that the edges are

made to curve and get wider towards the bottom; the vertical divisions between the stones are staggered, even though the horizontal courses are straight; the same applies to the upright edges of the titanium sheets. The outside of the terrace is also curved along the edge of the tension pool and supported by the shallow curve of an arch underneath; even the stone pillar that supports what seems to be a porch or canopy does not appear to be quite straight, and neither do the metal glazing bars of the window behind.

This *faux* porch sits on a balcony whose sides are not at right angles but slanting slightly towards the building. But this is not the entrance: to enter the building you need to go back to the other side and then what appears to be the door to the museum takes you only to the restaurant. To get inside, you descend another staircase to below ground level; first you go through the ticket area and then move towards the gigantic atrium (Plate 82), which opens out and stretches 164 ft (50 m) from floor to ceiling. This dramatic space is lit by a series of skylights and windows that are irregular in size, shape and position, so the light seems to cascade through from all directions. Your eye travels upwards in a series of curves in an irregular spiral.

At first you wonder how you are going to get to the upper floors, as the main stairs and the lift are sheathed in glass divided into overlapping plates, which catch the light and look like fish scales. They also create movement because the overall shapes are curved like a fish's body and they do not come down to a horizontal edge at the bottom. The association with the fish in Gehry's work is important as we have seen on the exterior. Inside, it is more obvious that he has tried to use it as a metaphor for the free-flowing movement of space and of reflective surfaces. Gehry has said this about it:

> I was looking for movement earlier and found it in the fish. The fish solidified my understanding of how to make architecture move.
>
> (Friedman, ed., *Gehry Talks*: 44)

One is also reminded of the movement in Duchamp's painting of the *Nude Descending a Staircase* (Plate 27) or Tatlin's famous tower (see Plate 64). Indeed, the references to movement are close to the ideas of Futurism too and its links with the Italian baroque, which we explored in Chapter 2. Comparisons have been made with the sculptures of Boccioni although Gehry himself denies this; but he would

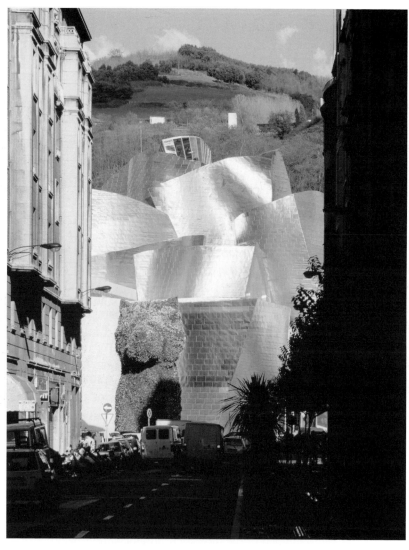

Plate 80 Frank O. Gehry, exterior of Guggenheim Museum, Bilbao (1997).
Photograph: David Heald, © Solomon Guggenheim Foundation, New York.

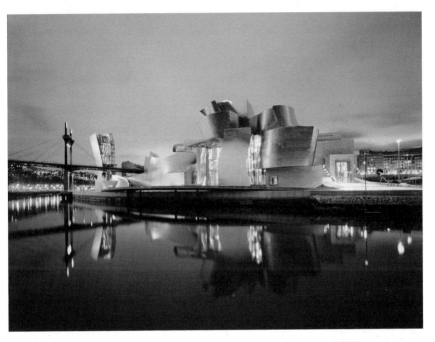

Plate 81 Frank O. Gehry, exterior of Guggenheim Museum, Bilbao (1997).
Photograph: David Heald, © Solomon Guggenheim Foundation, New York.

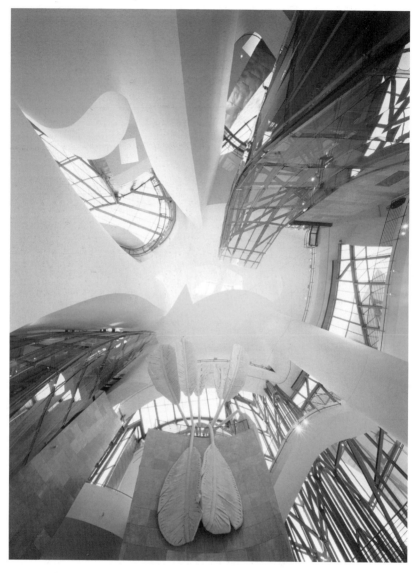

Plate 82 Frank O. Gehry, interior of Guggenheim Museum, Bilbao (1997).
Photograph: David Heald, © Solomon Guggenheim Foundation, New York.

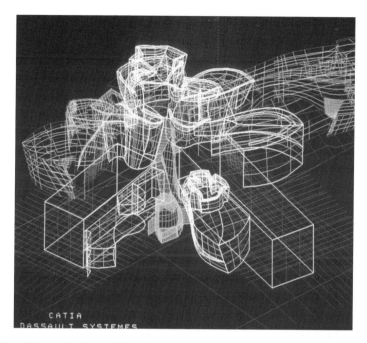

Plate 83 Frank O. Gehry, CATIA model for Guggenheim Museum, Bilbao (1994).
Courtesy of Gehry Partners, LLP.

be the first to admit that he has been inspired by fine art, that some of his best friends are artists and that he sees no separation between architecture, painting and sculpture:

> My artist friends like Jasper Johns, Bob Rauschenberg, Ed Keinholz and Claes Oldenburg were working with very inexpensive materials – broken wood and paper – and they were making beauty.
> . . . Painting had an immediacy that I craved for in architecture. I explored the process of new construction materials to try giving feeling and spirit to form. In trying to find the essence of my own expression, I fantasized that I was an artist standing before a white canvas deciding what the first move should be.
>
> (Guggenheim, Bilbao, a special edition
> of *Connaissance des Arts*: 31)

The search for new materials, referred to here, materials expressive of the kind of free-flowing movement and surface Gehry wants, is very important. The titanium on the outside of the museum had to be treated in a specific way:

> The titanium is thinner than stainless steel would have been; it is a third of a millimetre thick and it is pillowy, it doesn't lie flat and a strong wind makes its surface flutter. These are all characteristics we ended up exploiting in the use of the material on the building. It's ironic that the stability given by stone is false, because stone deteriorates in the pollution of our cities whereas a third of a millimetre of titanium is a hundred-year guarantee against city pollution. We have to rethink what represents stability.
> (*Handbook of the Guggenheim Museum, Bilbao*, 2000: 141)

The construction of this extraordinary building was made possible by a computer program called CATIA which is used in aircraft design. This enables a three-dimensional diagrammic plan (Plate 83) to be made, which will give accurate measurements for the complex joints and angles. Gehry's drawings are free-flowing:

> A fervent ice hockey player, he likens drawing to skating across paper and loves the feeling of the felt pen sliding over it: 'Everything connected with everything else seems freer, not taking your hands off. I love the free flow.'
> (Ibid: 37)

At first Gehry's drawings look like expressive doodles, but they can be translated into a computerized image by technicians in order to make the design realizable. Neither the materials nor the methods employed are conventional in this museum and neither is the layout of the galleries. On the ground floor they radiate concentrically from the atrium; they are designed to hold large works like Richard Serra's *Snake* or Jenny Holzer's installation of neon signs; on the first and second floors some of the spaces are simple rectangles top-lit by daylight in order to house sections of the modernist and early twentieth-century holdings from the Guggenheim collection. But of course the function of this building is more than just an art gallery: it has become a symbol for the regeneration of the city of Bilbao. People have been flocking to see Gehry's creation and so bringing wealth and vitality back into the capital city of the ancient Basque country.

DECONSTRUCTION

Like the Russian Constructivists with whom we began this chapter, Gehry sees architecture, painting and sculpture as united. But in a more general and wider sense, Gehry belongs to the aesthetic of postmodernism in architecture, which we looked at briefly in Chapter 5, because he is interested in meaning first, and form and function second. In the Guggenheim Museum he used the metaphor of the fish as a starting point for the expression of the building and the design grew from that. But many people would also consider Gehry to be connected with a more extreme branch of Postmodernism known as Deconstruction because he does not use traditional methods of building and design. But Gehry refuses to read the writings of Jacques Derrida and his contemporaries which form the basis of this set of ideas. In the *Journal of Architectural Theory and Criticism*'s *Deconstruction: A Student Guide*, Gehry is described as pragmatic in his approach:

> There's no reason why Gehry should even try to read Derrida when he 'deconstructs' so splendidly anyway. But neither he nor his apologists can deny others the right to see parallels between what he does and committed deconstructors do Gehry clearly is a pragmatist as one sees from his many trial and error models, sketches and experiments on site.
>
> (Broadbent, *Deconstruction: A Student Guide*: 80–81)

Connecting Gehry with Deconstruction is right in the sense that his work is exciting, unpredictable and experimental in ways that would not have been possible before the late twentieth century.

Now we need to go on and look at what this theory of Deconstruction is about. In architecture it means moving right away from traditional methods of building and designing, in the way that Gehry and others have done, and it derives its justification for this from a literary theory of the same name. Deconstruction rests on what Paul Crowther calls 'one major insight': that meaning is not fixed but constantly shifting and changing according to your point of view. This theory is centred on the work of a cluster of French thinkers like Roland Barthes, Jacques Derrida and Michel Foucault. Essentially they believe that there is no such thing as the underlying truth. In the architectural guide to Deconstruction the author says that it attacks certain fundamental principles of European thought:

ETHNOCENTRISM: the belief that one's own culture or ethnic group somehow is superior to others and therefore [sets] standards by which the others can and should be judged.

LOGOCENTRISM: a belief that at the roots of all existence there are abstract 'truths' organized in absolute and inevitable 'categories'. These exist only in the Mind and Word of God but all 'real' things are formed from them. We can penetrate to them only by the use of language.

PHONOCENTRISM: the idea that speaking is better than writing since it came first and gives us direct access to the speaker's thoughts; speech is transparent in a way that writing can never be.

METAPHYSICS: the age-old search by philosophers for truth.

(Ibid: 36)

Deconstruction goes against the humanist mode of thought and the classical tradition and moves into a realm where theoretically anything is possible. It was applied first to language and literature, and moved from there to architecture. Roland Barthes would say for instance that you can look at a text from any point of view and that the author's intentions do not matter because you are able to interpret a meaning from any selected angle. In *Criticism as Language*, Barthes says:

The rules governing the language of literature are not concerned with the correspondence between that language and reality (whatever the claims made by schools of realism), but only with its being in line with the system of signs that the author has decided on. . . . It is not the business of criticism to decide whether Proust told the truth.

(Barthes, in Lodge, *Twentieth-Century Literary Criticism*: 649)

Jacques Derrida takes up the same sort of idea, suggesting in *Structure, Sign and Play* that we live in 'a world of signs without fault, without truth and without origin, which is offered to our active interpretation'. This means that a text, a building or any work of art is not fixed by cause and effect of what he calls a centre, but open to interpretation according to your viewpoint and this is more legitimate than any claim to a universal idea of truth.

This was the moment when language invaded the universal problematic, the moment when, in the absence of center or origin, everything became a discourse – provided we can agree on this word – that is to say, a system in which the central signified, the original or transcendental signified, is never absolutely present outside a system of differences. The absence of the transcendental signified extends the domain and the play of signification infinitely.

(Derrida, in Lodge (ed.),
Modern Criticism and Theory: 110)

Michel Foucault takes a similar stance on the concept of discourse in his essay, 'What is an author?' where the idea is not to try to answer questions about authenticity which 'have been rehashed for so long'.

'Who really spoke? Is it really he and not someone else? With what authenticity or originality? And what part of his deepest self did he express in his discourse?' Instead, there would be other questions, like these: 'What are the modes of existence of this discourse? Where has it been used, how can it circulate, and who can appropriate it for himself? What are the places in it where there is room for possible subjects? Who can assume these various subject functions?' And behind all these questions, we could hardly hear anything but the stirring of indifference. 'What difference does it make who is speaking?'

(Foucault, in Lodge,
Modern Criticism and Theory: 210)

A discourse then, according to Deconstruction, is not about finding a universal truth but instead it is about a field where meaning is always changing, because it is produced in a context that varies and is more likely to be determined by what Crowther calls 'relations of power organized on the basis of class, gender, race, religion and the like'. This means you can approach a subject from any of these or other angles, and organize your argument or discourse accordingly.

These ideas have been enormously influential all over the fields of arts and humanities, but the connection between them and architecture is hard to quantify. Yet it is strange that the word used to describe this literary theory of Deconstruction is a word that could be derived from the world of construction, of building and designing –

and the same is true with other theories like Structuralism and Post-Structuralism, which are beyond the scope of this brief discussion. Also, words like 'metaphor', which used to be used as a tool in English language, can now be applied more generally. Gehry's use of the fish form, for instance, can be referred to as a metaphor. In her book *Architecture after Modernism*, Diane Ghirardo says that the adoption of literary theory was intended to give new developments in architectural design some sort of academic respectability in the aftermath of Modernism in the late 1960s and early 1970s:

> It seemed that if theories drawn from other fields could be found to work in architecture, the status of architecture as an academic discipline would be enhanced. It is worth repeating that the number of architects and educators who were interested in applying new theoretical structures to architecture was extremely limited and marginal. But their presence in the larger architectural discourse was not. Through such journals as *Perspecta*, *Opposition* and the *Harvard Architectural Review*, and through an exhausting round of conferences and exhibitions, those who were investigating linguistic theories acquired a significance altogether greater than the import of their architectural production.
>
> (Ghirardo, *Architecture after Modernism*: 34)

Whichever way you look at it, the fact remains that the theory of Deconstruction has been very important to artists and architects in particular for many reasons, not least because it turns a number of traditional assumptions upside down. Certainly Gehry would come into that category, because of his radical experimentation, and so would Daniel Libeskind whose Jewish Museum we looked at in Chapter 4. The reason for this is that both Libeskind and Gehry are interested in metaphor and meaning as part of the construction of their buildings, rather than as simply linking form and function. The geometry and methodology is radical, just as the work of the theoreticians is too.

As we have seen in other sections of this book, there was a move away from the abstract geometrical basis of Modernism to a set of ideas that were more plural and less ideological, and which laid more stress on meaning and the spectator's participation. It is interesting that Barthes, Derrida and Foucault came to the fore in the 1960s, as did Beuys, Conceptual Art, Minimalism, Arte Povera and Pop Art. All these movements laid stress on meaning and context, and the

spectator's active participation. It may seem that we have come a long way from the concept of dynamic space and form with which we started this chapter but, though the emphasis has changed with the culture of Postmodernism, all the artists we have considered would agree, I hope, that the spectator's experience of space and form in their works is dynamic and/or conceptual rather than static.

Light and Colour

IMPRESSIONISM

The fascination with painting light in terms of colour is largely a nineteenth-century phenomenon seen at its best in the work of artists like Turner and the impressionists. Turner was greatly helped in this not only by his understanding of science but also by his knowledge and technical expertise with watercolour. His great watercolours of the 1840s – those of Venice for instance – show just how skilful he was at using the white paper in the background to create the light and allow the form of buildings to loom forward in an astonishingly three-dimensional way and appear to float on the surface of the water.

The greater understanding of colour theory among nineteenth-century painters is important in the development of Impressionism and the painting of light. The idea that it was possible to paint light came about famously with the discoveries about the spectrum, which makes up white light (see *Learning to Look at Paintings*, Chapter 5). Colour then became the most important element and artists could start painting the envelope of light surrounding an object rather than its local colour. You can see this most clearly in the neo-impressionist paintings of Seurat, like the *Sunday Afternoon on the Island of the Grande Jatte* where the composition is built out of spots or dots of primary and complementary colour like atoms of matter. It now seems that, although scientific colour theory was important, much of this new understanding came from the theories of colour photography which were published at about the time that Impressionism was developing. As early as 1869 the photographers Cros and Ducos de Hauron brought out their book in which the idea of recording light in terms of colour was propounded also the view that painting landscape is more about the painting of a field of vision. In the catalogue

to the exhibition *Impression: Painting Quickly in France*, Richard Brettell explained this:

> Both men referred to nature in terms of what Cros called *Le Champ de Vision* (the field of vision). This field was filled with points of light that could be read by the eye, or according to their new processes, by colour sensitive gels in transparent layers, the combination of which could produce a fully and accurately coloured photograph. Colour was divisible into components, there were primary and secondary colours, and the juxtaposition or superimposition of points of those colours could produce a flat facsimile of reality. Black and white, not being natural colours, were eliminated from their photographic palettes, at precisely the same moment that the painters achieved the identical conceptual breakthrough. They also eschewed line and never discussed the illusion of depth or shadow, referring only to colour sensations. Their photographs were much discussed in scientific circles. The earliest prints by Ducos du Hauron that survive (from the later 1870s) have a pale and compositionally conventional quality, suggesting that it was not the photographs themselves but the theory behind their creation that could be linked with early theorizing about the Impression.
>
> (R. Brettell in Catalogue of *Impression: Painting Quickly in France, 1860–90*: 60)

Colour Plate 19 *Boating on the Seine* by Pierre Auguste Renoir, c.1879–80

This picture by Renoir of *Boating on the Seine* shows a clear use of the primary and complementary colours of blue and orange, yellow and violet, and red and green in various parts of the picture. It shows the effects of light through the use of a higher colour key, which means brighter and stronger colours than you would see. He is paying more attention to that field of vision or the envelope of light surrounding the figures than to their local colour.

But in the twentieth century, artists wanted to take these experiments further in an attempt to paint the light in a more dynamic way, to show the interaction between light and colour and so make them more active and expressive elements in the picture. We shall see this in the work of late Monet, Bonnard and the Delaunays. More recently there have been moves to work with real light in the form of fluorescent tubes or electric light generally.

In the work of Dan Flavin and James Turrell, the aim is to express the intrinsic qualities of light itself. Dan Flavin works with coloured fluorescent tubes and builds them into forms like pieces of constructed sculpture. He was influenced by the work of Vladimir Tatlin and the Russian Constructivists who made form out of space. Flavin makes form out of light and retains the architectural aspects of the Russian work which we explored in Chapter 6. James Turrell talks about 'making light visible' to the onlooker; he makes installations that encourage us to really experience and feel the light itself. Both these artists are orchestrators rather than traditional craftsmen in the way we saw with Robert Morris and his minimalist contemporaries in Chapter 5.

This is typical of the Postmodernist stance: the work of Flavin and Turrell is not about easel painting or sculpture in the usual sense, but about working with ready-made materials and turning them into installations or three-dimensional designs. We shall see that both are in their different ways conceptual artists. Flavin leans more towards Minimalism perhaps and Turrell towards Land Art.

The installations of Anish Kapoor are more solid and deal with saturated colour and shape; he expresses a need to communicate a generally spiritual dimension, often through suggestive titles like *At the Edge of the World*. We end with the work of Norman Foster at the British Museum, where the aim is to make the visitor aware of natural rather than artificial light. We shall see how he has used late twentieth-century technology to achieve this. In Chapter 6 we referred to the effect of electric light on the space in modernist interiors. In architecture in the last few years there has been a return to the use of natural light as we shall see later on in this chapter.

EXPRESSING LIGHT IN TERMS OF COLOUR

Colour plate 20 *Soleil couchant* (Setting Sun) by Claude Monet, 1918–26

These large paintings of the lily ponds in Monet's garden at Giverny are mounted on the curving walls of two oval rooms of the Orangerie in Paris. They are all about 2 m high and over 8 m wide. As you stand in the centre of these rooms you feel surrounded by the paintings. Monet was primarily a painter of light through colour and you can see that here. If you concentrate on one picture, like *Soleil couchant* in room one, you will see that there is no horizon in the picture and

there are no edges either: you cannot see where the subject begins and ends. As the canvas is curved you feel the edges coming out round you on either side and you start to feel part of it. As your eye is drawn to the saturated yellow near the centre of the picture you sense the dark greens on the right-hand side and in the front so that the yellow appears to recede and make you hover on the surface, then the complementary violet behind it pulls you into the distance.

The composition is expressing the nature of water and Monet was quite clear that the painting was not meant to be a description of the water lilies themselves:

> The water-flowers themselves are far from being the whole scene; really, they are just the accompaniment. The essence of the motif is the mirror of water, whose appearance alters at every moment, thanks to the patches of sky which are reflected in it, and which give it its light and movement. The passing cloud, the freshening breeze, the light growing dull and then bright again, so many factors, undetectable to the uninitiated eye, transform the colouring and distort the plane of water. One needs to have five or six canvasses that one is working on at the same time, and to pass from one to the next, and hastily back to the first as soon as the original, interrupted effect has returned.
>
> (John House, *Monet*: 24)

These paintings are about expressing light and reflections on the surface of the water with colour through subtle use of different brushstrokes; they are also about creating a field of vision for the spectator, one that is wider than one would normally see. But Monet's lily paintings are about more than just the translation of visual experience.

For the most part the Orangerie paintings were done in Monet's large studio at Giverny and are more like a meditation on the lily ponds than a faithful recording made at the scene. Of course Monet knew his water garden extremely well, as he had designed it and painted it and watched it mature. But it is also now clear from recent research that he was interested in symbolist art theory and was a friend of the poet Stephane Mallarmé. Monet would also have been aware of the Bergsonian ideas that we explored earlier; but they may have filtered through to him via Mallarmé rather than from reading Bergson or attending his lectures (as Pissarro and Bonnard probably did).

In the catalogue to *Monet in the '90s*, Paul Hayes-Tucker has this to say about Mallarmé and Monet:

> Mallarmé's enthusiasm for Monet's work stemmed from his own insistence on the importance of mystery and allusion. He felt that one should never fully describe things in an empirical fashion but rely instead on the powers of suggestion. . . . Like other Symbolist critics therefore, Mallarmé tended to write about the poetry of Monet's vision and the ethereal quality of his art, stressing in particular his fascination with the dematerialising effects of light.
>
> (Paul Hayes-Tucker in Catalogue of *Monet in the '90s*: 101–2)

It is as well to remember, though, that the Grandes Décorations in the Orangerie were painted long after the series paintings of the 1890s, at the very end of the artist's life. By that time, Monet had lived through the major art movements of the avant-garde in the early twentieth century and yet he continued to work on these poetic evocations of his garden at Giverny. It is said that he could hear the guns on the Western Front from his studio. He offered these large lily paintings as a memorial to those who lost their lives in the First World War and to the more general sufferings of France.

The lily paintings have since become very famous because of their influence on American Abstract Expressionist painters in the 1950s and on Jackson Pollock in particular. The emphasis on lack of focus, the size, the brushwork and the overall effect of Monet's paintings appealed to the American painters of this period:

> For us [the French] it [the discovery of Abstract Expressionism] was an extraordinary adventure: we discovered a painting triumphant with the freedom of colour and rhythm. There was a great impulse given by Pollock. The American painters, on the other hand, those who came to Paris after the war with the famous G.I. Bills, they were impressed by European culture, and they all rushed like flies to one place: the Orangerie, to look at the Nymphéas by Monet, those coloured rhythms with no beginning and no end.
>
> (R. Golan in Catalogue of *Monet in the 20th Century*: 96)

So although Monet is really a nineteenth-century artist, his work overlaps into the twentieth century and reaches into the generation after 1945. This was not just because he happened to live a long time

but because his researches into painting light led him to a free fluid handling of paint on a large scale, which appealed to the American artists of the post-Second World War period.

Colour plate 21 *White Interior* by Pierre Bonnard, 1932

The first point that strikes you about this picture is the number of different shades of white the artist has used; they move from the foreground on the left-hand side, then into the background and across to the middle distance on the far right; it is brightest in the oblong panel behind the back of the orange chair and most translucent in the door; it is dullest in the radiator and the left-hand French window; it is opaque in the fireplace and in the right-hand French window. In the tablecloth in the foreground, the white is covered with crockery and so fades more into the background where one's eye travels first of all.

The light is coming through the half-open door, as well as shining underneath it and onto the yellow wall. But there also seems to be light shining on our side of the door and coming in through the open window. So there is certainly more than one light source. It has also been suggested that perhaps the electric light was left on, which would account for the golden highlight on the door.

The most extraordinary characteristic of all is the way you do not see the figure of Bonnard's wife until long after you have seen the white light effects. Marthe is in the foreground bending down to feed the cat, which looks at us from below the orange teapot. Yellow strikes the top of Marthe's head but it is not certain where it is coming from unless it is from an electric light above the table that we cannot see.

Bonnard was interested in moments like this when, through intense observation, you could catch what Bergson would have called the sudden intuitive response, which we referred to in Chapter 2 where we noted that Bonnard had probably attended some of Bergson's lectures. But the most interesting point about this is the way Bonnard used the colour and light to make you see the picture in a certain way so that you do not notice Marthe and the cat till later. He recorded this moment in a drawing in his diary on 29 April 1929. But he also did other drawings of the small sitting room at Villa Le Bosquet. Photographs also have been taken of this room. In the photographs the contrasts between light and dark are more

obvious, whereas in the drawings the textures and the tones are more varied. In the painting the viewpoint is much wider than you would ever actually see and the extreme angle has been measured as

an extraordinary horizontal angle of view of one hundred and thirty degrees and a vertical angle of about seventy-five degrees. To get it all in we had to take three exposures with our widest-angle lens and then join them together.

(Sargy Mann in Catalogue of *Bonnard at Le Bosquet*: 31)

The point being made here is that the composition and the light effects are not as you would see them. Bonnard himself, though, was quite clear about what he was doing. In an interview in 1943, he explained that he recorded the moment of a particular light effect in his diary and then worked from that idea in his studio:

I often see interesting things around me, but for me to want to paint them they must have a particular charm – beauty, one could call it beauty. While I paint them I try not to lose control over the original idea. I am weak and if I let myself go . . . in no time at all I have lost what I first saw, I don't know where I am going. . . . For the painter the presence of the object, of the motif, gets in the way while he is painting . . . so that after working for a time the painter can no longer recapture the idea he started with and relies on incidentals. . . . He does the shadows that he sees. He tries to describe certain shadows he notices or some detail that did not strike him at first. . . . In short, there is a conflict between the original idea, the right one, the one in the painter's mind and the variable, varied world of the object, of the motif that causes the first inspiration.

(P. Bonnard, interview with Angèle Lamotte, *Verve* magazine, 1943, in Friedenthal, *Letters of Great Artists*: 244)

We can recognize what Bonnard is saying here as deriving from the symbolist art theory of the late nineteenth century, which we looked at earlier, but it has now become more than just creating an air of mystery. Bonnard wants to make the spectator see a particular light and colour effect that he noticed and then translated through a process of imaginative recall, which he carried out in the studio months or years later.

Let it be felt that the painter was there; consciously looking at the objects in their light already conceived from the beginning.

(Catalogue of *Drawings by Bonnard*: 16)

So Bonnard brings a transcendent and visionary quality to his intimate domestic subjects which derives from a moment's observation of a particular light effect.

COLOUR AND MOVEMENT

Colour plate 22 'Une Fenêtre: étude pour *Les 3 fenêtres*' ('A Window') by Robert Delaunay, 1912

The use of colour to transmit and express light is very evident here. It is as though the colours have been broken up prismatically and we are being shown the sides of a glass cube. The primary and complementary colours are all there, not so much to blend into an impression as they would in a painting by Monet, but more to reveal the clarity, contrast and translucence of the colours. The different sections of the painting are divided into facets, some more translucent and some more opaque than others. The white areas are also very important for conveying luminosity. The whole effect is to make you feel that you could move through the colours to the back of the picture as if it was an open window.

Delaunay was certainly familiar with nineteenth-century colour theory; he had read Chevreul's book on the *Principles of Harmony and Contrast of Colours*, and was familiar with the work of Seurat and his followers and the theories behind Neo-Impressionism. But the faceted angles and the multiple viewpoints give similar feelings to those experienced in front of a Cubist painting, except that you do not sense the movement out into your space as you do in Braque's *Mandola* for instance; it is really a version of Cubism done with colour. In his poem called 'The Windows', Apollinaire evokes the same kind of feeling especially in the last two lines:

The window opens like an orange
The beautiful fruit of light

(Apollinaire, *Selected Poems*: 45)

In a lecture in 1913 Apollinaire gave the name Orphism to Delaunay's work, which he related to the god Orpheus and his lyre.

We have already seen how music and painting were connected at this period and the importance of Apollinaire's ideas. By this time also, Delaunay had met Kandinsky, who was very interested in the relationship between colour and music as we saw in Chapter 4. In a letter to Kandinsky in 1912, Delaunay wrote about his attitude to colour:

> I am still waiting until I can find greater flexibility in the laws I discovered. These are based on studies in the transparency of colour, whose similarity to musical notes drove me to discover 'the movement of colour'.
> (Robert Delaunay, in Chipp (ed.), *Theories of Modern Art*: 318)

When Delaunay went to visit Kandinsky in Murnau in Bavaria, he met his future wife, Sonia. She also did semi-abstract paintings of light, like the one called *Prisms électrique* for instance; in the title of this picture there is recognition of modernity in the reference to electricity and the prism. It has rhythm, movement and translucence in the use of the primary and complementary colours and it is dynamic in the way that one expects from painting at this period. In his essay on 'Light' of 1912, Robert Delaunay used the vocabulary that is familiar in the movements of early Modernism.

> Impressionism; it is the birth of Light in painting.
> Light comes to us by the sensibility. Without visual sensibility there is no light, no movement.
> Light in Nature creates the movement of colors.
> Movement is produced by the rapport of *odd elements*, of the contrasts of Colors between themselves which constitutes *Reality*.
> This reality is endowed with *Vastness* (we see as far as the stars), and it then becomes *Rhythmic Simultaneity*.
> Simultaneity in light is *harmony, the rhythm of colors* which creates the *Vision of Man*. Human vision is endowed with the greatest *Reality*, since it comes to us directly from the contemplation of the Universe. The *eye* is the most refined of our senses, the one which communicates most directly with our mind, our consciousness.
> The idea of the vital movement of the *world* and *its movement is simultaneity*.
> (Robert Delaunay, in Chipp (ed.), *Theories of Modern Art*: 319)

The use of the word 'simultaneity' here had a special meaning for

Delaunay: it refers to the idea of everything invading everything else, as the Futurists advocated and as we saw in Boccioni's painting of *Matter* in Chapter 2. Delaunay is expressing the ideas of rhythm, of simultaneity, of modernity and of a kind of cosmic mysticism, which we have come across in other chapters, particularly in Futurism, Vorticism and Suprematism; even the typography is set out in a particular way. But in Delaunay's case it is light that is of primary importance and in particular the idea of expressing it through colour. He would have agreed with what Apollinaire said in his book *The Cubist Painters*:

I love the art of today because I love light above all things. All men love light above all else; they invented fire.

(Apollinaire, *The Cubist Painters*: 41)

PAINTING ARCHITECTURE

Plate 84 *Renishaw, the North Front* by John Piper, c.1942–5

Renishaw is an example of the use of what is loosely termed theatrical lighting, because it can come from any direction to create the atmosphere required by the artist, rather than being a study of the light as it was at a certain time of day. The building is partly lit from behind so that the pinnacles and castellations stand silhouetted against the sky. White light shines onto the left-hand side of the façade and violet, orange, yellow and warm reds and ochres spread over the rest of the façade. The architectural features of the building are drawn into the colours to emphasize their topographical character as they would have been in a more traditional architectural drawing. The colours are used to show up the forms of the windows and to contrast with the darkness of the battlements above.

As a result of this use of light and colour, the house seems to lose its solidity and appears to resemble the backdrop of a set design. John Piper had worked for the theatre intermittently and later did so in a more concentrated way after the Second World War. He had been a member of the avant-garde in England in the 1930s and for a time he had turned to abstract painting. He had experimented with collage in the 1920s, and in many paintings of the war years – like *Christ Church Newgate Street* of 1941 – you can see the influence of that phase of his work. The simplified patches of colour and texture and the way they

are arranged in layers close to the picture plane remind us of collage even though there are often no found objects or glued paper.

But Piper's pictures are closely tied to the traditions of English landscape and topographical painting as well. In 1938 when war was imminent, Piper had returned to the subject. When writing about this phase of his life, he says:

> By 1938 the looming war made the clear but closed world of abstract art untenable for me. It made the whole pattern and structure of thousands of English sites more precious as they became more likely to disappear. Anyway, what I had learned was now part of me, and an integral and prominent part at that. The abstract practice taught me a lot that I would not have learned without it, and all the time I had hold, through the collages, of a lifeline to natural appearances – and so to early Palmer, to Turner, early and late (topographical and less purely topographical) and to our whole Romantic tradition in which it has always been possible

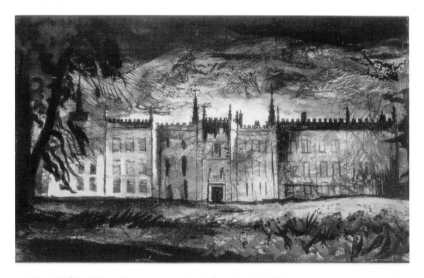

Plate 84 John Piper, *Renishaw, the North Front* (*c.*1942–5). Ink and watercolour, 18 × 30 cm.

Courtesy of The Piper Estate. Photograph: courtesy of Sir Reresby Sitwell, Renishaw Hall, Derbyshire.

for meaningful details to shine like beacons in the damp misty evanescence of our beautiful island light and weather.

(R. Ingrams and J. Piper, *Piper's Places*: 22)

Piper is suggesting here that it is possible to emphasize certain elements in a landscape or an architectural subject in order to create a special atmosphere. Certainly in the painting of Renishaw Hall, Piper wanted to convey more than just the character of the building. In the catalogue to one of his exhibitions entitled *Derbyshire Domains*, he describes the spooky atmosphere in the fog and the feeling of the remains of the coal mining industry that lie beneath the ground; he clearly wanted to convey the feeling that the surface of the house and the site that it is standing on may not be all that it seems. In his diary on 15 November 1942, Piper wrote:

Day beginning with fog and ending with a nineteenth century sunset. Sun a fireball in the fog, and Renishaw rising from ground mist, only top storey visible. Blue trees round orange folly temple. A grey scabrous wreathing on the swimming pool and lake. (A young man here convinced it was a shiny uprising from the bottom). Stationary swans. Burnt out grass, colourless. Midland refuse tips and blackened trees at their best in the disappearing mist.

(Ibid: 102)

The idea of using architecture and landscape to create mood was a legacy of the English Romantic movement of the early nineteenth century; Turner, as we discussed at the beginning of this chapter, was a master of light used for just this purpose. Piper continues this Romantic tradition but gives it a more dramatic emphasis, as if it was artificial light and colour as used in the theatre.

THREE-DIMENSIONAL LIGHT DESIGN

Colour plate 23 *To Donna* by Dan Flavin, 1971

Instead of painting light and its effects with colour on canvas, Dan Flavin uses real light in electric fluorescent tubes; he has created an installation. Like numbers of other artists we have looked at in the postmodern era, Flavin has rejected the traditional crafts in favour of using ready-made materials. In this piece he has placed the tubes in a square across a corner. To the right and left are dark opaque verticals,

which create a frame for the light as does the triangle on the floor, with the palest areas in the horizontals. On the left, the light behind the upright seems to be blue with a firmly delineated blue band down the left-hand side. On the right, the line of light is blue with yellow softly blurred behind. The horizontals have a pinkish tinge in order to contrast with the places where the blue turns greenish . . . This light installation is made of primary and complementary colours and is reflected back onto the walls of the corner and appears to dissolve them. So this piece is all at once a sculpture, because it makes the corner into a separate three-dimensional shape, but at the same time it has an architectural quality too so you are not sure how to categorize it. One point is quite certain, that it is about light and how it affects its surroundings.

The materials Flavin uses are bland and ready-made and can be bought in any hardware store. The fluorescent tubes are in standard sizes and colours. When the work is switched off it seems no longer to be there and of course it is an installation and not an easel painting. We can recognize the qualities of Minimalism here, which we have already noticed in the work of Robert Morris and others in Chapter 5. The connection between Flavin and the Postmodernist aesthetic is clear here; Joseph Kosuth, whom we came across in Chapter 3 as one of the architects of Conceptual Art, collects Flavin's work and is quite articulate about why it relates to Minimalism and Postmodernism. At the beginning of this passage, Kosuth refers to the year 1963:

> By then it was already clear that Flavin (along with Judd) had started the activity of just making art, not sculpture or paintings. It was, simply put, the beginning of the end of Modernism. (There, I said it.) The implications of this were profound, obviously, and they laid foundations for the major shift in how art that followed would be made.
> (Joseph Kosuth in Catalogue of *The Architecture of Light*: 18)

Flavin himself did not see his work as either painting or sculpture but interestingly he did not see this as a reason for getting rid of old orthodoxies. As long ago as 1967 he said:

> I feel apart from problems of sculpture and painting but, there is no need to re-tag me and my part. I have realized that there need not be a substitute for old orthodoxy anyhow.
> (Dan Flavin in Catalogue of *The Architecture of Light*: 85)

In another interview over twenty years later, in 1989, Flavin admitted to the influence of both Pollock and Duchamp. He says he turned towards the

> drip, dribble, dash painted systematics of Mr. Pollock at his apparently self assured uttermost. I sensed that they pretended towards infinity – to painting anywhere – ultimately nohow, nowhere.
>
> Another maturing source of interest became Marcel Duchamp's 'objectified' readymades. As ever I had to develop a simple straight forward, constructive, mediumistic approach away from his seeming off-putting art political positionings. In 1961 I began to discover an abusive artifice for the phenomenal facts of artificial light.
>
> By now, I have become enthralled with light somehow, anyhow.
>
> (Ibid: 86)

So in a way Flavin did not want to reject the past, but felt he had to approach the visual arts in a different way. His greatest source of inspiration was the Russian Constructivists, whom we looked at in Chapter 6, and in particular Vladimir Tatlin. His piece entitled *Homage to Tatlin* is made out of white fluorescent tubes only and mounted on the wall, so the outer edges are very clearly defined. The admiration by Flavin and others for the Russian artists of the early twentieth century has to do with their use of modern industrial materials to create pieces in which the design is the most important characteristic so that they can be made in several versions. Also, like the Russian Constructivists, Flavin's work has a strong architectural element and it is sometimes referred to as the architecture of light, as in the title of a recent exhibition at the Guggenheim Museum in New York.

There are other very interesting connections which can be made with Flavin's work; in his interest in colour and light he can be related to Seurat and the Neo-Impressionists and their idea of painting light in terms of colour. In *To Donna*, Flavin uses the primary and complementary contrast of colours but of course he is working with real light. As a minimalist he was not bothered by craft in the traditional sense of that word. But although he limited himself to using the standard production of fluorescent tubes, in terms of colour and length he still made it clear that 'with or without colour I never neglect the design'. So, like any good artist, he sees the composition and organization of the work as being of paramount importance.

EXPERIENCING REAL LIGHT

Colour plate 24 *The Other Horizon* by James Turrell, 1998

This is part of a series of sky spaces, which James Turrell has been working on from 1972 to the present. They are extraordinary because they place the spectator inside a container in which the walls and roof are sloping. In the roof a hole is cut to allow you to see the sky; this space is wider at the top than at the bottom and also has sloping sides. The bottom of the opening is placed above the horizon line and as you look at it you become aware of the sky not as an endless canopy dipping towards the horizon but as a substance that conveys light and space. The edges of the aperture are very carefully treated so that the patch of sky almost appears like a piece of material stretched over the opening. Inside the container are seats for the spectators around the walls and soft ambient light rising from behind them. As you sit there at different times of the day the colours change as does the sky; this effect is impossible to capture in a photograph but the walls alter from violet to pale buff to deep gold so that you are aware all the time of the primary and complementary contrast in the colours.

James Turrell says that he is interested in turning a painter's vision of light into three dimensions and making the spectator feel the light inhabiting the space. He was trained as an experimental psychologist and has made installations which explore the Ganzfeld effect of disorientation, where all edges are dissolved and you and the walls are drenched in coloured light. He is also an experienced solo pilot who enjoys being alone in the sky but not for mystical reasons:

> For Turrell, though, the personal reference point for this kind of perceptual boundary-blurring is not mysticism, but his experiences as a pilot (an aviation buff he flew reconnaissance missions over South-east Asia while still a teenager, and later supported himself as an aerial cartographer), particularly during flights when weather conditions create what are known as 'lost horizons' – deceptive spatial illusions which inevitably tempt pilots to trust their eyes rather than what their instrument panels are telling them.
>
> (Ralph Rugoff, 'Lost Horizons' in *Tate* magazine, Summer 1999: 26)

Turrell is interested in the experience of empty space. Here the sky and its light become the subject. Since 1974 he has been working on the Roden Crater project, making viewing spaces inside a dead volcano in Arizona.

Many artists have tried to paint light, but the one who comes closest to Turrell is Turner. In a painting like *Norham Castle, Sunrise* of 1840–5, Turner was using colour to convey the feeling of light and space. The objects are dissolved in the light but you do feel their presence and they help you to orientate yourself in the landscape. Turrell too is interested in the painter's vision, but also in making the light surround you in a material way so that you really see it.

> My works are about light in the sense that light is present and there; the work is made of light. It's not about light or a record of it, but it is light. Light is not so much something that reveals, as it is itself revelation.
>
> (James Turrell in Catalogue of *The Other Horizon*: 228)

In these ideas Turrell comes close to the Romantic vision, which wanted to convey a sense of the infinite, but he is using real light and colour to achieve it. The spectator is not looking at the light in a painting but being surrounded by it and feeling it.

SCULPTURE AND COLOUR

Colour Plate 25 and Plate 85 *At the Edge of the World* by Anish Kapoor, 1998

Another artist who has a cosmic vision is Anish Kapoor, but his works are much more solid and sculptural; he covers them with saturated colour. So this is not about light in the same way as other artists in this chapter but it is very much about colour. The red here is saturated and the form is suspended from the ceiling like a great bell. As you look up at it you feel yourself drawn into the centre, into nothingness, so that you can experience the cosmic dimension, the edge of the world. Like James Turrell, Kapoor is interested in getting the spectator to lose him- or herself in the work and to have a spiritual or at least a poetic experience. Kapoor is quite clear that he is not interested in the expression of his own feelings but wants the spectator to become aware of another dimension to our existence:

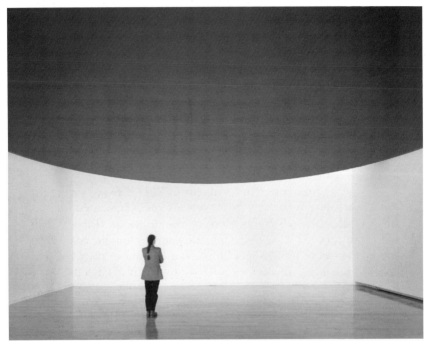

Plate 85 Anish Kapoor, *At the Edge of the World* (1998). Fibreglass and pigment, 500 × 800 × 800 cm. (See also colour plate 25.)

Courtesy of the artist. Photograph: John Riddy London, courtesy of the Lisson Gallery.

I think it's my role as an artist to bring to expression, it's not my role to be expressive. I've got nothing particular to say, I don't have any message to give anyone. But it is my role to bring to expression, let's say to define means that allow phenomenological and other perceptions which one might use, one might work with, and then move towards a poetic existence.

(Kapoor, Catalogue, *Anish Kapoor*, Hayward Gallery, 1998: 11)

Although Kapoor has lived in England a long time he originally came from India. The kind of spiritual understanding spoken of in this passage is often thought of as belonging to Eastern culture, particularly in the lack of self-projection and self-expression. The colour on the piece is not paint but pigment in the form of highly coloured chalk dust which is sold in Indian markets; its matt, velvety finish gives a depth and richness to the surface that would be difficult to achieve in paint.

The body of the sculpture is moulded fibreglass so, although it looks heavy, it is in fact very light with a fragile, pigmented surface. All this helps to enhance its mysterious and metaphorical presence. If this is the edge of the world, where are you standing in relationship to it? You must be out in space but where you are is indefinable. The fact that the whole piece is suspended from the ceiling adds to the spectator's feeling of being outside. It has a slightly dangerous and edgy quality because you understand that, if it fell on you, you would be lost and overwhelmed.

LIGHT IN ARCHITECTURE

Plates 86 to 88 The Great Court at the British Museum, London, by Norman Foster and Partners, 2000

The transformative properties of light in relation to space in architecture are well demonstrated here: it is an example of how letting light in can make a space lucid and intelligible. The central quadrangle at the British Museum had been covered over and filled with book-stacks, which served the great, round Reading-Room at its centre. But when the books were removed to the new British Library at St Pancras, there was the possibility of returning the quadrangle to the way that Robert Smirke had designed it. Originally there were four neo-classical porticoes, one on each side, leading to different sections

of the British Museum's collections. So, when you entered the main door of the museum you were able to see where to go when you came into the quadrangle. But with the bookstacks there, everybody had to move around the museum by avoiding the centre, which made it virtually incomprehensible to the ordinary visitor.

Norman Foster's idea about how to use this space was adventurous rather than just restorative, because he wanted to make a feature of it by covering it in a glass-and-steel roof that would make the space usable in all weathers. There are 3,312 glass panels and each has a unique shape, because the whole form is curved like a transparent arch all round; from the air it looks like a plump pillow surrounding the circular Reading Room. The glass is treated so that it controls the heat and cold, which would otherwise make the area unbearably hot and stuffy in summer and freezing cold in winter.

Your desire to move through the space is encouraged by the roundness of the Reading Room building in the centre and the staircase attached to it to provide access to the galleries on the north side. In the plan you can see that Foster has turned the shell of the Reading Room into a semi-ellipse to make room for a shop on the ground floor, and a restaurant and educational facilities higher up. The glass roof allows daylight to pour in from above, creating a space which is naturally lit and therefore low-cost from the energy point of view. Foster is famous for his belief that daylight should be used whenever possible to light buildings and the Great Court is an example. This marks a change from earlier in the century, when the emphasis was on light generated by the new electricity.

So the Great Court becomes a light and airy space, which makes you aware of the light coming through the glass ceiling as different kinds of light are generated by changes in the weather. When the sun shines, the grid pattern of the glass roof is reflected onto the white limestone cladding of the Reading Room: the sky changes from blue, to blue and white, to grey and then to midnight blue/black at night.

The creamy-white staircase around the Reading Room emphasizes the circle within the square and you see the movement of the clouds when they are there, sailing across the sky. All the time you are aware of changing light and weather conditions and the way they can alter the space below; these effects give tremendous life to the interior and encourage you to experience the space more clearly as a result. The architect has made the space more dramatic through his control and articulation of the natural daylight.

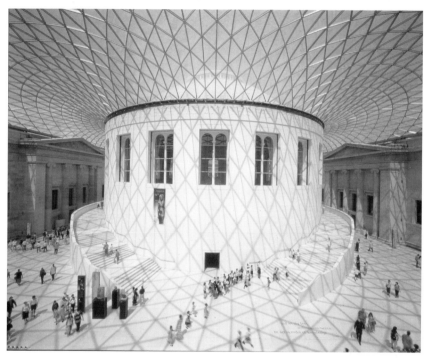

Plate 86 Foster and Partners, The Great Court, British Museum, London (2000), general interior view of Great Court and Reading Room.

Photograph: Nigel Young, Foster and Partners.

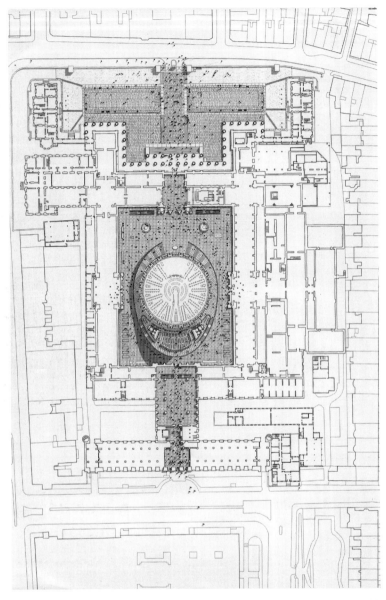

Plate 87 Foster and Partners, The Great Court, British Museum, London (2000), site/circulation plan.

Photograph: Nigel Young, Foster and Partners.

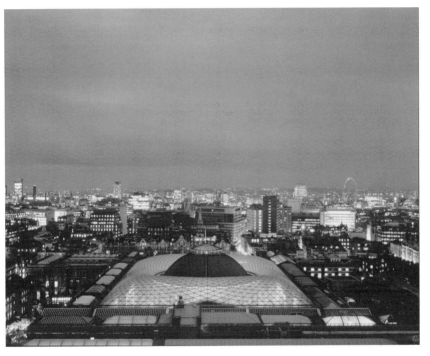

Plate 88 Foster and Partners, Great Court at the British Museum, London (2000), aerial view of the roof at night.

Photograph: Nigel Young, Foster and Partners.

CONTINUITY

We started this chapter in the nineteenth century with the discoveries about light and colour in the work of Turner and the Impressionists. Yet their discoveries went on influencing other artists – younger and further afield – through the twentieth century. Bonnard, for instance, was working till the 1940s, when Monet's late work was influencing American Abstract Expressionism. So there can be a considerable overlap between modern art and earlier times.

Also, some of the themes which I addressed in this chapter have cropped up in other places in this book: the rejection of Modernism in favour of a more pluralistic view of art and ideas; the repudiation of easel painting since the 1960s and the development of a closer relationship between sculpture, painting, architecture and design; the embracing of modern materials and techniques and the move away from the traditional art object towards the installation and the impermanent work of art. In Chapter 8 we shall see that these ideas do not apply to all the art of recent times.

Chapter 8

Traditional Subjects

TRADITION AND AVANT-GARDE

Many artists during the twentieth century have continued to work in highly individual ways. Sometimes, like Picasso, they have been connected with specific movements, but sometimes they have not. Using the language of modern art, they have often continued to work with traditional subject-matter in fresh and new contexts. By traditional subject-matter we mean the human figure, historical and religious subjects, landscapes, portraits, still life and genre painting, or scenes of everyday life. This work is usually figurative and not abstract, although there are exceptions to this as we shall see; it belongs broadly to the categories of the so-called hierarchy of the genres as laid down in the theories of academies of art (see *Learning to Look at Paintings*, p. 129).

The history of twentieth-century art has often been considered as the history of the avant-garde, the various movements seen as the most advanced in art or expressing the newest attitude to art. In the meantime, in the background and as individuals, many artists have continued to practise outside the mainstream of twentieth-century innovation. Sometimes there may be associations with major movements like Paul Nash with Surrealism for instance or Ed Ruscha with Pop Art; we have already seen examples of this in artists like Rauschenberg or Bonnard and it also applies to those working today like Rachel Whiteread or Michelangelo Pistoletto. But even these artists can be seen as having 'advanced' attitudes, so there can be an overlap between different groups. There are also artists like Lucian Freud or Chuck Close who still prefer painting in spite of much talk of its demise as a medium. A traditional approach in architecture will be explored too, in Richard MacCormac's re-interpretation of the

classical and picturesque traditions in the new Garden Quadrangle at St John's College, Oxford.

A number of previous themes will recur, like the blurring of the distinction between painting and sculpture, the breaking down of traditional categories of subject, and the use of new materials and methods, video in particular. There also continues to be the importance of theory, context and the communication of meaning and the need for the spectator to be active and participatory in their response.

In the epilogue, we will look briefly at examples of the relationships between fine art and film and fine art and the photograph, with particular reference to subject-matter. Most (but not all) of the examples in this chapter will be taken from the second half of the twentieth century in order to redress the balance from the early part of the book, which concentrated on the period before 1914, when many of the themes of modern art were set in motion.

THE HUMAN FIGURE

Plate 89 *The Venus of Gas* by Pablo Picasso, 1945

In the first chapter we saw some examples of Picasso's radical treatment of the human figure in *Les Demoiselles d'Avignon* and the portrait of *Ambroise*. During the rest of his life Picasso continued to experiment and to invent ways of making figures, especially the female nude, look different. In particular he was interested in sculptural expression, in drawing and the interaction between space and form. His friend, the sculptor Julio Gonzalez, writing in 1936, described his preoccupation like this:

> It gives me great pleasure to speak of Picasso as a sculptor. I have always considered him a 'man of form', because by nature he has the spirit of form. Form is in his early paintings and in his most recent.
>
> In 1908 at the time of his first Cubist paintings, Picasso gave us form not as a silhouette, not as a projection of the object, but by putting planes, syntheses, and the cube of these in relief, as in a 'construction'.
>
> With these paintings, Picasso told me it is only necessary to cut them out – the colours are only the indications of different perspectives, of planes inclined from one side or the other – then assemble them according to the given by the colour, in order to

find oneself in the presence of a 'sculpture'. The vanished painting would hardly be missed. He was so convinced of it that he executed several sculptures with perfect success.

(Catalogue of *Picasso: Sculptor/Painter*: 41)

Gonzalez is saying here that Picasso was interested in sculptural qualities to such an extent that he was interested in turning Cubist paintings into sculptures, and that it was the construction of the object that was important. In Chapter 5 on composition we discussed the advent of collage, which presented new possibilities; indeed, constructed (as opposed to carved or modelled) sculpture was developed by the Russian Constructivists like Gabo as we saw in Chapter 6. So Picasso worked in two and three dimensions, blurring the distinction between painting and sculpture as he did so and moving between more naturalistic and more dislocated treatments as well. One example I have chosen demonstrates transposition from one form to another; it shows him experimenting with sculpture, which we have not looked at so far, although we saw him painting the human figure in his Cubist phase in Chapter 1.

Although Picasso was never a full member of the Surrealist group around André Breton, his ability to transpose one object into another could be described as one of the characteristics of Surrealism; it is strongly present in *The Venus of Gas* of 1945. The gas burner has become the trunk of the body and the feet could be the legs of the stove, with a supporting projection becoming the neck and head. The ability to see one object in terms of another is very obvious here, but it is also thought to have a more sombre and symbolic meaning with an oblique reference to the gas ovens of the concentration camps. *The Venus of Gas* coincides with work that Picasso was doing on a painting called *The Charnel House*, a picture of fragmented bodies piled up in the foreground of the composition and painted in grisaille, like the more famous, earlier picture of *Guernica*.

Picasso always believed that art had a role to play in the expression of ideas and issues. In the spring of 1945 he made this statement:

What do you think an artist is? An imbecile who has only his eyes if he's a painter, or ears if he's a musician, or a lyre at every level of his heart if he's a poet, or, even if he's a boxer, just his muscles? On the contrary, he's at the same time a political being, constantly alive to heart-rending, fiery or happy events to which he responds in every way. How would it be possible to feel no interest in other

Plate 89 Pablo Picasso, *The Venus of Gas* (1945). Metal, 25 × 9 × 4 cm.
© Succession Picasso/DACS 2003.

people and, by virtue of an ivory indifference, to detach yourself from the life which they so copiously bring you? No, painting is not done to decorate apartments. It is an instrument of war for attack and defense against the enemy.

(Patricia Leighton, *Re-ordering the Universe*: 97)

In 1944 Picasso had become an official member of the Communist Party and this statement was made to refute the accusations that this was an insincere move; in it he allies himself with the view of the Communists that art should carry a message. In 1948 Picasso attended the Conference for Intellectuals for Peace in Wrocław in Poland; he visited Auschwitz, Kraków and Warsaw. The full horror of what had happened in the Holocaust was being expressed in many ways, as we saw in Chapter 5, in the work of Jean Fautrier and his contemporaries. Like them, in *The Venus of Gas* and *The Charnel House* Picasso was communicating feeling about what had happened. In the post-war period, Picasso continued with experiments in his treatment of the human figure, particularly in the sculptures he did in sheet metal.

Plate 90 *Venice Woman I–IX* by Alberto Giacometti, 1956

Giacometti's nine figures in a group seem to have an extraordinary presence and one is tempted to ask immediately why this is. They are tall and thin, and vary in height. The texture of the bronze from which they are made is rough and appears unfinished. They look emaciated and iconic, almost like totem poles; the influence of ethnographic art comes to mind. Then, when you start to look at the spaces in between the figures, you see that somehow they are also important, not only the large spaces between the figures but also the small ones between the arms and the torsos. There is also a strong sense of distance and recession with some of the figures closer together and others further away. All of them are facing forwards, except the one on the far right and the one on the extreme left, where the position of the head is ambiguous.

The features on the faces are not distinct; some of them look as though their arms are rigidly down their sides and their legs stuck together, like pedestals on their simple plinths. You feel the space pressing in on the forms as if trying to make them narrower. Whereas in traditional sculpture the form displaces the space, here it is moving

in on it as though trying to reduce the volume to the minimum. The roughened surface adds to this effect: it looks like corrosion, as if it has been affected by its environment or by something that has been done to it. Of course these figures are miles away from the classical tradition in terms of harmony and proportion; these qualities were no longer important to this generation of post-war artists. They were profoundly affected by the photographs of concentration-camp victims and the emaciated and suffering people returning to Paris in the aftermath of war.

One is reminded of the statement by Simone de Beauvoir about having seen history in its most terrible form, which we looked at in Chapter 5. The spectator becomes gradually aware of the resonance of this in front of Giacometti's figures and in particular by the sense that they could have been affected by powers beyond their control in the way the space impinges upon them, making them seem pressed in upon themselves and consequently thinner than they would otherwise be. The spectator feels invited to look at them from the point of view of symbolic meaning as well as from that of their purely artistic and tactile presence.

Other artists of this period were preoccupied with the same kinds of ideas – Jean Fautrier for instance, whom we looked at in Chapter 5. The bronze figures by Germaine Richier (a contemporary of Giacometti), which look burned or damaged, would be another example. The same sort of effect can be found in Giacometti's paintings. He drew and painted the same models over and over again like those of *Annette in the Studio*. He was interested in achieving what he called resemblance and the figure is worked over and over in order to realize that.

Giacometti had been a member of the Surrealist movement in the 1930s and so he would have been familiar with ideas about symbolism, suggestion and association; however, he himself always denied any direct association between his work and the ideas of the period he was living in. He suggested that it was stylization, like the work of the Egyptians, that made a work convincing:

> Have you ever noticed that the truer a work is the more stylised it is? That seems strange because style certainly does not conform to the reality of appearances, and yet the heads that come closest to resembling people I see on the street are those that are least naturalistic – the sculptures of the Egyptians, the Chinese, the archaic Greeks and the Sumerians.
>
> (Catalogue of *Paris Post-War*: 106)

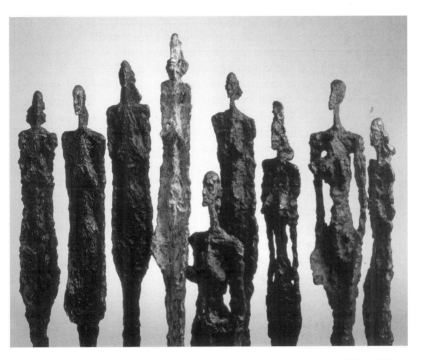

Plate 90 Alberto Giacometti, *Venice Woman I–IX* (1956). Bronze, 106 × 13.5 × 29.5 cm for No. I (others similar).

© ADAGP, Paris and DACS, London 2003. Courtesy of Fondation Marguerite et Aime Maeght, 06570 Saint-Paul, France.

In spite of these denials and assertions by Giacometti, the inter-pretation of the spectator is also important and the fact that these figures were made during this post-war period must still have signif-icance for us. The context and time in which a work is made can certainly contribute to its appearance.

Giacometti was classically trained in the traditional craftsmanship of sculpture. He went to the École des Beaux Arts and attended Bourdelle's life classes; he also became a painter and alternated between the two arts although he remained first and foremost a sculptor. Henry Moore, his contemporary in England, was similar in the sense that he is famous for his drawings as well as his sculpture, particularly the Shelter Drawings of the Second World War (see *Learning to Look at Paintings*, pp. 178–80); he was also fascinated with carving in both wood and stone and proved an outstanding talent from an early age. Along with Germaine Richier, a pupil of one of Rodin's assistants, Giacometti and Moore were interested in Rodin's idea of sculpture as 'the art of the hole and the lump', in which the surface shows the hand of the artist either because it is rough and textured or because it is beautifully crafted and polished. Their interpretations of the human figure were not classical in terms of traditional proportion and all were interested in turning to ethno-graphic or pre-classical alternatives for inspiration.

In previous chapters we have seen examples of how sculpture has changed during the twentieth century: the early avant-garde work of Epstein, Gaudier-Brzeska or Boccioni, the use of modern materials by the Russian Constructivists, the development of Conceptual Art and the installation. But there are still sculptors working today who take the human body as their inspiration. One of the most famous examples of this is Antony Gormley whom we shall look at later in this chapter.

Plate 91 *Small Naked Portrait* by Lucian Freud, 1973–4

It is the nakedness of the subject in Freud's picture which strikes you first; it is about stillness, vulnerability and scrutiny. The figure is lying still, not just because this is required of an artist's model but because she is asleep and, because of that, she is vulnerable and lying in a semi-foetal position, childlike and unselfconscious. It is a portrait of a naked woman rather than a nude. The artist has scrutinized the figure from above, painting her very skilfully from the front with

extreme foreshortening. Freud himself says he goes on looking until there is nothing more to see and there is an intensity about the un-diluted focus of this picture. The figure fills the canvas. There is no background apart from the difference between the pale and dark grey. The skin is painted to include blemishes, for instance on the feet and hands. The way the skin is painted is tactile, as you might find in a figure by Courbet (see Chapter 1) whom Freud admires; but in this case you feel that, if you touched her, she would wake with a start.

Although the picture is very small, only 22×27 cm, nevertheless it conveys a sense of scale and a strong feeling of form. The limbs make an interesting and complex collection of angles that help to express this, particularly the leg on the left lying down and the one on the right coming forwards. The dark shadow under the chin and the different skin tones of the hands and feet are also important, especially in relation to the projection of the breast. The bulk of the back has been slightly increased to push the upper arm forward and to emphasize its angles in relation to the body. Although it is full of feeling, there is no polemical message here, as you feel there might be in the painting by Jenny Saville that we look at next.

Despite the connection with his grandfather, Sigmund Freud, Lucian is much more interested in conveying outward appearances as a result of very careful observation rather than looking for inward expression in a psychological way. His friend and contemporary, the artist Frank Auerbach explains the character of Freud's painting very well:

> I am never aware of the aesthetic paraphernalia. The subject is raw, not cooked to be more digestible as art, not covered in a gravy of ostentatious tone or colour, not arranged on the plate as a 'com-position'.
> The paintings live because their creator has been passionately attentive to their theme, and his attention has left something for us to look at. It seems a sort of miracle.
>
> (Catalogue of *Lucian Freud*: 51)

Auerbach believes, then, that the kind of observation done by Freud allows us as the spectators to see more, to stop and contemplate the object in depth, in order to gain a deeper understanding of its form and its naked 'uncooked' humanity.

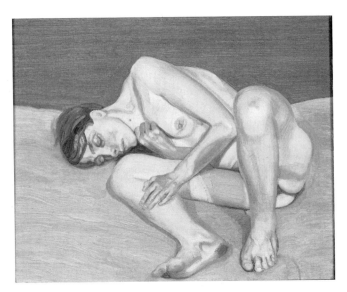

Plate 91 Lucian Freud, *Small Naked Portrait* (1973–4). Oil on canvas, 22 × 27 cm.
© Lucian Freud. Image courtesy of the Ashmolean Museum, Oxford.

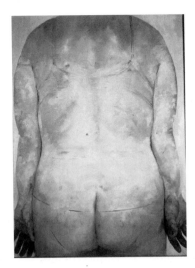

Plate 92 Jenny Saville, *Trace* (1993–4). Oil on canvas, 213.5 × 182.8 cm.
Courtesy of the artist and Gagosian Gallery, New York. Image courtesy of The Saatchi Gallery, London.

Plate 92 *Trace* by Jenny Saville, 1993–4

Jenny Saville's painting *Trace* is an unnerving picture because it is not what you expect at all in paintings of the nude. To start with, you can see only the torso and it is certainly not idealized in any way. The figure stands with her back to us, and her arms close to her sides, as if she was being inspected as one among many. We do not know where she is, but it could be the hospital because of the lines drawn on the buttocks as if for an x-ray, or a scan. The skin is covered in blemishes and there are two places on the back to the right and left in the middle which look like scars; but higher up, it appears that she is still wearing a brassiere and/or a camisole; near the top on the left-hand side you can also see a small hole; she is large and fat and looks cold, vulnerable and possibly dead.

The body is beautifully painted in terms of the use of the brush, the feeling of form, and its palpable reality, which is created by the way the torso fills the canvas except for a few cool blue sections around the edge. The light is harsh and seems to be shining full on the back like a searchlight or a surgery spotlight; it has a strong feeling of clinical or medical observation about it rather than a sensual, erotic or idealizing vision. Like much art of the present day this picture poses more questions than it answers, but it also asks us to think about women not in terms of ideal beauty or the male gaze but in the sense of who they really are. One of the issues raised by Feminism, as we saw in Chapter 4, is the treatment of women as people, as individuals, without always presenting them as sexual objects. Jenny Saville is keen to make us think about women in unromantic situations like the hospital or the doctor's surgery; she is interested in painting and in the life model, but not in the conventional treatment of the female nude. Both Freud and Saville have an involvement with the processes of painting that quite belies any stories of its demise.

RELIGIOUS SUBJECTS

Plate 93 'Thirteenth Station' from *The Stations of the Cross* by Barnett Newman, 1965–6

It hardly needs saying that these paintings are uncompromisingly abstract, but they are about the stages on the Road to Calvary. The different stations were established in medieval times and their titles are as follows: Christ falling under the weight of the cross three

times, the meeting with his mother, with Simon of Cyrene and St
Veronica, Christ stripped of his garments, the nailing to the cross,
the crucifixion, Christ laid in the arms of his mother, and the
entombment. Altogether, there are usually fourteen episodes in the
enactment or depiction of this subject; Newman chose to do them all
but he did not give them individual titles, only numbers.

The overall title, according to the Tate Modern Catalogue of *Barnett
Newman*, is Lenea Sabacthani. These words from Psalm 22 are echoed
in the gospels by the Aramaic words 'Eli, Eli, lama sabachthani', which
is the cry, 'Father, Father, why have you forsaken me?' This is the
lowest point in the gospel story, when Jesus is being crucified and gives
way to despair. The paintings provide a series of images made from
black or white paint and raw canvas, the most basic materials you can
use; they vary of course from canvas to canvas, but the materials are the
common theme and so is a more or less uniform size of 198 × 152 cm.

When they are installed together in a gallery, these pictures have a
powerful presence, both because of their size and because we know
what they are about: we are made to meditate on the subject of
Christ's crucifixion in an abstract, spiritual and generalized sense. The
important point is that we know what the subject is. Newman has not
just called them Untitled or Composition, but given us a specific sub-
ject to think about in an open-ended way rather than a narrative one.

If you take a single example, like the Thirteenth Station (Plate 93),
it has an imposing presence and the white vertical bar on the right
appears to divide the two areas of black and then the pale vertical on
the left-hand side seems to go off the edge except for the artist's sig-
nature in the bottom left-hand corner. Newman achieved the stripes
with masking tape so they are very precisely defined. The picture is
imposing but at the same time visually satisfying because of its propor-
tions, and because, the more you look at it, the more three-dimensional
it becomes; the saturated black seems to recede into space and the
cream seems to become more solid and come towards you. In the
original, when you stand in front of them, the pictures affect you as the
spectator and encourage you to contemplate and to feel the void.

Newman certainly believed in the idea of the sublime and wanted
it to be seen and considered without any distortion. In an article pub-
lished in 1948 called 'The sublime is now', Newman wrote this:

> Instead of making *cathedrals* out of Christ, man, or 'life', we are
> making it out of ourselves, out of our own feelings. The image we
> produce is the self-evident one of revelation, real and concrete,

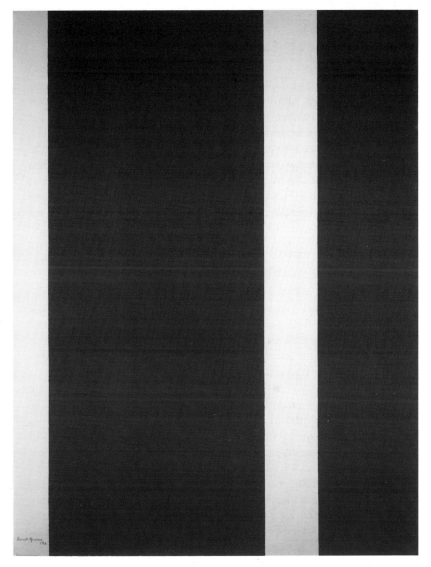

Plate 93 Barnett Newmann, 'Thirteenth Station' from *The Stations of the Cross* (1965–6). Acrylic on canvas, 198.2 × 152 cm.

that can be understood by anyone who will look at it without the nostalgic glasses of history.

(Barnett Newman, Harrison and Wood (eds)
Art in Theory 1900–1990: 574)

So the communication of the sublime and the spiritual is better achieved by non-figurative rather than figurative art because that avoids the distorting mirror of tradition. You could say that, like the Existentialists in Europe, Newman was painting despair in 1966, when the issues about war and the bomb and the possible annihilation of the human race were always there like shadows in the background. But there is also an autobiographical element in that some years before Newman had suffered a heart attack and painted an abstract picture called *The Outcry* which became the prototype for *The Stations of the Cross*.

Plate 94 *Untitled (for Francis)* by Antony Gormley, 1985

Balthus, another famous traditional artist of the twentieth century, is known to have been moved by the 'divine aspect of reality', but we somehow do not expect any reference to the idea of the divine in twentieth-century art. There is something strange about Gormley's figure because it has holes in the chest and in the hands that symbolize the idea of the stigmata. The reference to Francis in the title does mean Saint Francis, who is famously supposed to have miraculously received the stigmata. There is something mysteriously vulnerable about this figure with its arms outstretched, and its feet apart and its head looking upwards as if towards something coming from heaven.

Gormley's figures are not like traditionally sculptured human beings, because he uses himself as the model. After being wrapped in cling film, he is covered with plaster, waits till it sets, and then has the cast cut off in pieces; he then covers those sections with lead, leaving the marks where the saw went through the plaster to express the way it has been put together. So the figure is exactly life size and somehow different because it has been cast rather than modelled; and yet it is not like a replica because there is only a suggestion of features on the face; it is certainly not a self-portrait, and yet its life-size scale gives it an uncannily real presence. He seems alive and yet not alive, touchable and yet not touchable, like the idea of the divine presence

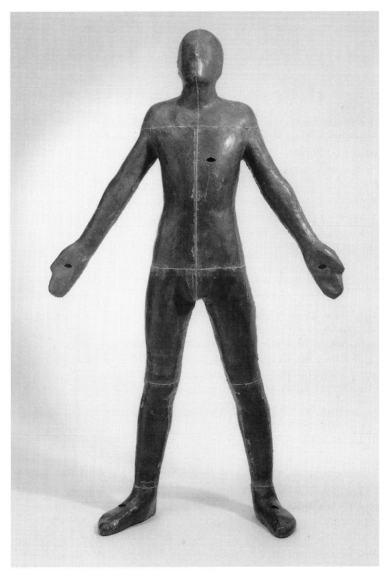

Plate 94 Antony Gormley, *Untitled (for Francis)* (1985). Lead, plaster, polyester resin and fibreglass, 190 × 117 × 29 cm.

Courtesy of the artist and Jay Jopling/White Cube (London). Photograph © Tate, London 2003.

in a profound religious experience. Yet, the reference to St Francis is oblique and the figure encourages the spectator to ask questions, to speculate and to think in the way that much conceptual and postmodern work intends, as we have already seen in previous chapters.

Plate 95 *Angel* by Mark Wallinger, 1997

Antony Gormley is more famous for his huge figure on the motorway approaching Newcastle known as the *Angel of the North*. Again, just like the saints or the stigmata, we do not expect angels to be mentioned or indeed turned into art in our secular world. This video installation by Mark Wallinger is actually entitled *Angel*. The main subject is a figure wearing dark glasses and carrying a blind person's white stick. He is walking on the spot at the bottom of the down escalator at the Angel tube station (named after the nearby pub in Islington, North London). Wallinger speaks the first five verses of St John's Gospel about the Word as the Light and the darkness not comprehending it:

1. In the beginning was the Word and the Word was with God and the Word was God.
2. The same was in the beginning with God.
3. All things were made by him and without him was not anything made that was made.
4. In him was life; and the life was the light of men.
5. And the light shineth in darkness and the darkness comprehended it not.

(St John's Gospel: 1: i–v)

The words are spoken phonetically and backwards by Wallinger so that the sound remains familiar but becomes difficult to comprehend except for the odd word or phrase. To achieve this effect 'Wallinger devised a notation for speaking the sounds of the words in reverse', according to Ian Hunt in the catalogue of Wallinger's exhibition at Tate Modern, Liverpool. This installation is part of a trilogy, together with *Hymn* and *Prometheus*, in which Wallinger plays the part of Blind Faith, with this figure in the white shirt, dark tie and trousers, dark glasses and white stick.

In *Angel*, the figure of Blind Faith appears to be walking backwards at the bottom of the central escalator, trying to maintain his position. Is he a metaphor for the God of the Incarnation coming

Plate 95 Mark Wallinger, *Angel* (1997). Projected video installation, 7 mins 30 secs.
Video still © the artist, courtesy of the Anthony Reynolds Gallery.

into our world? The musical accompaniment as he recites the gospel is the introduction to Handel's anthem 'Zadok the Priest' with the strings winding up the tension until, as the choir comes in, the figure of Blind Faith goes into reverse and disappears backwards up the escalator as the world does not comprehend and the light cannot bring God to the people living in darkness.

This is how it appears certainly, but when you go into it in more detail you discover that in fact it is not only the language that is in reverse but

> an entire performance was planned in reverse so that it could be screened backwards in the gallery. Everything that happens has already happened, as in some versions of Christian faith. . . . The man strives to remain at a still point in a turning world; time turned against itself, unfolds, until he stops walking and standing still at last is carried to the final elevation.
>
> (Ian Hunt in Catalogue of *Credo* exhibition,
> Tate Modern, Liverpool, 2000: 26)

The irony is that Blind Faith appears to be moving backwards when he should be moving forwards and vice versa and the language he speaks is reversed as well. So our responses are deliberately left in confusion as they often are today in relation to religion.

In a lecture he gave in Oxford in January 2001, when he was artist in residence at the University Museum, Wallinger spoke about the need for the kind of transcendent religious element that existed in the art of the past, being brought back in a postmodern way.

Certainly, the juxtaposition of the reading, the music and the escalator, with the passengers appearing to pass by indifferently on either side, creates a moving experience, especially when you hear and see it all the way through with an audience in a lecture theatre. Of course, it is made to be shown as a video projected installation, which is looped so it runs continuously. Wallinger is looking for a new metaphor for a transcendent message, one that will move the spectator and make them think and feel the meaning in a new way.

HISTORY PAINTING

Plate 96, The *Confrontation* triptych by Gerhard Richter, 1988

In the past this picture would have been described as a history paint-ing because it is concerned with a specific event, the story of the Baader-Meinhof terrorist gang, the leaders of which were found dead in their prison cells in 1977. It was never clear whether they com-mitted suicide or were killed. Richter paints from photographs as is very evident here; in reproduction that is what his pictures at first look like. Photographs form a very important part of Richter's work and over the years he has collected an archive of them known as Atlas, which has been exhibited as an installation (for instance in Barcelona in 1999).

Richter has a collection of photographs of the Baader-Meinhoff story, so the photograph forms the basis of his pictures in a very spe-cific way. In a collection of essays about the relationship between photography and painting in Richter's work, the use of the photo-graphic image was explained like this:

> The initial reality, the model is no longer a motif à la Cézanne, but a photograph, that is to say, already an image. . . .
> He is not so much interested in the iconic value, nor in the traumatic shock of the thing photographed, but in the latent power of the image itself, which calls for pictorial fulfilment – because this power, in its generality, is already that of painting,
>
> (Benjamin Buchloh, in *Photography and Painting in the Work of Gerhard Richter*: 37)

For Richter it is through painting that we can experience the more complex meanings behind the photographic image. He was classically trained in academic painting techniques and his skill with the brush is very evident here in the subtle use of tone and the blurring of the edges of the forms; they look as though they are moving and as though the young woman is passing in front of our eyes as we look at her. But of course she does not go away, as she would in a television news clip, and we are left with plenty of time to contemplate the narrative of what this is about. Altogether, Richter made a series of fifteen paintings of this story and the background is quite complex. These three paint-ings capture the ambivalence and vulnerability – but perhaps not the

determined rebellion and aggression – that characterized this gang; the artist himself is said to have had mixed feelings about the story too.

The Red Army Faction – or Baader-Meinhoff group, as it was popularly called after two of the protagonists – was one of the most extreme factions of the left-wing protest movement of the 1960s and 1970s; basically they were against the involvement of the West in various wars, including Vietnam, and the affluence of West Germany, which seemed to be ignoring the east of the country as well as the terrible events of the recent past. Like Beuys, with whom Richter worked in Dusseldorf or Pistoletto whom we looked at in previous chapters, the Baader-Meinhoff group felt it was important to face up to the past and deal with national memory.

Coming as he did originally from East Germany, Richter says he was partly sympathetic with them, but could not condone their guer-rilla war against the establishment which involved the killing of innocent people:

> I was impressed by the terrorists' energy, their uncompromising determination and their absolute bravery; but I could not find it in my heart to condemn the state for its harsh response. That is what states are like and I have known other, more ruthless ones.
>
> (Catalogue of *Gerhard Richter: Forty Years of Painting*: 76)

Here Richter is referring to the communist state of East Germany, which he had experienced at first hand. You can see from just this short passage that Richter's attitude was ambivalent – as was many others' – and that is what he expresses in these beautiful grisaille paintings. The young woman is Gudrun Ensslin, one of the gang; she is presented at a moment when she was confronted by press and photographers at the prison where she was being held. In the first picture she looks uncer-tain what to do; in the middle one there is a moment of recognition; and then, disillusioned by their attitude, she turns away.

The control of tonal contrast is very subtle, particularly in the cen-tral picture. The sharpest contrast is where the neck comes out of the collar of the black shirt, enhanced by the shadow behind and the dark hair. The variations in shades of grey in her overshirt help to give form to the body, and then the face is shown in sharper definition on the left than on the right; this allows the eye to move into the back-ground on the right-hand side, creating the expression of uncertainty about exactly what is there. The final picture, by contrast, is much more clearly defined, expressing a more determined frame of mind.

Plate 96 Gerhard Richter, *Confrontation* ('Gegenüberstellung') nos. 1, 2 and 3 (1988). Oil on canvas, 44 × 40¼ ins (112 × 102 cm) each.

Ensslin was found hanged in her cell and nobody ever knew whether she had freely taken her own life or been killed by her captors. The whole story is uncomfortable and messy with no clear-cut answers and no real means of finding the truth. Richter's paintings at least allow us to consider this problem, to think about it and discuss it. The triptych, along with his other twelve pictures on this subject, also makes us realize that painting still has the power to move, whatever some may say about it being outmoded.

LANDSCAPE

Plate 97 *We are Making a New World* by Paul Nash, 1918

In previous chapters we have seen various types of landscape that have not been paintings at all, if you think of the work of Ian Hamilton Finlay or Walter de Maria. But most people would consider Paul Nash to be a landscape painter in the more traditional sense; however, these two pictures are about much more than nature alone. The earlier painting presents vividly the horrors of the First World War and in particular what they did to the landscape. The title makes reference to the idealism and bravery of the men who went to fight for their respective countries and, like all the best war works, it does not take sides.

Nash paints a devastated countryside in which the trees are reduced to bare trunks and branches and in which nothing grows on the ground, which is covered with craters made by shells and gunfire. The hills in the background are painted blood red and make a telling contrast with the black, brown and ochre of the foreground. The sun is rising on this scene of devastation and, what is more usually seen as a symbol of hope in the dawn of a new day, reveals a scene in which death is overwhelmingly present. Nash believed in expressing what he called 'the genius loci or the spirit of place' and he has certainly done that here. In a letter he wrote to his wife from the Western Front in 1917 he described his experience vividly:

> I have just returned last night from a visit to Brigade Headquarters up the line and I shall not forget it as long as I live. I have seen the most frightful nightmare of a country more conceived by Dante or Poe than by nature, unspeakable, utterly indescribable.
>
> (Paul Nash quoted by Richard Cork
> in Catalogue of *A Bitter Truth*: 198)

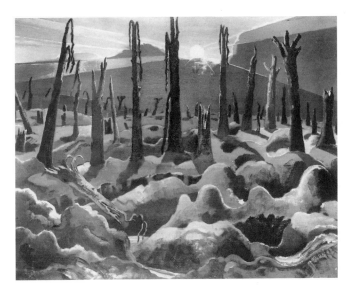

Plate 97 Paul Nash, *We Are Making a New World* (1918). Oil on canvas, 71.1 × 91.4 cm.

Courtesy of The Imperial War Museum, London.

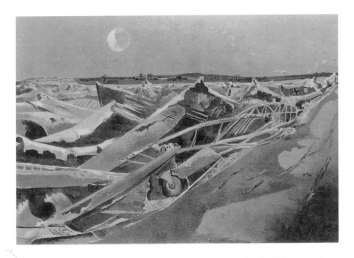

Plate 98 Paul Nash, *Totes Meer* ('Dead Sea', 1940–1). Oil on canvas, 101.6 × 152.4 cm.

Plate 98 *Totes Meer* ('Dead Sea') by Paul Nash, 1940–1

In a way Nash's 1918 painting is more like a history subject than a landscape and the same is true of *Totes Meer*, which Nash painted at the height of the Second World War. It looks as though it could be some sort of seascape because of the way the broken bodies, wings and undercarriages of aeroplanes undulate and stretch away to the horizon; the sickly yellow in the foreground on the right and the cold, greyish blue in the middle ground under a leaden sky express the experience of more devastation. Nash himself saw quite clearly the way that this sort of picture could have the qualities of landscape and yet contain a message about events:

> The thing looked to me suddenly like a great inundating sea. You might feel – under certain influences – a moonlight night for instance – this is a vast tide moving across the fields, the breakers rearing up and crashing on the plain. And then, no: nothing moves, it is not water or even ice, it is something static and dead. It is metal piled up, wreckage. It is hundreds and hundreds of flying creatures which invaded these shores. . . .
>
> (*Tate Gallery: Companion*: 185)

Nash sees the planes as a sea of wreckage; this ability to see one thing in terms of another had been encouraged by his interest in Surrealism, where the transposition of one object into another and the associations between them were very much part of the driving force, as we have seen in Salvador Dalí or Max Ernst for instance.

The fluidity and flexibility of categories in modern art mean that things are less clear than in the past. These landscapes could be construed as history paintings, because they remind us very eloquently of the destructive forces at work in the twentieth century. Two world wars were fought within a generation and Paul Nash worked as a war artist in both of them.

Plate 99 *A Certain Trail* by Ed Ruscha, 1986

This image of some indistinct objects moving up a slope fills the whole canvas as it might do on a cinema screen. Ed Ruscha freely admits to the influence of the cinema and has said that 'Like everyone else I'm a frustrated film director.' Certainly Ruscha lives and works in California and many of his works show a direct or indirect

influence of film; his painting of *The Back of Hollywood*, with the famous letters on the hillside above Los Angeles seen from behind, testifies to his interest in the wide-screen image, and to his considerable technical ability in terms of perspective and colour, so that you feel a sense of the landscape and the wide, open, treeless space.

But the picture of *A Certain Trail* is much more resonant and is one of a series of monochrome, big-scale cinematic images that Ruscha worked on in the 1980s. The painting itself becomes like a cinema screen: the image is large and spreading but fills only about one-third of the canvas. The earlier Hollywood picture is painted with a brush, very skilfully because the surface is so undisturbed, but *A Certain Trail* has been done with an air brush in order to create a texture that resembles moving black-and-white film. The train of objects does look as though it is moving because of the blurring of the edges of the forms. The feeling of bulk is conveyed by the density, opacity and darkness of the shapes; they are suggestive of a wagon train or the cumbersome movement of a line of buffalo; the spectator is left to wonder which as they move from right to left across a canvas that is 305 cm wide but only 119 cm high. The cloudy background could be dust or clouds of smog or the light at dawn or dusk, but it creates the sensation of movement and a cinematic view for the spectator.

There are echoes here of Ruscha's fascination with travel and especially with travel to the West; two of his favourite films are John Huston's *The Grapes of Wrath* and Alfred Hitchcock's *North by North West* in both of which the road plays a very important part:

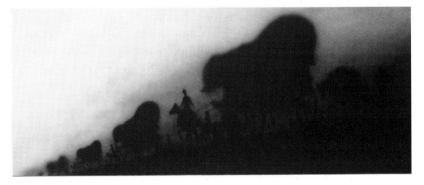

Plate 99 Edward Ruscha, *A Certain Trail* (1986). Acrylic on canvas, 119 × 305 cm. Courtesy of the artist. Photograph: Paul Ruscha.

The image of a train that we have from movies is from lower right to upper left; it is a force of exaggeration that we've seen many times. It parallels the concept of speed, going from nowhere to somewhere, nowhere to everywhere. If you can get that into a painting then there is a sense of accomplishment. There's a kind of conviction in the awkwardness of doing that that appealed to me.

(Catalogue of *Ed Ruscha*: 165)

So the feeling of the need to convey movement is important and the challenge of doing that in a painting is part of it; the air-brush technique, which removes the need for the painter's hand, helps with this too because the grainy surface he can make looks like old black-and-white film.

Ruscha is often considered as part of the Pop Art movement, which he would always deny. However, he does freely admit to the influence of magazine pictures, advertisements and the world of commercial art, which first appealed to him as a student in the late 1950s:

There seemed to be a world of possibilities out there for photography, cartooning, or maybe humour, and abstract painting. May be they all came together in one story. But I didn't just eliminate everything in my history and study only fine art. It just didn't happen that way.

(Ibid: 145)

As this passage indicates, much of Ruscha's subject-matter has come from the world of signs and advertisements like the painting of *The Back of Hollywood*. In 1959, Ruscha went to a lecture by Richard Hamilton about the work and interests of the Independent Group in England and their desire to associate the fine and popular art worlds; we have already seen in Chapter 5 how important this was in allowing fine art, graphic and commercial art, and film to inform and interact with one another.

However there is also another element playing its part in the impact of *A Certain Trail* and that is memory and communication of some sort of meaning:

At one point I used to think that art was strictly visual, and you're not supposed to go and dig deeper into messages. But now I believe it all has to do with tantalizing your memory.

(Ibid: 154)

It seems that Ruscha wants to suggest memories to the spectator about old films, past times, a kind of non-specific nostalgia for the pioneering past of America, its relationship with the landscape, and its epic qualities.

STILL LIFE

Colour plate 26 *Still Life on a Glass Table* by David Hockney, 1971–2

This is a quintessentially modern version of a traditional subject. The composition is set on a thick, glass table with the objects arranged at carefully judged intervals in order to relate aesthetically to the space between the uprights of the metal table legs. The colours are cool and based on blue, lavender, turquoise, pink and soft orange through to yellow. The observation is as acute as any in an Old Master painting: look at the way the glass water jug is painted with its translucency and reflections, and how the handle and part of the top are edged in the pale aquamarine that belongs also to the pot on the left, parts of the metal lampshade, the shadow of the hexagonal vase, and the glass one to the right, behind.

The artist's choice of a thick, glass table-top enables you to see the legs behind, and Hockney edges it with the same opaque green as the foliage of the tulips. The movement in the forms of the tulips creates variety for the eye and is echoed by the bubbles in the lampshade on the left. Variety is also made in the surfaces between opacity and translucency all the way through the composition.

This picture is contemporary with Minimalism and you can see the influence of those ideas we discussed in Chapter 3: the coolness of the colours, the spare and simplified character of the design and the emphasis on machine-made precision in the shapes of most of the objects. The quality of the brushwork is a cross between a watercolour and an oil because this was painted with acrylics; these have the versatility of oil paint because you can change your mind, and move more flexibly between dark and light; but they also have the transparency and lightness of watercolour, which is very evident in the reflections on the surface of the table-top. There is symmetry in the way the table is set into the background, and the colours of the wall and the floor set

off the colours and shapes of the objects on the table. The table itself is equidistant from the upright sides of the canvas, and the horizontal line of the floor could be on the golden section giving a satisfyingly harmonious look to the whole arrangement.

Clear, cool and modern are all words you could use to describe this picture and yet Hockney is working within a long-standing tradition of still life painting; he is fascinated by Western European art and has shown it recently through interviews and his book *Secret Knowledge*. But as a young artist, Hockney was part of the Pop Art movement, wanting to reflect the idea of the contemporary in the way we have seen; he was at the Royal College of Art when Pop grew out of the Independent Group in the early 1960s, replacing the drabness of the post-war period with jolly, light-hearted images and signs reflecting the new consumer society and the prosperity of the young. This still life is modern, not in the pictorial sense of Modernism in spite of its exquisite qualities of arrangement, but in the sense of being contemporary and belonging to the design style of its time.

PORTRAITS

Colour plate 27 *Self-Portrait* by Chuck Close, 1997

When you first see a room full of Chuck Close's portraits you are struck first of all by their size. This one for instance measures over 2.5 × 2.0 m, big enough for a life-size, full-length portrait, yet it shows only the head, which fills the near-square shape of the canvas and touches the sides. The image first of all reminds you of a close-up on the television or in the cinema because there is no background. The man looks as though he could be being interviewed on a news programme or possibly being caught by the camera looking at something in the distance beyond the spectator. The eyes are expressive, the nose is slightly blurred, and yet the whole effect is solidly three-dimensional.

The spots of colour are like large pixels in colour photography or a digital or computerized image; but Close said in an interview recently that his work is entirely achieved by working away in the studio with brush and paint on canvas:

> Some people wonder whether what I do is inspired by a computer and whether or not that kind of imaging is a part of what

makes this work contemporary. I absolutely hate technology, and I'm computer illiterate, and I never use any labour saving devices, although I'm not convinced that a computer is a labour saving device. I'm very much about slowing things down and making every decision myself. But, there's no question that life in the twentieth century is about imaging. It is about photography. It is about film. And it is about new digitalized things. There are layers of similarity I suppose that are to do with the way computer generated imagery is made from scanning. I scan the photograph as well, and I break it down into incremental bits.

<div align="right">(Catalogue of Chuck Close: 99)</div>

Close is saying that his picture surface is not computer-derived but he does use photographs. He breaks the image into squares on a traditional composition grid and the colours are placed in them; they are the colours used in colour photography, magenta, blue and yellow, and from them all the other colours can be made. He establishes a grid of squares over the whole image and then blows up that grid onto a large canvas so that he can scale up the composition and judge where to put the painted marks. The little squares or diamonds look like the glass tesserae in a mosaic and appear to reflect off one another; they also look like raindrops on a window pane and it seems as if you might be looking at the image through wet or frosted glass, or even bubble-wrap perhaps.

As a young artist in the 1960s and 1970s, Close worked with an air brush and spray gun, putting the colour into the squares of the grid one by one. This extremely laborious process he did by hand, just as he does now, having returned to using the brush after his illness in 1988; he works from a wheelchair with his paintbrush strapped to his hand. Many of his pictures are self-portraits or else they are of sitters who come from Close's own circle of artist friends, rather than celebrities as you would find with Warhol. Close admits to being influenced by Andy Warhol because he found a solution to the problem of what to do with figurative painting without returning to old formulas. Close's technique is also reminiscent of the nineteenth-century pointillism of Seurat which we referred to briefly in Chapter 7.

Close is primarily a painter whose engagement is with the process of painting and with the subject and finding new solutions to visual problems. When many others moved into conceptual art as we have seen, Close remained with painting.

It doesn't matter where the whole art world is going. I've got my own little trajectory. I guess the thing about the way I work that is most important is that the things I make answer particular problems that I have posed for myself. They are my private solutions, and I get a hell of a kick out of it. It's one of the great things about the dialogue an artist has with his or her own work. It's you alone in the room. Now, I have other people around me, but I still try and make the studio just me and the canvas.

(Ibid: 101)

This passage is still about the craft of painting and the whole business of making pictures. His works do obsessively continue with the portrait, the single head, but they express it in a way that is totally modern, and belonging to the late twentieth century. In spite of the watershed of 1968, like Richter and Hockney and others in this chapter, Close did not feel the need to move away from painting; photography is important as a starting point but then he is able to turn it into a hand-crafted work, which requires great technical skill in order for it to succeed and be convincing.

GENRE SUBJECTS

Plate 100 *Triptych* by Paula Rego, 1998

This is a genre painting or scene from everyday life, but a particularly sad and unpleasant aspect of it. This triptych tells the story of the plight of women and the need for abortion in Catholic countries; Paula Rego comes from Portugal where abortion has not been legalized, so these women have to go to the back streets where it is done in secret. In the first picture a woman lies curled up on a basic hospital bed; she looks uncomfortable and frightened and appears to be looking down in lonely agony as if not wanting to be seen; the black plastic chair and bucket in the foreground look ominous. In the middle picture a woman is lying on her back on a bed or a surgical table; we cannot see the legs or the ends of this piece of furniture so it remains anonymous. Is she waiting for the procedure to be done and is that why she is raising her head anxiously for someone to come? In the third picture a girl still in school uniform is sitting on the bucket

with a look of resignation, inevitability and discomfort on her face.

Although the woman in each picture appears to look the same, she is wearing different clothes as though we are to look at the symbolic figure with the same face and hair but in different situations. The most poignant picture is the schoolgirl still in school uniform but with the feminine lines of maturity: will her life be ruined? Will she be able to have more children? Will she suffer from a social stigma because of what has happened? Will she still be marriageable? I have used the future tense here but in fact, time is dislocated by the older contours of the girl/woman so that you feel we could be reflecting back on the past and its consequences as well. The issues of womanhood in a Roman Catholic country are rehearsed here in the sense that this triptych is about entrapment in convention at the same time that women are supposed to be free.

Rego is a Portuguese émigré living in England which gives her a direct and more objective view of the position of women in her country, where they are still not fully emancipated. Most of her pictures are about women and family – topical and appropriate in the context of Feminism, which we looked at in Chapter 4. In an article called 'Imagiconography' (written by her husband, the artist Victor Willing, before his death in 1988) it is suggested that Rego is preoccupied with two main themes, domination and time passed. Willing defines them like this:

> Domination takes many forms. We see for example the child dominated by the parent or teacher; the individual by the State; the psyche by the dream or ideal; the personality by passion; conscience by guilt . . .

and then later on Willing says:

> This time theme is not typically nostalgic as the artist is commenting on the existence of the past in the present, not simply glorifying past time.
>
> (Catalogue of *Paula Rego*: 34)

We see in these pictures the domination of women's bodies by church and state and the kind of secret, private suffering it implies in terms of past and future. The triptych could be seen as a sequence of

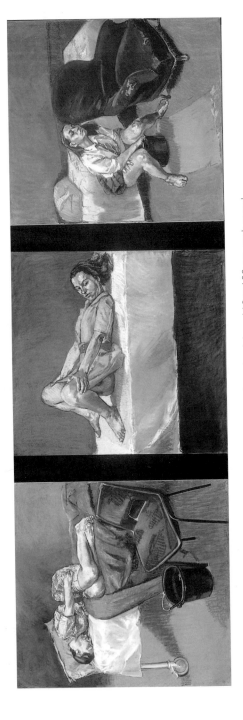

Plate 100 Paula Rego, *Triptych* (1998). Pastel on paper mounted on aluminium, 110 × 100 cm each panel.

© the artist. Courtesy of Marlborough Fine Art (London) Ltd.

film stills and it is well known that Rego has been influenced by the cinema, particularly the work of Walt Disney in *Fantasia* and *Snow White*. She is also a great admirer of Hogarth and you can see why, because these are paintings with a moral except that the narrative is not clear in the patronizing way it would be in a Disney film or as explanatory as a Hogarth painting. Rego says that her storytelling is a way of finding out what it is she wishes to say. Her husband explains it like this:

> We can see then several levels of content on different levels of con-sciousness: the story or ostensible subject; secondary content of a personal nature; painting about painting; painting about the artist painting this picture; the pre-conscious theme which is gradually revealed and unconscious personal content.
>
> (Ibid: 40)

So the iconography, or 'imagiconography' as Willing calls it, is inti-mately tied up with the images; it is personally imaginative and many layered so the meaning is not necessarily entirely decipherable by the spectator.

The technique Rego has used in these pictures is pastel and she is first and foremost a draughtswoman, making many preparatory draw-ings. But like another artist she admires greatly, Edgar Degas, Rego is uncompromising in the precision with which she uses the medium. The colours are stark and acid and the edges of the forms are clearly delineated, so you are in no doubt about the plastic qualities of the bodies in each of the pictures. This use of pastel, with its dense opaque quality, helps to enhance the unidealized and unblinking realism, which needs to include only what is necessary for this painful subject; there are no backgrounds and only the attributes required for the narrative are included.

REINTERPRETING ARCHITECTURE

Plate 101 Garden Quadrangle at St John's College, Oxford by Richard MacCormac, 1993–4

The most fascinating characteristic of this building is its use of dif-ferent levels and the feeling of being sometimes underground and sometimes above ground. The use of light to create space and pro-vide illumination is also intriguing because you often cannot see

immediately where it is coming from. The Garden Quadrangle is so called because it faces onto the garden of St John's College, which is particularly rich in trees; as you look out from this site you feel as though you might be in a wood, much as you do at many villas and palaces in Italy, like the Villa Borghese in Rome or those at Fiesole above Florence. The close relationship between buildings and nature is a strong characteristic of the English Picturesque tradition, where irregularity is part of the design. The role of the garden in the history of the English country house is a case in point and you are reminded of this here.

When you approach this new quadrangle, you take a meandering path from the great lawn at the back of the college; then you go down a passage open on one side to the garden and on the other decorated with shallow niches which extend from floor to ceiling; this then expands into a square space dominated by a circle in the ceiling which is open to the sky. On three sides of the square there are oak doors slatted with glass which are entrances to three rooms, a lecture theatre, a dining room and a reception area; the fourth side is open to the garden. Each room is effectively underground with light from a glass lantern in the centre of the ceiling and high windows at picture-rail height. Light is also borrowed from the square space outside and made to filter through frosted-glass screens on either side of the entrance doors.

As you come out of each of these interiors you catch sight of the stairs up to the terrace above. Here there are a series of buildings like little pavilions, which house undergraduate and postgraduate rooms. Pale whitish reinforced concrete, made to look like stone, is used in combination with yellow brick. At either end of the terrace are what look like round columns or lanterns where light is taken to the rooms below. Flower beds and evergreen bushes are arranged in blocks and contrast well with the colours of the building, making a dark medium and light tonal effect, which complements the woodland in the garden in front. There are steps and ledges at intervals, where you feel free to sit and talk or just look at the view. Everywhere you are aware of geometrical shapes, squares, circles and rectangles, and of being able to explore a controlled but meandering space.

Inside each of the pavilions is a spiral staircase made in pale concrete. The decoration on the walls is of smooth and rough concrete made into bricks. This gives the walls a warmth and variety so they can act as a foil to the pale oak of the doors. Glass in the doors

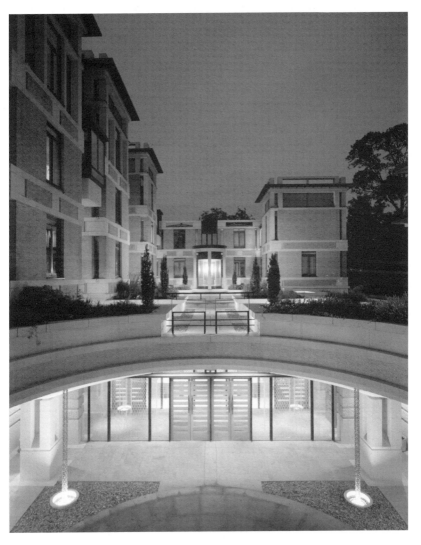

Plate 101 Richard MacCormac, Garden Quadrangle, St John's College, Oxford.
Image © Peter Durant/arcblue.com.

allows the light from windows inside to pass onto the staircase. In addition there is a lantern at the top through which light filters down too. The simple banister with its undulating steel rail adds to the feeling of spiral movement. Upstairs on the first floor there is a glazed niche where you can sit and look out onto the terrace and the trees beyond.

There are subtle references in many places to the classical tradition: the effect of the terracing and steps is similar to the garden of a classical villa; the circular opening above the quadrangle is like an oculus and connects with the idea of daylight coming through the top of a dome, as it does in the Pantheon in Rome. In the auditorium and dining room there are stretched domed ceilings like that of the breakfast room of Sir John Soane's House in Lincoln's Inn Fields. The borrowed light reminds one of Soane's mausoleum at Dulwich Picture Gallery. The brickwork and detailing in the upper storey at Garden Quadrangle are similar to the exterior at Dulwich. These classical and neo-classical references give this building a postmodern flavour, but it is not a pastiche because the classical tradition has been absorbed and re-stated in a new way. The space is meandering rather than flowing, and contemplative rather than dynamic, but that is entirely appropriate to the atmosphere and image of an Oxford college.

CONTINUITY

In looking at traditional subjects in modern art the first point that strikes you is the sheer variety of interpretation. Even so all the examples in this chapter belong to their period, just as works of art in the past have done; you would know that they were twentieth-century by the way they use the visual language of their time in their materials and techniques, in their interpretation of the subject and its meaning, or in their relationship with the spectator. They have not divided into Modernist and Postmodernist works in the same way as in other chapters, although you could say that Barnett Newman was Modernist and Mark Wallinger is Postmodernist.

But the main thrust of this chapter has been different; it has been about the subject-matter and the content of modern works of art, and the way they have still adhered to traditional subjects to express it. We have also seen a number of issues that have come up before like the relationship between fine art, photography and film, which we will explore further in the last chapter, the Epilogue. The expression

of pain and suffering after the two world wars that we see in the work of Nash and Giacometti or the extreme abstraction of Barnett Newman reminds us of Dix and Grosz or Mondrian and Jackson Pollock respectively. The survival of painting and its techniques has been significant too, in the work of Hockney and Close for instance; the same could be said of sculpture in the traditional craftsmanship of Giacometti and his contemporaries like Richier and Henry Moore. The less idealized treatment of the nude female figure by Freud, Savile and Rego follows up a theme from Chapter 1, which we saw developed by artists like Louise Bourgeois or Cindy Sherman in Chapter 4.

Perhaps this chapter could have been written by referring back to examples already looked at in this book, but the modern concern with traditional subjects is an area of interest in its own right in the twentieth century; it is still very much alive amongst those considered as individual artists and those seen as part of an avant-garde movement, as well as those belonging to both categories.

Chapter 9

Epilogue: Film, Photography and Fine Art

In the course of this book, film and photography have been mentioned many times. Even in Chapter 8 on traditional subjects, we have seen examples of the influence of film and photography on artists like Richter, Ruscha, Close and Rego. But the interaction between film or photography and fine art can be quite specific, and I want to have a look at this in a more concentrated way, starting with film.

It is often said that the cinema has taken away many of the subjects hitherto depicted in painting. Of course this is true in the sense that the business of telling a story in pictures has become the function of the film. The movie has taken away the role of the religious fresco cycle or the heroic battle painting; you could say for instance that the battle pictures of the Napoleonic era in France have become the war films of the modern period. However, this is an oversimplification because artists are still engaging with important issues connected with spiritual belief and contemporary events; Mark Wallinger and Gerhard Richter are examples of this. Many artists are fascinated by film; a recent development is video art, which we have already looked at in the work of Mark Wallinger, Bill Viola and Sam Taylor-Wood.

It might be even more interesting to explore some examples of the interaction of fine art with film and photography, and the way one has been used to enhance the other, in both directions.

SURREALISM AND FILM

Plate 102 Opening sequence of *Un Chien Andalou* by Luis Buñuel and Salvador Dalí, 1929

An important and interesting connection between fine art and cinema is that between Surrealism and the film. The collaboration

between Salvador Dalí and Luis Buñuel in *Un Chien Andalou* in 1929 and *L'Age d'Or* in 1930 must be the most famous example. In his autobiography, Buñuel described working on *Un Chien Andalou* with Dalí:

> A few months later I made *Le Chien Andalou*, which came from an encounter between two dreams. When I arrived to spend a few days at Dalí's house in Figueras, I told him about a dream I'd had in which a long tapering cloud sliced the moon in half, like a razor blade slicing through an eye. Dalí immediately told me that he'd seen a hand crawling with ants in a dream he'd had the previous night.
>
> (Buñuel, *Autobiography*: 103–4)

These images, of course, made the opening titles of the film and about the making of it Buñuel goes on to say:

> Our only rule was very simple. No idea or image that might lend itself to a rational explanation of any kind would be accepted. We had to open all doors to the irrational and keep only those images that surprised us, without trying to explain why.
>
> (Ibid: 104)

Buñuel went on to make a whole string of films like *Belle de Jour* in 1967 or *That Obscure Object of Desire* ten years later, in which Surrealist (and particularly, Freudian) elements, feature all the time. The fundamental aspect of this as we have seen is dislocation, often seeing familiar things in unfamiliar situations as you might in a dream. In the section on Surrealist composition in Chapter 5 we saw how Giorgio de Chirico used this sort of effect in his appropriately named Enigma paintings and how he influenced that great maker of Surrealist images, Max Ernst. Buñuel's interest in dislocation is similar. In a chapter entitled 'Dreams and reveries' in his autobiography he describes a number of dreams that contain this kind of experience:

> I used to dream that I was in a church. I press a button behind a pillar, the altar pivots slowly, and I see a secret staircase. Nervously I descend the stairs and find myself in a series of subterranean chambers. It's a long dream and mildly upsetting, a feeling I enjoy.
>
> (Ibid: 95)

Plate 102 Luis Buñuel and Salvador Dali, opening sequence of *Un Chien Andalou* (1929).
© DACS. Courtesy of Contemporary Films, London. Still: courtesy of the British Film Institute.

So the idea is to disrupt and dislocate your expectations which the cinema is very capable of doing. The very fact of entering the dark place that is the cinema and seeing pictures coming before your eyes is like the experience of a dream and films are sometimes referred to as celluloid dreams. A great film director who understood this as well as anyone was Alfred Hitchcock. Hitchcock acknowledged the importance of Surrealism and its powers of suggestion and indeed its origins in symbolist writers such as Poe and Lautréamont:

And Surrealism? Wasn't it born as much from the work of Poe as from Lautréamont? This literary school certainly had a great influence on cinema, especially around 1925–30, when surrealism was transposed onto the screen by Buñuel with l'*Age d'Or* and *Un*

Chien Andalou, by René Clair with *Entr'acte*. . . . An influence
that I experienced myself, if only in the dream sequences and the
sequences of the unreal in a certain number of my films.

(Catalogue of *Notorious: Alfred Hitchcock and
Contemporary Art*: 14)

In his films, Hitchcock is the master of seeing the unfamiliar in the
familiar to create a menacing or uncertain atmosphere. All of us can
remember sequences or bits of sequences in which this is achieved
with great skill, like the one in *The Birds* which starts with a single
black bird on the climbing frame in the school playground and builds
until it is literally covered with them. Less well known or under-
stood is that Hitchcock too collaborated with artists, notably
Salvador Dalí for the dream sequence in *Spellbound* with its curtain of
floating eyeballs. These kinds of general points are worth making, but
we need to go on now and make some more detailed analyses of the
interaction between fine art and film. For parts of these sections I am
particularly indebted to two essays by Christopher Frayling in the cat-
alogues of two exhibitions entitled *The Visionary Art of Ken Adam*
and *Spellbound*.

FILM-SET DESIGN

Plate 103 *Nighthawks* by Edward Hopper, 1942

**Plate 104 The Nighthawks Bar set in *Pennies from
Heaven* designed by Ken Adam, 1981**

This is another interesting example of the interaction between fine art
and the cinema. The film-set designer Ken Adam used the image
from *Nighthawks* for the film based on Dennis Potter's television
series *Pennies from Heaven*, which was transposed from 1930s
England to the Chicago of the same period. As we shall see, Adam
describes vividly how they used a number of images to create the
street in the film, including Hopper's picture.

Everything in the *Nighthawks* picture is sharply defined, particu-
larly at the edges of the canvas; this is helped greatly by the strong
chiaroscuro and the dramatic lighting; the contrast between the
transparency of the interior of the bar and the opacity of the back-
ground enhances the light effects as does the colour; the opaque
brick red of the building behind is picked up in the woman's dress

and complemented by the acid green around the bar window; the complementary relationship between red and green is seen also in the green blinds of the background building; the yellows on the door to the far right and down the side of the window help to emphasize the dark blues in the men's jackets and the paler blue across the street.

But most of all this painting is about atmosphere, in terms of the relationship between the men and women in the bar. The man on the side nearest to us is isolated and lonely, all the more so because the other three appear to be conversing together. You are not sure what the connection is between the man and the woman – are they strangers or companions for the evening? – but they do not look as if they are man and wife. In the drawing Hopper made for this picture there was greater intimacy between the man and the woman to start with; in the painting he increased the distance between them and moved the barman further away, so that the atmosphere becomes cooler and more enigmatic. Hopper altered a number of other elements in order to sharpen up the composition, particularly around the edge where he changed the position of the door and the urns in relation to the upright window bar. He also darkened the background in order to make the contrast with the pale interior walls much more telling.

Like other artists of the twentieth century whom we have looked at, Hopper had been fascinated by French nineteenth-century Symbolism and its ideas about suggested meaning. He had studied in Paris in the early 1900s and made several trips there between 1906 and 1910; he remained fond of the poetry of Verlaine and Rimbaud throughout his life. He was quite clear about what he wanted to express in *Nighthawks*:

> *Nighthawks* seems to be the way I think of a night street. I didn't see it as particularly lonely. I simplified the scene a great deal and made the restaurant bigger. Unconsciously probably I was painting the loneliness of a large city.
>
> (Catalogue of *Edward Hopper, the Art and the Artist*: 63)

Certainly loneliness and lack of communication between people is a recurring theme in many of Hopper's paintings as he records it in the office, the hotel and other urban or semi-urban settings. He too was fascinated by the cinema and is supposed to have told a friend:

> When I don't feel in the mood for painting I go to the movies for a week or more. I go on a regular movie binge!
>
> (Ibid: 58)

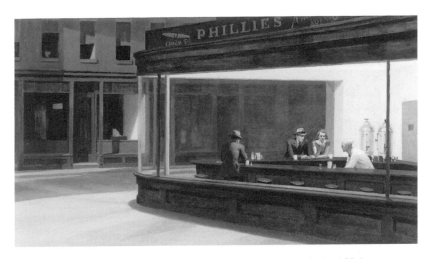

Plate 103 Edward Hopper, *Nighthawks* (1942). Oil on canvas, 84.1 × 152.4 cm.

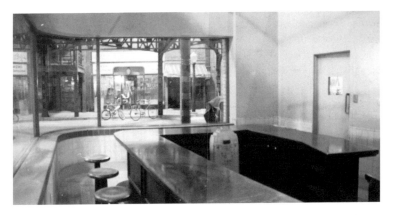

Plate 104 Ken Adam, 'Nighthawks Bar'. Set designed for *Pennies from Heaven* (Herbert Ross, 1981).

So it seems appropriate that some of Hopper's work has been used in films. *Nighthawks* proved very helpful to Ken Adam when he designed the bar in *Pennies from Heaven*:

> The reality of an actual street was elusive, but with our superb craftsmen and painters I think we managed to get it. The street was designed for interiors and exteriors, and included Arthur's record shop, the Nighthawks bar and the cinema. Herb (Herb Ross, the director) was particularly keen on some of the painters of that period, like Reginald Marsh and Edward Hopper. So I incorporated Marsh's *A Movie Theater* and Hopper's *Nighthawks* bar into the street. The employment agency and the pawnshop came from photographs by Walker Evans, and a second floor fur shop was also included. It became a jigsaw puzzle of varying artists of the period.
>
> (Catalogue of *The Visionary Art of Ken Adam*: 112)

The set is made up of lots of different kinds of pictures, as you might find in a collage, but instead of being juxtaposed they are put into a logical space. The photograph is taken from inside the bar and the light is blander, because it is daylight and the spectator feels more down-to-earth when looking at the set rather than at the slightly spooky atmospheric painting. The set needs to be brought alive by the presence of the actors and the moving-image camera before its full effect can be seen. This aspect of movie making is very important, as we shall see in the next section.

Plate 105 Drawing for The War Room by Ken Adam, 1962, in *Dr Strangelove or: How I Learned to Stop Worrying and Love the Bomb* directed by Stanley Kubrick, 1964

Ken Adam is best known for designing the sets and props, like the famous Aston Martin, for the James Bond films; he is very interesting when he talks about the need to make the imaginative reality convincing for the narrative just as painters had done in the past when wanting to tell a story. For the film *Goldfinger*, Adam had to imagine the interior of the gold bullion room at Fort Knox where nobody except a select few are allowed to visit so he could not see the real place. He described his design, where he had stacked the gold from floor to ceiling behind bars:

In reality, no vault would ever look like that, because you would never stack gold more than a couple of feet high. I had seen that for myself at the Bank of England. The gold would be much too difficult to move about. But I decided that to stack the gold up, forty feet high, would look interesting for the biggest gold depository in the world. After all, the public wanted to see gold! You have to convince people about your visual ideas. . . . Everyone is now convinced Fort Knox looks like that. As a film designer you can create a reality which is more acceptable to the public than the actual thing. I'm sure the inside of Fort Knox is very dull with low vaults and a few trolleys travelling around.

(Ibid: 42)

The need to create an environment that is imaginatively convincing and feels real is the most important ingredient for narrative and this is even more true of *Dr Strangelove*. The War Room is one of the most inventive film sets ever created, for a compelling film about one of the central and most pressing issues of the twentieth century: what to do about war, the nuclear bomb and the prevention of Nazism or its equivalent ever happening again.

The room is shaped like a giant loft space with what would be the roof sloping at a steeper angle on one side than on the other. The right-hand side is covered with huge maps. In the centre, lower down, is the round War Room table lit by a circular lamp from above which creates a pool of light in the centre of the space. The initial studies show the room with two tiers but eventually that idea was scrapped in favour of the design in the final drawing. Originally there were going to be onlookers observing from above but in fact, as it turned out, the isolation and insignificance of the members of the War Cabinet is better expressed by them being all by themselves in this vast space.

Adam's drawing style has been compared with that of the printmaker Giovanni Battista Piranesi (see *Learning to Look at Paintings* pp. 192–5) or the French eighteenth-century architect Etienne Louis Boullée. Certainly the menacing quality reminds one of Piranesi and the scale is close to Boullée; but what makes Adam different is that these imaginative drawings are made to 'come alive' on film. So real are they that when Ronald Reagan became president he thought this was the War Room in the Pentagon and asked to be taken to see it. The story is significant because Reagan had been a film star and should perhaps have realized it was imaginary, which only goes to prove how believable it was.

Plate 105 Ken Adam, 'War Room'. Set designed for *Dr Strangelove* (1962; extended 1999). Felt-tip pen on card, 31.5 × 80 cm.
Courtesy of Ken Adam.

The drawings are very expressive of the kind of space which is required to create the appropriate effect. Adam found the felt-tipped flow pen to be best because it helped him with depicting atmosphere with broad strokes and for emphasis of tonal contrast as you would do with pen and ink. His drawings are expressive in the sense that they carry an emotional charge and this is because of the deliberate exaggeration of the contrast between light and dark and the energy of the line and tone. You look at the final drawing as if at a wide screen and your eye is directed to the small figures in the middle, which is the area of greatest contrast: they are dwarfed by the maps on the right and the immensity of the surrounding space redolent of the huge issues at stake. This lighting of the figures in the centre was crucially important to Stanley Kubrick as the director, and he and Adam spent some time experimenting with it:

Stanley does it; he's a brilliant camera man. He wanted only source lighting. I had designed a circular light fitting that could be suspended. We sat in my office and experimented with varying types of photofloods. I would sit in the chair, and he'd put up a photoflood at a certain distance to see how light would fall on my face. The lighting of all the personnel around the table was done through that circular light fitting.

(Ibid: 69)

This makes it very clear that it is the designer's job to bring the director's visualization alive and emphasizes the collaborative nature of film making.

In 1964 *Dr Strangelove* brought us face to face with our anxieties about the bomb and our possible extermination by it, and our fears of Fascism and Nazism and what had so recently happened in Europe. The way the film deals with its themes is through satirical comedy, a kind of twentieth-century version of Hogarth's comic history painting in which the audience was made to laugh but also to think and take in a serious moral message about contemporary life (see *Learning to Look at Paintings*, pp. 130–3). In a recent interview the film director Barry Sonnenfeld described how *Dr Strangelove* has been a constant source of inspiration to him and he has lost count of how many times he has seen it. He puts his finger on the fact that this is comedy with a serious message:

> Every performance, camera angle, location, line of dialogue in *Strangelove* is specific to this tone. Kubrick achieves this consistency by creating an absurd situation with absurd characters but making every actor play it straight. There is no one in that movie who is noticeably performing in comedy.
>
> (Barry Sonnenfeld interviewed by Sarah Donaldson, *Daily Telegraph*, 27 July 2002)

So the audience has to make up its own mind not only about what is funny but what the serious message is; it is a classic case of film being able to do what painting used to do. But, as we have seen in the work of Paula Rego and others, there is no reason why the two should not exist side by side; they are not mutually exclusive. Ken Adam certainly sees both fine art and film as having been a great inspiration to him; he was trained as an architectural draughtsman at the Bartlett School of Architecture but he left after two years because he felt the teaching was unimaginative, although the techniques of architectural drawing have stood him in good stead. He also came into contact with modernist architecture through the M.A.R.S. group, where he worked in his spare time. He was born and grew up in Berlin until his family left in 1934 as part of the diaspora of those who wanted to escape the Hitler regime. It is that background of film making, architecture and painting that he believes formed the foundation of his work as a designer:

> The Berlin of the twenties formed the foundation of my future education. . . . The Berlin of the U.F.A. Studios, of Fritz Lang, Lubitsch and Erich Pommer. The Berlin of the architects Gropius, Mendelsohn and Mies van der Rohe. . . . The Berlin of the painters Max Liebermann, Grosz, Otto Dix, Klee and Kandinsky.
> (Catalogue of *The Visionary Art of Ken Adam*: 48)

So Adam recognizes not only the early films as formative but also the architecture and fine art of the period, some of which we have looked at earlier in the book; for him the interaction between fine art and film has been both creative and instructive.

Plates 106 and 107 *Three Studies for Figures at the Base of a Crucifixion*, **by Francis Bacon 1944**

Plate 108 The Creature from the film *Alien* directed by Ridley Scott, 1979

In the catalogue to the *Spellbound* exhibition at the Hayward Gallery in 1996, Philip Dodd mentions the influence of Francis Bacon on the director Ridley Scott and it is interesting to analyse these two images from the point of view of interpretation. Francis Bacon's picture is meant to be frightening because it calls up imaginative associations with man as beast or predatory bird. In the central panel (Plate 107, detail), the body is bird-like with long legs and neck, and faintly resembles an ostrich. But the head is blindfolded with a bandage and the mouth is snarling and gaping. The figure on the left Plate 106 has a mouth that appears to be screaming so much that the face appears to be all mouth; the rest of it could perhaps be a four-legged animal, except that it only has one foreleg and we cannot see the ones that should be at the back; it stands on what looks like a bed of nails and it is clearly suffering. The figure in the right-hand panel has more human features, at least in the relationship between the head and neck and shoulders. It looks as though it might be kneeling in a long skirt but the face seems to have two noses and is grossly deformed. All three figures are set against an opaque blood red background.

The screaming mouth of Bacon's central figure was the inspiration for the Creature in Ridley Scott's film *Alien* of 1979 (Plate 108). Here, the spectator's fear arises from the Creature's apparently human rather than animal appearance. When you look at the

photograph of the upper half of the Creature, the mouth could be taken off a skull and the head is shaped like one too. The chest area looks like a rib cage and we can just see an arm, so something that could not possibly be human has human associations in a horribly subhuman context. In the end of course the figure looks quite different, but the initial inspiration came from Bacon's painting.

It is also well known that Francis Bacon himself was influenced by film and the whole idea of moving pictures; he acknowledged his love of the cinema and the photograph in conversation with David Sylvester in 1992. Sylvester asked Bacon about the influence of Eisenstein's film *Battleship Potemkin* and the famous still of the screaming nanny in particular. Bacon answered like this:

> It was a film I saw almost before I started to paint and it deeply impressed me – I mean the whole film as well as the Odessa steps sequence and this shot. I did hope at one time – it hasn't any psychological significance – to make the best painting of the human cry. I was not able to do it and it's much better in the Eisenstein and there it is.
>
> (David Sylvester, *Interviews with Francis Bacon*: 34)

Bacon is not interested then in the psychological impact of the screaming – as Munch was (see Chapter 1) but more in its form. Later in the conversations with David Sylvester, when asked about this, Bacon said:

> Whether one is saying anything for other people I don't know. But I'm not really saying anything because I am much more concerned with the aesthetic qualities of a work than perhaps Munch was.
>
> (Ibid: 82)

The preoccupation with the form of the head or the body comes out very clearly in Bacon's life paintings, where the figure often looks as though it is moving. In real life it is often impossible to see the whole of a person because they are constantly moving around so the form seems dislocated. But Bacon's understanding of the human figure allows them to hang together even though parts may appear to be missing. So he is interested in distortion not for emotional expression but more for what it does to the shapes in a more abstract sense.

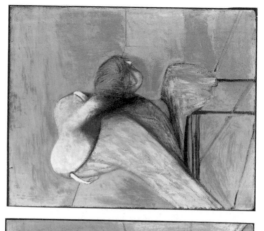
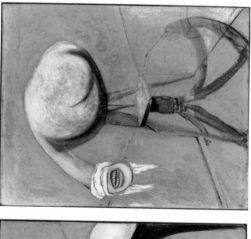
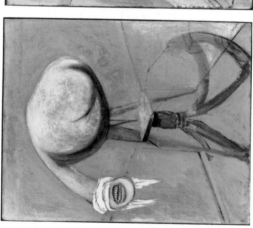

Plate 106 Francis Bacon, 'Three Studies for Figures at the Base of a Crucifixion' (1944). Oil on canvas, 940 × 737 cm each panel.
© Tate, London 2003.

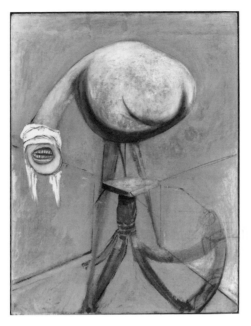

Plate 107 Francis Bacon, detail of central figure from 'Three Studies for Figures at the Base of a Crucifixion' (1944). Oil on canvas, 940 × 737 cm each panel.
© Tate, London 2003.

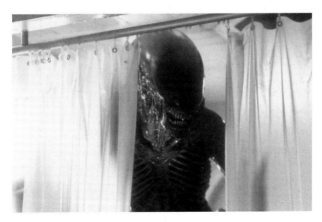

Plate 108 Creature from *Alien*, directed by Ridley Scott (1979).
© Twentieth-Century Fox. Courtesy of The Kobal Collection.

FINE ART, FILM AND ADVERTISING

Ridley Scott, who directed *Alien*, came out of the milieu of the Royal College of Art, which was responsible for promoting some of the ideas of the Independent Group. This group, which we looked at in Chapter 5, developed into what came to be known as Pop Art. They wanted greater recognition of the visual imagery of the advertising world and less division between fine art and film, photography and the commercial world of graphic design and advertising:

> Scott went on to the R.C.A's Post-Graduate school of Graphic design at a key moment in its development: a course devoted to Television and Film Design (taught by George Haslam) was introduced in October 1958 just as Scott was beginning; the role of 'photography as a design medium' was billed in the prospectus as a 'recent addition'.
>
> (Catalogue of *Spellbound*: 119)

Scott trained as a graphic artist but had the opportunity at the Royal College to move in and out of fine art, to study photography and to make films; eventually he went into advertising and we have seen how that world became important to fine art in the work of Andy Warhol in America. Scott says that it was this that was crucial in his development as a film director:

> My training in commercials was really my film school. It helped build my awareness of how to present and – 'manipulate' is a bad word – *fascinate* the audience and hold it in a kind of dramatic suspension. I learned how to communicate immediately, to use every conceivable visual and aural device, to work on the scenes and grab the audience's attention.
>
> (Ibid: 123)

It is well known that advertising film techniques influenced Scott's film *Blade Runner* where the superimposition of one image on another is a key characteristic of the film; it shows the influence of collage and of Surrealism in the sense that compositions are put together by juxtaposition of objects or images rather than by any overall geometrical framework, as we saw in Chapter 4. For this reason *Blade Runner* is seen as Postmodernist and less coherent in a traditional narrative sense:

The combination of Scott's background as a postgraduate student at that particular time, his apprenticeship as a BBC set designer and his 'film school' training in commercials – sometimes several a week (I still think of ads as little films) – certainly helps explain his unusually *visual* approach to big budget movie making. A clichéd criticism of his work is that design comes first, with words a poor second, to which Scott has replied that film is, after all, supposed to be a visual medium.

(Ibid: 123)

You could say that in making films you are using the camera instead of the brush to make pictures. Certainly it has often been said that the collaborative work between different disciplines on a film is like that of a Renaissance workshop.

PHOTOGRAPHY AND FINE ART

Still photography of course is not usually a collaborative process in the same way as film making but the photograph and its impact on art has been the subject of debate since the 1850s. Gerhard Richter, whom we saw using photographs very creatively, is a great admirer of Courbet, around whom the arguments about the legitimacy of photography crystallized. Courbet used photography – for instance, in his paintings of nudes like the *Bathers* – and Delacroix was interested in its effects, as we saw in Chapter 1. In a footnote to an essay on Richter, J. F. Chevrier suggests that it was Courbet's friend, the critic Francis Wey, who saw that

> Courbet proved that photography could not only furnish painters with useful models, but also with a criterion of truth. It was by following this criterion, and not by refusing it in the name of an historical ideal that the painter could – and should – surpass the exactitude of photographic reproduction.
>
> (Chevrier, in, *Photography and Painting in the Work of Gerhard Richter*: 54)

Using photographs as models enabled you to come at your work in a fresher and more direct way, without recourse to historical precedent or the classical tradition. Certainly the relationship between photography and fine art has become much closer in the twentieth century. Photographers like Man Ray or Brassaï or Gursky or Struth,

whom we are going to look at now, are regarded as artists in their own right; once again traditional lines of demarcation have evaporated.

Plate 109 *Lee Miller: Torso* by Man Ray (Emanuel Rudnitsky), 1930

Man Ray's image is deliberately manipulated. We do not see the head or the lower part of the body below the navel, and the forearm on the left appears not to exist. The torso is presented as if it were a classical fragment, but we know that the head is really there as is the arm and hand, and that the lower part of the body is only hidden by underclothing of one sort or another; there is even the hint of a thigh on the right hand side and a dark shadow where the genitalia would be. The light falls on the body through a lace curtain, or something like that, so that the striations of light and dark enhance the sensual and erotic qualities of the female form in the way the lines seem to travel over it like patterns in the sand of the desert.

At the same time though, there are other ambiguities, like the muscular upper arm on the right or the enlarged muscles in the shoulder and neck; these look more like the characteristics of a male body rather than a female one, and the gender of the figure becomes for a moment ambiguous even though the rest of it is evidently feminine. There is a suggestion here that this picture could be interpreted by the spectator in a number of ways, as we have already found with Duchamp's work, and with Dada and Surrealism. Man Ray was associated with these movements and the group around André Breton which we discussed in Chapter 3.

Plate 110 *Statue of Marshal Ney in the Fog* by Brassaï (Gyula Halasz), 1932

Another photographer, Brassaï, was also associated with the Surrealists and he believed in deliberately not interfering with the image and allowing it to speak for itself. In the *Statue of Marshal Ney in the Fog*, the full subtlety of the image does not strike you at first because you are looking at the beauty of the tonal contrasts and the way they make the composition work. The dark area in the foreground is contrasted with the silvery, medium and lightest tones in the background. You feel you are standing immediately behind the statue so the figure and the plinth rises high above you. The marshal

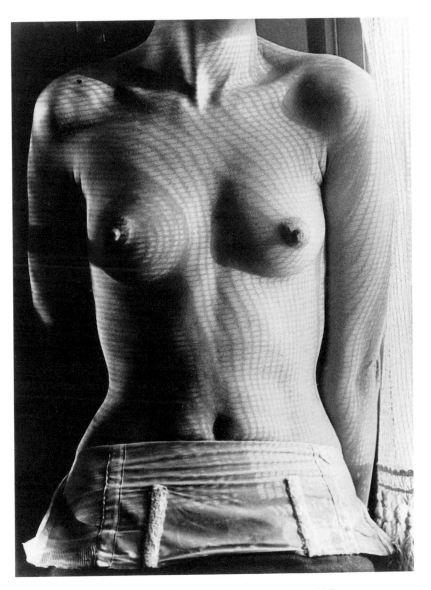

Plate 109 Man Ray, *Lee Miller: Torso* (1930). Photograph, 29.6 × 22.5 cm.
© Man Ray Estate/DACS. Photograph courtesy Lee Miller Archives.

is brandishing his sword and shifting his weight as if to move forward into action. For a minute, you think he could be a real person because of the way the light picks up the folds of his clothes, the spur on his left foot and the angle of his head.

When you look into the background, you are suddenly surprised and mesmerized by the brightly lit hotel sign shining like a beacon in the fog, without any other indication of a building being nearby. You cannot even see the street. So, how far are the railings from the background, and where is the hotel? What else might loom out of the fog and what do the lightest areas represent? When you are looking at the statue and its railings you feel you know where you are, but beyond them, all is uncertain and disorientating: even the hotel sign appears to be floating in the middle of nowhere. This mysterious atmosphere adds interest and visual focus to the photograph, not by ambiguous suggestion as in Man Ray's picture, but in a more straightforward and direct way.

Brassaï himself was very clear about this distinction between the manipulated and the natural image, and the differences of approach between him and Man Ray:

> We were almost at opposite extremes in our approach to photography. Man Ray wanted to remove all referenceto reality, whereas I was looking for the surreal in reality itself. If I could be said to have invoked the god of Chance as I took my picture, Man Ray did the same in the darkroom, hoping to create surprises and accidental effects by manipulating his negatives: his Dada frame of mind even influenced his photography.
>
> (Catalogue of *Brassaï*: 160)

Brassaï suggests that in his own photographs the Surrealist aspect was not achieved by the manipulation of the negatives in the darkroom but through reality made more surreal by his way of seeing:

> The Surreal exists within us, in the things which have become so banal that we no longer notice them, and in the *normality of the normal*.
>
> There was a misunderstanding. People thought my photographs were 'Surrealist' because they showed a ghostly unreal Paris, shrouded in fog and darkness. And yet the surrealism of my pictures was only reality made more eerie by my way of seeing.
>
> (Ibid: 160)

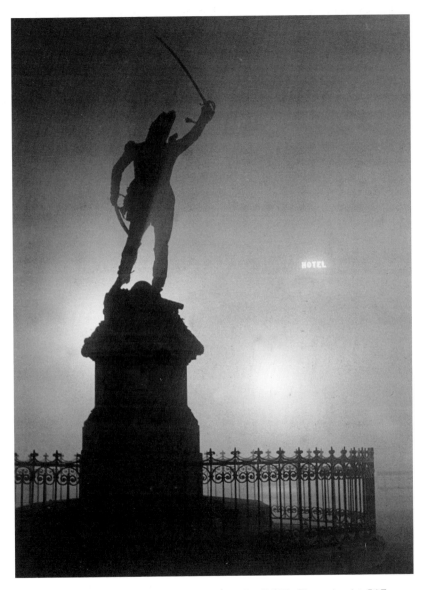

Plate 110 Brassaï, *Statue of Marshal Ney in the Fog* (1932). Silver salt print, 56.7 × 40.5 cm.

Brassaï Archives: N. 165 AM 1987-624. © Estate Brassaï – RMN.

Most of Brassaï's photographs were published in books such as the one he refers to here, called *Paris after Dark*; they would therefore have been for the most part book-plate size. More recently with the advent of large-scale colour photography, other possibilities have been opened up.

Plate 111 *Chicago Board of Trade II* by Andreas Gursky, 1999

Both Gursky and Struth work with the colour photograph on a large scale, a scale which is usually associated more readily with paint- ing. One of the main reasons for their ability to do this is the size of the negative on the one hand and on the other, technical advances in colour photography. In the catalogue of the recent Gursky exhibi- tion, this development was explained:

> Colour photography had been available for some time to amateurs content with Kodachrome slides or prints ordered at the drug- store, and for still longer to professionals who had the money and the skill for the expensive and demanding process. But it was only in the 1970s that color materials had become cheap and easy enough for independent artists to work with them.
>
> (Catalogue of *Andreas Gursky*: 21)

These and other technical developments have allowed the making of colour prints as big as 2 m high by 5 m wide without losing detail.

In the *Chicago Board of Trade*, Gursky evokes the teeming world of business and the global markets; the people fill the frame from edge to edge. He makes us see more detail than we would be able to see with the naked eye, but the pictorial arrangement is also very important here in the disposition of the primary and complementary colours and how they are picked up in different parts of the picture. Blue, green, yellow and red have been enhanced to give them greater prominence; Gursky regularly uses a computer to alter his images. You look at the trading floor from above as if you were scanning it yourself through a lens; you see people everywhere looking at screens, some gesticulating, some just sitting or standing; you can almost hear the noise that would be rising up towards you.

There are no defined edges to the composition, so you feel that the scale of the subject is even bigger than what you are being shown and this makes you feel you are part of it. This huge picture measures

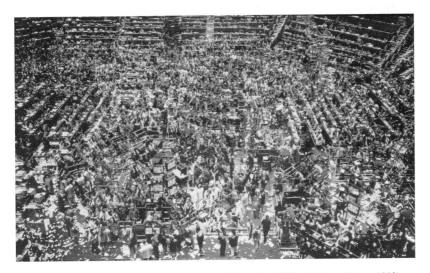

Plate 111 Andreas Gursky, *Chicago Board of Trade II* (1999). C-Print, 81½ × 132⅝ ins.
GURA.PH.9528 © Andreas Gursky/DACS, London 2003. Courtesy of Matthew Marks Gallery, New York.

over 2 m by 3 m including white mount and frame; the image is set between two pieces of plexiglass to give it greater substance and clarity and to prevent the surface appearing too much like paper; it has been made more monumental and more worth looking at because of its scale, its order and its composition. Also the sharp detail of the print makes it stand out. We are made to feel that we are at the centre of our contemporary world, where screens and digital communication have become a major means of contact between human beings. This presents a complete contrast to the picture by Thomas Struth.

Plate 112 *Pergamon Museum II* by Thomas Struth, 2002

Thomas Struth's picture of the Pergamon altar in the Pergamon Museum in Berlin is about the importance of museums in twenty-first-century culture and the contemplation and stillness of people.

The world rushes about frenetically as it does in Gursky's picture but in the museum all is quiet and time lengthens, so you can look, think and focus on individual items. Instead of pictures flashing by and being juxtaposed arbitrarily these museum objects are there permanently for you to look at.

When you stand in front of this photograph you immediately feel a sense of space and of the monumentality of the Pergamon altar; it was discovered in Turkey by German archaeologists in the nineteenth century and bought from the Turkish government. Struth creates a light and airy space in which the ancient monumentality of the remains of this Greek building can be clearly seen; his large photograph brings out the white of the museum walls and the luminosity of the light shining through the skylight and this shows off the various shades of buff and oatmeal in the stone. The spectators, wearing subtle but different colours, look dwarfed by the architectural forms and the space surrounding them; the attitudes of their bodies communicate rapt attention and a sense of deep concentration in front of one of the masterpieces of classical art.

This picture is the second in a series of five where Struth has employed extras for his composition and placed them where he wants them to be. Generally though, Struth does not manipulate his pictures; in a recent article in the *New York Times* it was suggested that he does not like artificiality:

> Artificiality bothers him even in traditionally posed genres. . . . The same ethos keeps him from digitally manipulating his images, a technique that has become popular with other well known photographers like Mr Gursky and Jeff Wall.
>
> 'I'm not radically against it', Mr. Struth said, 'But somehow you fog the information stream. I'm still very interested in the things you lose with that – the immediacy and the psychology of the picture. . . . Most "action" photographs are very unsuccessful. Increasing speed is not my department. There are enough people taking care of that'. Instead he said he thinks of 'stretching a moment and making it longer, which opens it up to a new manner of understanding'.
>
> (*New York Times*, 28 April 2002)

Where Gursky is recording frenetic activity in a global market, Struth is looking at the opposite, the silence and contemplation of people in a museum.

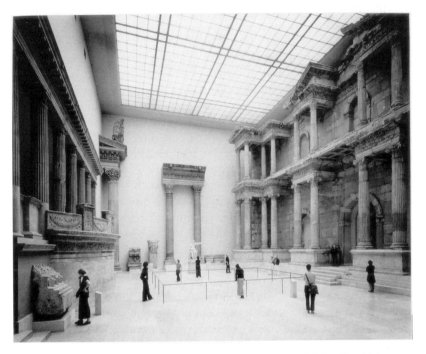

Plate 112 Thomas Struth, *Pergamon Museum II Berlin* (2002). C-Print, 73 × 91 ins
Courtesy of the Marian Goodman Gallery, New York. Photograph

It is no accident that several of the late twentieth-century buildings we have looked at in this book are museums. They are the new temples of the postmodern era, a new kind of sacred place in our secular world; some people think that in this sense looking at art has replaced going to church. All through this book we have considered artists who believed in the spiritual or transcendent dimension in art from Kandinsky to Wallinger; so, far from disappearing from modern art, it is still very much present.

SOME THEMES TO CONSIDER WHEN
LOOKING AT MODERN ART

It would be difficult to summarize what has been discussed in this book because it has not aimed to present a particular point of view of modern art, but has tried instead to see it from a number of angles. However, several themes have emerged which could be helpful as pointers in guiding us to look at modern art in a more objective and analytical way; some of these are concerned with why modern art works look as they do and some are of a more cultural nature, in terms of links with major events and theoretical background.

We started with four major directions at the beginning of the twentieth century. First there was Cubism, which was fundamentally about re-orientating the way we look at and experience the world. Then, only slightly later, there was Futurism which was concerned with embracing modernity, especially the industrial urbanity of the city and the motor car. After this came Duchamp and his search for new meanings in modern art and his emphasis on the role of the spectator in his new kind of iconography. At the same time there was Expressionism and the desire to communicate new spiritual and emotional qualities in the visual arts. Each of these themes can be seen to evolve and change during the twentieth century; we explored these themes further on in Chapters 3 and 4, and then again – from different angles – by looking at composition, space and form, and light and colour in Chapters 5 to 7.

Also there has been a continuing concern with tradition among artists who still continue to work within the established genres of subject-matter but often in very original ways. These were considered in Chapter 8, but in fact we have seen a dialogue with the past that has gone on since early in the century with Picasso and the tradition of painting the nude figure, or Boccioni and baroque sculpture. Later on, we discovered Ian Hamilton Finlay looking at Claude and Poussin, and Bill Viola studying Pontormo and Hieronymus Bosch. So the view that modern art is entirely without respect for tradition is unfounded and not just in the work of the more conservative artists but in that of the avant-garde as well.

Another issue which has arisen in several chapters is the difference between the conceptualization early in the century and Conceptual Art during and after the 1960s. In Cubism, Futurism and Vorticism, the desire was to communicate a more dynamic view of the world and express much that lies beneath the surface of appearances. But

the development of Conceptual Art was more concerned with meaning and the move away from easel painting and traditional forms of sculpture into three-dimensional design and installations; the theory here is very important and sometimes makes this work seem more like philosophy than art. But this cerebral and intellectual direction of much Conceptual Art like the Minimalism of Robert Morris or Dan Flavin is not the whole story; there is an emotional appeal in the work of Joseph Beuys or Mona Hatoum, for instance, which arouses a more intuitive, emotional and instinctive reaction in the observer.

In this context one of the most significant themes to emerge in the evolution of modern art has been the growth in the importance of the spectator and their interaction with the work of art; this involves the need to keep an open mind but also to question, discuss and learn to develop one's own opinion by looking from a more informed point of view. This is about orientating oneself to where the artist is coming from and understanding some theory, particularly about the chronology and sensibility of Modernism and Postmodernism, which we have been exploring all the way through this book. This has been another major theme which, as suggested in the introduction, has formed a background to the consideration of what happened to the visual arts earlier and later in the period.

In terms of techniques which have been important, inventions like the collage have brought painting and sculpture closer together and made new kinds of composition possible in all sorts of fields. The abandonment of traditional skills in fine art in favour of ready-made materials has changed the look of much visual art in an initially incomprehensible way; at the same time it is worth noting that, although it was beyond the scope of this book, the twentieth century has seen a great revival of traditional skills in the applied arts like the designing and making of furniture.

The development of science and technology in relation to art has been hugely influential. Early in the twentieth century the use of new materials like perspex and plastics enabled an artist like Gabo to express form through space. At about the same time, new possibilities were created in architecture through the invention of reinforced and pre-stressed concrete and steel beams, making the work of Frank Lloyd Wright and Le Corbusier achievable. Later in the century the development of computer-aided design made new shapes and forms realizable in a way they would not have been before as in the buildings of Liebeskind and Gehry or the high-tech feats in the work of Norman Foster at the British Museum for instance. The use of video

and photography has affected artists in all sorts of ways, as we have seen, particularly in the interaction between fine art and film.

In a more general and cultural way you would have to say that the huge growth in the number of visual images available compared with what people would have been able to see in the past, and the influence this has on the way we look at art, must be significant. The photographic reproduction of works of art means that we can familiarize ourselves with pictures before we go to look at the original. Walter Benjamin, whom we discussed briefly in the introduction to Chapter 5, thought that reproduction made works lose their aura in terms of the power of the original. But in fact most people would agree I think that there is no substitute for a visit to a gallery to experience the real work, even if it is not in its intended setting or is not meant to have a permanent identity like an installation. In this way the visiting of original works of art has become a kind of pilgrimage with people going to galleries in distant places to see specific examples.

The Pop Art movement took modern commercial and reproductive imagery to its heart and brought about a return to figuration. Andy Warhol celebrated the media and celebrity, which have since become mixed up with the visual arts, making it difficult sometimes to see them clearly. Now the advent of the knowledge of cyberspace makes for a different kind of awareness because it seems to be without boundaries in the normal sense of that word. Much experimental work is being done, but really the possibilities for art are still wide open; electronic means of expression are very much part of the postmodern sensibility because the images are mediated through reproduction and they do not necessarily lead to an unambiguous expression.

The influence of the study of psychology in all its forms has freed up behaviour and ideas in major ways; it has expanded what it is permissible for art to do and so virtually anything is possible. Whatever you think about this, it has been very liberating and makes it necessary for the spectator to become more discerning in their judgement about what is art. The disruption of traditional and social belief structures has been going on throughout the last hundred years, particularly through the influence of potent ideas in science and philosophy. These have been set in motion by thinkers like Einstein, Freud and Nietzsche and picked up by all and sundry because they coincided with the attitudes of the time. The two world wars caused enormous disruption and contributed to much recent thinking,

especially in reaction to the terrible happenings in World War Two. Since then, and particularly since the 1960s, our ways of thinking have been altered radically in the arts and humanities not least by movements like Existentialism, Feminism and Deconstruction.

We have seen that the utopian certainties and ideologies behind Modernism earlier in the century were questioned fundamentally after 1945. This has led to a more shifting and uncertain sensibility very characteristic of Postmodernism. We have been made aware all the way through this book that whilst these changes were not universal they have helped to reshape our ways of looking at and thinking about the world substantially. They form an important accompaniment and background to the process of learning to look at modern art.

This book has been about learning to look at modern art; it ends with a large colour photograph of people in a museum gazing at a great monument from ancient Greece. We began with Picasso's painting of *Les Demoiselles d'Avignon*, which largely repudiated classical art in favour of ethnographic traditions. Since then we have been on a visual journey during which we have been learning to look in a variety of ways which allow for understanding of modern art in terms of similarities to, and differences from, tradition.

Appendix I

Questions to ask yourself when looking at modern art

1. **Your initial response:** Analyse your reaction. Do you like it? Does it make you think or does it encourage you to look? Or does it do both?
2. **Type of work:** What kind of work do you think it is? Is it a painting, a sculpture, a collage, an installation, a three-dimensional design, architecture or something else?
3. **Aesthetic and pictorial qualities:** Can you see any aesthetic qualities in it? That is to say pictorial elements, composition, space, form, tone and colour?
4. **Subject-matter:** Does it have a subject? If so, what kind of subject? Is it a story? Is the subject the main figure or object depicted? Or is the subject the viewer's feelings?
5. **The meaning:** How important is the meaning? Is thinking more important than looking in relation to this work?
6. **The setting:** How important is the setting? How does it affect the work and your reaction to it?
7. **Spectator participation:** Think about your role as the spectator. How active are you meant to be?
8. **Your response:** Has your response changed while you have been looking? If so, how?

Glossary of some modern art terms

Modern art is so wide-ranging that its vocabulary can be extended almost indefinitely, making a glossary of this kind more like a dictionary. So this list of terms is selective and relates to those used in the text, in particular those words which we use in other contexts but which take on a different meaning in relation to modern art. Others, like 'iconography' for instance, are used in art history anyway but involve a different emphasis in relation to the more recent past. Some words on the other hand are the same as those used in *Learning to Look at Paintings* but are included here as well.

Abstract Often used to describe works with no recognizable subject; can also refer to the abstract or pictorial qualities like composition, space, form, tone and colour, as discussed in this book.

Acrylic paint A type of paint in which the pigment is bound in synthetic resin; it is soluble in water and yet more flexible than watercolour because you can change your mind when building up the tones and do not have to work always from the lightest to the darkest ones; it can be used in an opaque as well as a translucent way.

Airbrush An instrument that looks like a fat fountain pen with a reservoir for the pigment, which can be paint or coloured dye; a fine jet of compressed air picks up the pigment and blows it onto the surface to be painted. The main advantage of airbrushing is the almost imperceptible way the tones or colours in a picture can be graduated. Airbrushes vary in size according to whether they are used for large expanses of colour or fine detail. The technique originally came from commercial art, where it could be used for touching up photographs imperceptibly. See Chapter 8 on Ed Ruscha.

Anarchism The belief that society can govern itself without the state, the church or the institutions of capitalism; it lays more emphasis on liberty than on equality. It was widespread as a political philosophy in the second half of the nineteenth century and the first half of the twentieth; many artists were sympathetic to anarchism, such as Pissarro, Seurat, Picasso and Apollinaire.

Arcadia The classical ideal of nature, beauty and the natural world, in art a poetical or pastoral interpretation of landscape where no harm can come to you. See Chapter 3 and the comparison between Ian Hamilton Finlay and Nicolas Poussin.

Assemblage see **Collage**.

Avant-garde The 'advance guard', out in front, forward looking. Used since the nineteenth century to describe art that is in advance of public opinion and only understood by members of artistic circles who know how to look at it.

Beam Can be used in the sense of a beam (or beams) of light or supporting beams in a building. In particular steel I-beams are characteristic of some modern architecture, especially that of Mies van der Rohe who runs I-beams up the outside of his sky-scrapers to express the underlying structure, although they themselves do not always perform a functional purpose.

Brightness/dullness Terms used to describe qualities of colour, which are not necessarily tonal in the sense of being darker or paler: see Chapter 7 particularly on Pierre Bonnard.

Cadence A term normally used in relation to music, meaning the exact subtle quality of a particular sound; in the visual arts it usually refers to colour. The interaction between visual and musical terminology is common in writing about colour in modern art.

Cantilever A section of roof, a beam or a platform that protrudes from the wall of a building without any visible support, often because the reinforcing steel rods inside the concrete are providing it. See F. L. Wright and the Robie House in Chapter 6.

Chronophotography Pioneered by Etienne Jules Marey for taking sequential photographs to record movement. This was also done by Eadweard Muybridge. Muybridge's famous horses are separate sequential images of the horse's movements, whereas Marey's pictures of the bird's wing for instance show the sequence of movement within one photographic image. See section on Marcel Duchamp in Chapter 3.

Classical language of architecture A phrase used to describe the

characteristics of classical architecture and the terms by which the different parts of a building are known – for instance, pillar, pediment, portico, frieze, entablature and the order in which they are used in traditional buildings; it also implies harmony and proportion particularly that of the **golden section**.

Collage *Papier collé*, combine, assemblage, photomontage. All these words imply the same principle namely the use of what are called **found objects**, – photographs, paper or anything which has possibly been discarded – to make a picture or a three-dimensional work out of what would normally be regarded as rubbish. The composition will then be constructed or built from these objects; painting and/or drawing may be added to enhance the three-dimensional effects which are achieved without conventional tonal contrast or perspective. Invented by Picasso and Braque in 1912 as part of the development of Synthetic Cubism, collage was also used by Kurt Schwitters, Robert Rauschenberg and many others; it is an important development in modern art because of the way it has blurred traditional distinctions between painting and sculpture. The artists of the Pop Art movement also employed collage techniques but in order to release meaning rather than for aesthetic considerations. See Chapter 5.

Combine see **Collage**.

Commodification Has come to mean the making of products as easy and convenient as possible and turning everything into an item that can be bought and sold. See **consumerism**.

Commodity A product for sale. Ease and convenience is implied as well as commercial gain. Articles sold in supermarkets are commodities. The idea of avoiding treating works of art as commodities fuelled the development of **Conceptual Art** and the idea of the **installation**. See Chapters 3 and 5.

Computer program In modern art this usually refers to computer-aided design, like the CATIA program used by Frank O. Gehry (see Chapter 6). The use of computers in art is expanding all the time and it has moved out into all sorts of experimental work, which is at the cutting edge of this new technology.

Conceptual Art This term is used to describe a whole collection of types of art from the 1960s and 1970s onwards. Like much that is connected with modern art, the meaning is not precise; it can be used to describe land art, minimalist art, performance art and installations. This covers a huge range and includes artists as different as Cindy Sherman (Chapter 4), Walter de Maria (Chapter

5) and Dan Flavin (Chapter 7). Essentially, Conceptual Art is about ideas and about involving the spectator in a dialogue about them; aesthetic considerations are not of paramount importance although they are often present. Much past art could be described as conceptual, particularly when it has complex iconography and is involved with telling a story. But in modern Conceptual Art the meanings are not certain. See Chapters 3, 4, 5, 6 and 7.

Concrete This can be used in the most normal sense of something resembling cement, but reinforced concrete is strengthened through the use of steel bars within it. Architects can do away with traditional forms of construction like bricks and mortar or stone. In skyscrapers, a steel frame can be clad in concrete; wooden shuttering contains the wet concrete until it is set and is then taken away to reveal the material. It is very versatile and was used to revolutionize the shape and form of buildings as in the work of Le Corbusier and Mies van der Rohe (see Chapter 6).

There is also the idea of concrete poetry, where the meaning is conveyed as much by the layout of the words on the page as by the words and phrases themselves. See the section on Apollinaire in Chapter 2.

The word 'concrete' can also describe a kind of abstract art that is completely non-figurative, reduced to geometrical shapes and primary colours, as in the work of Mondrian. The word was first used in this sense by Theo van Doesburg, the leader of the De Stijl movement in 1930. See Chapter 6.

Construction Obviously this can be applied to the construction of a building, but it is also a term used loosely to describe the compositional organization and structure of a picture. Sometimes refers to works that are not carved or modelled and where the borderline between painting and sculpture has become blurred. Some types of collage, in which three-dimensional materials like wood are applied to the surface of the picture, are called constructions, as are the three-dimensional works of Russian Constructivism (see Chapters 5 and 6).

Consumerism The buying and consuming of material things, where the packaging and advertising of the object is particularly important in relation to the person buying it, the consumer. It is important, especially in connection with Pop Art, which embraced the world of advertising. This had changed the appearance of the postwar world from the 1950s onwards; see Chapter 5. See also **commodity**.

Décalcomanie A technique in which colour is laid on moderately thin, white paper. Then this is covered with another sheet of paper while the colour is still wet, so that the pigments flow into one another to create accidental or chance images. Invented by Oscar Dominguez and developed by Max Ernst. See **frottage**, **grattage** and Chapter 5.

Deconstruction see Chapter 6.

Dislocation In modern art this can mean the making of images that are physically broken up, as in Cubism or Futurism (see chapters 1 and 2), or upsetting your expectations of what you think something would look like or mean. For example, the use of space and proportion in a painting by de Chirico (see Chapter 5) or where the normal association between objects is disjointed as in Surrealism (see Chapter 3). It can also be applied to cultural disruption such as that caused by the two world wars (see references all the way through this book).

Divisionism or Neo-Impressionism, or Pointillism. A technique invented by Georges Seurat to combat the lack of structure in impressionist painting. It involved painting with spots or small strokes of primary and complementary colour, all of equal size. The surface of the picture is thus more disciplined and controlled, and the image becomes clearer. See Chapter 7 and *Learning to Look at Paintings*, Chapter 3.

Dynamic A word used (particularly, early in the twentieth century) to describe the moving modern world of mechanization, industrial processes and flying. In modern art it is particularly influential in the context of the creation of space which is interpreted as not being static and measured as it was in earlier times. Influenced by changes in science and philosophy, the idea of movement and flux is very much part of modern art in a more general sense as well.

Ethnography The study of cultures different from our own. Ethnographic art such as traditional African sculpture was particularly important in its influence on Picasso, Matisse and early German Expressionists like E. L. Kirchner (see chapters 1 and 2). It is also important in relation to the study of art history where ethnicity in terms of race can become a point of view from which to study the subject, just as with Feminism or Deconstruction (see Chapters 4 and 6)

Facet The side of a three-dimensional object, which can be manipulated in its reconstruction, as in Cubism; see **planes.**

Feminism see Chapter 4.

Fibreglass A material used in some types of sculpture. It combines strength with lightness. It consists of strands or fibres of glass set in a resin, but can be made to appear solid and heavy. See section on Anish Kapoor in Chapter 8.

Figurative and **Figuration** These refer to a work of art with a recognizable or partly recognizable subject. See also **Non-Figurative**.

Formalism and **Formalist** These refer to the **abstract** qualities (particularly of paintings) like composition, space, form, tone and colour, and their arrangement. Used especially by critics such as Clement Greenberg to denote modernist qualities in which the processes of making the work of art are more obviously visible than they would be in a Dutch seventeenth-century still life painting, for instance. Having said that, though, there are artists who display those tendencies all the way through the history of Western art, certainly from the Renaissance onwards; see Introduction and Chapters 1 and 3.

Found Objects Refers to items of a throwaway kind used in a **collage**. They could be driftwood or anything picked up by an artist who finds them attractive.

Free Association A phrase coined by Sigmund Freud to imply the disjointed imagery we experience in dreams, where objects or events are juxtaposed in ways they would not be in everyday life. It can also refer to a technique used in psychoanalysis to free a patient's mind, in order to release (often painful) connections from the person's past, which are embedded in the unconscious. Although dreamlike imagery had existed before in the traditions of Fantasy Art and Symbolism, it was developed in the modern period by artists like de Chirico, surrealists like André Breton, Ernst and Dalí, and film-makers like Hitchcock and Buñuel. It can also be connected with **collage** except that in fantasy and surrealist work the compositions are entirely painted. See also **collage** and Chapters 3 and 5.

Frottage A technique devised by Max Ernst to aid the creation of the dreamlike images of Surrealism. Essentially, frottages imitate the effect of brass rubbing with oil paint, but in all sorts of ways in order to create a variety of textures suggestive of moods, images and associative ideas. See also *décalcomanie* and **grattage** in Chapter 5.

Genre A term to describe different types of subject-matter as in the so called 'hierarchy of the genres'. These include religious, his-

torical and mythological subjects, followed by portraits, landscape, still life and 'genre' (which in this context means scenes of everyday life). See Chapter 8.

Glazes Used in oil paintings to create luminosity. The pigment is thinned down so that light can travel through it. Used by most artists in oil painting to a greater or lesser extent, particularly the old masters.

Golden section The proportion of roughly three-eighths to five-eighths, whose exact mathematical calculation is complex. It is a proportion whose regularity occurs not in its measurement into equal parts like a half or a quarter or a third, but in the fact that the relationship of the smaller part to the larger part is the same as the larger part to the whole. The principle derives from the Greek mathematician Euclid who described it in Book vi, Proposition iii of the *Elements*.

Gouache Opaque watercolour painting.

Gradation Usually applied to colour or tone in relation to very carefully graded tints or shades. The gradual movement from one colour or shape to another, eliminating hard lines. In this book it could be applied to all sorts of artists but is particularly obvious in the work of Kandinsky and Klee in Chapter 4 and in the **airbrush** technique of Ed Ruscha in Chapter 8.

Graffiti Drawing and painting on walls particularly in public places in a free and unformed way. It is often used to make a political point with slogans added to the images. However it has become part of mainstream modern art since the time of Art Informelle in post-war Paris, see Chapter 5.

Grattage Another technique used and developed from **frottage**. In this case, wet oil paint is applied over layers that have already dried. Then a razor blade is used to remove sections of the wet paint to reveal unexpected shapes below. Another type of **free association** process, used by the Surrealists, particularly Max Ernst; see Chapter 5.

Happening see **Performance Art**.

I-Beam see **Beam**.

Iconography Connected with the understanding of subject-matter and its meaning, with particular reference to painting of the past. The study of what a subject meant to the patrons and spectators of the period when a painting was made; see *Learning to Look at Paintings*, Chapter 6. In modern art, iconography is not so much about a programme of meaning

but more concerned with the power of suggestion and the presentation of an image that encourages spectators to participate and make up their own minds about what it means to them. See Chapters 3, 4 and 5.

Iconology A broader term than **iconography**, referring to the study of symbols and the development of their meaning in the visual arts. In modern art the question of symbolism is not about specific meanings but more concerned with suggestive and generalized ones.

Ideal and **Idealization** Making objects or people more beautiful than they really are. It achieves a kind of generalization so that the representation of a tree, for example, can stand for all trees. This can be seen in *The Arcadian Shepherds* by Poussin, in Chapter 3. In modern art, ideal is more usually connected with some of the ideology in artists' manifestos, and also with the ideal city and the general **utopian** aspirations behind the idea of the 'design for living' (see Chapter 6).

Imagery In past art the meaning of this word would be obvious because it was about the making of visual images. But in modern art, visual imagery and in particular the reproduced image has become much more important. It is a cliché to say that we live in a world of images but it is more true of the modern period than ever before and has had a profound influence on the visual arts in all sorts of ways.

Impasto The technique, which usually refers to oil painting, where the paint itself becomes thicker in order to convey form. It stands out from the surface of the canvas and creates a feeling of solidity. Palette knife, fingers or brush can be used to achieve this. In modern art the term can be applied not only to artists like Lucian Freud or Jenny Savile (in Chapter 8) but also to the techniques of Jean Fautrier (in Chapter 5).

Installation This very broad term refers to a wide range of mainly three-dimensional work, but with one important distinction: it is not meant to last as a permanent work of art. It is installed, hence its name, on a particular site and then has to be dismantled before it can be moved. Also, importantly, it is often not 'made' or crafted by the artist in the traditional sense, but is carried out and put together by others; the term can also be applied to video art, which involves the installation of screens and the use of film – so it can apply equally to work by artists as different as Robert Morris, Bill Viola or Mark Wallinger. See

also **Conceptual Art** and Chapters 3, 4, 5 and 7.

Japan paper Usually refers to the thin Japanese rice papers hand-made from vegetable fibres, which are boiled to a pulp with rice and veni root as a binder. These papers are fine, delicate and very absorbent, particularly for watercolour. Very elegant results can be achieved, as in the work of Paul Klee (see Chapter 4).

Japanese print Made from very hard wood blocks. The Japanese Ukiyo-e school, which included Hiroshige and Hokusai, did relief printing in which the raised areas of the block take the ink. They were very influential on early Modernism because of the extreme simplification of their design and the use of overlapping flat planes to create the space and bright colours. Artists like Dégas, Van Gogh, Gauguin and Toulouse-Lautrec loved the Japanese print particularly, but the influence was passed on to the early twentieth century. Frank Lloyd Wright certainly thought that modern art and design had been influenced by the Japanese print. See Chapter 6 for more detailed discussion of the Japanese print and its influence; see *Learning to Look at Paintings*, Chapters 1 and 5.

Kinetic The idea of moving sculpture, from which the mobile originates. It was invented by the Russian Constructivists. It consists of sculptures that are not solid and are often suspended from the ceiling so that they move constantly. Sometimes they may have a motor inside to make them oscillate. Kinetic sculpture comes from the same set of ideas as those about dynamic, moving and flowing space; see **dynamic** and Chapter 6.

Machine aesthetic A phrase used by Le Corbusier and his contemporaries to refer to a design whose initial idea derived from engineered forms like those of ocean-going liners, cars and aeroplanes, in other words, designs that were modern because they derived from industrial processes. See Chapter 6.

Media A term applied to radio, film and television, and also to newspapers and magazines. They are all forms of communication, which allow information and opinion to be passed to a wider public than ever before. Photography and film have become generally very important in the visual arts in all sorts of ways. Mentioned throughout the book and particularly in the Epilogue.

Mediation This means that the art we look at is often arrived at through reproductive imagery rather than being originally made

from scratch as in more traditionally crafted arts like painting and sculpture. Of course print-making has always involved processes of reproduction, but not always in such a ubiquitous and mass-produced way. The idea of mediation is particularly important in Postmodernism (see Introduction).

Medium As well as being the singular of **media**, and connected with photography and film, it can also mean the material and process through which a work of art is created, such as oil paint, watercolour or various kinds of print. The technique on the other hand refers to the way the medium is used, hence the phrase 'technique and medium'.

Merz A term used by Kurt Schwitters to describe his work in collage. He arrived at it when fitting the letterhead of the Commerz und Privats bank, cut out of a newspaper, into one of his collages. It exemplifies the idea of using rubbish to make compositions and expresses the anti-establishment attitudes of the Dada movement, with which Schwitters was loosely connected. See *Learning to Look at Paintings*, Chapter 3.

Monochrome or **Monochromatic** Black-and-white or simple colour. Drawings and prints are mostly monochrome because they usually only use black and white, or a simple colour in varying tones. The term also applies to black-and-white photography, of course; see Man Ray and Brassaï in the Epilogue.

Mortar Refers to the type of cement used between bricks or stones in a wall.

Mosaic A technique where pictures are made out of small pieces of cut or facetted glass called tesserae. They are laid close together in a plaster base at slightly different angles in order to catch the light. This applies particularly to mosaics on ceilings and walls. The effect of mosaic is referred to in connection with the work of Chuck Close in Chapter 8.

Multiple image A repetitive series of images as in Andy Warhol's soup cans, which appear to be the same but actually are not (see Chapter 5). Warhol also produced multiple portraits as in the 25 coloured Marilyns; see Chapter 6 in *Learning to Look at Paintings*. These works make a direct reference to mass production, advertising and the media.

Multiple-viewpoint perspective Used of paintings that include more than one viewpoint for their depiction of space and form; see Picasso and Braque in Chapter 1.

Multiples Can mean works of art made in more than one version –

like bronzes for instance which have always been reproducible – although it usually refers to **media**-based works.

Mythological and **Allegorical** Adjectives used to describe subject-matter taken from myths of the ancient world, as written down by classical poets, like Ovid in the *Metamorphoses*. When mythological, the subject-matter is narrative. Very closely related is the allegorical subject, where the story is told as a metaphor for the communication of an idea. This is referred to briefly in Chapter 1.

Nihilism A word meaning no belief in anything and usually applied to moral or religious areas. However, it can be used in the arts as an expression of the desire to destroy all established beliefs and question all traditional standards. Very characteristic of the Vorticists (see Chapter 2) and Duchamp and Dada (in Chapter 3).

Non-figurative Works of art without a recognizable subject. A more specific way of describing **abstract** painting. See also **figurative**.

Oil painting A technique where the pigment is mixed with oil in varying amounts and a solvent like turpentine. It can be thinned down to make **glazes** or mixed thickly to create **impasto**. Dries more slowly and so is altogether more flexible than other techniques; if you change your mind you can scrape it all off and start again. Most commonly used on canvas or panel, when it can be referred to as easel painting, because it is supported by an easel while the artist is working on it.

Oil transfer A technique developed by Paul Klee in which a drawing in oils is transferred to a subtly painted watercolour background (see Chapter 4).

Opaque A word used to describe density in colour. Also for techniques like **pastel** or **gouache**, which are not translucent.

Papier collé see **Collage**.

Pastel A pigment bound in glue so that it becomes solid like a stick of chalk. As in **gouache**, the colours are **opaque**. Although you hold it like a chalk or crayon, the effect is more like painting, so it is sometimes referred to as pastel painting. It is very soft so you can smudge it and alter it as you go along. However, it requires great control on the part of the artist because it can easily become messy and imprecise. See Paula Rego in Chapter 8.

Pastoral see **Arcadia**.

Performance Art This can also be referred to as a Happening, in which the work involves a performance in the theatrical sense with people doing things over a certain length of time. The spec-

tator might need to attend on a certain day and in a certain place in order to see it. Sometimes it might contain the seeds of its own destruction as in the famous example by Yves Tinguely; it also blurs the distinction between fine art and theatre or film. See Chapter 3.

Perspex A form of translucent or transparent plastic, which can be cut and moulded. Perspex is an industrial product often used in place of glass. Used by the Russian Constructivists (see Chapter 6).

Photography see **Media**.

Photomontage see **Collage**.

Pictorial The characteristics or elements in a picture that are connected with its visual qualities such as composition, space, form, tone and colour.

Picture plane In linear perspective this is the horizontal line nearest the viewer, which corresponds with the surface of the picture. You look through it as if through a pane of glass. But it can be disrupted in various ways through illusionism and the creation of space in front of it rather than behind; see Cubism in Chapter 1.

Picturesque Literally this means 'like a picture' but, in the later eighteenth century particularly, it came to have a complex and quite specific meaning connected with the relationship between buildings and the landscape surrounding them. One of its chief theorists, Uvedale Price, said that it involves the characteristics of 'intricacy', 'irregularity' and 'roughness'. In Chapter 8, reference is made to Richard MacCormac's Garden Quadrangle at St John's College, Oxford, which contains some of these qualities, particularly in the way it relates to the garden; it could also be applied to Ian Hamilton Finlay's garden at Stoneypath, referred to in Chapter 3. Both these works can be said to be part of the Postmodernist sensibility in the way they re-interpret tradition.

Piloti A French word for pillars or piles. Modern architects like Le Corbusier or Mies van der Rohe raised some of their designs on *piloti* to allow space below for cars and to create a more freestanding spatial expression for a building (see Chapter 6).

Pixels The points of light in primary and complementary colours, which are used to make a digital image. They are the electronic equivalent of the minute dots used in colour printing. The effect of the pixels is rather like **divisionism** in painting in the sense that the points build up into the appearance of solid forms. Digital imaging has become quite important in the development of computer-aided design; see Chapter 8 on Chuck Close.

Planes The horizontal lines that recede at diminishing intervals towards the horizon line in linear perspective. The planes of a three-dimensional object are the direction of its different surfaces (see Chapter 1).

Plasticity Traditionally this word refers first and foremost to modelling and the conveying of three-dimensional qualities generally. Sometimes referred to as sculptural; in this sense, the term plastic can be applied to sculpture and architecture as well as painting. All three can be referred to as the plastic arts. However, in modern art it can also be used in Apollinaire's sense of the juxtaposition of words in a poem or found objects in a **collage**; or it can be used in Frank Lloyd Wright's sense of a **dynamic** and free-flowing space. See Chapters 5 and 6.

Plinth The platform or base on which a sculpture is mounted. Putting sculpture on the ground without a plinth was part of the development of modern sculpture and really began with works like Rodin's *Walking Man* (see Chapter 2).

Primary and **complementary colours** The constituents of white light as revealed through the prism or in a rainbow. There are seven prismatic colours: red, yellow and blue are the primaries, and green, orange, indigo and violet are the complementaries. All these colours contrast with one another, but the strongest contrasts are between the primaries and complementaries; see start of Chapter 7 and *Learning to Look at Paintings*, Chapter 5.

Radical Implies advanced views or positions of an extreme kind, whether they be artistic or political. It can be applied to many of the abrupt, forward-moving changes of direction which can be charted in modern art. See also **avant-garde**.

Readymade A work created out of objects that already exist, which deliberately does not express aesthetic considerations; it invites the spectator to think about whether and why it can be thought of as art. The **readymade** was invented by Marcel Duchamp and has been very influential on the development of **Conceptual Art**. See also Chapter 3.

Reinforced concrete see **Concrete**.

Relative A loose term used to imply a lack of absolutes. It applies in modern art particularly to the new understanding of space in the early twentieth century, which was altered from a three-dimensional one to include the fourth dimension, which is time. Therefore it becomes relative, because it is constantly changing; it refers to Albert Einstein's theory of the universe that all

motion is relative. In philosophy it means human knowledge is only relatively true or certain and in psychology that sensations are significant only in relation to other sensations.

Reproductive Applies to imagery that is reproducible by digital or mechanical means; see **media** and **imagery**; it can also apply to all kinds of printing like lithography or screen printing.

Resonance In the context of modern art, this can be used to describe echoes or associations in terms of meaning – for instance, in Fantasy Art or Surrealist painting. See Chapters 3 and 5.

Retinal painting A term used by Marcel Duchamp to describe painting that was primarily concerned with how we see the world and the processes of making a picture. Duchamp suggests that this trend began with Courbet and therefore it can be interpreted as a reaction to those modernist tendencies referred to above which came to be called **Formalism**. Duchamp's emphasis on meaning rather than aesthetics was an important impetus behind the development of **Conceptual Art** in the 1960s (see Chapters 1 and 3).

Saturated A term for colour that is concentrated and undiluted. More pigment may be added but the colour cannot be made any more intense.

Scanning The movement of a scanning device over an image before printing it from a computer. It is connected particularly with digital imagery, but is also used to describe the way we quickly take in visual information from all over an image or a view as in scanning the horizon.

Screen printing and **Serigraphy** A stencil method of making prints, where the design is stamped out of protective sheets and the ink is pressed into the vacant spaces with a squeegee.

Sequential imagery Similar to chronophotography in the sense that it is the recording of a sequence of movements, but they are in separate frames rather than being in a single image. Applies to the work of Eadweard Muybridge and Etienne Jules Marey; see **chronophotography**.

Serial art A term used to describe the standard components often used in Minimalism and set in a regular pattern on a modular principle as with the work of artists like Carl Andre, Sol Le Witt or Dan Flavin; see Chapters 5 and 7.

Serial imagery Implies repetition of the same picture over and over again, as in any form of commercial printing. It can be applied to the multiple images of Andy Warhol or the screen prints of

Eduardo Paolozzi but these are not modular as in **serial art**.

Series painting An expression usually applied to the later work of the impressionists, where artists like Monet or Pissarro would do paintings of the same subject over and over again with variations arising from the time of day or weather conditions or a different viewpoint.

Simultaneity Derived from Chevreul's theory of the simultaneous contrast of colours and used by Robert Delaunay and Apollinaire to describe the experience of seeing and feeling everything at once in a **dynamic** and constantly changing way. It could be applied to Cubism, Futurism and Vorticism, but was mostly used in relation to Delaunay's Orphism; see Chapters 1, 2 and 7.

Skyscraper The tall buildings designed first in Chicago at the turn of the century. This involved a completely different method of building compared to the traditional use of stone or bricks and mortar; the skeletal steel structure, like the bones of a body, is put up first and then the **concrete**, glass or other materials are used as a cladding. The invention of the electric lift or elevator was crucially important for this kind of design, as was the manufacture of **steel** for the frame, and the beams to support floors, ceilings and **cantilevered** roofs.

Spraygun see **airbrush**.

Steel A product with greater tensile strength than wrought or cast iron, because it has a higher proportion of carbon within it. It was developed in the nineteenth century and has had a huge influence on architecture and design. See also **skyscraper**, **concrete** and Chapter 6.

Steel joists see **cantilever**.

Stylization This is where the design of a figure or a form is not, strictly speaking, naturalistic but everything is treated more for the purposes of expression – as, for instance, in African sculpture; see Chapter 1.

Sublime A concept developed in the eighteenth century to suggest the experience of something greater than oneself. In art it was applied to landscape painting in England, particularly where the scale of the natural world was made to look huge in relation to the size of a person, as in the work of Turner. Barnett Newman uses 'sublime' more in the sense of a great spiritual experience; see Chapter 8.

Texture In modern art this is not necessarily about the description

of surface but where the surface of a work of art is part of its expression, as in the painting of Jackson Pollock or the sculpture of Giacometti.

Topographical A type of picture in which the aim was to record a particular place or building in great detail. Often a drawing with a watercolour wash. In modern art, the work of John Piper is a good example of the reinterpretation of this tradition; see Chapter 8.

Transposition Where the shape and form of an object is changed into another so that its meaning is different. Typical of surrealist painting. A good example would be Picasso's sculpture of the *Venus of Gas* (see Chapter 8).

Treatment The way artists interpret a subject or the way a particular technique is used.

Utopian An adjective with a long and complex history. In modern art it is used to describe the expression of **ideals**, particularly about architecture and the design of the city, and also the language of some of the early twentieth-century manifestos. See **ideal** and **idealization**, and Chapter 6.

Vertical architecture A name for tall buildings collectively; see also **skyscraper**.

Warm and cool colours Within the spectrum, some colours are warm and have a shorter wavelength and others are cool and have a longer one. When placed in a picture, the warm ones will tend to come forward and the cooler ones stay back. They can also be used for creating mood. See Matisse in Chapters 2 and 6 and Kandinsky, Klee and Rothko in Chapter 4.

Watercolour Pigment mixed with water and a soluble glue and used usually on paper. A fluid medium which dries quickly, where the lightest areas are made by dilution with water, allowing the pale paper to show through, rather than by the addition of white.

References and Further Reading

This is not a comprehensive bibliography: it would be impossible to list all the sources of different kinds that I have consulted. The written material is as diverse as modern art itself, as these titles show. The following lists are mainly of works mentioned in the text. They fall into three groups:

- general introductions and reference works, including primary sources
- writings by or about individual artists
- catalogues of exhibitions and collections.

GENERAL

The Oxford History of Art series gives a lively, thematic presentation of modern art; new books are continually being published. The Thames & Hudson World of Art series has good, broadly chronological introductions to specific modern movements and individual artists. The *Encyclopaedia Britannica* is also useful: the entries are mostly written by experts for the general reader.

The Oxford Companions (by Brigstocke and Osborne) and the Tate books (the Companion was first published in 1990 as *Tate Gallery: An Illustrated Companion*) consist of alphabetical entries and essays, but offer more than any dictionary. The *Dictionary of 20th-Century Architecture* – edited by Lampugnani, the updated successor to the *Encyclopaedia of Modern Architecture* of 1963 – has helpful descriptions of modern materials and (in more recent editions) useful definitions of Postmodernism and other terms.

Much writing about modern art is mixed up with theory, whether it is one artist's manifesto or the critical position of a whole movement, such as Feminism, Marxism or Deconstruction. In this book, many of the quotations from such primary sources are taken from Chipp or Harrison and Wood.

Books in the Fontana Modern Masters series summarize the ideas of the twentieth century's most influential thinkers, like Einstein, Nietzsche and

Freud. There are now similar series published by Routledge and Oxford University Press. In trying to understand recent art and architecture, some knowledge of Postmodernist theory can be extremely helpful; Broadbent and the two books edited by Lodge supply a lay-person's guide to this difficult area.

Chadwick and Robinson are two standard works on the way the Feminist movement has changed attitudes, especially in the humanities, and the status of women.

Bowness, A., *Modern European Art* (Thames & Hudson, 1972)

Brettell, R. R., *Modern Art, 1851–1929* (Oxford University Press, 1999)

Brigstocke, H. (ed.), *Oxford Companion to Western Art* (Oxford University Press, 2001)

Broadbent, G., *Deconstruction: A Student Guide* (Academy Editions, 1997)

Causey, A., *Sculpture since 1945* (Oxford University Press, 1998)

Chadwick, W., *Women, Art and Society* (Thames & Hudson, 1990)

Chipp, H. B. (ed.), *Theories of Modern Art* (University of California Press, 1968)

Crowther, P., *The Language of Twentieth-century Art: A Conceptual History* (Yale University Press, 1997)

Curtis, P., *Sculpture 1900–1945* (Oxford University Press, 1999)

Frampton, K., *Modern Architecture: A Critical History* (Thames & Hudson, 1980, revd 1992)

Ghirardo, D., *Architecture after Modernism* (Thames & Hudson, 1996)

Harrison, C. and Wood, P. (eds), *Art in Theory, 1900–1990: An Anthology of Changing Ideas* (Blackwell, Oxford UK and Cambridge USA, 1992)

Hopkins, D., *After Modern Art, 1945–2000* (Oxford University Press, 2000)

Hughes, R., *The Shock of the New: Art and the Century of Change* (1st edn BBC, 1980; Thames & Hudson, 1991)

Kemp, M. (ed.), *Oxford History of Western Art* (Oxford University Press, 2000)

Lampugnani, V. M. (ed.), *Dictionary of 20th-century Architecture* (Thames & Hudson, 1988)

Lodge, D. (ed.), *Twentieth-century Literary Criticism: A Reader* (Longman, 1972)

—— *Modern Criticism and Theory: A Reader* (Longman, 1988)

Osborne, H. (ed.), *Oxford Companion to Twentieth-century Art* (Oxford University Press, 1981)

Robinson, H. (ed.), *Feminism–Art–Theory: An Anthology, 1968–2000* (Blackwell, Oxford UK and Cambridge USA, 1992)

Russell, J., *The Meanings of Modern Art* (Thames & Hudson, 1981)

Sandler, I., *Art of the Post-Modern Era from the Late 60s to the Early 90s* (HarperCollins, 1996)

Tate Gallery: An Illustrated Companion (Tate Publishing, 1990)

The Tate Britain Companion to British Art (Tate Publishing, 2001)

Tate Modern: The Handbook (Tate Publishing, 2000)

Woodham, J. M., *Twentieth-century Design* (Oxford University Press, 1997)

ARTISTS

This is a selection of writings by or about artists discussed in the text, or by their contemporaries, as well as useful histories of art in the modern period. Books on modern art often refer to Bergson and Steiner, but anthologies are more likely to include writers like Freud or Nietzsche.

Apollinaire, G., *The Cubist Painters* (1st edn, 1913), trans. P. Rosebery (Broadwater House, 2000)
—— *Selected Poems*, trans. O. Bernard (Penguin, 1965)
Baldassari, A., *Picasso and Photography: The Dark Mirror* (Flammarion and Museum of Fine Arts, Houston, 1997)
Banham, R., *Theory and Design in the First Machine Age* (Architectural Press, London, 1960)
Baudelaire, C., *The Painter of Modern Life, and Other Essays*, ed. and trans. J. Mayne (Phaidon Press, 1964 and 1981)
Benjamin, W., *Illuminations*, ed. with intro. H. Arendt, trans. H. Zorn (Pimlico, London, 1999)
Bergson, H., *Matter and Memory* (1st edn, 1896), trans. [1911] N. M. Paul and W. S. Palmer, Muirhead Library of Philosophy (Harvester Press, London, 1978)
Bourgeois, L., *Writings and Interviews, 1923–1997: Destruction of the Father, Reconstruction of the Father* (Violetter Editions, 1998 and 2000)
Buchloh, B., Chevrier, J. F., Zweite, A., and Rochlitz, R. *Photography and Painting in the Work of Gerhard Richter: Four Essays on Altas* (Consorci del Museu d'Art Comtemporani de Barcelona, 1999)
Buñuel, L., *An Autobiography: My Last Sigh*, trans. A. Israel (Vintage Books, 1984)
Clark, T. J., *Farewell to an Idea: Episodes from a History of Modernism* (Yale University Press, 1999)
Costa Meyer, E. da, *The Work of Antonio Sant'Elia* (Yale University Press, 1995)
Delacroix, E., *The Journal of Eugène Delacroix*, ed. H. Wellington, trans. L. Norton (Phaidon Press, 1951)
Fried, M., *Manet's Modernism* (Chicago University Press, 1996)
Friedenthal, R. (ed.), *Letters of Great Artists*, Vol. 2: Blake to Pollock (Thames & Hudson, 1963)
Friedman, B. H., *Jackson Pollock: Energy Made Visible* (1st edn, 1972; Da Capo Press, 1995)
Friedman, M. (ed.), *Gehry Talks* (Rizzoli, New York, 1999)
Greenberg, C., *Art and Culture* (Beacon Press, Boston, 1961)
Handbook of the Guggenheim Museum, Bilbao (Connaissance des Arts, 2000)
Hopkins, D., *Marcel Duchamp and Max Ernst: The Bride Shared* (Oxford University Press, 1998)

House, J., *Monet* (Phaidon Press, 1977)

Ingrams, R. and Piper, J., *Piper's Places* (Chatto & Windus, Hogarth Press, London, 1983)

Jencks, C., *The Language of Post-Modern Architecture* (Academy Editions, 1977)

Kandinsky, W., *Concerning the Spiritual in Art* (1st edn, 1910; Dover Books, 1979)

—— *Point and Line to Plane* (1st edn, 1926; Dover Books, 1979)

Le Corbusier, *Towards a New Architecture* (1st edn, 1923; Architectural Press, 2000)

Leighten, P., *Re-ordering the Universe: Picasso and Anarchism, 1897–1914* (Princeton University Press, 1989)

Libeskind, D., *The Jewish Museum in Berlin* (Studio Libeskind, Hélène Binet and G. & B. Arts International, 1999)

—— *The Space of Encounter* (Thames & Hudson, 2001)

Lomas, D., *The Haunted Self: Surrealism, Psychoanalysis and Subjectivity* (Yale University Press, 2000)

Mullarkey, J. (ed.), *The New Bergson* [in particular the essay on 'The rhythms of duration and the art of Matisse' by Mark Antliff] (Manchester University Press, 1999)

Pissarro, C., *Letters to His Son Lucien* (Da Capo Press, 1995)

Richardson, J., *A Life of Picasso*, 2 vols (Pimlico, 1992–6)

Rubin, J. H., *Gustave Courbet: The Manifesto of Realism* (Phaidon Press, 1997)

Rugoff, R., 'Lost horizons' in *Tate Magazine* (Summer 1999)

Safranski, R., *Nietzsche: A Philosophical Biography* (Granta Books, 2002)

Severini, G., *The Life of a Painter* (Princeton University Press, 1995)

Shattuck, R., *The Banquet Years: The Origins of the Avant Garde in France, 1885 to World War One* (Jonathan Cape, 1968)

Spurling, H., *The Unknown Matisse* (Hamish Hamilton, 1998)

Steiner, R., *Anthroposophy in Everyday Life: Four Lectures* (Anthroposophic Press, 1995)

Summerson, *Heavenly Mansions* (1st edn, 1948; W. W. Norton & Co., 1963)

Sylvester, D., *Interviews with Francis Bacon* (1st edn, c.1975; Thames & Hudson, 2002)

Tomkins, C., *Marcel Duchamp* (Henry Holt & Co., 1996 and Owl Books, 1998)

Van Bruggen, C., *Frank O. Gehry* (Guggenheim Museum, Bilbao)

Venturi, R., *Complexity and Contradiction in Architecture* (Museum of Modern Art, New York, 1966)

Washton-Long, R.-C. (ed.), *German Expressionism: Documents from the End of the Wilhelmine Empire to the Rise of National Socialism* (University of California Press, 1993)

West, S., *The Visual Arts in Germany, 1890–1937: Utopia and Despair* (Manchester University Press, 2000)

Whitford, F., *The Bauhaus* (Thames & Hudson, 1984)
Wright, F. L., *Autobiography* (1st edn, 1932; Horizon Press, 1977)

CATALOGUES

Those listed here are just a selection, but they are a very good source for all modern art, especially the most recent work. They are often the work of many contributors so they are not listed by author, but by subject (if an individual) or title, ignoring '*A*' or '*The*'.

Adam. *Moonraker, Strangelove and other Celluloid Dreams: The Visionary Art of Ken Adam* (Serpentine Gallery, London, 1999)
Amazons of the Avant Garde in Russia (Royal Academy of Arts, London, 1999)
American Art of the Twentieth Century (Royal Academy of Arts, London, 1993)
Apocalypse (Royal Academy of Arts, London, 2000)
Art of the Avant Garde in Russia: Selections from the George Costakis Collection, ed. M. Rowell and A. Z. Rudenstine (The Guggenheim Museum, New York, 1981)
A Bitter Truth: Avant Garde Art and the Great War (Barbican Gallery, London, 1994 and Yale University Press)
Bonnard. *Drawings by Bonnard* (Arts Council, 1984–5)
—— *The Graphic Work of Pierre Bonnard* (The Metropolitan Museum of Art, New York, 1989–90)
—— *Bonnard at Le Bosquet* (Hayward Gallery, London, 1994)
Brassaï. *No Ordinary Eyes* (Hayward Gallery, London, 2001)
British Art of the Twentieth Century (Royal Academy of Arts, London, 1987)
Close. *Chuck Close* (Hayward Gallery, London, 1999)
Dix. *Otto Dix* (Tate Gallery, London, 1992)
Encounters: New Art from Old (National Gallery, London, 2000)
Flavin. *The Architecture of Light* (Solomon R. Guggenheim Museum, 1999)
Freud. *Lucian Freud*, ed. W. Feaver (Tate Britain, 2002)
German Art of the Twentieth Century (Royal Academy of Arts, London, 1985)
Grosz. *The Berlin of George Grosz* (Royal Academy of Arts, London, 2000)
Gursky. *Andreas Gursky* (Museum of Modern Art, New York, 2001)
Hitchcock. *Notorious: Alfred Hitchcock and Contemporary Art* (Museum of Modern Art, Oxford, 2001)
Hopper. *Edward Hopper: The Art and the Artist* (Whitney Museum of Modern Art, 1981)
Impression: Painting Quickly in France, 1860–1890 (National Gallery, London, 2001, and Yale University Press)
Estorick Collection of Modern Italian Art (Umberto Allemandi, Turin and London, 1988)

Italian Art of the Twentieth Century (Royal Academy of Arts, London, 1989)

Kapoor. *Anish Kapoor* (Hayward Gallery, London, 1998)

Lista. *Giovanni Lista: Futurism and Photography* (Merrell Publishers, London, 2001)

Monet in the '90s (Royal Academy of Arts, London, 1990)

Monet in the 20th Century (Royal Academy of Arts, London, 1999)

Newman. *Barnett Newman* (Tate Modern, London, 2002)

Paris Post-War: Art and Existentialism, 1945–55 (Tate Gallery, London, 1993)

Picasso: Sculptor/Painter (Tate Gallery, London, 1994)

Pop Art (Royal Academy of Arts, London, 1991)

Purism in Paris, 1918–25 (Los Angeles Museum of Art and Harry Abrams, 2001)

Rego. *Paula Rego* (Tate Gallery, Liverpool, 1997 and Tate Publishing)

Richter. *Gerhard Richter: Forty Years of Painting*, ed. R. Storr (Museum of Modern Art, New York, 2002)

Rothko. *Mark Rothko* (Tate Gallery, 1987)

Ruscha. *Ed Ruscha* (Museum of Modern Art, Oxford, 2001)

Sensation (Royal Academy of Arts, London, 1997)

Spellbound (Hayward Gallery, London, 1996)

Surrealism: Desire Unbound (Tate Modern, London, 2001)

Turrell. *The Other Horizon* (MAK, Vienna, 1998–9)

The Vigorous Imagination (Scottish National Gallery of Modern Art, Edinburgh, 1987)

Vorticism and its Allies (Arts Council, Hayward Gallery, London, 1974)

Whiteread. *Rachel Whiteread*, ed. L. G. Corrin, P. Elliot and A. Schlieker (Scottish National Gallery of Modern Art, Edinburgh and Serpentine Gallery, London, 2001)

Index